the bauhaus
#itsalldesign

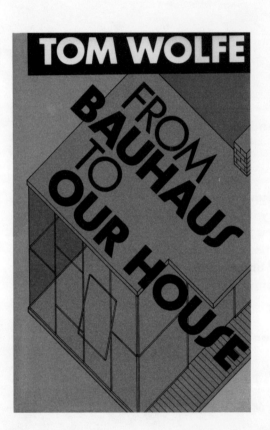

■001 **Cover of *From Bauhaus to Our House*,
Tom Wolfe, 1981,** Farrar, Straus and Giroux

There is virtually no other movement in the twentieth century that has been as thoroughly researched as the Bauhaus – from the history of its founding, to its art and architecture, its teaching concept, its protagonists and ideals through to its closure in 1933 under pressure from the National Socialists' seizure of power. Much has also been published about individual aspects of design at the Bauhaus – for example about furniture design, textile art and ceramics. Until now, however, there has not been an extensive exhibition about design at the Bauhaus. This gap is set to be filled by *The Bauhaus #itsalldesign* and this book. It focuses on the Bauhaus design concept, how it manifested itself in objects, publications, production processes and workshops and how it continues to resonate today.

When one considers the much talked-of "Bauhaus design", what comes to mind first are the design clichés of classical modernism: geometric, ascetic, industrial, cool. Tom Wolfe produced a wonderful celebration and critique of these stereotypes in his wicked pamphlet *From Bauhaus to Our House* (1981) ■001.[1] And in fact the Bauhaus was permeated by the spirit of an emerging industrial society, by rationality, technology, geometry – together with the everyday diktat of modernism that derived from this. Yet today, the postmodern critique of Bauhaus dogma is itself already history and we know that it is only one of many readings of the Bauhaus. Research has shown that there was not just one Bauhaus, but instead that rationalist, esoteric, experimental, socialist or life-reforming tendencies existed in "productive discord" (Joseph Albers).[2] An epoch-making phenomenon such as the Bauhaus therefore requires new interpretations and readings in each generation, and these readings are largely determined by the historical perspective of the time. From what perspective, then, do we look at Bauhaus at the beginning of the twenty-first century?

One answer to this is supplied by the book's subtitle: *today everything is design*. No longer just the design of an industrial product, but also the design of digital surfaces, the organization of social participation, of aesthetic codes, the design of bodies and ways of life. Many of the current debates about design revolve around digitization and the issues it generates – such as data security and authorship – but it is also the case that many familiar questions crop up again within this context. What is the relationship between design and art, between craft and industry? Who is the author of an object – an individual designer or a collective? What scope for design do the new technologies open up, and what responsibilities do they entail?

Many of these questions are strikingly similar to those that were already under discussion at the Bauhaus: the potential offered by new production processes and materials, the role played by designers in society and the advantages of interdisciplinary collaboration – discourses that can be pursued almost identically with current concepts such as 3D printing, smart materials, open design, critical design or social design. The open, cross-disciplinary understanding of design which extends far beyond pure product design and which is increasingly prevalent appears to be a continuation of what Walter Gropius called for at the Bauhaus under the slogan of "Kunst und Technik – Eine Einheit" [art and technology – a new unity]. At that time in Germany, this unity had not yet been given the name of design (instead it was known as "industrial art" or "everyday art"), eventually establishing itself under the term in the second half of the twentieth century.

In order to reinterpret design at the Bauhaus from this perspective, *The Bauhaus #itsalldesign* includes a wide range of exhibits, among them furniture, small objects, textile patterns, stagecraft, film and typography as well as examples from art and architecture. In addition, documents and important background information are shown, concerning, for instance, the work carried out in the workshops or in collaboration with manufacturers and industry, the debates around industrial and everyday art, and also about patents, copyright and the utilization of Bauhaus products. In this respect, an important source was the estate of patent lawyer Anton Lorenz, which is kept at the Vitra Design Museum. To date this is one of the most significant collections for the understanding of the early steel tube furniture industry, which played a crucial role in the mythologization and commercialization of the Bauhaus phenomenon.

The current perspective on the Bauhaus is illustrated by juxtaposing exhibits from the Bauhaus era with a number of works by contemporary designers, architects and artists. We received an extraordinary number of responses to our large-scale survey about the Bauhaus – among them contributions by Lord Foster, Alberto Meda, Hella Jongerius and also younger designers such as Thomas Lommée, Studio Unfold and Open Desk. Within this context, four projects are of particular significance in that they were designed especially for the exhibition and express today's view of the Bauhaus in a very precise way: Leipzig artist Adrian Sauer and architect Wilfried Kuehn have reconstructed some of the famous Bauhaus interiors in colour and so created a striking series of works that updates our notions of Bauhaus spaces through a new perspective between scientific research and digital image production; artist Olaf Nicolai has continued the concept of the Bauhaus book series by making use of the existing but unpublished titles; architect and curator Joseph Grima links the Bauhaus toy with the virtual worlds of the computer game Minecraft – both assemble the world from building blocks, making it "graspable" for everybody. Architect Philipp Oswalt investigates Bauhaus lamps, demonstrating how an object becomes a fetish, an icon and trademark – a search for clues and a case study about the Bauhaus myth.

In the confrontation between these contributions and historic works from the Bauhaus era, such a complex picture of design at the Bauhaus emerges that any talk of a uniform concept of "Bauhaus design" is finally dispatched to the history books. Indeed, it is in this diversity of different, at times contradictory, positions on design at the Bauhaus that its strength lies.

This is also evident from the fact that many of the current designers represented here take up equally diverse, subjective and in part just as contradictory readings of the Bauhaus. In so doing, the exhibition ultimately delivers a new view of the Bauhaus as a whole – the open concept of design that is addressed here can in fact be seen as a leitmotif for the Bauhaus overall, under which art, architecture, craft and industry were to come together.

This comprehensive exhibition was only made possible thanks to the support of numerous people and institutions. Our sincere thanks go to those who agreed to lend their works to us for an unusually long period of time: the museums, archives and individuals, especially Mr Bernd Freese, who has made his collection available for the exhibition, and Mr Udo Breitenbach, from whom we were able to acquire several significant works for our own collection. We would also like

to express heartfelt thanks to the three German Bauhaus institutions for numerous discussions in the preparation stage, for the support from their image archives as well as loans in one form or another. In the discussion with these three institutions, it became clear that the anniversary of the foundation of the Bauhaus coming up in 2019 has already been giving rise to new reflections on the Bauhaus and that *The Bauhaus #itsalldesign* project forms a part of this re-evaluation. This can also be seen in the fact that the exhibition was funded by the state of Baden-Württemberg within the context of the Bauhaus Verbund 2019.

It is thanks to countless partners that such a comprehensive publication could be released with the exhibition: the authors and their knowledgeable contributions, the team of editors and translators under Christina Bösel's direction (Textschiff) and the graphic designers Birthe Haas and Mark Kiessling (Greige). Moreover, our heartfelt appreciation applies to our Advisory Board (Joseph Grima, Wilfried Kuehn, Olaf Nicolai, Philipp Oswalt) as well as Wilfried Kuehn and Mira Schröder (Kuehn Malvezzi) for the design of the exhibition architecture.

We would also like to thank the team at the Vitra Design Museum as well as at the Bundeskunsthalle for their unfailing committment.

Last but not least, we owe a sincere thank you to all of our sponsors. Without their financial support this exhibition project would never have occurred on this scale. Our two main sponsors, HUGO BOSS and Mercedes-Benz, both feel a close connection with the Bauhaus in terms of their content and were therefore important dialogue partners on the question of how the Bauhaus is received today – whether this is in a fashion collection or in the choice of material for a car interior. Further funding came from the IKEA Foundation, for which we are also extremely grateful. Jolanthe Kugler managed the difficult task of developing a new perspective on a theme that to date has been the subject of numerous controversies, debates and scandals. This not only makes every exhibition about the Bauhaus a touchstone for one's own curatorial work, but also ensures that the theme remains intensely disputed today – because the Bauhaus is not history, it is a living part of the design of our age.

Dr Mateo Kries, Director, Vitra Design Museum
Rein Wolfs, Director, Bundeskunsthalle

1 Tom Wolfe, *From Bauhaus to Our House*, Farrar, Straus & Giroux, New York 1981.
2 Josef Albers, quoted in *Bauhaus* no. 6, 01/2014, p. 142.

Opening words

No other cultural institution is integrated so closely with the HUGO BOSS
identity than the Bauhaus. It stands for clarity, stringency and precision,
which also plays a pivotal and inspiring role in our collections.

Given this close association with our company, the exhibition *The Bauhaus
#itsalldesign* plays a special role in our two-decade long Arts Sponsorship
programme. It demonstrates impressively how the Bauhaus still today
influences designers and artists around the world, proving that the movement
possesses a unique relevance that has never waned. We wish to thank
the curator Jolanthe Kugler for her support and her inspirational contribution
in the lead-up to this project. We also wish to express our special gratitude
to all the participating artists and designers, and to the Vitra Design Museum
– specifically to the directors Mateo Kries and Marc Zehntner and their team –
for their wonderful ideas and impressive execution of this exceptional project.

Dr Hjördis Kettenbach, Head of Cultural Affairs, HUGO BOSS

the bauhaus

Bauhaus is one of the most influential style directions, seen as a revolutionary archetype in the fields of art, architecture and design. Simplicity of design and reduction to an object's essence are elements that can also be seen in Mercedes-Benz designs. Our philosophy of sensual clarity is an expression of modern luxury, as we aim to create designs that are truly timeless. We combine tradition with progress, creating the perfect balance between intelligence and emotion, driven by a constant desire to create icons of the future.

We would like to thank the Vitra Design Museum, in particular curator Jolanthe Kugler and her colleagues, for enabling such a successful collaboration. We are looking forward to this first step developing into a partnership that will yield many further creative projects.

Gorden Wagener, Head of Design at Daimler AG

#itsalldesign

9

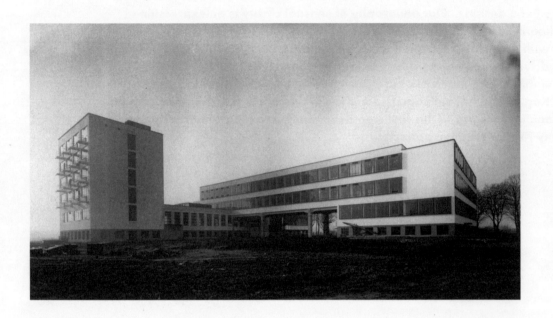

■002 **Lucia Moholy, Bauhaus building, Dessau,
northeast view, 1926,** silver gelatin print, 12.5 × 22.5 cm,
Bauhaus-Archiv Berlin

Few other institutions have been surrounded by as many myths as the most influential school of art and design in the twentieth century: the Bauhaus. Despite its brief existence (1919–33), the school not only succeeded in setting standards for avant-garde art, but also played a leading role in societal transformation at the same time. The Bauhaus gathered many of the most prominent national and international protagonists of its time: artists, scientists, art patrons and architects. They taught, held guest lectures, published books in the Bauhaus publication series, or became members of the circle of friends.[1] The idea of creating a new society by reshaping all spheres of life united them all. With great alacrity, the Bauhaus set out to search for "typical" characteristics of the new industrialized society (machines, mass production and traffic), to define a design concept that would shape the twentieth century and to prepare possibilities and approaches for a twenty-first-century design concept.

Although the Bauhaus was for a long time mistakenly understood as a cradle of cool rationalism and functionalism, it nevertheless attempted to assign a comprehensive societal role to new, upcoming designers right from the start. Combining fine arts and crafts under the primacy of architecture as a structured element of society, the Bauhaus strove for aesthetic synthesis, i.e. its products were to meet the needs of the wider public, thus achieving social synthesis. Accordingly, its functional concept always embodied a social orientation, giving both the issue of mass requirements and life and working conditions serious consideration.[2]

By making these demands on the designer's role and believing in the power of good design for the purpose of social transformation, the Bauhaus laid the foundation for what we would today describe as an "extended design concept" or "social design". It was all about design practice that did not wish to provide purely technological or consumer-oriented goods and services, but rather to create added social value. The Bauhaus wanted design to be an advocate of social matters that would develop solutions for everyday life – both interdisciplinary and together with users – from simple basic commodities to complex structures such as social and economic systems. This concept does not limit design merely to the level of product and industrial design, but insists that it is possible to shape all areas of human life. Hence everything becomes a question of design – and, ultimately, it's all design.

Whether intentionally or not, Viktor Papanek referred to that specific Bauhaus concept in the introduction of his controversial book entitled *Design for the Real World* in the 1970s. He was convinced that design could contribute to solving complex social problems, stating that the possibilities of intelligent design today and tomorrow are greater than ever, for the world is facing the need to reassess and renew its systems.[3] Today, his statement has lost none of its validity, because tomorrow has already begun.

Meanwhile, computer-assisted techniques have radically changed creative working methods, with designing, model building, prototyping and production processes all running at the same time. Besides enabling users around the world to take part in the process, the internet also provides a platform for new forms of joint designing. Since the late 1990s, the traditional concept of "product" has also changed.[4] As a result, not only hardware, but software such as interfaces, services and events are now involved in a process of conscious or subconscious

design. Movements like the Makers, crafting, co-working, Free Agent Nation, Volks-Entrepreneurship, prosuming, Fabbing, mass customization, open source, crowdsourcing, social commerce, Glokalpolitik and so on are growing rapidly and beginning to transform the world as we know it along with its production and distribution structures and consumer behaviour.[5] Today's designers, too, face the challenge of redefining their role in society – just like those Bauhaus pioneers did so many years ago.

The Bauhaus represented both a concept and a vision of life:[6] not so much a style, but more a new way of thinking, on a small and large scale. That is exactly what this exhibition aims to show. Visitors are guided through four thematic areas presenting examples of the Bauhaus's creative work, as well as its methods and approaches. Historical exhibits are accompanied by contributions from contemporary artists, designers and architects who introduce various approaches for tackling those topics today: #createcontext puts the ideas and concepts of the Bauhaus in the context of that time with its "daily torture", as Lyonel Feininger described it in a letter, and its new "attitude to the postwar psyche".[7] To be constantly aware of, and develop a view on, the environment with its social, political and economic conditions is a basic necessity in order to take an active part in shaping (or changing) the environment. #learnbydoing presents examples from the Bauhaus's test laboratories, training and production workshops, pottery and metal workshops, and carpentry and bookbinding workshops, accentuating the importance of gaining experience by doing things yourself. To do that, you have to be bold enough to imagine things as they could be, and not as they are, thus venturing beyond familiar borders – an approach that is clearly visible in the Bauhaus artists' contributions as well as the selected examples by contemporary designers. #thinkaboutspace further explores the Bauhaus's spatial concepts and visions. These include theoretical and artistic approaches to space such as Paul Klee's *Zeichnung zur Zimmerperspektive* [Drawing for Room Perspective] (1921) on the one hand, as well as concrete attempts to implement new spatial concepts such as Walter Gropius's and Fred Forbát's modular construction system on the other. They strove to apply methods of industrialization to architecture, thus hoping to do justice to social requirements by providing good, inexpensive living space for everyone, using structures made of prefabricated room units.

Moreover, it was considered just as essential to study the impact of colours and surfaces, since the Bauhaus not only saw colour as a decorative element, but also as a means of shaping spaces that would have a targeted effect on people's wellbeing.

Finally, #communicate presents examples of the Bauhaus's comprehensive communication strategy, from Bauhaus books, journals and exhibitions to a focus on images and typography. Like no other institution before, the Bauhaus was aware of the necessity to visualize and explain its own concepts as a vital requirement for putting them into practice. For new concepts need friends, and you can only gain friends through convincing communication strategies.

The structure of this catalogue corresponds to that of the exhibition. It also contains a glossary with key words related to all aspects of the Bauhaus, from avant-garde to zeitgeist and vegetable garden to dance, as well as several essays. While Arthur Rüegg shows how discussions on the industrial product in

theory and practice affected the Bauhaus, Claire Warnier and Dries Verbruggen view Bauhaus concepts from the perspective of contemporary designers who are yet again facing the challenge of how to deal with changed design and production structures, and what the implications will be for social and economic structures. Sebastian Neurauter's essay focuses on questions concerning usage structures and copyrights pertaining to the Bauhaus that still cause problems today. Based on selected exhibitions, Ute Famulla exemplarily shows that the focus was either on architecture – from the Weimar house Am Horn in 1923 to Hannes Meyer's Volkswohnung at the Bauhaus's 1929 travelling exhibition – or on the pedagogical concept (exhibitions shown in exile such as Hannes Meyer's 1930 Moscow exhibition as well as Walter Gropius's and Herbert Beyer's 1938 New York exhibition). Patrick Rössler traces the Bauhaus's presence and its representation in the contemporary press at that time.

Although the Bauhaus has been subject to in-depth research in the past, it remains somewhat blurred because of its great diversity, a phenomenon that Hiroshi Sugimoto captured impressively in his *MoMA Bauhaus Stairway* photograph (2013). Since the Bauhaus hosted a multitude of controversial tendencies existing side by side "in productive unity"[8] and inspiring each other all at the same time, it seems impossible to reduce the institution to one common denominator. Despite boasting enormous productivity, the Bauhaus nevertheless remained an idea, a fictive orientation, a utopian quest for entirety. And that is exactly what makes it so fascinating: it delivers countless points of contact in almost all areas of design, from architecture and textile design to the question of the designer's attitude to society and his or her role in shaping it. Only recently, Jean-Louis Cohen described the Bauhaus as being "a statement to society".[9] It is high time for such a statement again today, to bridge the gap between profession and vocation that Gropius increasingly found to be so alarming.[10] Good design, then, emerges from an attitude, hence from both ethics and aesthetics (of the designer and producer).[11] Discussions in years to come will be determined by how that statement and contemporary designers' attitudes can affect society.

We believe that this exhibition and catalogue should, can and will initiate a fruitful debate on this issue.

Jolanthe Kugler, Curator

1 Among others, Peter Behrens, H. P. Berlage, Adolf Busch, Marc Chagall, Hans Driesch, Albert Einstein, Herbert Eulenberg, Edwin Fischer, Gerhart Hauptmann, Josef Hoffmann, Oskar Kokoschka, Hans Poelzig, Arnold Schönberg, Adolf Sommerfeld, Dr Strzygowski and Franz Werfel.

2 László Moholy-Nagy, quoted in Bernhard E. Bürdek, *Geschichte, Theorie und Praxis der Produktgestaltung*, 3rd edition, Birkhäuser, Basel/ Boston/Berlin 2005, p. 33.

3 Viktor Papanek, *Design for the Real World: Human Ecology and Social Change*, Pantheon Books, New York 1971, p. 139.

4 S. Bernhard E. Bürdek, *Geschichte, Theorie und Praxis der Produktgestaltung*, 3rd edition, Birkhäuser, Basel/ Boston/Berlin 2005.

5 S. Holm Friebe and Thomas Ramge, *Marke Eigenbau. Der Aufstand der Massen gegen die Massenproduktion*, Campus, Frankfurt am Main/ New York 2008.

6 Wolfgang Holler, Director of Klassik Stiftung Weimar, in an interview with SWP on 30 December 2011.

7 Letter from Lyonel Feininger to Wilhelm Köhler, 1920, Bernd Freese Collection.

8 Josef Albers, quoted in *Bauhaus* no. 6, 01, 2014, p. 142.

9 Jean-Louis Cohen, in *Bauwelt*, no. 21, 2014, p. 28.

10 Walter Gropius, *Architektur*, Fischer Bücherei, Frankfurt am Main 1956, p. 42.

11 Rolf Fehlbaum, quoted in Bürdek 2005, op.cit., p. 350.

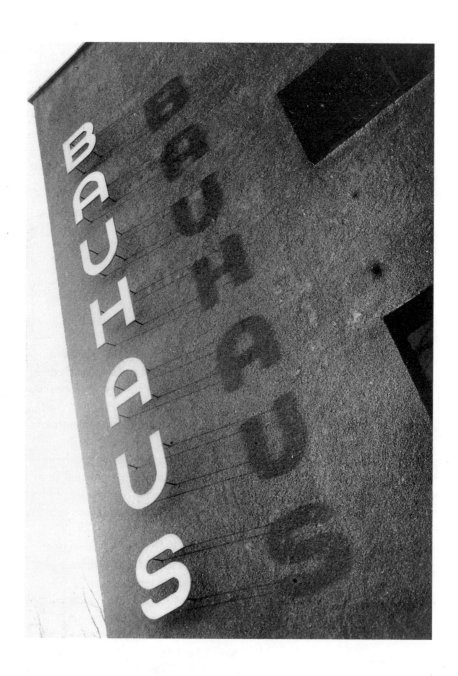

■003 Unknown, BAUHAUS lettering at the
Bauhaus building Dessau, c. 1930, silver gelatin print,
10.7 × 7.8 cm, Bauhaus-Archiv Berlin

1915

Closure of the Grand Ducal School of Arts and Crafts, which originated in Henry van de Velde's private arts and crafts school in 1908. The School of Art takes over the building, selling some of the furnishings and fittings. Walter Gropius is considered as the successor to van de Velde, to set up a department of architecture and applied arts at the School of Art.

1916

Gropius submits his "Suggestions for founding an educational establishment as an artistic advice centre for industry, trade and craft professions" to the Ministerial Department of the Interior. The statement criticizes the fact that the proposal is too strongly biased in favour of large companies and factories, focusing only on increasing the quality of industrially manufactured products and failing to give adequate attention to craft professions.

1917

The staff of the Weimar School of Art submit suggestions to the Ministerial Department of the Grand Ducal House regarding reorganization of the School of Art. The plan is to add a department of architecture and applied arts and thus to make the school a united academy combining free and applied arts and architecture under a single roof.

1918

Henry van de Velde is considered for reappointment.

1919

Walter Gropius signs a contract on 11 April, backdated to 1 April, making him Director of the Academy of Applied Arts. Fusion of the Grand Ducal Art School and the former Grand Ducal School of Arts and Crafts. The name of the new educational establishment, State Bauhaus in Weimar, is applied for by Walter Gropius and approved on 12 April. The manifesto and programme of the State Bauhaus is published, with a cover woodcut by Lyonel Feininger.

1921

The first statutes of the Bauhaus, published in January as a brochure, come into effect in February. Of particular interest is § 6, which defines the conditions for admission to the Bauhaus: the Council of Masters decides whether to admit candidates not on the basis of their "talent for art" but rather on their previous education.

§ 1 Purpose: The Bauhaus aims to train artistically skilled persons as creative craftsmen, sculptors, painters or architects. Thorough education of everyone in craft skills serves as a standardized foundation.

§ 4 Teaching : [...] Principle of teaching: Each apprentice and journeyman is taught by two masters at the same time, one master of craft and one master of form theory. Both are closely connected in terms of teaching.

§ 7 Rights and duties of the students: [...] Each work created with Bauhaus material belongs to the Bauhaus. Exceptions are subject to special provisions [...] Works finally taken over by the Bauhaus will be reimbursed to the maker. [...] Works not taken over by the Bauhaus may be sold or given away freely by the maker after paying for material and general costs in cash.

Bauhaus Timeline

1922
Foundation of the Bauhaus Housing Cooperative, with a housing plan comprising different types of residential building. Oskar Schlemmer designs a new Bauhaus logo, replacing the old "Star Manikin" by Karl Peter Röhl.

1923
15 August – 30 September: first major Bauhaus exhibition in Weimar. Demanded by the Government of Thuringia, it served as a report for further financing. With concerts, lectures and stage performances during the Bauhaus week, the Bauhaus gains national and international fame. The publication *Staatliches Bauhaus Weimar 1919–1923* is published in the autumn.

1924
Termination of the Bauhaus masters' contracts by the Minister of Popular Education and Justice (to take effect by 31 March 1925). Foundation of the "Circle of Friends of the Bauhaus".

1925
Relocation to Dessau and resumption of classes. Young masters trained at the Bauhaus take charge of the workshops. Bauhaus GmbH is founded, with a number of licences for the production of Bauhaus designs awarded to various manufacturers. First volumes of the Bauhaus books are published. Start of construction work on the new school building and masters' houses.

1926
The Bauhaus now carries the epithet "University of Design". Training now corresponds to a course of studies completed with the Bauhaus diploma. The new buildings are inaugurated with a big celebration.

1927
The newly opened department of architecture is headed by the Swiss architect Hannes Meyer.

1928
Gropius resigns as Director of the Bauhaus on 1 April, proposing Hannes Meyer as the new Director. The first Bauhaus designs are sold to the industry for series production.

1929
Basel's Gewerbemuseum opens the *bauhaus travelling exhibition*, giving a representative overview of the work of the Bauhaus under Hannes Meyer as Director. The Bauhaus is geared to Meyer's maxim, "The needs of the people instead of the need for luxury."

1930
Bauhaus wallpaper goes on sale and is a big commercial success. Dessau local government dismisses Hannes Meyer; new Director is the architect Ludwig Mies van der Rohe.

1931
Workshops and department of architecture merged. The department is now known as "Building and Interior Decoration".

1932
The Bauhaus closes. Mies van der Rohe negotiates with other cities with regard to a takeover. It reopens as a private institute in Berlin, headed by Mies van der Rohe.

1933
Under pressure from the Nazis, Mies van der Rohe dissolves the Bauhaus with the consent of the Council of Masters.

Glossary

At the beginning of the twentieth century, European artists began to raise their voices in manifestos and exhibitions, demanding the end of both "old rationality" as well as the end of existing rules in art. They started to look towards a new age, one of a supremacy of cosmic uproar, driven by a desire for the undividable being, which, according to Franz Marc, shaped the fundamental feeling behind all works of art and should, as of now, be expressed in abstraction.

There are many fathers of abstract art and, after the Swedish artist Hilma af Klint was rediscovered, also a mother of abstract art. The best-known pioneers of abstract art are Kandinsky, Kupka, Mondrian and Malevich, although Malevich developed his own unique position with his term "non-objectivity" (or "non-representation" according to Anja Schlossberger). He thus titled his book in the Bauhaus series (no. 11) *The Non-Objective World*. The publication radically rejected figurative art and made repeated claims of self-referentiality in the manner of Hubertus Gassner, meaning that it focused purely on design laws intrinsic to art. However, contributions were also made to abstract art that arose from a "referent" found in internal perception, opening up new design worlds. Kandinsky, who had taught at the Bauhaus since 1922, described the widest possible scope of action four years after the school had closed. In 1937, he participated in an interview with art dealer Karl Nierendorf, giving the following answer to the question of whether abstract art no longer had anything to do with nature: "No! And again no! Abstract painting leaves the 'skin' of nature behind but not its laws. Allow me to let the cosmic laws do the talking." WK

Dietmar Elgar and Uta Grosenik, *Abstrakte Kunst*, Taschen, Köln 2008

Wassily Kandinsky, *Essays über Kunst und Künstler*, Benteli, Bern 1973

Kasimir Malewitsch – Die Welt als Ungegenständlichkeit, exhibition catalogue, Kunstmuseum Basel 2014, Hatje Cantz, Ostfildern 2014

According to Heidegger, a work of art is a thing just as other things are things. Pictures hang on walls in the same manner as hunting rifles or hats, they are transported just like musical scores or coal from the industrial Ruhr Valley in Germany and lie in storage rooms of publishing houses like potatoes in a cellar. The founding father of aesthetics Alexander Baumgarten would have very much approved of this approach. After all, it was not only art that he was referring to in his 1750 publication *Aesthetica,* when he joined in the discussion on the whence and whereto of knowledge. He found the perception *(aisthesis)* of all lifeworlds equally important – whether the profane or the sublime, science or art. This idea was expressed in his plea for "sensuous knowledge", for "sensual awareness", also described as "beautiful thinking". Parallel to the philosophical discourse, a provocative, often misunderstood process of detaching art from contemporary life began, defined by terms such as architecture and forging. According to Kant, art gained its own quality and no longer wanted to be anything other than art. Artists fought to free aestheticism from the need for every object to have a practical use. All this led to more and more new positions being taken regarding what was beautiful, true and good as well as what was important for the sensual experience of all forms of being. The scope of different interpretations continued to extend – from Hegel, to the critical positions of Kierkegaard, to Adorno and Peter Weiss's *Aesthetics of Resistance,* until an anaesthetic of sensual escape (Wolfgang Welsch) created an alternative world. Despite or perhaps because of this, we now, more than ever, perceive the beauty that shapes our everyday life as being aesthetic – whether this is the shape of household equipment, the flight of a flock of birds or the design of a sports car. Aesthetics is as good a selling point as it ever was. WK

Hans-Georg Gadamer, *Die Aktualität des Schönen,* Reclam,
 Stuttgart 2009
Wolfgang Fritz Haug, *Kritik der Warenästhetik,* Suhrkamp,
 Frankfurt am Main 1971
Friedrich Schiller, "Über die ästhetische Erziehung des Menschen
 in einer Reihe von Briefen", in Gerhard Fricke and Herbert C. Cöpfert,
 ed., *Sämtliche Werke,* vol. 5, Munich 1980
Wolfgang Welsch, *Ästhetisches Denken,* Reclam, Stuttgart 2003

The understanding of architecture at the Bauhaus was largely defined by its directors Walter Gropius (1919–28), Hannes Meyer (1928–30) and Ludwig Mies van der Rohe (1930–33). The programme and the Bauhaus manifesto, with Lyonel Feininger's woodcut *Cathedral* on the cover, already proclaimed "The Great Build" – architecture – to be the focus of their work, due to its being a field where all artistic disciplines are brought together. However, it was not until 1927 that the Bauhaus started to offer formal architectural training.

Up until then, architectural training was undertaken by Walter Gropius's private architecture office, together with his assistant Adolf Meyer: they were responsible for integrating the Bauhaus workshops, which all focused on different fields of design, into architecture. As of 1922, they also followed Gropius's guiding principles of "art and technology – a new unit" and "to build is to design life" and, as of 1928, Hannes Meyer's principle of "the needs of the people instead of the need for luxury". Bauhaus architecture is characterized by a modern, new language of forms, the conscious use of materials and technologies, and a high level of functionality. This approach is exemplified by the impressive exhibition house Am Horn, constructed in 1923 in Weimar by Georg Muche, as well as by the Bauhaus houses for the masters, the Dessau-Törten housing estate and the Dessau employment centre, constructed by Gropius between 1927 and 1929 (a UNESCO World Heritage site since 1932). The Federal School of the General German Trade Unions in Bernau near Berlin, designed by Hannes Meyer and Hans Wittwer and constructed between 1928 and 1930, is one of the most important school buildings of its time. Unrealized buildings also played an important role in shaping the architectural discourse of the time – such as the 1922 competition entry by Mies van der Rohe, a design for a glass high-rise building for the Friedrichstrasse train station in Berlin, or Meyer and Wittwer's 1927 design for the Palace of the League of Nations in Geneva. Today, the term "Bauhaus architecture" is often incorrectly used as a synonym for all the architectural modernism of the interwar period. MS

Winfried Nerdinger, *Walter Gropius*, Gebr. Mann Verlag, Berlin 1985

Klaus-Jürgen Winkler, *Der Architekt Hannes Meyer. Anschauungen und Werk*, VEB Verlag für Bauwesen, Berlin 1989

Wolfgang Pehnt, *Deutsche Architektur seit 1900*, Deutsche Verlags-Anstalt, Munich 2005

Painters and sculptors played an important role in Bauhaus education. They not only taught free painting classes (Paul Klee, Wassily Kandinsky) or life drawing (Oskar Schlemmer) but were also responsible for foundation courses (Johannes Itten, László Moholy-Nagy, Josef Albers) as well as instruction in form and colour theory. In line with the declared aim of the Bauhaus to create a new "art of building" through the "reuniting of all the arts and crafts disciplines – sculpture, painting, applied arts and crafts", they were assigned the post of "master of form" in individual workshops. The significance of their works can be seen in the interplay that results from free artistic work, workshop activities and actual lessons. A key notion of the early twentieth-century avant-garde was based on the universal and direct readability of abstract forms. Artists such as Johannes Itten, Paul Klee and Wassily Kandinsky subscribed to this concept, which, starting from abstraction in art, allowed them to combine an amalgamation of formal reduction and a systematically driven, analytical study of creative techniques. The questioning of the unity of art and craft together with a growing concentration on new techniques such as photography and film as well as methods of industrial production subsequently led to conflicts, in the course of which some fine artists left the Weimar Bauhaus – Johannes Itten and Lothar Schreyer, for instance. At the Dessau Bauhaus, fundamental doubts as to the importance of painting and sculpting as basic subjects for architectural training were raised by László Moholy-Nagy and Hannes Meyer, so that – as Ernst Kállai stated in 1929 – "painting at the Bauhaus was entirely isolated from the practical workmanship of the institute". Eventually Paul Klee and Oskar Schlemmer also left the Bauhaus; only Josef Albers and Wassily Kandinsky stayed on until it was closed down. UW

Andreas Bossmann, "Kunst im Widerspruch. Maler am Bauhaus", in Burkhard Leismann, ed., Das Bauhaus. Gestaltung für ein modernes Leben, Wienand, Cologne 1993, pp. 27–63
Eberhard Roters, Maler am Bauhaus, Berlin 1965

The Bauhaus developed from a series of reform efforts in mid nineteenth-century Germany, which included reform of the art schools. The reform movement saw the academic separation of fine and applied arts as the retreat of art from people's everyday lives, an obsolete notion that needed to be done away with. The Arts and Crafts movement in England or Jugendstil in Germany with Henry van de Velde, pioneer of the modern movement "Kunst und Handwerk" with Richard Riemerschmid and the Deutsche Werkbund, sought to implement these reform concepts and to unify art and crafts in practice.

In the midst of the revolutionary atmosphere following the First World War, Walter Gropius gave emphatic support to these reform ideas in his Bauhaus foundation manifesto of 1919: "Architects, sculptors, painters, we must all return to craft skills! Because there is no craft of art. There is no difference between the artist and the craftsman."

The term "art school reform" applies to virtually all the anti-academic tendencies that were in the air between 1900 and 1933 together with all the different educational curricula which they promoted. Both before the Bauhaus and parallel to it were numerous schools that had been reformed, and sought to implement the objectives of the movement on a more-or-less radical basis – for example, the Reimann School in Berlin and Burg Giebichenstein in Halle, the Stuttgart School of Arts and Crafts and the Breslau (Wrocław) Academy of Art and Applied Arts, the College of Fine Arts in Frankfurt and in Moscow the Higher Artistic and Technical Workshops (WChUTEMAS) – the institution with the biggest flow of fresh ideas and the greatest influence after the Bauhaus. On the other hand, the attempt by Hendrik Wijdeveld, Erich Mendelsohn and Amédée Ozenfant to establish an Académie Européenne Méditerranée on the Côte d'Azur, with the aim of establishing "classic modernity", is a forgotten failure. GB

Hans M. Wingler, ed., *Kunstschulreform 1900–1933: dargestellt vom Bauhaus-Archiv Berlin an den Beispielen Bauhaus Weimar Dessau Berlin – Kunstschule Debschitz München – Frankfurter Kunstschule – Akademie für Kunst und Kunstgewerbe Breslau – Reimann-Schule Berlin*, Gebr. Mann Verlag, Berlin 1977

Kai Buchholz and Justus Theinert, *Designlehren. Wege deutscher Gestaltungsausbildung*, Arnoldsche Art Publishers, Stuttgart 2007

John V. Maciuika, *Before the Bauhaus. Architecture, Politics, and the German State 1890–1920*, Cambridge University Press, Cambridge 2005

Artist-Craftsmanship

Since ancient times, the forerunners of fine art and design have been bracketed under the category of *artes vulgares*. They were considered to be crafts until, during the eighteenth century, art became an object of reflection. As the development of serial production and industrialization progressed, the artist-craftsman, or artisan, sought to differentiate himself from traditional crafts by claiming an artistic approach to his work. He produced one-off pieces or small series in which design and construction were all carried out by one hand. When, around 1900, design evolved as an independent discipline and attempted to realize artistic ideas within the context of industrial production, the artist-craftsman came under growing pressure. In 1919 the discussion around the relationship between crafts and industrial design was in full swing, and Bauhaus Weimar was no exception. During the first phase, influenced by Expressionism, crafts were ascribed a special role there. So it was that the founding manifesto declared: "Architects, sculptors, painters, we must all return to the craft skills!" Artists were, it was claimed, "an elevated version of the artisan". The proclaimed unity of art and crafts was expressed in the objectives, principles and teaching at the Bauhaus. Students were to be trained as "competent craftsmen or independent creative artists"; an education in craftsmanship formed the foundation. The shift towards Constructivism at the Bauhaus brought with it the first relativization in 1923. Type building, technical processes and serial production methods now came to the fore. The Bauhaus lamp eventually ignited a debate around the future of the crafts at the Bauhaus: Hannes Meyer criticized the way the lamp was produced as a one-off, handcrafted piece. Despite this fundamental criticism and a growing marginalization, the workshops and their production of unique items and very small-scale series remained an important aspect of teaching at the Bauhaus until it closed in 1933. UW

Bauhaus-Archiv Berlin, ed., *Experiment Bauhaus*, Kupfergraben
 Verlagsgesellschaft, Berlin 1988
Michael Siebenbrodt, ed., *Bauhaus Weimar. Entwürfe für
 die Zukunft*, Hatje Cantz, Ostfildern 2000

It is important to differentiate between the avant-garde as an art historical (style) term and the avant-garde as an attribute or a value judgement of the present day. The former is normally used to describe the art groups of the first half of the twentieth century. Here the Futurist Manifesto of 1909 represents a crucial watershed, including a few typical characteristics of the "classical" or "historic" avant-garde: it must be a group that addresses the public in texts, proclamations and manifestos with dramatic wording and whose name bears the suffix "-ism". French philosopher Henri de Saint-Simon was an ideological pioneer in this respect. In the early nineteenth century he took the term – originally used in the military – and applied it to art, so propagating artists' claim to leadership in society. According to Pierre Larousse, however, Napoleon saw the duty of the avant-garde as no longer lying purely in forward movement, but rather in manoeuvring: movement in itself. Thus the avant-garde should not be equated with progress, but instead with agility – with a change in position and perspective. This aspect of movement is emphasized by the lively exchange between individual groups and also their publishing activities. Fundamentally, an avant-garde calls for careful observation of one's environment. It reacts to the current situation and at the same time is active in its creative energy. In this way it brings a dynamic to the perceived (overall) status. Hence change should not come about selectively but comprehensively, in the sense of a *Gesamt(kunst)werk*, a total work of art: "The ideal is old, but its rendering always new" – Oskar Schlemmer's assertion from the programme manifesto of the 1923 *Bauhaus-Ausstellung* describes the essence of the avant-garde and at the same time demonstrates the limits of a definition. HM

Peter Bürger, *Theorie der Avantgarde*, Suhrkamp, Frankfurt am Main 1974

Astrit Schmidt-Burkhardt, *Stammbäume der Kunst. Zur Genealogie der Avantgarde*, Akademie Verlag, Berlin 2005

Klaus von Beyme, *Das Zeitalter der Avantgarden. Kunst und Gesellschaft 1905–1955*, C. H. Beck, Munich 2005

Walter Fähnders, *Avantgarde und Moderne 1890–1933*, 2nd edn, updated and extended, J. B. Metzler, Stuttgart 2010

The Bauhaus is not only an institution but also an era of modernism.
It was here that a momentous search began for the best ways to shape
industrial culture using conscious design. The Bauhaus is a reaction
to the chaotic beginnings of the twentieth century. Around 1900, the
prevailing opinion was that industrialization and increasing humanization
would lead to a happy future. In 1914, these dreams came to an abrupt
end. The values of the individual, fraternity and humanity were lost
in the trenches of the First World War. As a result of this, artists focused
their energies on creating a new world. Ideas such as the welfare state,
the League of Nations, pacifism and internationalism provided fertile soil
for reform movements to flourish – including the unique experiment that
was the Bauhaus.

The Bauhaus resulted from the amalgamation of the Weimar
Saxon-Grand Ducal Art School with the Grand Ducal School of Arts and
Crafts. It was proposed that Walter Gropius succeed Henry van de Velde,
who had already resigned. On 25 January 1916, Gropius submitted a
suggestion "for setting up an artistic advice centre for industry, crafts and
the manual trades", including a description "of the type of impact of art
on industry and craft". It was not until three years later, on 11 April 1919,
that he signed his employment contract. The next day, the renaming
of the Bauhaus to "Staatliches Bauhaus in Weimar" was approved and
the manifesto was published. The school was closed in 1925 for political
reasons and was reopened in the industrial town of Dessau as a school
of design. After it was dissolved in 1932, Mies van der Rohe made one last
attempt to continue running the school – this time privately and in Berlin.
However, Bauhaus ideas were irreconcilable with Nazi ideology, meaning
that the Bauhaus had to be closed for good in 1933. JK

Volker Wahl, *Das Staatliche Bauhaus in Weimar: Dokumente
 zur Geschichte des Instituts 1919–1926*, Böhlau,
 Cologne 2009
Volker Wahl, *Henry van de Velde in Weimar*, Böhlau, Cologne 2007
Ute Ackermann, "Zur Funktion und Geschichte des Meisterrats
 am Staatlichen Bauhaus Weimar", in Volker Wahl, ed.,
 *Die Meisterratsprotokolle des Staatlichen Bauhauses
 Weimar 1919–1925*, Verlag Hermann Böhlaus Nachfolger,
 Weimar 2001
http://bauhaus-online.de/atlas/das-bauhaus/idee

Bauhaus GmbH

In Weimar, there were already plans to conceptualize the Bauhaus not just as a school but also as a production operation. The ideas were based on changing the course and the programme focus, moving towards industrial series production, which was introduced by Walter Gropius in 1923. However, it was not possible to convince any industrial firms in Weimar to produce Bauhaus designs and, for the time being, the Bauhaus workshops undertook the series production themselves. In order to avoid the threat of closure, it was an urgent requirement to improve the economic organization of the production operation at the Bauhaus. Negotiations were undertaken with the state ministry with the aim of convincing it that a Bauhaus GmbH should be founded to organize the sale of prototypes and products, but they were unsuccessful. It was not until the school moved to Dessau that it became possible to sign the articles of association for Bauhaus GmbH, on 7 October 1925. This step was, however, less than successful – the company generated losses. Later, Gropius and other Bauhaus members evaluated their activities as being successful, but scientific source research confirmed that the institution itself was inefficient. The Bauhaus commercial department in Dessau gradually took over business transactions. Directed by Hannes Meyer, the economic prosperity of the Bauhaus then reached its high point. There was greater concentration on cooperation with industry than on direct sales, and licences ensured a healthy and long-term share of the profits from the products. Although Bauhaus GmbH still existed on paper, there is no proof of any activities being undertaken. In the end, Bauhaus GmbH played no role in the economic practices at the Bauhaus. GB

Sebastian Neurauter, *Das Bauhaus und die Verwertungsrechte, eine Untersuchung zur Praxis der Rechteverwertung am Bauhaus 1919–1933*, Mohr Siebeck, Tübingen 2013

Within three decades of the creation of the German Empire in 1871, the old royal residence seat, administrative centre and garrison city of Berlin took a leap forward to become the most modern metropolis in Europe. "Berlin is speculation, unhealthy acceleration of pace [...] it greedily grabs whole sections of land and stuffs them full of ugliness," Alfons Goldschmidt wrote, and Walter Rathenau complained: "The Athens on the Spree is dead, and now it is long live Chicago on the Spree." Berlin became the industrial heart of Germany with AEG, Siemens, Borsig, Agfa. The face of the city changed at an enormous pace as trams and the overhead and underground railways together with motor cars moved in. Simultaneously the city became an important centre for the avant-garde in art in the pre- and inter-world war years when art dealers and agents such as Herwarth Walden with his journal and gallery *Der Sturm* provided a platform for aesthetic dialogue, and sought to overcome the prevalent national prejudices. The still unknown artists of the avant-garde were often first seen in Germany at this gallery. Many of them were later called upon to work as Bauhaus teachers by Gropius – himself a part of the Berlin avant-garde – who had worked with Mies van der Rohe for Peter Behrens and was a co-founder of the Werkbund. In this context it is not surprising that Mies van der Rohe moved the Bauhaus to Berlin-Steglitz following the closure in Dessau. The licence income from Bauhaus products – wallpaper, textiles, lamps, toys and Bauhaus frosted glass – ensured the continuation of the school as a private institute. In April 1933, however, the Berlin Bauhaus building was searched by the police on the orders of the public prosecutor in Dessau, and more than thirty students were arrested and detained in police custody for one or two days. The Bauhaus was temporarily closed and, after its members declined the Gestapo conditions for reopening, it closed permanently with the agreement of the staff on 20 July 1933. UW

Bauhaus-Archiv Berlin, ed., *Bauhaus in Berlin. Bauten und Projekte*, Bauhaus-Archiv Berlin, Berlin 1995
Peter Hahn, ed., *bauhaus berlin. Auflösung Dessau 1932. Schließung Berlin 1933*
Bauhäusler und Drittes Reich. Eine Dokumentation, compiled by the Bauhaus-Archiv Berlin, Kunstverlag Weingarten, Weingarten 1985

the bauhaus

Bauhaus always made effective use of print media to spread its ideas
and those of European modernism. One of the first highlights was
the exhibition catalogue *Staatliches Bauhaus in Weimar 1919–1923*,
created for the 1923 Bauhaus exhibition. Its elaborate design was created
by László Moholy-Nagy. In 1924, Gropius and Moholy-Nagy started
a Bauhaus publishing initiative, which led to Bauhaus books being
published. Between 1925 and 1929, around fourteen of the forty titles
planned for release were published by Albert Langen Verlag in Munich.
The first book to be published was the volume *Internationale Architektur*
by Walter Gropius, in which he published the results of the 1923
international architecture exhibition at the Bauhaus. Other important
titles followed such as *Pädagogische Skizzenbuch* by Paul Klee, *Die Bühne
am Bauhaus* by Oskar Schlemmer, *Neue Gestaltung* by Piet Mondrian,
Grundbegriffe der neuen gestaltenden Kunst by Theo van Doesburg,
Malerei, Photographie, Film by László Moholy-Nagy, *Punkt und Linie
zur Fläche* by Wassily Kandinsky, *Die gegenstandslose Welt* by Kasimir
Malevich and *Kubismus* by Albert Gleizes. Even the titles that were
never released, some of which can be seen in a 1924 advertisement,
still succeeded in documenting both the contemporary European
design approach and the range of content produced by Bauhaus artists.
Planned books included "Merz-Buch" by Kurt Schwitters, "Futurismus"
by Marinetti and Prampolini, "Die Arbeit der Ma-Gruppe" by Kassák
and Kállai, "Reklame und Typographie" by El Lissitzky and "Architektur"
by Le Corbusier. This series of books, designed by Moholy-Nagy,
Farkas Molnár, Adolf Meyer, Oskar Schlemmer, Herbert Bayer and Theo
van Doesburg, was also a high point of modern book design and typology.
As of 1965, Bauhaus books were published as reprints by Kupferberg
Verlag in Mainz, and as of 1991 by Gebr. Mann Verlag in Berlin. MS

Ute Brüning, ed., *Das A und O des Bauhauses*, Edition Leipzig, Leipzig 1995
Gerd Fleischmann, *bauhaus drucksachen typografie reklame*,
 Marzona, Düsseldorf 1984
Patrick Rössler, ed., *bauhauskommunikation. Innovative
 Strategien im Umgang mit Medien, interner und externer
 Öffentlichkeit*, Neue Bauhausbücher, vol. 1, Bauhaus-Archiv Berlin,
 Berlin 2009

A woodcut by Lyonel Feininger adorns the cover of the four-page leaflet in which the founding manifesto and programme of the Bauhaus were presented in 1919. It shows a Gothic cathedral whose towers, stretching skywards, are crowned with stars. Their rays are refracted, extending into infinity. The cathedral embodies an idea that Walter Gropius had already formulated as a member of the Work Council for Art: "Let us strive for, conceive and create the new building of the future that will unite every discipline, architecture and sculpture and painting, and which will one day rise heavenwards from the million hands of craftsmen as a clear symbol of a new belief to come." Here Gropius was referring to the principle of the medieval *Bauhütte* (lodge) in which craftsmen from different guilds combined forces to create a *Gesamtkunstwerk*, a total work of art: the Gothic cathedral. However, unlike the artists and craftsmen of those sacred buildings, the designers of the buildings of the future were not supposed to work in the service of God but purely in the service of construction: "The ultimate goal of all art is the building!" Gropius was not the first to coin this reference to the image of the cathedral. The Gothic period and its sacred buildings were rediscovered at the beginning of the twentieth century as a spiritual antidote to the age of materialism, thanks to Wilhelm Worringer's groundbreaking publications *Abstraktion und Einfühlung* (1907) and *Formprobleme der Gotik* (1911). The sense of community felt in the Gothic age was contrasted with the individualism of the ancient world and the Renaissance. Hence the cathedral emerges as a leitmotif in Kurt Schwitters's work – "as an expression of the truly spiritual vision of what elevates us into eternity: absolute art" – and the new factory buildings that paid homage to technical progress were described as "cathedrals of work". AvT

Magdalena Bushart, "Am Anfang ein Missverständnis. Feiningers
 Kathedrale und das Bauhaus-Manifest", in Bauhaus-Archiv
 Berlin and others, ed., *Modell Bauhaus*, Hatje Cantz,
 Ostfildern 2009, pp. 29ff.
Wallraf-Richartz-Museum and Fondation Corboud, ed.,
 Die Kathedrale. Romantik – Impressionismus – Moderne,
 Hirmer Verlag, Munich 2014

The emergence of the collage came about thanks to the outstanding artists of Cubism and Dadaism – figures such as Pablo Picasso, Georges Braque, Hannah Höch and Kurt Schwitters. Like the Bauhaus programme itself, as a concept and working method it places the focus on material and form and hence on connecting different elements. In line with the credo of the interwar avant-garde of "art as process", the collage met the desire for surprise and the sharpening of the senses by shifting the familiar into new, often unsettling perspectives. Because of its use of chance finds – such as bulk printed matter – it was guaranteed the seal of modernity. Collage pioneer Robert Michel showed his works at the exhibition for the opening of the Weimar Bauhaus, while Herbert Bayer introduced the process to the workshop for print and advertising in Dessau, and master of photomontage László Moholy-Nagy taught there. And yet, despite this, initially collage was not well represented at the Bauhaus. In the preliminary classes given by Johannes Itten, László Moholy-Nagy and Josef Albers, material studies were always practised in the form of assemblages, the three-dimensional sister of collage. It was only under Joost Schmidt as head of the advertising department that the production of collages and photomontages became part of the syllabus. None the less, as a technique and approach to alienating the old, to discovering the reliable and new, collage is closely related to the Bauhaus, which operated pragmatically in the field of communication and production. Apart from those by Marianne Brandt, probably the most famous collage was made by a student who later made his name as an architect and photographer: as early as 1932, Iwao Yamawaki's *Der Schlag gegen das Bauhaus* addressed the theme of the threatened closure of the Bauhaus for political reasons, depicting National Socialist troops marching over the toppled facades of the academy. AvT

Herta Wescher, *Die Collage/Geschichte eines künstlerischen Ausdrucksmittels*, DuMont Schauberg, Cologne 1968
"Collage und Realität. Historische Aspekte zum Thema Collage", in *Aspekte der Collage in Deutschland von Schwitters bis zur Gegenwart*, Hans Thoma-Gesellschaft, Reutlingen 1996, pp. 7–24

Colour

According to the clichés, classical modernity is white. In fact, the very opposite is true. One of modernity's great merits is its focus on colour as a tool for design and its research into colour's physiological and psychological characteristics – and therefore also into the effect it has on people. Although there was no Bauhaus colour theory, the Bauhaus masters' preoccupation with the topic has left us a great deal more knowledgeable about colour. A hundred years previously, Goethe began a paradigm shift in research, emphasizing the sensual experience of colours and their emotional and spiritual aspects, freeing colour from the constraints of the physical optics of light.

In additional to Goethe, members of the Bauhaus were inspired by Philipp Otto Runge's colour sphere, Wilhelm Ostwald's mathematical colour system and Adolf Hölzel's contrast colour theory. Johannes Itten's colour lessons were therefore based on Goethe and Hözel as well as Runge. His twelve-part colour star based on complementary colours is an opened-up version of Runge's colour sphere with an additional twelve shades of brightness. Like Goethe, synaesthete Gertrud Grunow understood shades and colours to be dynamic phenomena. Wassily Kandinsky searched for binding rules for colour both in space and in art, developing his own synaesthetic colour theory in *Über das Geistige in der Kunst*, which was closely connected to Goethe's ideas. Paul Klee's colour lessons also connected to Kandinsky's ideas, referring to the fundamental artistic rules of the movement. His colour matrix was therefore shaped by dynamic transitions, whereas Hinnerk Schepe's colour seminar was mainly based on the strict, schematic colour patterns of Wilhelm Ostwald.

Colour lessons at the Bauhaus were not only a theoretical experiment but also a practical one, as is impressively revealed by the numerous colourfully designed rooms, textiles and printed materials as well as by Alma Siedhoff-Buscher's ship-building game. JK

Hajo Düchting, *Farbe am Bauhaus*, Gebr. Mann Verlag, Berlin 1996

Harald Küppers, *Schnellkurs Farbenlehre*, DuMont, Cologne 2005

Sabine Schimma, "Die Lebendigen Kräfte der Farben", in Ute Ackermann and Ulrike Bestgen, ed., *Das Bauhaus kommt aus Weimar*, exhibition catalogue, Klassik Stiftung Weimar, Deutscher Kunstverlag, Berlin 2009

From the time when it was founded in 1919 through to its closure in 1933, the Bauhaus was the target of hostility. Afterwards, blazing disagreements remained a feature of how the Bauhaus was perceived. Not just its polemical positions, but also its status as a role model made it the projection surface for frictions of all kinds.

Although mobilized by the atmosphere of a revolutionary awakening after the First World War, the Bauhaus's break with the artistic traditions of the Wilhelmine era still provoked heavy criticism in conservative circles. It was, however, the political attacks launched from both right and left wings that proved significant. Offensives by the right forced the Bauhaus to change city twice: in 1925 it moved from Weimar to Dessau, and in 1932 to Berlin. In 1933 it was finally shut down under pressure from the Nazi Party.

The basic principles of modern design taught there were, on the other hand, attacked by Theo van Doesburg, proponent of the Dutch De Stijl movement, which led the Bauhaus to revise its initial position. Spiteful public criticism also accused the "Bauhaus style" of being increasingly stuck in Formalism, such as under director Hannes Meyer. After its closure the disputes continued, chiefly with reference to the utilization rights of objects, a dispute which continues today. Time and again there were discussions about the Bauhaus's position as a role model, such as in the "Bauhaus debate" of 1953 among the architects of postwar Modernism. Max Bill, the first director of the Ulm School of Design, provoked an argument when he claimed his college as the successor to the Bauhaus concept, while Asger Jorn announced a new start in the spirit of the school entitled *bauhaus imaginiste*. The fact that the Bauhaus remained continuously a subject of controversy attracted public attention, thus contributing significantly to its mythologization. GB

Philipp Oswalt, ed., *Bauhausstreit 1919–2009. Kontroversen und Kontrahenten*, Hatje Cantz, Ostfildern 2009
Ulrich Conrads et al., ed., *Die Bauhaus-Debatte. Dokumente einer verdrängten Kontroverse*, Walter de Gruyter, Berlin/Boston 1994

Unlike the art reform movements of the pre-war period – which were already discussing the use of machines and occasionally gaining practical experience of semi-industrial serial production – the Bauhaus initially concentrated entirely on craft: "Let us therefore form a new guild of craftsmen without the class divisions that set out to raise an arrogant barrier between craftsmen and artists!" stated its founding manifesto in 1919.

Yet by 1923 at the latest, Walter Gropius was publicizing the slogan "Art and technology – a new unity". Design for industrial large-scale production now defined itself as different from craft, the traditional production of single items: "The Bauhaus does not pretend to be a crafts school, or to cultivate eccentricity in crafts; instead, contact with industry is consciously sought, for the crafts of the past no longer exist" (Gropius 1923).

None the less, crafts were not abandoned – a problem for the Bauhaus was that its studios lacked the necessary equipment to fulfil the conditions required for industrial large-scale production. The internal serial production of the models offered for sale by the Bauhaus after 1923 was therefore largely carried out by hand.

In retrospect, Gropius legitimized this lack: "Crafts training in the workshops at the Bauhaus was not an end in itself, but rather an irreplaceable means of education. [...] The workshops were principally laboratories in which models for such products were carefully developed and continually improved. Even if the models were made by hand, the designers still needed to be familiar with the production methods on an industrial basis." GB

Michael Siebenbrodt, "Die Werkstätten. Fundament der
 Bauhauspädagogik und der Designentwicklung am Bauhaus",
 in Ute Ackermann and Ulrike Bestgen, ed., Das Bauhaus
 kommt aus Weimar, exhibition catalogue, Klassik Stiftung
 Weimar, Deutscher Kunstverlag, Berlin 2009, pp. 73–143
Klaus Weber, Die Metallwerkstatt am Bauhaus, exhibition
 catalogue, Kupfergraben Verlagsgesellschaft, Berlin 1992,
 in the Bauhaus-Archiv Berlin
Anja Baumhoff, "Zur Rolle des Kunsthandwerks am Bauhaus",
 in Jeannine Fiedler and Peter Feierabend, ed., Bauhaus,
 Könemann, Cologne 1999, pp. 80–87

Bauhaus teaching until 1930 was characterized by practical training
in workshops, a generalist and pluralist approach to teaching, creativity
training and teamwork, and a high level of internationality and equal
opportunities. The phase of Bauhaus formation in Weimar lasted
from 1919 to 1922 – with workshops and a preliminary course being
installed under the dominant leadership of Johannes Itten. The systematic
appointment of the Bauhaus masters consolidated the structure of
teaching and curricula in the various fields of study. Responsibility for
the workshops was divided among the avant-garde artists as masters
of form and the rather conservative master craftsmen – a dual principle
that encouraged creativity, with students having to develop their own
positions. The mandatory probationary semester, the preliminary course,
was followed by three years of training in the workshops, concluding
with the apprentice's final examination. The best graduates could go on
to train as architects. The roughly thirty hours of working in the workshops
each week were complemented by eighteen hours of artistic and
scientific/technical instruction. The print shop and, particularly, the stage
workshop were open to all students for individual and joint projects.

The sole responsibility of the "Young Masters", as they were known,
for training in the workshops at Bauhaus Dessau as of 1925 was the first
turning-point in the educational concept. Under the leadership of the
second Bauhaus director, Hannes Meyer, architecture and supplementary
subjects were given greater emphasis and the curriculum was geared
to scientific aspects. Free painting classes were also installed. Under
Ludwig Mies van der Rohe, workshop training was greatly reduced
for economic reasons and the Bauhaus was transformed into a modern
academy of architecture. MS

Magdalena Droste, *Bauhaus 1919–1933*, Taschen, Cologne 1998
Lutz Schöbe and Michael Siebenbrodt, *Bauhaus 1919–1933. Weimar Dessau Berlin*,
 Parkstone International, New York 2009
Klaus-Jürgen Winkler, *Der Architekt Hannes Meyer. Anschauungen und Werk*, VEB Verlag
 für Bauwesen, Berlin 1989
Peter Hahn, ed., *Bauhaus Berlin*, Kunstverlag Weingarten, Berlin 1985

Dance at the Bauhaus is inextricably linked with the work of Oskar Schlemmer. Having already premiered his main work, *Triadische Ballett*, in 1922 in Stuttgart, in 1923 he took over the Bauhaus stage class from Lothar Schreyer. Schlemmer's stage works were informed by the notion of a *Gesamtkunstwerk* as well as the intention of systematic abstraction. It was the typical and not the individual that stood at the centre of the artistic work, which in this way formed a counterposition to modern expressive dance as established by Mary Wigman or Rudolf von Laban at Monte Verità. In Schlemmer's work the body was not set free or even undressed, but instead masked; it was on the one hand extended into space with three-dimensional costumes (spatial sculpture), and on the other restricted in its system of movement. Thus for Schlemmer, choreographing meant the organization of movement in space; geometry and "mechanisation" formed the basis for stage, costumes and choreography and entailed a taming of the imagination. Schlemmer himself describes how reflection and order superseded the playful, Dadaist, chaotic early phase (such as *Rüpeltanz der Wandervögel*): "regularities have broken free from the unconscious and chaotic and concepts such as norm, type, synthesis mark the way intended to lead towards the idea of design" (see "Stage"). The names of the dances developed by Schlemmer after 1926 on the specially created Bauhaus stage in Dessau have a systematic reduction that indicate the analytical approach in terms of "fundamental research" as Gropius defined it – space dance, form dance, gesture dance, pole dance and hoop dance (both danced by Manda von Kreibig), scenery dance and mask dance – and yet still bear testament to the human power of creation. Schlemmer's student Alexander "Xanti" Schawinsky especially deserves a mention in this context. HM

Oskar Schlemmer, "Die Bauhausbühne", in *Das Werk*, no. 1, 1928
C. Raman Schlemmer and Maria Müller, *Oskar Schlemmer – Tanz, Theater, Bühne*, Hatje Cantz, Ostfildern 1994
Christian Hiller, Philipp Oswalt and Thorsten Blume/Stiftung Bauhaus Dessau, ed., *Bühne und Tanz – Oskar Schlemmer*, Absolut Medien, Berlin 2014

The city of Dessau had been an important centre for enlightenment
and pedagogy since the end of the eighteenth century. Immanuel Kant
described the Dessau Philanthropinum as an influential educational
institution "of philanthropy and sound knowledge", the "ancestor of all
good schools". As of the beginning of the twentieth century, Dessau
combined the tradition of enlightened education with contemporary
industry based on progress, providing fertile soil for Bauhaus ideas – one
example was the Junkers aircraft manufacturer. After Bauhaus Weimar
was closed, Dessau council gave permission for the Bauhaus to take over
the institution in the capital of the province and to construct a new Bauhaus
building with masters' houses attached, which were officially opened
on 4–5 December 1926. Several changes accompanied the move to
Dessau: industry collaboration was promoted, masters became professors,
a Bauhaus magazine was produced and there was an increase in
advertising for the Bauhaus and the school's products. Hannes Meyer
was appointed as master architect and later as Director of the Architecture
Department, prompting a functioning architecture department to be
institutionalized at the Bauhaus for the first time in 1927.

 In the Dessau period, new architecture concepts developed at the
Bauhaus were able to be implemented in an impressive way from the very
beginning. The city administration commissioned the construction of
the Reichsheimstättensiedlung settlement in Dessau-Törten, which took
place between 1926 and 1928 under the guidance of Walter Gropius.
In 1928/1929 Gropius also constructed the Dessau employment office.
Other members of the Bauhaus – such as Hannes Meyer (extension of the
Dessau-Törten settlement, balcony access houses), Georg Muche and
Richard Paulick (steel house) and Carl Flieger (apartment building)
– were also able to realize their designs in the city, which followed a new
functionalistic approach to architecture. However, in 1932, the Nazis
forced the closure of this school which had opened in such a climate
of hope. UW

Christine Engelmann and Christian Schädlich, *Die Bauhausbauten
 in Dessau*, VEB Verlag für Bauwesen, Berlin 1991
Walter Gropius, *bauhausbauten dessau*, Bauhausbücher, vol. 12,
 Gebr. Mann Verlag, Berlin 1930
Stiftung Bauhaus Dessau and Margret Kentgens-Craig, ed.,
 Das Bauhausgebäude in Dessau 1926–1999, Birkhäuser,
 Basel 1998

Economic and social change led to the desire for a contemporary reorientation of exhibitions in the early 1920s, with the aim of bringing current specialist discussions to the wider public using an appropriate, accessible approach. In order to reach this objective, there was a conscious move towards creating presentations in a trade fair style, within traditional museum exhibition typologies.

From the very beginning, Bauhaus members used exhibitions as a way to present and spread their ideas, at the same time communicating the respective positons of the three directors. What all Bauhaus presentations had in common was their focus on architecture; it was in this field that you could see all art disciplines come together. The main exhibit at the 1923 exhibition was the exhibition house Am Horn. Here, both the industrialization of construction and the synthesis of all art fields were made visible in the building. Hannes Meyer's travelling Bauhaus exhibition focused on residential buildings, contributing to the current discussion on affordable social housing (*Volkswohnung*), a focal point that could also be seen in the *Section Allemande* of the Parisian Werkbund show, designed by Walter Gropius and Herbert Bayer, in the form of a minimal apartment. However, the apartments here were not conceived as a cheap and practical solution but rather as a utopian vision of a new society.

The self-image of the Bauhaus communicated through the exhibitions was very divergent. This was because the exhibitions were constantly being reworked and also reflected the very different conceptual and artistic positions of the three directors. In the 1930s, both Hannes Meyer and Walter Gropius collaborated with Herbert Bayer to organize Bauhaus exhibitions in exile. They were, however, less than successful. One interesting feature of the two exile exhibitions in Moscow and New York was the dramatic change in the way the Bauhaus was portrayed. Rather than being an active agent in the architecture debate, the school came to represent a new style of teaching. LN

"Ausstellungen am Bauhaus", in Jeannine Fiedler and Peter Feierabend, *Bauhaus*, Könemann, Cologne 1999
Dara Kiese, "Hannes Meyers Bauhaus – die 'Wanderschau' 1929–30", in Patrick Rössler, ed., *bauhauskommunikation. Innovative Strategien im Umgang mit Medien, interner und externer Öffentlichkeit*, Neue Bauhausbücher, vol. 1, Gebr. Mann Verlag, Berlin 2009, pp. 215–22
"Zum Komplex und zur Bedeutung der Ausstellungstätigkeit im frühen 20. Jahrhundert" in Winfried Nerdinger et al., *100 Jahre Deutscher Werkbund 1907/2007*, Prestel, Munich 2007

The font that is now most commonly used for publications on the Bauhaus is Futura. This reveals the all-consuming power of the "Bauhaus brand" as Futura was not designed at the Bauhaus, nor was it used there. In larger production runs of their publications, Bauhaus members simply took the fonts used in the respective printing house, such as a Grotesk font at Schelter & Giesecke type founders. None of the fonts designed at the Bauhaus were cast in lead, meaning that they were not made widely available – despite the fact that typography lessons became part of the curriculum in 1919. This course was first taught by Dora Wibiral and later by Lothar Schreyer and Joost Schmidt. The shape of the fonts drawn and designed at the Bauhaus were initially influenced by Expressionism. The sans serif fonts that people now connect with the Bauhaus only gained in importance after the 1923 exhibition, a change brought about particularly by László Moholy-Nagy and Herbert Bayer. Both made consistent use of these fonts in their letter paper designs and in other media used to shape the public image of the school and to market Bauhaus designs. The most famous font to be designed at the Bauhaus was Universal, which Herbert Bayer originally only created in small letters. In 1925, he designed the capital letters B, A, U, H and S, which were attached to the new Bauhaus building in Dessau. In 1975, Americans Ed Benguiat and Victor Caruso adapted Universal, using it to develop ITC Bauhaus. This font was widely used for phototypography and later also as a digitally available font. It was in no way only used in connection with the Bauhaus, mainly being used for the lettering on chemists, driving schools, solariums and other similar buildings. Bayer was incredibly annoyed not to be given a part of the profits made with this font. JM

Ute Brüning, ed., *Das A und O des Bauhauses*, exhibition
 catalogue, Bauhaus-Archiv Berlin, Leipzig 1995
Herbert Bayer, "Versuch einer neuen Schrift", 1926. Published
 in "Bauhaus-issue" of journal *Offset – Buch- und Werbekunst*,
 Kraus reprint, Munich 1980, 1. Dessau edition 1926,
 p. 398ff.
Josef Albers, "Zur Ökonomie der Schriftform", in *Offset-, Buch-
 und Werbekunst, Bauhaus-Heft*, vol. 3, issue 7, 1926,
 pp. 395ff. Kraus reprint, Munich 1980

Functionalism

In architecture and design, the term "functionalism" denotes a movement that emphasizes technical, functional aspects and objective design based on pure utility thinking over (aesthetic) form. Closely connected with this was faith in technical feasibility and trust in the latest scientific findings. In the early twentieth century, functionalism became a central buzzword in Modernist architecture and design discourse, denoting a rejection of the forms of inferior mass products and the material excesses of florid luxury gods. The Deutscher Werkbund, and later the architects of the New Objectivity – such as Hannes Meyer, Walter Gropius and Mies van der Rohe – rejected "all aesthetic speculation, all doctrine and all formalism". They saw functionalism primarily as a cultural and aesthetic programme of social dimensions with which to overcome the challenges posed to society by advancing industrialization. Based on the assumption that human needs are to a great extent always the same, they set out with the aid of scientific, technological innovation and advanced production methods to create things that "serve their purpose perfectly, that is, they must fulfil their function usefully, be durable, economical, and 'beautiful'."

The reduction of the concept of functionalism to pure aestheticism and a one-sided fulfilment of purpose that neglected the social dimension, above all in the 1950s and 1960s, led to sharp criticism as well as an increasingly negative judgement. It is often wrongly equated with a style of design whose formal features are a reduction to basic geometric forms, a renunciation of ornament, and a technical appearance. MT

Adolf Behne, *Der moderne Zweckbau*, Drei Masken Verlag,
 Berlin 1926; reprinted by Gebr. Mann Verlag, Berlin 1998
Henry-Russell Hitchcock and Philip Johnson, *The International
 Style*, 1935; new edition, Norton, New York 1997
Ute Poerschke, *Funktionen und Formen. Architekturtheorie
 der Moderne*, transcript Verlag, Bielefeld 2014

Modernity and the Life Reform movement of the early twentieth century reflected the desire for an "indivisible whole, anchored in people themselves, which only acquired sense and meaning through living a vivid life" (Gropius, "Idee und Aufbau des Bauhaus", 1923). The artists were driven by the synthesis of all art forms as well as of art and science and of science and life. Richard Wagner in particular is seen as being a pioneering figure in the synthesis of the arts. For him, a *Gesamtkunstwerk* did not just mean the interaction of art, poetry, stage design and architecture. He aimed to increase the perception and reception faculties of the artists involved as well as of the listeners and viewers. The idea of the "indivisible being" (Franz Marc) can also be found in architect Hermann Muthesius's slogan "from sofa cushions to urban development". This architect played an important role in the development of the Hellerau garden city *Gesamtkunstwerk*, anticipating much of what later emerged at the Bauhaus. In the 1930s, the *Gesamtkunstwerk* was perverted by the ideological requirement of totality. Both then disappeared with the defeat of fascism, not re-emerging until Harald Szeemann created a powerful reminder with his exhibition *Der Hang zum Gesamtkunstwerk* (Kunsthaus Zürich 1983). This exhibition made Wagner's vision of the *Gesamtkunstwerk* "as the necessary conceivable common work of the people of the future" (Wagner, *Kunstwerk der Zukunft*, chapter 5) into a topic for discussion again. Variations on the idea of the *Gesamtkunstwerk* can be seen in art forms such as happenings, fluxus and performance art as well as in forms given the label of intermediality, which are becoming increasingly prominent. WK

Harald Szeemann, ed., *Der Hang zum Gesamtkunstwerk*, Sauerländer, Aarau/Frankfurt am Main 1983
Richard Wagner, "Kunstwerk der Zukunft" [1850], in Sven Friedrich, ed., *Richard Wagner; Werke, Schriften und Briefe*, Directmedia, Berlin 2004

Harmonization Theory

Between 1921 and 1924, music teacher Gertrud Grunow taught harmonization theory at the Bauhaus together with her assistant Hildegard Heitmeyer-Nebel. This was a form of rhythmic education, which was also taught at other schools. Grunow's lessons were based on the synthesis of colour, sound and shape (movement), and aimed to bring into balance "the different physical and mental idiosyncrasies of the individual". The purpose was to introduce "the young people to an exact and immediate perception of formal realities" (Giulio Carlo Argan). The class aimed to develop the students' active and receptive faculties – sensory perception and awareness were to be understood as a creative mental act.

In the Bauhaus curriculum, harmonization theory was of fundamental importance, accompanying the students throughout the entirety of their training, even overriding in importance the courses themselves. It was represented by a horizontal beam that also formed the visual foundation of the three pillars of Bauhaus training, which consisted of productive studio work, material studies and free design work, and shape and colour theory.

With its holistic approach and its rhythmic and musical exercises, harmonization theory had an important influence on the Bauhaus's orientation during the early years, later becoming part of the preliminary course. Grunow's role was also to provide student assessments, recommending them for particular workshops. JK

Sabine Schimma, "Die Lebendigen Kräfte der Farben", in Ute Ackermann and Ulrike
 Bestgen, ed., *Das Bauhaus kommt aus Weimar*, exhibition catalogue, Klassik Stiftung
 Weimar, Deutscher Kunstverlag, Berlin 2009
Cornelius Steckner, "Die Musikpädagogin Gertrud Grunow als Meisterin der Formlehre am
 Weimarer Bauhaus: Designtheorie und produktive Wahrnehmungsgestalt", in *Das frühe
 Bauhaus und Johannes Itten*, Hatje Cantz, Ostfildern 1994
Giulio Carlo Argan, *Gropius und das Bauhaus*, Vieweg, Wiesbaden 1992

Following the Expressionist phase of 1922/23, the Bauhaus entered a phase of production influenced by constructivism and machine aesthetics, with an increasing focus on functional design criteria and industrial production techniques. The sale of the first prototype licences for industrial production led to the Bauhaus GmbH copyright collective, which was founded in 1925. Over the following years, Bauhaus GmbH cooperated with industry and entered into copyright contracts for products developed in the workshops – with Polytex (Berlin) for textiles, with Körting & Mathiesen (Leipzig) for lighting, with Gebr. Rasch carpet factory (Bramsche) for wallpaper, with Kunzendorfer Werke trade union (Kunzendorf) for frosted glass and with Pestalozzi-Fröbel-Verlag (Leipzig) for toys. Le Corbusier's dictum of the house as a machine for living also influenced Bauhaus architecture, as can be seen from Walter Gropius's idea of "Baukasten im Großen" (large-scale construction kit). He designed standardized houses, which he and Hannes Meyer realized in sites such as the Dessau-Törten housing estate, using techniques implemented when building industrialized and rationalized housing for the masses. Under the direction of Hannes Meyer, the Constructivist creed, "using machines means to act in the spirit of our century" (László Moholy-Nagy), was combined with economic and socio-political demand for industrialized mass production of furniture and everyday objects, which was meant to improve the living standards of the wider population. Industrial mass production was to satisfy "the needs of the people instead of the need for luxury" (Hannes Meyer). UW

Bauhaus-Archiv Berlin, ed., *Bauhaus-Möbel. Eine Legende wird besichtigt*, Berlin 2003
Justus Binroth et al., *Bauhausleuchten? Kandemlicht! Die Zusammenarbeit des Bauhauses mit der Leipziger Firma Kandem*, Stuttgart 2002
Tapetenfabrik Gebr. Rasch and Stiftung Bauhaus Dessau, ed., *Bauhaustapete. Reklame & Erfolg einer Marke*, Cologne 1995

Money is confidence in print form; it is transportable power. The erosion of material monetary value was more traumatic for Germany than any other nation, and its effects still live on in the collective subconscious today. The year when the Bauhaus was founded, 1919, also brought – as a logical consequence of the financing of the First World War by the printing of banknotes – the turning-point in a creeping devaluation of the Reichsmark that now veered towards galloping hyperinflation. By the end of 1923 you needed a drawerful of worthless paper to pay for a loaf of bread and, even then, you had to be quick about it.

Inflation (from the Latin meaning "swelling") had at the time both a material and mental component: the conviction that there was too much of everything – and above all that too many people had poured into the large cities in their masses during the second industrial revolution. In Weimar Germany, Siegfried Kracauer identified the "mass ornament" as a symptom of the times in which the model of industrial mass production translated into social choreographies. "Vermassung", or massification, became the slogan of the educated middle classes, who saw their aspirations being swept away in the ocean of mass culture. In his essay "The Revolt of the Masses", José Ortega y Gasset exemplified the conservative unease regarding democratized mass consumption: "They have acquired tendencies and needs that until now were considered refined because they were the privilege of the few" – an inflation of sophisticated tastes, in theory completely in line with Bauhaus ideology. The de- and revaluation of all values unlocked a utopian potential. It called new gurus and sectarians into action, known as the "Inflationsheiligen", the saints of inflation. In Thüringen a charismatic called Friedrich Muck-Lamberty and his "Junge Schar", or New Flock, walked around playing bugles and swinging brightly coloured cloths, tempting young people to stray from the path of virtue. This inflationary pre-hippie commune spirit left its mark on the young Weimar Bauhaus, too. HF

Niall Ferguson, *The Ascent of Money: A Financial History of the World*, Allen Lane, London 2008; trans. as *Der Aufstieg des Geldes*, Econ, Berlin 2009

Christina von Braun, *Der Preis des Geldes*, Aufbau, Berlin 2013

Siegfried Kracauer, *Das Ornament der Masse* [1927], Suhrkamp, Frankfurt am Main 1963

José Ortega y Gasset, *Der Aufstand der Massen* [1929], Rowohlt, Reinbek bei Hamburg 1964

Rüdiger Safranski, *Romantik. Eine deutsche Affäre*, Hanser, Munich 2007

As a state school of design, the Bauhaus adapted the tried and tested principle of workshop training, which was used by the Weimar Saxon-Grand Ducal Art School, connecting it directly with the Chamber of Crafts' regular journeyman training. This meant that studies at the Bauhaus had a mandatory length of three years. This was extended by one semester for the preliminary course, which functioned as a trial semester, making the journeyman qualification equivalent to a design diploma. The first Bauhaus students completed their journeyman exams in 1922, and some of them stayed on to work in the Bauhaus production workshops as staff journeymen. These workshops were established alongside the training workshops in 1922. They provided journeymen and apprentices with a space to duplicate prototypes and complete commissions. One aim behind this was to improve the financial situation at the Bauhaus. For example, potters Theodor Bogler and Otto Lindig established a ceramic casting workshop and Gunta Stölzl and Benita Koch-Otte created a dye studio for the textile workshop.

Until 1922, "journeymen" referred to full journeymen who met the requirements of the Chamber of Crafts. As of 1922, full journeymen could apply to take a further exam at the Bauhaus. If they showed sufficient formal and craft-related skills, the masters gave them the title of "Bauhaus journeymen". As of 1925, the most talented journeymen were appointed as "young masters" at Bauhaus Dessau, where they were given the task of leading the workshops. Bauhaus journeymen Erich Dieckmann, Otto Lindig and Richard Winckelmayer were given comparable teaching positions at the Weimar Art School, and Benita Koch-Otte taught at the Burg Giebichenstein Art School in Halle an der Saale. Out of the 638 students at Bauhaus Weimar, only around 5 per cent completed the journeyman exam. In Dessau in 1929, this exam was almost entirely replaced by the Bauhaus diploma. MS

Folke Dietzsch, "Die Studierenden am Bauhaus", dissertation
 HAB Weimar, 1990
Ute Ackermann and Ulrike Bestgen, Das Bauhaus kommt aus
 Weimar, exhibition catalogue, Klassik Stiftung Weimar,
 Deutscher Kunstverlag, Berlin 2009
Sebastian Neurauter, Das Bauhaus und die Verwertungsrechte,
 eine Untersuchung zur Praxis der Rechteverwertung am Bauhaus
 1919–1933, Mohr Siebeck, Tübingen 2013

There were immediate reactions to the structural problems in society resulting from mid-nineteenth-century industrialization and urbanization – with Marx's and Engel's tongues, anarchy, psychoanalysis, expressionism, futurism and spiritualism. However, reformist figures also focused on everyday life. The land reform and settlement movement developed, which was based on the fundamental idea of common property, referring to both property and land. The increasing industrialization of agriculture was confronted with the solution of embracing an organic lifestyle. The middle class adopted natural medicine, organic clothing, health food shops, vegetarianism, nudism and even temperance in their search for a new, fulfilling life. Islands of a new world – from Friedrichshagen and Worpswede, to Dresden-Hellerau, Mathildenhöhe and Monte Verità above Ascona – became pilgrim destinations for people who rejected the grey everyday of city life and wanted to enter a promising new world. New concepts for bringing up children and education played an important role here, as did social coexistence and urban development. The reform movement was driven forward by numerous organizations and unions who were not connected by a superordinate organization but simply by a desire not just to think about utopia but to live it. One of the most important ideals of the time was the fusing of art and life. Here, art was not one's master, "but rather life which had become art and was generated by art" (Kurt Breysig, *Das Haus Peter Behrens*). The direct connection between the Deutscher Werkbund [German Association of Craftsmen] founded in 1907 and the reform movement is therefore unsurprising. There was another line of connection linking the Association of Craftsmen to the Bauhaus, created in particular by Peter Behrens, in whose architecture office Walter Gropius, Ludwig Mies van der Rohe and Le Corbusier had worked. The pathos of the reformists can clearly be felt in the founding manifesto written in 1919. WK

Kai Holz, Rita Latocha, Hilke Peckmann and Klaus Wolbert, ed., *Die Lebensreform. Entwürfe zur Neugestaltung von Leben und Kunst um 1900*, exhibition catalogue, Institut Mathildenhöhe, Darmstadt 2001

Diethart Kerbs and Jürgen Reulecke, ed., *Handbuch der deutschen Reformbewegungen 1880–1933*, Hammer, Wuppertal 1998

"we always use small letters because this saves time." This is what Herbert
Bayer added to the bottom of the letter paper he designed for Bauhaus
Dessau in 1925. A different letter paper design reads: "using small letters
does not take anything away from our language. it is made easier to
read, easier to learn and far more economical." The emphasis that Bayer
and the other Bauhaus members placed on small letters led to resistance
from the city administration of Dessau as well as to fierce discussion
in the specialized press. The press was shocked that an institution that so
vehemently demanded small letters used capital letters for the titles of
its books. Much of the printed materials produced at the Bauhaus really
did give the impression that, if given the choice between small and capital
letters, the larger option was preferred. Even the lettering on the Bauhaus
building, designed by Herbert Bayer himself, was in capitals. The usage of
small letters is symptomatic of a recurring problem at the Bauhaus: there
was frequently a contradiction between rhetoric and reality. For example,
the Bauhaus claimed to produce economical products, despite the fact
that this was not possible at the beginning. The small letters problem also
illustrates opposition from members of the public, who were often provoked
by the Bauhaus's radical demands. Furthermore, it demonstrates the
capability of the Bauhaus members to radicalize and emphasize something
that already existed, and connect it to the Bauhaus name. It is important
to realize that small letters had been demanded and used long before
the Bauhaus was founded – for example, by Jacob Grimm, Stefan George
and Walter Porstmann, whose pioneering book Bayer was referring to
in the note he added to the letter paper. JM

Walter Porstmann, *Sprache und Schrift*, Verlag des VDI, Berlin 1920
Walter Scheiffele, *Bauhaus, Junkers, Sozialdemokratie – ein Kraftfeld
 der Moderne*, "Weltsprache und Weltschrift", form + zweck,
 Berlin 2003, pp. 55–65

Between 1900 and 1930, countless new magazines appeared. They disseminated to the public a vast range of associations' ideas about art, architecture, literature, music, crafts and science, but also about social issues. The most important publications included, among others: *Sturm*, published from 1910 onwards by Berlin publisher and gallerist Herwarth Walden; the Dutch magazine *De Stijl* (1917); in France, Amédée Ozenfant and Le Corbusier's *L'Esprit Nouveau* (1920); and *Die Form*, issued by the Deutscher Werkbund (1925). It is therefore not surprising that the Bauhaus also made use of this proven tool in order to spread its ideas. The first issue of *bauhaus* was published on the opening of its new building on 4 December 1926 in Dessau. The editor was Walter Gropius; László Moholy-Nagy was responsible for content and design. It was intended to counter growing criticism of the Bauhaus and at the same time provide information about activities and tuition there, as well as its positions on architecture and art. There were also advertisements for the "products of the bauhaus workshops", and several special issues appeared – such as those on Bauhaus architecture and on the stage at Bauhaus. After its second year, the magazine was given the subtitle *Zeitschrift für Bau und Gestaltung*. After the double issue 2/3 in its second year (1928), Hannes Meyer and Ernst Kállai assumed responsibility for content. The magazine was now given the subtitle *zeitschrift für gestaltung*, and the number of pages increased to over thirty. With its comprehensive range of themes from architecture and art, to pedagogy and urban planning, through to film and typography, *bauhaus* rapidly became a key voice of the artistic and architectural avant-garde. In 1931 three final issues appeared – published by Ludwig Mies van der Rohe together with Ludwig Hilberseimer, Josef Albers and Wassily Kandinsky. UW

bauhaus, 14 issues, Dessau 1926–31 (facsimile Nendeln,
 Kraus reprint 1977)
Annete Ciré and Haila Ochs, ed., *Die Zeitschrift als Manifest.
 Aufsätze zu architektonischen Strömungen im 20. Jahrhundert*,
 Birkhäuser, Basel 1991

Manifestation – in the sense of public statement – is the central expression of the avant-garde and includes agendas, treatises and theoretical essays. The *Futuristische Manifest* (1909), for instance, exalted the machine, speed and the concept of a new order through the destruction of the old, while the *Dadaisten* (1919) sought to destroy "this [German] culture … with all the instruments of satire, bluff, irony and finally, violence."
A manifesto also marks the beginning of the Bauhaus: *Das Manifest und Programm des Staatlichen Bauhauses in Weimar*, published as a four-page pamphlet by Walter Gropius in 1919 with Lyonel Feininger's woodcut *Kathedrale der Zukunft*. Its purpose was to announce the founding of a new school of art and architecture, emphasizing its divergence from traditional art academies while presenting its objectives and principles as well as its new teaching concept to the public.
The founding manifesto focused on calling for the "unified work of art" – the "great building" – which all arts were meant to serve, and which is proclaimed as the "ultimate aim" of the new design teaching. During the Weimar period there followed numerous further manifestos written by Bauhaus teachers, in which both the principles and the teaching concept of the Bauhaus were specified and published in the form of flyers and leaflets as well as almanacs and catalogues – for example those by Johannes Itten (the *Utopia* almanac), Wassily Kandinsky, Paul Klee (*Katalog Staatliches Bauhaus Weimar 1919–1923*) and Oskar Schlemmer (leaflet entitled *Die erste Bauhausausstellung in Weimar 1923*). The refocusing of design principles in line with technology and industrial production, the proclamation of a new kind of architecture and the social and political implications for the design of new ways of life stand at the core of the Dessau Bauhaus manifestos, which mainly appeared in *bauhaus* magazine. UW

Wolfgang Asholt and Walter Fähnders, ed., *Manifeste und Proklamationen der europäischen Avantgarde (1909–1938)*, Metzler, Stuttgart/Weimar 1995
Hans M. Wingler, *Das Bauhaus 1919–1933. Weimar, Dessau, Berlin und die Nachfolge in Chicago seit 1937*, 3rd revised edition, DuMont, Cologne 1975

"The school serves the workshop and one day they will merge into one another. This is the reason why we do not have teachers and students at the Bauhaus but rather masters, journeymen and apprentices," wrote Walter Gropius in the 1919 Bauhaus programme. In a conscious move away from the academic approach of the nineteenth century, the term "architecture" was replaced by the term "construction" and the word "professor" was replaced by the word "master". Gropius appointed European avant-garde artists including Lyonel Feininger, Johannes Itten, Wassily Kandinsky, Paul Klee, Oskar Schlemmer and László Moholy-Nagy as masters of form at the Bauhaus in Weimar. They were not only responsible for teaching the basics of design in preliminary courses, giving lessons in shape and colour and even life drawing, but also for managing the workshops and providing creative inspiration there. Craft training was provided by proficient master craftspeople such as Carl Zaubitzer in the printing shop, Otto Dorfner in the bookbindery, Helene Börner in the textile workshop, Max Krehan in the pottery workshop and Christan Dell in the metal workshop. These craftsmen and women had to hold a teaching qualification from the Chamber of Crafts. Initially, students who had studied with the masters at the Bauhaus school of design were called "young masters". The dual training system in the Bauhaus Dessau was abandoned and, in 1925, the most talented "young masters" took over responsibility for workshop training. Joost Schmidt led the plastic arts workshop, Herbert Bayer led typography and advertising, Marcel Breuer led carpentry, Hinnerk Scheper led mural painting and Gunta Stölzl, the only woman, led the weaving workshop. The workshop leaders combined technical and design training and the principle of the "junior professor" was born. In 1927, the title of professor was reintroduced and, in 1929, the craft training with its qualification as journeyman was replaced with the Bauhaus diploma.
MS

Hans M. Wingler, *Das Bauhaus 1919–1933. Weimar Dessau Berlin*, Gebr. Rasch, Bramsche 1962

Michael Siebenbrodt, ed., *Bauhaus Weimar. Entwürfe für die Zukunft*, Hatje Cantz, Ostfildern 2000

Volker Wahl, ed., *Die Meisterratsprotokolle des Staatlichen Bauhauses Weimar 1919–1925*, Hermann Böhlaus Nachfolger, Weimar 2001

Mobility refers to the change between places or positions in physical, geographical, social or virtual spaces in the context of specific actions or objects. Starting in the mid-nineteenth century, new technologies and machines have led to a dramatic acceleration of economic, political and social relations. Late nineteenth-century and early twentieth-century art trends often reflected the ways that scientific and economic developments influenced one another. Mobility and the mobile use of all resources appeared to be the solution to the unbalanced abundance of technology and its momentum. The echo of military mobilization within the term "mobility" is in no way incidental. After all, the reciprocal advancement in war technology, economy and science had a hand in both world wars. In 1926, Hannes Meyer spoke of "semi-nomads of contemporary economic life" in his text "Die neue Welt" [The New World], also writing of mobile living in "mass apartment buildings, sleeping cars, living yachts and transatlantique", astutely outlining a new living environment to which humans still needed to adapt. Walter Gropius also focused on the topic of mobility, designing a car for Adler. The Bauhaus did not only want to tackle the challenge of integrating people's needs and skills into industrial modernity but also to take an era made more mobile by developments such as new means of transport and telecommunication and change it for the better. The Bauhaus was confronted with the important question of whether design could tame a dynamic and developed industrial culture and deal with it in a productive manner. LN

On mobility in general, see http://de.wikipedia.org/wiki/Mobilität
(in German)
Hannes Meyer, "Die neue Welt", in *Das Werk*, vol. 23,
no. 6, July 1926, pp. 205–24
Gert Selle, *Geschichte des Design in Deutschland*, Campus,
Frankfurt am Main/New York 1994
*The Moderns. Wie sich das 20. Jahrhundert in Kunst und
Wissenschaft erfunden hat*, exhibition catalogue, mumok
Vienna, Springer, Vienna 2012
Hans M. Wingler, *Das Bauhaus 1919–1933. Weimar Dessau
Berlin*, Rasch, Bramsche 1962

For the purposes of national-conservative ideology, the Nazi Party branded the Bauhaus in Dessau a symbol of cultural modernism and closed it down in 1932. It was initially continued as a private institute in Berlin before its teachers dissolved it once and for all on 20 July 1933, due to the hostile climate and financial pressure. Many Bauhaus associates were banned from practising their profession. A large number of its famous advocates emigrated and in doing so contributed to the worldwide dissemination of Modernism, especially in the USA. In 1937, works by Bauhaus painters were defamed in the *Entartete Kunst* [Degenerate Art] exhibition; over sixty Bauhaus students were imprisoned or murdered for anti-Communist or anti-Semitic motives. And yet the Cold War myth that as a "school of democracy" the Bauhaus stood up against National Socialism is, in fact, debatable: in fact, one could not even describe the Bauhaus administration as apolitical. In May 1932, for instance, Federal Curator Grote consulted with Mies van der Rohe on negotiations with the not yet art-reactionary wing of the Nazi Party, and the Bauhaus won the temporary support of Alfred Rosenberg, head of the Militant League for German Culture, against the threat of closure. Many easily found work and a livelihood in art professions outside prestigious contracts for the state or society. Gropius, Mies and other well-known Bauhaus associates left Germany not least for career reasons. Previously they were involved in the proximity of the Nazis at exhibitions and also (unsuccessfully) in competitions for prestigious buildings. Kandinsky merely regretted that, unlike Italian fascism, German fascism misunderstood Modernism, as he saw it. Herbert Bayer designed exhibitions such as *Deutsches Volk – Deutsche Arbeit* (1934) and *Deutschland* at the 1936 Olympic Games. Wilhelm Wagenfeld enjoyed success working for the Lausitz Glassworks; Hanns Dustmann was Reichsarchitekt for the Hitler Youth, while Fritz Ertl was deputy construction manager in Auschwitz. HB

Peter Hahn, ed., *Bauhaus Berlin. Auflösung Dessau 1932. Schließung Berlin 1933. Bauhäusler und Drittes Reich*, Kunstverlag Weingarten, Weingarten 1985

Elaine S. Hochman, *Architects of Fortune. Mies van der Rohe and the Third Reich*, Weidenfeld & Nicolson, New York 1989

Winfried Nerdinger, ed., *Bauhaus Moderne im Nationalsozialismus – Zwischen Anbiederung und Verfolgung*, Prestel, Munich 1993

After the traumatic experiences of the First World War, avant-garde photography aimed to do visual justice to a changed reality by looking through the camera lens with a radical gaze. Since the 1920s, the term "Neues Sehen" [New Vision] had stood for a radical break with the familiar perception of the world and its photographical portrayal. Rejecting all Impressionist and pictorial photography trends, a new generation of photographers began to reflect on the specific qualities of photography and attempted to achieve a consistent contemporary depiction of modernity. Experimental approaches to the photographic subject and formal qualities – such as the use of unbalanced image sections, unusual close-ups and extreme close-ups, extreme high-angle and low-angle shots and distortion – celebrated the dynamic that was so characteristic of city modernity and the new machines. The increasing use of photographs in mass media increased the demand for images. This new way of taking photographs revolutionized what people were used to seeing as well as their perception, making Neues Sehen into an expression of a media-shaped perception of reality that affected films, advertisements, fashion and typography. The influence of Neues Sehen could be seen in photography at the Bauhaus. It was particularly used to create spontaneous, natural snapshots of students' working and private lives and was not, as Andreas Haus stressed, used as a formal stylistic device. László Moholy-Nagy made use of Neues Sehen in advertisement and typographic design, leading to him becoming a central figure within a new aesthetic of advertisement. LN

Christine Kühn, *Neues Sehen in Berlin: Fotografie der Zwanziger Jahre*, Kunstbibliothek Museum für Fotografie – Staatliche Museen zu Berlin, Berlin 2005

Wolfgang Kemp, "Das Neue Sehen. Problemgeschichtliches zur fotografischen Perspektive", in *Foto-Essays zur Geschichte und Theorie der Fotografie*, Schirmer/Mosel, Munich 1978, pp. 51–101

Rainer K. Wick, *Das neue Sehen: von der Fotografie am Bauhaus zur subjektiven Fotografie*, Klinkhardt and Biermann, Munich 1991

Jeannine Fiedler, *Fotografie am Bauhaus*, Bauhaus-Archiv Berlin, Berlin 1990

Andreas Haus, "Fotografie am Bauhaus: Die Entdeckung eines Mediums", in ibid., pp. 127–84

the bauhaus

Play

Alongside the preliminary course, teamwork and workshop sessions, one of the pedagogical achievements at the Bauhaus was the use of creative and experimental play. The Bauhaus became a new sort of school: a school of discovery. Based on the new pedagogical ideas of Pestalozzi, Fröbel and Steiner, Bauhaus artists used creative play as a creative method, encouraging and practising it at all stages of Bauhaus training. This can particularly be seen in the stage projects at Bauhaus Weimar. These projects were realized by students from all the Bauhaus workshops – examples include the plays *Die Abenteuer des Kleinen Buckligen* and *Der Mann am Schaltbrett* by Kurt Schmidt. The same use of creative play can be seen in the famous Bauhaus festivals and the lantern and kite festivals, to which the public was invited. A Bauhaus band was founded by Andor Weininger in 1924, providing an opportunity for creative play in the field of music.

These experiences were transported back into the world of children through the numerous designs created by Bauhaus students. This can particularly be seen in the children's room in the exhibition house Am Horn in Weimar, which was designed by Bauhaus graduate Alma Siedhoff-Buscher. In 1923, she realized a multifunctional play area, with versatile furniture and walls to be painted on. Plans were also made for cinematographic apparatus. Her robust but soft throw dolls were patented and her cut-out sheets were published. The rug in the children's room, designed by Benita Koch-Otte, and the children's furniture, designed by Marcel Breuer, are now design classics. Most famous of all is the Bauhaus chess set designed by Josef Hartwig, with pieces shaped to express their function in a unique manner. MS

Ute Ackermann and Ulrike Bestgen, *Das Bauhaus kommt aus Weimar*, exhibition catalogue, Klassik Stiftung Weimar, Deutscher Kunstverlag, Berlin 2009

Michael Siebenbrodt and Stiftung Weimarer Klassik und Kunstsammlungen, ed., *Alma Siedhoff-Buscher. Eine neue Welt für Kinder*, Weimar 2004

Paul Legado, Christine Ruiz-Picasso and Bernard Ruiz-Picasso, ed., *Toys of the Avant-Garde*, exhibition catalogue, Fundación Museo Picasso, Málaga 2010

In 1919, the preliminary course was introduced by Johannes Itten (1888–1967) as an obligatory trial semester at the Bauhaus. Basic design principles of form and colour were taught and, by playing with materials, students were able to experience the connections between construction, function and form. Furthermore, the preliminary course even provided mental training, with exercises in concentration to be done both while stationary and while moving. These exercises were inspired by meditation techniques from the Far East. The aim was to train and sensitize the perception of the senses – in particular the senses of sight and touch. With the "analyses of old masters", Itten provided students with a methodology for investigating works of art and the environment by means of language, mathematics, and subjective and abstract drawings. At the same time, students were encouraged to investigate their own personalities, talents and abilities as well as to discover and work on their weaknesses. The aim was to give students the tools needed to decide in which direction they would like to continue their training and therefore which Bauhaus workshop would be the most suitable. This trial semester also made it possible to make an early and qualified decision not to study at the Bauhaus. The preliminary course was an opportunity to see what would be taught at the Bauhaus and to experience the community work that took place outside the framework of the workshops. Only when the preliminary course was completed successfully and all semester work had been exhibited was it possible to participate in one of the Bauhaus workshops. After Itten resigned in 1923, László Moholy-Nagy and Josef Albers took over responsibility for the preliminary course, placing greater emphasis on systematic material exercises to provide training with a greater focus on design. Today, works produced during the preliminary course at the Bauhaus are often believed, incorrectly, to be art works. MS

Johannes Itten, *Gestaltungs- und Formlehre. Mein Vorkurs am Bauhaus*, 9th edition, Urania, Freiburg 2007
Till Neu, *Von der Gestaltungslehre zu den Grundlagen der Gestaltung*, Otto Maier, Ravensburg 1978
Thomas Föhl, Michael Siebenbrodt et al., *Klassik Stiftung Weimar. Bauhaus-Museum*, 5th edition, Deutscher Kunstverlag, Berlin 2015

the bauhaus

"The Spirit is Certainly of Importance" was the title of a column written by Emanuel Derman, physicist, investment banker and professor at Columbia University, published 14 September 2012. He gained fame mainly due to the financial mathematical models he developed. But at the same time he made himself unpopular in the financial world as he kept warning of the consequences of not maintaining a critical approach to the models. He grew up as a critical rationalist but was also an attentive reader of philosophical works, which taught him one thing above all – amazement. He rediscovered Goethe's plea for "matter never without spirit and spirit never without matter" in a different form in writings by Spinoza, who believed spirit and matter to be attributes of a fundamental substance, which shaped the essence of the world. Or in other words: the spirit is no epiphenomenon of matter and matter is no epiphenomenon of the spirit.

We are talking of the spirit of the time, of the spirit of laws, of the spirit of God, of a spiritless time, a chaos of the spirit or even an "architectonic spirit" (Walter Gropius, *Bauhaus-Manifesto*). We often behave like a helium atom, which avoids symbiotic relationships with other atoms because it is complete in itself, although this means that it remains entirely alone (Linus Reichlin). The spirit is a matter of belief; this is what the fathers of the church used to say when they stated that knowledge refers to material on earth and belief refers to the world of God and the spirit. However, this division never proved to be particularly successful.

Whether reality, model or metaphor, the spirit "blows where it will", but above all it comes from a clearly logical designation. Everyone perceives this spirit, experiencing it as being meaningful or disruptive, as being integrating and dispersive. Kandinsky's seminal work *Über das Geistige in der Kunst*, still influences art today. At the time, it signalled the beginning of the "era of great spirituality". But whoever was planning the twentieth century had a more deadly turn of events in mind. WK

Martin Heidegger, *Der Ursprung des Kunstwerkes*, Reclam, Stuttgart 1960

Wassily Kandinsky, *Über das Geistige in der Kunst* [1911], Benteli, Bern 2004

F. W. J. Schelling, *Bruno oder über das göttliche und natürliche Prinzip der Dinge. Ein Gespräch*, hg. von Manfred Durner, Meiner, Hamburg 2005

Maurice Tuchmann and Judi Freeman, *Das Geistige in der Kunst*, Urachhaus, Stuttgart 1988

The Bauhaus stage workshop was founded in 1921 and directed by Lothar Schreyer until 1923. He had a great interest in Expressionist theatre and, up until then, had been the director of the Sturm-Bühne Theatre in Berlin. Performing arts were of particular importance at the Bauhaus as they connected different fields of art in a similar way to architecture. "As an orchestral unit, stage work is intrinsically connected to the work at the Bauhaus," for which reason it was necessary to redefine theatre and therefore to research "the individual problems of space, body, movement, form, light, colour and sound" (Walter Gropius). The Bauhaus theatre, which was directed by Oskar Schlemmer from 1923, developed into a site for experimentation, where the elemental "rules of mechanics, optics and acoustics" (Gropius) were applied and different forms of light art, movement art and space art were tried out. Abstract or total theatre was the aim, with individual actors playing either a marginal role or no role at all. Instead, the stage was conceived as a *Gesamtkunstwerk*, produced using architecture (space), painting (colour), plasticity (spatial extension), music (sound) and dance (movement) in the manner demanded by Wassily Kandinsky in his study "Über die abstrakte Bühnensynthese" (1923). In addition to experimental work by Kurt Schmidt, Ludwig Hirschfeld-Mack and Kurt Schwerdtfeger, Wassily Kandinsky's *Bilder einer Ausstellung* (1928) and in particular Oskar Schlemmer's *Triadisches Ballett* (1922), in which three dancers performed twelve dances in eighteen costumes, were the most famous implementations of abstract and synthetic theatre concepts. In Schlemmer's ballet, the figurines appear as "moving architecture" (L. Lang). The Bauhaus theatre shows analogies to Erwin Piscator's theatre concepts – especially when Walter Gropius's unrealized design for a total theatre is taken into account. UW

Oskar Schlemmer, László Moholy-Nagy and Farkas Molnár, *Die Bühne im Bauhaus*, Bauhausbücher, vol. 4, Langen, Munich 1925
Dirk Scheper, *Oskar Schlemmer. Das Triadische Ballett und die Bauhausbühne*, Academy of Arts, Berlin 1988

Bauhaus founder Walter Gropius took a decisive step to make a breach with style tradition, and he stood firmly against a reduction to any single definition of style. Not style but the "organization of life processes" was to be the decisive principle for design work at the Bauhaus. This has now been an issue of contention for several decades: on the one hand, style was rejected as eclectic while, on the other, its loss was deplored as an altogether special form of expression and behaviour. Alois Riegl's *Stilfragen* gathered reflections on the defining psychical capacities and capabilities of human beings with the visible objectivizing of cultures and epochs. Adolf Loos brought the most radical thinking on a definition of style: a social relationship that was reflected in the ability of its user – of no matter what social origin – to establish an intelligent relationship with everyday things.

While Gropius rejected any single style definition, his illustrated book *Internationale Architektur* of 1925 presented the "unity of manifestations" though the example of numerous buildings, which embodied a new striving for an expression of form. The "inevitability of style" (Werner Oechslin) was then to prevail in the *Modern Architecture: International Exhibition* of 1932 at the Museum of Modern Art in New York. The material gathered in Europe on new building by Alfred Barr, Henry-Russell Hitchcock and Philip Johnson was given a new reading against the background of the American debates – as International Style. There are few formal features in the attributes of International Style: an understanding of architecture as space, the effort to achieve a modular regularity and the renunciation of any ornament. The return to a typological definition as represented by International Style has found an established place in the history of the Bauhaus and its reception, with the result that Bauhaus and International Style are frequently used synonymously. RB

Regina Bittner, ed., *Bauhausstil zwischen International Style und Lifestyle*, Jovis, Berlin 2003

Henry-Russell Hitchcock and Philip Johnson, *Der Internationale Stil 1932*, Braunschweig 1985, p. 26

Werner Oechslin, "Mainstream-Internationalismus oder der verlorene Kontext", in Vittorio Magnago Lampugnani, ed., *Die Architektur, die Tradition und der Ort. Regionalismen in der europäischen Stadt*, Deutsche Verlags-Anstalt, Stuttgart 2000, p. 98

Wolfgang Thöner, "Austreibung des Funktionalismus und Ankunft im Stil. Von der Ausstellung 'Modern Architecture: International Exhibition' zum Buch 'The International Style'", in Regina Bittner, ed., *Bauhausstil zwischen International Style und Lifestyle*, Jovis, Berlin 2003, p. 127

Karin Willhelm, "In Amerika denkt man anders", in ibid., p.197.

"As soon as you enter the school, you notice the difference. You are in a school that does not smell of dust, ink and fear but rather of sun, blond wood and childhood." This quotation refers to Samskola – a school following an entirely new approach, which was founded in Gothenburg in 1901. The lines were written by Rainer Maria Rilke, who was invited to go to Sweden in 1904 by Ellen Key, author of the well-received book *Das Jahrhundert des Kindes*. The search for the "new humanity" was prompted by industrialization and all its side effects – such as the emergence of the industrial proletariat – which repeatedly posed new challenges for the social structure. Around the turn of the century, the school system also began to be criticized in both the USA and Europe. Instead of drills and discipline, children were encouraged to develop initiative, creative potential and individuality, meaning that art was given a central position in the syllabus. These developments were greatly influenced by the art education movement started by Alfred Lichtwark. At the Laboratory School in Chicago, founded by John Dewey in 1896, the most important methodical principle was "learning by doing", whereby great importance was given to democratic education. Maria Montessori and Anton S. Makarenko developed reform concepts inspired by their work with children from the poor quarters of Rome (Montessori, Casa dei Bambini, 1907) and with young offenders in Russia (Makarenko, Gorky Colony, 1920). In Germany, the new concepts were implemented at vocational schools (Georg Kerschensteiner), at progressive *Landerziehungsheime* (Hermann Lietz and Gustav Wyneken) and at Waldorf schools (Rudolf Steiner). Radical changes were made at arts (and crafts) schools, with the focus being placed "on detoxifying students from the educational burden that they have brought with them", reflecting the maxims that Johannes Itten formulated for his preliminary course at the Bauhaus. WK

Dietrich Benner and Herwart Kemper, *Theorie und Geschichte der Reformpädagogik*, 3 vols., Beltz, Weinheim/Basel 2003
Ellen Key, *Das Jahrhundert des Kindes* [1902], Weinheim/Basel 1992
Herman Nohl, *Die pädagogische Bewegung in Deutschland und ihre Theorie* [1935], Klostermann, Frankfurt am Main 2002
Rudolf Steiner, *Die geistig-seelischen Grundkräfte der Erziehungskunst*, 12 lectures, Oxford 1922, Verlag der Rudolf Steiner-Nachlassverwaltung, Dornach 1991

Toy designs created in the context of Modernist product design had their roots in the progressive education movement and the Arts and Crafts movement that flourished around 1900. In 1902, numerous artists and architects, who were part of the Lebensreform movement and aesthetic education discussion, began designing toys. The focus started in Dresden and, despite initially being a German phenomenon, it eventually extended well beyond the country's borders. After 1920, it was considered at an institutional and academic level. The traditional vocational schools in Saxony and Thuringia which focused on the toy industry offered specific classes in toy design, as did design schools in Dresden, Berlin-Charlottenburg, Hamburg, Nuremberg, Stuttgart and Vienna. At the same time, Czechoslovakia began to give particular support to its traditional wooden toy industry. Training centres in the Bohemian Ore Mountains, Prague and Brno placed great emphasis on the shapes used in modern toys. Bauhaus toy designs developed within a very different artistic environment, where Alma Siedhoff-Buscher, Josef Hartwig, Oskar Schlemmer, Ludwig Hirschfeld-Mack and Eberhard Schrammen created toys that made use of programmatically different design. In addition, Lyonel Feininger and Paul Klee created wooden toys and hand puppets for their children. One-off designs by architects such as Bruno Taut, Hermann Finsterlin and Josef Hoffmann, toys from the Wiener Werkstätte environment and by the Dutch artists' group De Stijl complete the picture of toy ideas from that time. UL

Max Hollein and Gunda Luyken, ed., *Kunst ein Kinderspiel*,
 Revolver, Frankfurt am Main 2004
Paul Legado, Christine Ruiz-Picasso and Bernard Ruiz-Picasso,
 ed., *Toys of the Avant-Garde*, exhibition catalogue,
 Fundación Museo Picasso, Málaga 2010
Urs Latus, *Kunst-Stücke. Holzspielzeugdesign vor 1914*,
 Tümmel, Nuremberg 1998

In 1919 the acting head of the newly established Staatliches [State] Bauhaus, Walter Gropius, launched a competition for the design of a trademark – as a brand logo with which future Bauhaus products would be marked. This first competition, with 42 submissions, was won by the master student Karl Peter Röhl with his Expressionist "Star Manikin", which combined Asiatic and Germanic symbols. The head uses the Chinese yin and yang concept, while the body of the figure is based on the Germanic tree of life rune. In one hand the manikin holds a pyramid – symbolic of building and the "great build". Two years later the State of Thuringia demanded that since the Bauhaus was controlled and financed as a state institution it must use the official stamp of the State. Gropius successfully opposed this demand. He also launched a second trademark competition, this time among the masters – Oskar Schlemmer was the winner, selected from among 28 submissions – and succeeded in having what has become known as the "Schlemmerkopf" or Schlemmer Head accepted by the controlling authority and declared the official Bauhaus stamp in 1921. The Schlemmer trademark is a perfect circle enclosing designed logo lettering plus the image of a rhythmically staggered and stylized head in profile showing one eye.

The two winning designs show impressively how swiftly the Bauhaus was able to move on from the Expressionist syntax of its first year and boldly discover a new and faceless language of form. The other submissions again uniquely reflect not only the enormous breadth in the imagination, aspirations and wishes each Bauhaus member had for the new institution, but also the diversity of frequently very conflicting opinions that co-existed in a lively manner and that prompted Schlemmer to speak of the Bauhaus's "productive discord". JK

Volker Wahl, ed., *The Meisterratsprotokolle des Staatlichen Bauhauses Weimar 1919–1925*, Verlag Hermann Böhlaus Nachfolger, Weimar 2001

Constanze Hofstaetter, "Karl Peter Röhl und die Moderne. Auf der Suche nach dem ´neuen Menschen´. Zwischen Nachkriegsexpressionismus, frühem Bauhaus und internationalem Konstruktivismus", *Studies on International Architecture and Art History* 41, Michael Imhof, Petersberg 2007

Gert Selle, *Geschichte des Design in Deutschland*, Campus, Frankfurt am Main/New York 1994

The principle of technical reproducibility became a central item on the Bauhaus programme after about 1923. The change of course from a traditional craft with its single-item production to standardized design for industrial series and mass production was simultaneously accompanied by a turn to "Bauhaus functionalism", which was to characterize sustainably the image of the institution. It triggered the intuitive direction the school was to follow in its teaching method, aligned to the individuality of the students, and turned to binding instructions that were adjusted to the norms and standards of mechanical production: "because the nature of the machine will result in the 'genuineness' and 'beauty' of its products," Gropius reasoned in the "Grundsätze der Bauhausproduktion" [The Principles of Bauhaus Production] of 1925.

The metal workshop in particular was oriented to basic geometric and stereometric shapes. Even the handmade objects it turned out took on the external appearance of standard machine-made products through the use of specific metals with smooth surfaces. The use of primary colours was also regarded as the ideal prerequisite for mass production.

Other decisive influences on product design such as the laws of the market, fashion and the diversity of tastes among different social groups were misunderstood, however, and the belief was in universal solutions: "The creation of types for the useful objects of daily use is a social necessity. The necessities of life are essentially one and the same for the great majority of people" (Gropius, 1925). The generally binding nature of these rules was first questioned under the directorship of Hannes Meyer from 1928. GB

Christoph Asendorf, "Das Bauhaus und die technische Welt
 – Arbeit an der Industriekultur?", in Jeannine Fiedler and
 Peter Feierabend, ed., Bauhaus, Könemann, Cologne 1999,
 pp. 80–87
Ute Brüning, "Selbstdarstellung: Typochales und Normatives",
 in Das A und O of the Bauhaus, Edition Leipzig, Leipzig 1995,
 pp. 87–113
Walter Prigge, "Typus und Norm: Zum modernen Traum der
 industriellen Fertigung von Wohnungen", in Annett Zinsmeister,
 ed., Constructing Utopia: Konstruktionen künstlicher Welten,
 Diaphanes, Zurich 2005, pp. 69–77

Utopias (Greek, "no place") are future-oriented concepts of another world. While Plato and Thomas More envisaged better worlds, Aldous Huxley and George Orwell saw worse worlds: anti-utopias that serve as a critique of existing or feared states. The (concrete) utopias of Ernst Bloch, on the other hand, are entirely feasible visions of the future, a better social order for which the conditions are not yet available. The intellectual and artistic avant-garde of the 1920s made use of utopian designs in order fully to think through the new philosophical and aesthetic self-conception in broad areas of scientific, art and architectural theory. Thus utopian intentions pervade all of the development phases of the Bauhaus too. Its utopian concepts – which can be perceived as a "pursuit of absoluteness" (Wulf Herzogenrath) and as "artistic constructions of the unconstructable" (Hubertus Gassner) – range from paper architectural designs for a cosmically radiant *Kathedrale der Zukunft* (Lyonel Feininger) to the proclamation of a "unified work of art" (Walter Gropius) and an anti-aesthetic, scientific basis for architecture (Hannes Meyer) through to designs for ideal planned cities (Ludwig Hilberseimer). Utopian thinking in the Bauhaus is based on the assumption that one can use art to develop models for new ways of life and that the task of art design lessons should be to educate a "New Man" for a new fairer society in a new, future age. The utopian vision of a synthesis and/or translation of art into life as well as the educational or "therapeutic function of avant-garde art" (Donald Kuspit) relies – according to widespread criticism – on self-overestimation and excessive demands of art and leads to undemocratic, totalitarian thinking. UW

Jeannine Fiedler, ed., *Social Utopias of the Twenties*,
 Müller + Busmann Press, Wuppertal 1995
Hubertus Gassner, Karlheinz Kopanski and Karin Stengel, ed.,
 *Die Konstruktion der Utopie. Ästhetische Avantgarde und
 politische Utopie in den 20er Jahren*, Jonas, Marburg 1992
Wulf Herzogenrath, *bauhaus utopien. Arbeiten auf Papier*,
 Hatje Cantz, Stuttgart 1988

the bauhaus

Vegetable Garden

During the difficult period of time that followed the First World War, Bauhaus director Walter Gropius's main tasks were to find inexpensive studios, heated classrooms, sufficient teaching materials and enough food for the students. Every student was to receive at least one hot meal a day; to this end, he called upon the people of Weimar to finance so-called "free tables" and founded a Bauhaus garden and cafeteria, providing full board for up to two hundred people. At the beginning of 1919, the Bauhaus student representatives had already made the following suggestions: "The art school should take over the military hospital kitchen and use it as a canteen kitchen, where the students can eat cheaply." In June 1920, Gropius sent an application to the government, asking permission to garden on a piece of waste land, so that they could grow produce for the Bauhaus kitchen. A plot of land, 1.65 ha in size, was then cultivated and farmed by Bauhaus members. In 1922, almost 24,000 square metres of arable land and more than 7,000 square metres of garden were used to grow 2.5 tonnes of wheat, 8 tonnes of potatoes, 400 kg of peas, 500 kg of beans, 100 kg of lentils, one tonne of onions, one tonne of carrots and beetroots, one tonne of cabbage, 500 kg of tomatoes and 2,000 cucumbers, as well as lettuce, spinach and other vegetables. Fruit trees and bushes were also planted. On 6 October 1919, the Bauhaus canteen was opened with a celebratory party. In the time that followed, it provided up to a hundred students with full board, which consisted of five meals a week, charging a daily price of 3.50 Marks. The Bauhaus garden was always closely connected with the idea of a Bauhaus housing estate. It is therefore unsurprising that plans for the Bauhaus housing cooperative Bauhaussiedlungsgenossenschaft GmbH, created under Gropius's guidance, included this area from 1922 and that the exhibition house Am Horn was also built on this site in 1923. MS

Klaus-Jürgen Winkler, *Die Architektur am Bauhaus in Weimar*,
 VEB Verlag für Bauwesen, Berlin 1993
Sparkassen-Kulturstiftung Hessen-Thüringen, ed., *Das Haus
 "Am Horn"*, Frankfurt am Main 1999
Bauhaus files in the Thuringian State Archives Weimar,
 online catalogue

Like so many others, in August 1914 Walter Gropius set off for France in high spirits. From 1914 to 1918 he served in the field as an officer in the 9th Hussar Regiment. Initially euphoric and proud of his cold-bloodedness, he experienced unforgettable "uplifting moments". A year later – in the midst of the war – Henry van de Velde, Director of the Grand Duchy of Saxony School for Arts and Crafts Weimar, proposed Gropius as the successor to his post, from which he was obliged to resign on 1 April 1915. In January 1916 Gropius presented his ideas for the future direction of the school to the Grand Duke of Saxony-Weimar-Eisenach in Weimar. The main features he chose to outline were already those of the subsequent Bauhaus objectives; the intention was that artists should be consulted on the development of a modern styling of industrial products. Back at the front, he found military service increasingly exhausting: "For four long years now I have given my best for this crazy war and I have only lost, and lost," he wrote to his mother. At the end of the war Gropius returned to Berlin. Within a climate of ideological change, he contributed to the progressive ideas of his time, and in 1918 succeeded Bruno Taut as head of the Work Council for Art: "This is the kind of life that I have thought about for a long time, but the internal cleansing brought about by the war was necessary in order for it to happen. After much internal suffering in the war, I have turned from Saul into Paul. Like an intellectual idiot, demoralized as a result of the terrible war, on my way home three months ago I stumbled, like a maniac, into intellectual life." This sentence sums up the collective need of traumatized veterans for a new start. The promise of a new intellectual home was the Staatliche Bauhaus, founded by him as the successor to the School of Arts and Crafts in 1919. He came to Weimar in a turbulent state of mind, as he himself said, in order to "hammer together the age, heavy with ideas", into "something positively new." JKo

Reginald R. Isaacs, *Walter Gropius: der Mensch und sein Werk*, vol. 1, Gebr. Mann Verlag, Berlin, 1983
Nicholas Fox Weber, *The Bauhaus Group: Six Masters of Modernism*, Yale University Press, New Haven 2011
Volker Wahl, *Henry van de Velde in Weimar*, Böhlau, Cologne 2007

In 1999, the provincial town of Weimar in Thuringia became European Capital of Culture. The first documentary mention of Weimar was in 899 but it was not until 1552 that the town, now the new residence of the Duchy of Saxe-Weimar, attracted public attention, when Lucas Cranach the Elder took up residence. Its musical reputation goes back to 1491, when the Duchy orchestra (now the State Orchestra) was founded. Johann Sebastian Bach played an active role in the town between 1708 and 1717, as did Hummel, Liszt, Wagner and Richard Strauss in the mid-nineteenth century. An orchestral school, today called the University of Music Franz Liszt, was founded in 1872. Parallel to this, Weimar began to develop into a hub for literature and for European intellectual life. It became an important place for Goethe, Schiller, Herder and Wieland. The Weimar Princely Free Drawing School was founded in 1776. In 1860, the Weimar Saxon-Grand Ducal Art School was founded. It focused on *plein air* painting and, as a Weimar painting school, also placed great emphasis on art history.

 In 1900, Harry Graf Kessler tried to transform Weimar into a meeting point for European Modernism. It was on his initiative that Henry van de Velde became director of the arts and crafts school in Weimar. In 1903, he suggested that the Nietzsche Archive be set up and the Association of German Artists be founded. After the Bauhaus was pressurized into moving to a different location in 1925, the architectural school continued to uphold Bauhaus traditions during the final years of the Weimar Republic, until the Nazis started to use Weimar as a focal point for the persecution and destruction of Modernist art in 1930 (the Degenerate Art and Degenerate Music campaigns). They painted over Oskar Schlemmer's murals in the Weimar workshops in October 1930, dismissed the teachers and closed the school. UNESCO has now listed the Bauhaus sites, the Classical Weimar ensemble and Goethe's written estate as World Heritage. MS

Gitta Günther, Wolfram Huschke and Walter Steiner, *Weimar Lexikon zur Stadtgeschichte,* Hermann Böhlaus Nachfolger, Weimar 1993
Friederike Schmidt-Möbus and Frank Möbus, *Kleine Kulturgeschichte Weimars,* Böhlau, Cologne 1998

At the Bauhaus, workshops lay at the core of practical training. Basic craft training was closely connected with product development and, as of 1923, also took place in conjunction with small series production. Guidance was provided by masters of form such as Feininger, Klee and Schlemmer as well as by master craftspeople. As of 1925, Bauhaus graduates took over both functions, in their role as "young masters". Eleven workshops were established at Weimar: weaving, carpentry, mural painting, metalwork, pottery, printing, stone sculpture, wood sculpture, bookbinding, glass painting and stage work. In Dessau, pottery and glass painting were no longer offered and the sculpture workshops were transformed into a plastic arts workshop. In 1927, the construction department and the free painting classes were established and in 1929, the photography class came into being. In 1928, Hannes Meyer combined the workshops to form five departments: weaving, advertising, interior design, construction and stage. In 1931, Mies van der Rohe reduced the amount of workshop training and combined the construction and interior design departments; the stage workshop was closed. The weaving workshop, which was mainly attended by women, was, with an average of fifteen students, always the largest Bauhaus workshop, followed by carpentry and mural painting. As the apprenticeship was six semesters in length, there was a maximum of three students per semester in each workshop – and often there was only one. As of 1923, the best designs from the workshops were selected and classified. The classification began in the carpentry workshop with Breuer's wood-slat chair (Ti1a), in the metal workshop with the desk lamp by Jucker/Wagenfeld (ME1/MT9) and in the pottery workshop with Bogler's combination teapot. A complete list of the designs created up to 1925 as well as the monthly workshop reports by the workshop masters can be found in the Thuringian Central State Archive. MS

Klaus-Jürgen Winkler, ed., *Bauhaus-Alben 1–4*, Bauhaus University, Weimar 2006–9
Lutz Schöbe and Michael Siebenbrodt, *Bauhaus 1919–1933. Weimar Dessau Berlin*, Parkstone International, New York 2009
Sebastian Neurauter, *Das Bauhaus und die Verwertungsrechte, eine Untersuchung zur Praxis der Rechteverwertung am Bauhaus 1919–1933*, Mohr Siebeck, Tübingen 2013

"It's a great delight," declaims the student Wagner in Goethe's *Faust*, "to be moved by the spirit of the ages." And yet Goethe would not be Goethe if he were simply to accept such effusiveness, and thus he has Faust retort that "The spirit of the ages, that you find, / In the end, is the spirit of Humankind: / A mirror where all the ages are revealed." Barely a hundred years later, when Kandinsky sought to feed those souls falling ever deeper with the spiritual bread of an inspired art, Rathenau and Gropius challenged the Zeitgeist in their own way: rather than the pathos encountered among artists around the creation of the new, of people acting in harmony with the cosmos for more rationality, they instead advocated the total mechanization of everyday life and the anonymization of cities.

The process by which the Zeitgeist manifested itself at the beginning of the twentieth century is not easily reduced to a common denominator; it remains contradictory – but then that is, in essence, what it is. Awakening was followed by breakdown in 1918. Although still young, the century had lost its innocence and the Zeitgeist reshaped itself. Marked by his experience of war, Gropius read texts by Liebknecht and Rosa Luxemburg, wrote mystic poetry ("Spectrum mysticum / Iris leuchtet im Kristall / Farbenbrüder im Weltenall …"), brought Johannes Itten to the Bauhaus and announced with a sense of conviction: "The grace of fantasy is more important than any technology." Yet even such a spirit is ephemeral, since the Zeitgeist demands that from then on the objective gives the direction.

Some of the conflict at the Bauhaus and elsewhere could have been avoided if those involved had acted with the same insight as Robert Musil had when he noted in his diary: "Rationality and mysticism are poles of the age." Thus the Zeitgeist and what we do in its name steps outside the one-dimensionality that has always been attributed to it. Handling it remains a difficult task, since it means that tomorrow already begins to rain on today. WK

Winfried Nerdinger, *Walter Gropius*, Gebr. Mann Verlag,
 Berlin 1985
Peter Sloterdijk, *Zorn und Zeit*, Suhrkamp, Frankfurt am Main 2006
Christoph Wagner, ed., *Das Bauhaus und die Esoterik*, Kerber,
 Bielefeld/Leipzig 2005
Hans Dieter Zimmermann, ed., *Rationalität und Mystik*, Insel,
 Frankfurt am Main 1981

#itsall design

The Staatliche Bauhaus in Weimar was founded in 1919. The aim of this first school of design was to train a new type of designer, who was to be both artist and craftsperson. Designers learnt a craft in the workshop and, in lessons on theory and art, gained not only profound knowledge of design, colour, space and proportion but also of the human psyche and perception, of spatial laws and technical possibilities. A new type of designer was born.

These designers were to use an aesthetic born of materials and production processes to fight against the poor quality mass production taking place in an industrial society based on the division of labour. They would design useful, beautiful everyday objects that would last. The aim was to make it possible for everyone to live a better-designed life, not just the wealthy. This new type of designer was not only to design products but also buildings, cities, ways of life – und ultimately the whole of society. Everything was seen as designable and, in this way, everything became design.

The Bauhaus was the starting point of a comprehensive understanding of design that is in even greater demand today. With terms such as social design, open design and design thinking, the discussion of how designers can see their work in a broader context and thereby contribute to shaping society has begun anew. This shows that the Bauhaus was not only the place where a functionalistic design doctrine was developed, as has been believed for several decades, it was an open field of experimentation for a definition of design that has again become current in the context of the twenty-first century's changing processes of design, production and exploitation.

#create context

The new understanding of design at the Bauhaus presented new artist-craftspeople, who we would now simply refer to as designers, with a comprehensive design task. Designers were not only to design everyday objects, but to play an active role in re-shaping society.

 According to the Bauhaus understanding of design, this term therefore did not only refer to product design but also to a way of thinking and to an approach to society. In contrast to style, which refers to the beautification of the surface appearance of objects, design aims to improve everyday life by providing innovative solutions for objects, systems and structures. Designers have the task of analysing the present and making use of their profound knowledge of the past to develop such innovative solutions for the future. They thereby develop a deep understanding of very specific contemporary questions as well as of the social, economic, political and cultural context of their time.

■004 **Kurt Schmidt,** *Entwurf für das Mechanische Ballett,* **1923,** body colour, pencil on paper, 21 × 29.7 cm, Eckhard Neumann Estate, Freese Collection

Radical Change

The Bauhaus developed during a time of radical changes. The First World War had torn apart social values in the entire western world and industrialization had made old production structures obsolete. Reacting to these changes, artists searched for entirely new answers and tried to redefine constants such as shape, space, colour and movement. We still live in a period of radical change, experiencing economic and political crises while, at the same time, production structures are being shaped by the digital revolution, by the quest for sustainability, by participation and by a new form of social solidarity.

Although the historical context was very different, the topics that were discussed by Bauhaus members are, a hundred years later, as current as they were then: humans versus machines, individual versus society, authorship versus the collective, unique products versus mass production. In order to address these changes, designers return to the origins of industrial design, to movements such as the Bauhaus or De Stijl, with ironic comments or critical reflection. At the same time, they test the transferability of tried and tested methods such as the manifesto, which was used to spread new ideas at the beginning of the twentieth century.

The image on the cover contains the following text:

THE MUSEUM OF MODERN ART

CUBISM AND ABSTRACT ART

1890 · 1895 · 1900 · 1905 · 1910 · 1915 · 1920 · 1925 · 1930 · 1935

JAPANESE PRINTS

Gauguin d.1903
SYNTHETISM
1888 Pont-Aven, Paris

Van Gogh
d. 1890

Cézanne
Provence
d. 1906

Seurat d.1891
NEO-IMPRESSIONISM
1886 Paris

Redon
Paris
d. 1916

Rousseau
Paris
d. 1910

NEAR-EASTERN ART

FAUVISM
1905 Paris

NEGRO SCULPTURE

CUBISM
1906-08 Paris

(ABSTRACT)
EXPRESSIONISM
1911 Munich

FUTURISM
1910 Milan

MACHINE ESTHETIC

ORPHISM
1912 Paris

SUPREMATISM
1913 Moscow

CONSTRUCTIVISM
1914 Moscow

Brancusi
Paris

(ABSTRACT)
DADAISM
Zurich Paris
1916 Cologne
Berlin

PURISM
1918 Paris

DE STIJL and
NEOPLASTICISM
Leyden Berlin
1916 Paris

BAUHAUS
Weimar Dessau
1919 1925

(ABSTRACT)
SURREALISM
1924 Paris

MODERN
ARCHITECTURE

NON-GEOMETRICAL ABSTRACT ART

GEOMETRICAL ABSTRACT ART

CUBISM AND ABSTRACT ART

■005 **Alfred H. Barr Jr., Cover of the exhibition catalogue**
Cubism and Abstract Art, MoMA 1936, offset, printed in
color, 19.7 x 26 cm, The Museum of Modern Art Library, New
York. MA143

1919

■ 006 **Yuya Ushida, 1919, 2015,** digital print,
c. 30 × 21 cm, courtesy Yuya Ushida

The Bauhaus's legacy has left us many things: for instance, it left us respect for materials, respect for their function and their expressive potential, and awareness that there is an aesthetic of the constructive modality. In this sense, it left us an appreciation of how things work and not only their formal qualities.

ALBERTO MEDA, DESIGNER

■ 007 **Alberto Meda, *Lightness*, 2015,** 3D print,
polyamide, 32 × 30 × 15 cm, courtesy Alberto Meda

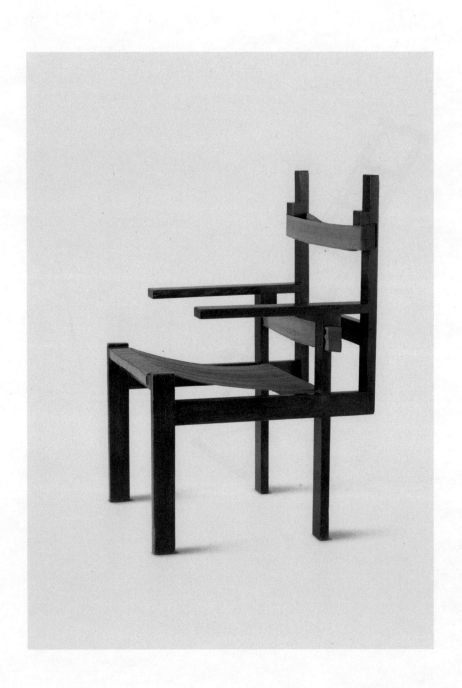

■ 008 **Marcel Breuer, armchair TI1a, 1922**
coloured oak, horsehair, 92.5 × 57.5 × 60 cm,
Vitra Design Museum Collection

#createcontext

83

■ 009 **Studio Minale-Maeda, Lego Buffet, 2010,** Lego, aluminium, 104.1 × 198.1 × 45 cm, Thomas Gallery Ltd, New York

Towards an Open Making Manifesto:

Excerpts from the 'last manifesto of the Bauhaus' (Hannes Meyer 1929)[1]

4	given proper embodiment
5	every creative design appropriate to living is
6	a reflection of contemporary society. –
7	building and design are for us one and the same, and they are a social process.
11	as creative designers
12	our activities are determined by society, and the scope of our tasks is set by society.
18	thus we take the structure and the vital needs
19	of our community as given.
71	art has always been nothing but organization.
72	we of today long to obtain through art solely
73	the knowledge of a new objective organization,
74	meant for all,
75	manifesto and mediator of a collective society.
93	everyone has an aptitude for something.
95	a capacity for symbiosis
96	is inherent in every individual.
97	hence education for creative design engages
98	the whole man.
101	it unites the liberation of the designer
102	with the capacity
103	for becoming identified with society.
104	the new theory of building
105	is an epistemology of existence.
108	as a theory of society
109	it is a strategy for balancing
110	co-operative forces and individual forces
111	within the community of a people.
112	this theory of building is not a theory of style.
113	it is not a constructivist system,
114	it is not a doctrine of technical miracles.
115	it is a system for organizing life,
116	and it likewise clarifies
117	physical, psychical, material, and economic concerns.
128	because this doctrine of building is close to life's
129	realities its theses are constantly changing:

The Open Making Manifesto v.1.0'
[original attribution Hannes Meyer]

1. Excerpts from "bauhaus and society" by Hannes Meyer (1929), translated from the German by D.Q. Stephenson.
From Hannes Meyer, Buildings, Projects, and Writings, (Teufen AR/Schweiz, Arthur Niggli Ltd: 1965).
The 'last Bauhaus manifesto' reference – The Bauhaus Idea and Bauhaus Politics by Eva Forgács (1991), translation by John Bátki (1995).

2. A call to collaboratively author the Open Making Manifesto – a public domain document developing open source design standards in keeping with new and social forms of production. As contemporary sharing platforms, digital manufacturing technologies and the Maker Movement develop, we have an opportunity to rethink how goods and services are made and distributed on a global scale.
Throughout the past century we have aspired towards a more socially-conscious and democratised idea of production – towards Gropius' new guild of craftsmen – new forms of civic infrastructure are bringing us closer than ever to realising this vision.

The Open Making Manifesto is hosted on GitHub via www.openmaking.is

June 22, 1937. M. BREUER 2,084,310
 FRAME FOR SPRING SEATS
 Filed Dec. 2, 1933

Fig.1 Fig.2 Fig.3 Fig 4

Marcel Breuer – Frame for Spring Seats (United States Patent Office, patent No. 2,084,310, filed Dec 2nd 1933)

Fig.1
CNC cutting pattern

Fig.2
Local making

Fig.3
Open source product

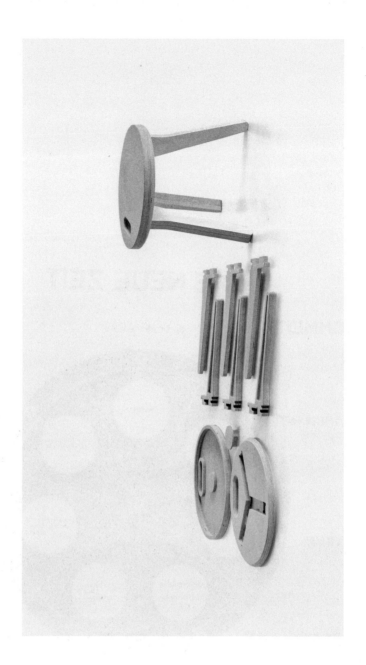

■ 010 Opendesk, *Towards an Open Making Manifesto*, **2015**

■ 011 Opendesk, **David and Joni Steiner (design 2013)**, **Edie stool, 2015**, multiplex, 28.5 × 15 cm, Vitra Design Museum Collection

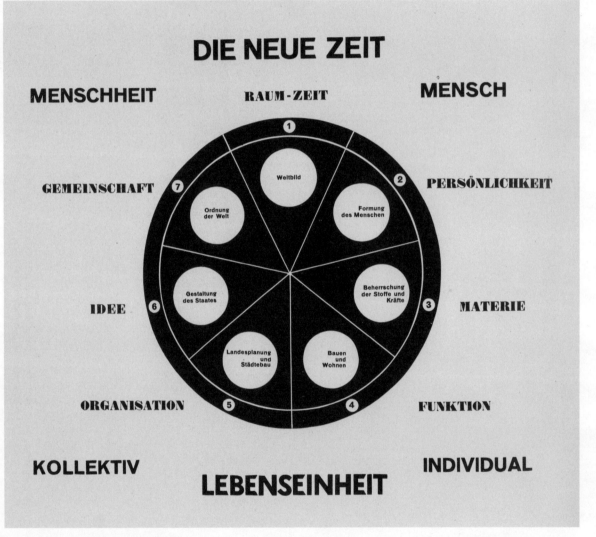

■ 012 **Ernst Jäckh, flow diagram of the exhibition**
Die neue Zeit, Internationale Werkbundausstellung Köln
(International Werkbund Exhibition Cologne), **1932**
in *Die Form*, 1929, no. 4, issue 15, p. 410,
Vitra Design Museum Collection

BEYOND THE ~~NEW~~

A SEARCH FOR IDEALS IN DESIGN

We advocate an idealistic agenda in design, as we deplore the obsession with the ~~New~~ for the sake of the ~~New~~, and regretfully see how the discipline lacks an intimate interweaving of the values that once inspired

■ 013 **Hella Jongerius, Beyond the New. A Search for Ideals in Design, 2015,** paper, courtesy Hella Jongerius/ Jongeriuslab

87

Zeitgeist

To capture the Zeitgeist, you need to question the familiar. You need to understand trends and tendencies, either strengthening them or providing contrasting alternative (utopian) designs. The Bauhaus was an expert at this, bringing together the Zeitgeist and numerous important protagonists from the world of art, architecture and many other disciplines in a social work community.

In the 1920s, art schools in Weimar were traditionally conservative, which would most likely have given the Bauhaus a difficult position to start from. In addition, students and masters were confronted with fundamental everyday problems of the war-torn Weimar Republic. There was a lack of clothes, food, building materials and money – which lost value by the hour, with inflation reaching crisis point in November 1923 when you needed four trillion German marks to purchase a kilo of beef.

Despite all this, artists and thinkers of the time continued work begun before the war with new vigour, founding newspapers and associations, writing manifestos and publications, and continuing the reform of art schools that had started at the end of the nineteenth century. They pulled art out of the ivory tower of academia and into real life, trying to use it to design the everyday world.

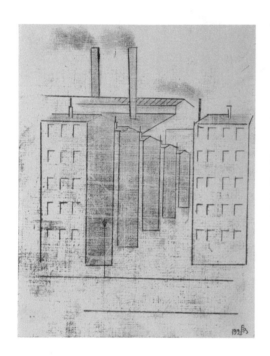

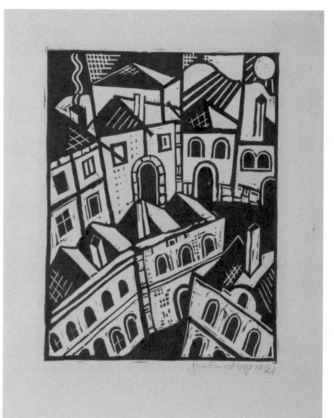

■ 014 **Erich Borchert**, *Fabrik*, **1928**, monotype,
27.5 × 21.5 cm, Freese Collection

■ 015 **Herbert Bayer**, *Alte Stadt*, **1921**, coloured linocut
on handmade paper, 22 × 17 cm, Freese Collection

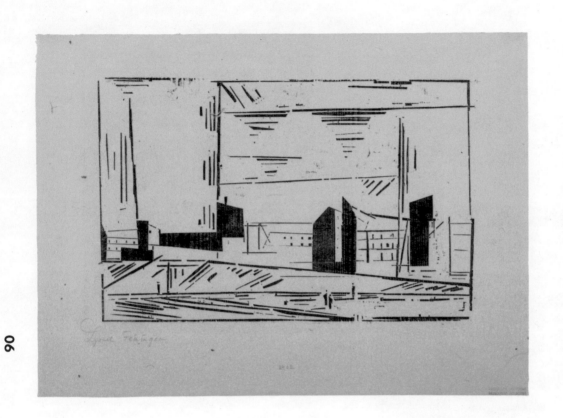

■016 **Lyonel Feininger,** *Vorstadt 1, Berlin-Spandau,*
1923, woodcut on Japanese paper, 23.5 × 37.7 cm,
Freese Collection

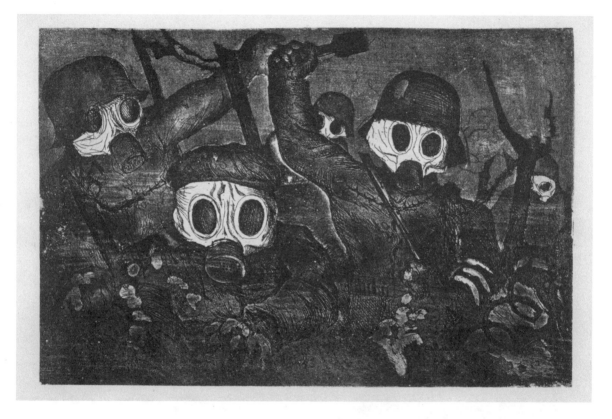

■017 **Otto Dix, *Der Krieg*, 1924,** 24 offset printings
after originals from etchings by Otto Dix, 26×18 cm,
Vitra Design Museum Collection

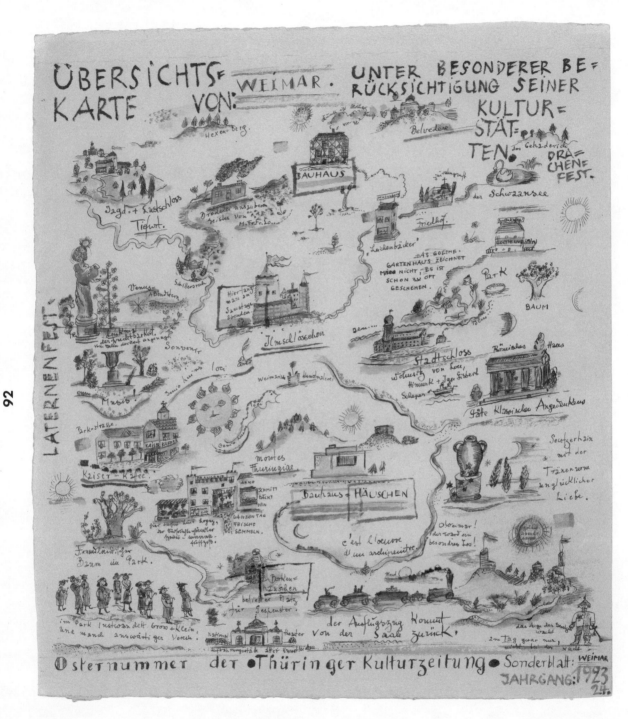

■018 Lou Scheper, *Humorous overview map of Weimar*, **1923,** ink pen, watercolour, 28 × 25.3 cm, Bauhaus-Archiv Berlin, photograph: Atelier Schneider

■019 **Lyonel Feininger, letter to Wilhelm Köhler,**
1920, ink on yellow silk paper, c. 28 × 23 cm,
Freese Collection

Für Fleisch, für Brot und Butter,
Für Milch und Hundefutter,
Petroleum und Licht,
Für Seife, Zucker, Eier,
Für Wurst und »Tante Meier«
Man *Karten* Dir verspricht —
Doch Ware kriegst Du nicht!

■020 **Unknown, postcard showing ration stamps, c. 1926**, 14×9.1 cm, Freese Collection

■021 **Herbert Bayer, emergency money of the Province of Thuringia, 1923**, letterpress, 7×13.8 cm, Vitra Design Museum Collection

■022 **Georg Muche, still life, 1923,** colour lithography
on vellum, 34.3 × 27.1 cm, Freese Collection

STAATLICHES BAUHAUS
WEIMAR
KÜCHENKOMMISSION ZU HÄNDEN
VON HANNS HOFFMANN.

Die Studierenden des „Staatlichen Bauhauses" in Weimar unterhalten eine gemeinschaftliche Speise-anstalt, deren Fortführung infolge der wirtschaftlichen Lage sehr in Frage gestellt ist.
Eine Schließung der Anstalt würde vielen Studier-enden die Weiterführung ihrer Studien unmöglich machen.
Die unterzeichneten Vertreter der Studierenden sehen sich daher gezwungen, dringend unterstütz-ende Hilfe für die Speiseanstalt zu erbitten.

Weimar, im Juni 1924.

Hanns Hoffmann
Heinrich Koch

■023 Heinrich Koch, Hanns Hoffmann, **call to support the soup kitchen, June 1924,** lithographic print, 28.4 × 22.5 cm, Freese Collection

■024 Albert Hennig, *Kinder auf der Suche nach Essbarem bei der Großmarkthalle* [Children looking for something to eat at the Market Hall], Leipzig 1928, vintage print, 35 × 25 cm, Vitra Design Museum Collection

■025 Albert Hennig, *Mann bei der Suche nach Resten auf dem Gelände der Großmarkthalle* [Man looking for something to eat at the Market Hall], 1928, vintage print, 35 × 25 cm, Vitra Design Museum Collection

Das Endziel aller bildnerischen Tätigkeit ist der Bau! Ihn zu schmücken war einst die vornehmste Aufgabe der bildenden Künste, sie waren unablösliche Bestandteile der großen Baukunst. Heute stehen sie in selbstgenügsamer Eigenheit, aus der sie erst wieder erlöst werden können durch bewußtes Mit- und Ineinanderwirken aller Werkleute untereinander. Architekten, Maler und Bildhauer müssen die vielgliedrige Gestalt des Baues in seiner Gesamtheit und in seinen Teilen wieder kennen und begreifen lernen, dann werden sich von selbst ihre Werke wieder mit architektonischem Geiste füllen, den sie in der Salonkunst verloren.

Die alten Kunstschulen vermochten diese Einheit nicht zu erzeugen, wie sollten sie auch, da Kunst nicht lehrbar ist. Sie müssen wieder in der Werkstatt aufgehen. Diese nur zeichnende und malende Welt der Musterzeichner und Kunstgewerbler muß endlich wieder eine bauende werden. Wenn der junge Mensch, der Liebe zur bildnerischen Tätigkeit in sich verspürt, wieder wie einst seine Bahn damit beginnt, ein Handwerk zu erlernen, so bleibt der unproduktive „Künstler" künftig nicht mehr zu unvollkommener Kunstübung verdammt, denn seine Fertigkeit bleibt nun dem Handwerk erhalten, wo er Vortreffliches zu leisten vermag.

Architekten, Bildhauer, Maler, wir alle müssen zum Handwerk zurück! Denn es gibt keine „Kunst von Beruf". Es gibt keinen Wesensunterschied zwischen dem Künstler und dem Handwerker. Der Künstler ist eine Steigerung des Handwerkers. Gnade des Himmels läßt in seltenen Lichtmomenten, die jenseits seines Wollens stehen, unbewußt Kunst aus dem Werk seiner Hand erblühen, die Grundlage des Werkmäßigen aber ist unerläßlich für jeden Künstler. Dort ist der Urquell des schöpferischen Gestaltens.

Bilden wir also eine neue Zunft der Handwerker ohne die klassentrennende Anmaßung, die eine hochmütige Mauer zwischen Handwerkern und Künstlern errichten wollte! Wollen, erdenken, erschaffen wir gemeinsam den neuen Bau der Zukunft, der alles in einer Gestalt sein wird: Architektur und Plastik und Malerei, der aus Millionen Händen der Handwerker einst gen Himmel steigen wird als kristallenes Sinnbild eines neuen kommenden Glaubens.

WALTER GROPIUS.

■ 026 Walter Gropius (text) and Lyonel Feininger (woodcut cover), *Manifest und Programm des Staatlichen Bauhauses in Weimar* [Programme of the State Bauhaus in Weimar, also known as the Bauhaus Manifesto], 1919, woodcut, letterpress, 31.9 × 39.2 cm, private collection

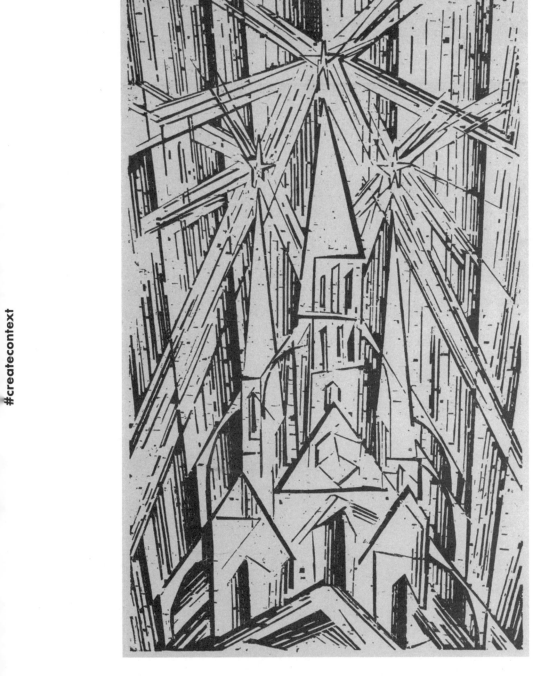

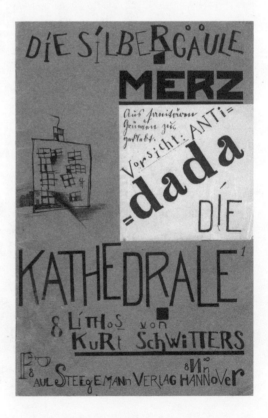

■027 Vilmos Huszár, title page of the magazine
De Stijl, no. 1, October 1917, woodcut, 25.8 × 19.3 cm,
Vitra Design Museum Collection

■028 Kurt Schwitters, *Die Kathedrale*, 8 lithographs,
1920, 22.5 × 14.5 cm, Schwitters Archive, Stadtbibliothek
Hannover

ARBEITSRAT FÜR KUNST

FRAGEN,
DIE DER KLÄRUNG
BEDÜRFEN

I.
Lehrprogramm
Welche Maßnahmen werden für geeignet gehalten, eine gründliche Reform der Ausbildung
für alle bildnerische Tätigkeit zu erreichen?

II.
Staatliche Unterstützung
Nach welchen Gesichtspunkten hat der sozialistische Staat Mittel für künstlerische Fragen
und Unterstützung der Künstler zur Verfügung zu stellen? (Ankäufe, Landes-Kunst-
kommissionen, Museen, Schulen, Ausstellungen usw.)

III.
Siedelungswesen
Welche Forderungen sind an die Staatsleitung zu richten, damit Gewähr gegeben ist,
daß die in den kommenden Jahren entstehenden Siedelungen nach weitgesteckten kul-
turellen Gesichtspunkten angelegt werden?

IV.
Abwanderung der Künstler ins Handwerk
Wie kann erreicht werden, daß die breite Masse des Kunstproletariats für das Hand-
werk gewonnen wird und bei der drohenden wirtschaftlichen Katastrophe dem Unter-
gang entgeht?
Welche Forderungen müssen an den Staat gerichtet werden, daß der Nachwuchs von
vornherein Ausbildung auf rein handwerklicher Grundlage erfährt?

V.
Der Künstler im sozialistischen Staat

7

VI.
Kunstausstellungen
Welche neuen Wege sind geeignet, um das Volk wieder für das Gesamtkunstwerk —
Architektur, Plastik und Malerei in ihrer Vereinigung — zu interessieren?
Staatliche Probierplätze anstelle Salon-Kunstausstellungen.

VII.
Wie können die Künstler der verschiedenen Kunstzweige
gegenwärtig einen Zusammenschluß und eine Einheit bilden?

VIII.
Farbbehandlung des Stadtbildes
Gedanken für farbige Behandlung des Stadtbildes, bunte Hausenstriche, Bemalung von
Fassaden und Innenräumen, Beseitigung des Rahmenbildes.

IX.
Gestaltung öffentlicher Bauten durch Künstler
Welche praktischen Forderungen müssen dem Staat gegenüber erhoben werden, damit
die öffentlichen Bauten von den Künstlern gestaltet werden, anstatt wie bisher von
Technikern und Baubeamten?

X.
Einklang mit dem Volk
Welche Wege sind geeignet, die Bestrebungen der modernen Künstler in Berührung
und Einklang mit dem Volk zu bringen?

XI.
Welche Vorbereitungen müssen getroffen werden, um das
in der Stille vorbereitete Material im geeigneten Augen-
blick an die Öffentlichkeit zu bringen?
Vorbereitung von Presseartikeln, Vorträgen, Ausstellungen, Sicherung von genügend
vielen Preßorganen für diesen Zweck.

XII.
Welche Wege sind einzuschlagen, um möglichst lücken-
lose Verbindung mit gleichgesinnten ausländischen
Künstlergruppen zu erzielen?

XIII.
Stellungnahme zur Anonymität des Künstlers in seinen Werken
Signet statt Namenszug.

8

■029 **Walter Gropius, Adolf Behne,** *Manifest des Arbeitsrats für Kunst* **[Manifesto of the Workers' Council for Art], 1919,** title vignette from a woodcut attributed to Max Pechstein, 1919, Akademie der Künste, Berlin, Arbeitsrat für Kunst Collection, 2a

■030 **Walter Gropius, Adolf Behne,** "Questions that have to be answered", in *Ja! Stimmen des Arbeitsrates für Kunst in Berlin,* **1919,** Vitra Design Museum Collection

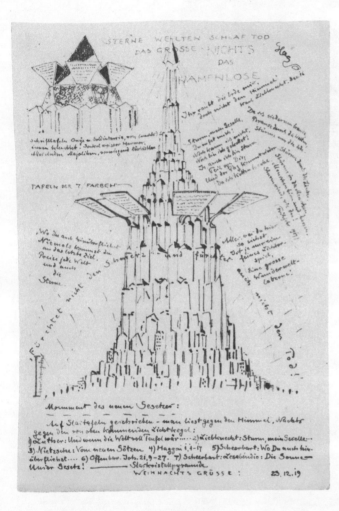

■031 **Bruno Taut, letter to the Gläserne Kette, 23 December 1919,** photostat, 34 × 23 cm, Akademie der Künste, Berlin, Gläserne Kette, collection in Hans-Scharoun-Archive, 118-71

■032 **Hans Scharoun, letter to the Gläserne Kette, no date,** 35 × 23 cm, photostat, Akademie der Künste, Berlin, Gläserne Kette, collection in Hans-Scharoun-Archive, 118-50

■033 **Hermann Finsterlin, letter to the Gläserne Kette, no date,** hectographed drawing, 26 × 21 cm, Akademie der Künste, Berlin, Gläserne Kette, collection in Hans-Scharoun-Archive, 118-16

■034 **Wenzel August Hablik, letter to the Gläserne Kette, 1920,** blueprint, 30 × 21 cm, Akademie der Künste, Berlin, Gläserne Kette, collection in Hans-Scharoun-Archive, 118-25

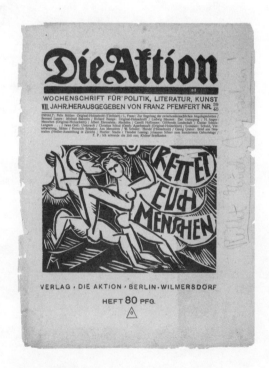

■035 **Lyonel Feininger (cover picture),** *Der Anbruch,* **Flugblätter aus der Zeit, 1919,** letterpress, c. 29 × 21 cm, Vitra Design Museum Collection

■036 **Students at Bauhaus Weimar, Eberhard Schrammen (cover picture),** *Der Austausch,* **first leaflet, May 1919,** letterpress, woodcut, 45.6 × 31.1 cm, private property

■037 **Conrad Felixmüller (cover picture** *Rettet euch Menschen),* *Die Aktion, Wochenschrift für Politik, Literatur, Kunst,* **8th year, no. 39/40,** woodcut, Vitra Design Museum Collection

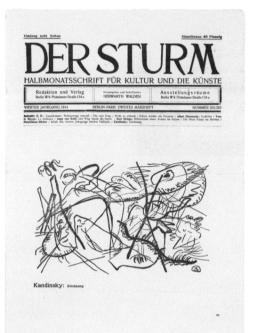

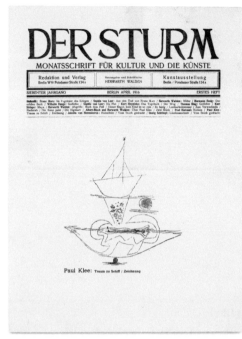

#createcontext

■038 **Wassily Kandinsky (cover picture),**
Der Sturm, **March 1914,** linocut, 30.4 × 23.2 cm,
Vitra Design Museum Collection

■039 **Paul Klee (cover picture** *Traum zu Schiff*),
Der Sturm, **April 1916,** linocut, 30.4 × 23.2 cm,
Vitra Design Museum Collection

■040 **Le Corbusier, Amédée Ozenfant,** *L'Esprit
Nouveau – Revue internationale d'Esthétique,*
no. 1, 1920, 25 × 16.5 cm, Freese Collection

■041 **Workshops at Burg Giebichenstein School of Arts and Crafts in Halle, c. 1925,** catalogue of the School of Arts and Crafts, with workshop list, 17.5×13.2 cm, Funkat Estate, Burg Giebichenstein Collection

■042 **Wladimir Fjodorowitsch Krinsky,** *Experimental methodical elaboration on colour and spatial composition,* **1921,** pencil, gouache on paper, 12×10 cm, Shchusev State Museum of Architecture, Moscow

■043 **Hendricus Theodorus Wijdeveld,** *An International Working Group,* **a Project with 16 Illustrations, 1931** letterpress, 21.1 × 21.1 cm, Vitra Design Museum Collection

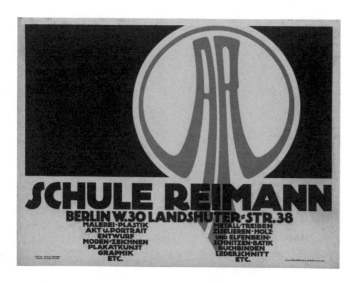

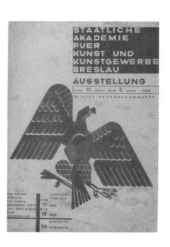

■044 **Brochure of Itten School at Konstanzer Str. 14, winter semester 1929/1930,** letterpress, Johannes Itten-Archiv Zürich

■045 *Julius Klinger, Reimann School poster, 1911* lithograph, 70.5 × 94.6 cm, Staatliche Museen zu Berlin, Kunstbibliothek

■046 *Johannes Molzahn, Kunstakademie Breslau exhibition poster, 1930,* colour lithograph, 60.3 × 45 cm, Silesian Museum in Görlitz

The Bauhaus Model

Among all the reformed art schools of the time, the Bauhaus played a special role. Founded by Walter Gropius in 1919, it emerged from a fusion of the Weimar Saxon-Grand Ducal Art School and the Grand Ducal School of Arts and Crafts in Weimar, which had been founded by Henry van de Velde. At the Bauhaus, Gropius wanted to make a long-needed concept a reality: he wanted to overcome the contradictions between art and technology and to combine theory and practice, maintaining a close relationship with industry and architecture. These aims would have unique consequences.

The Bauhaus was democratic and based on the principle of collaboration; artists with different ideas and concepts worked together in "productive disunity". Teachers, "Werkmeister" (crafts masters) and "Formmeister" (masters of form), and students who provided artistic inspiration, all met together to exchange ideas. The Bauhaus was seen as a complete social organism, with the school aiming to unify teaching methods and production systems, working towards life design and social design rather than object design, aiming to create a new type of person rather than to follow a pedagogical programme. It was not only a school but also a production site, a research laboratory and one of the greatest social experiments of modernity.

Idea and Structure

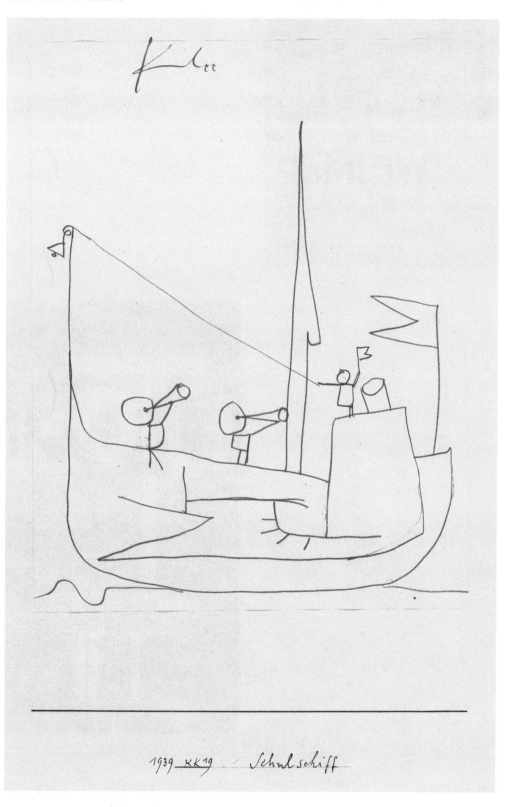

■047 **Paul Klee,** *Schulschiff* **[school ship], 1939**
699, pencil on paper on cardboard, 27 × 21.5 cm,
Zentrum Paul Klee, Bern

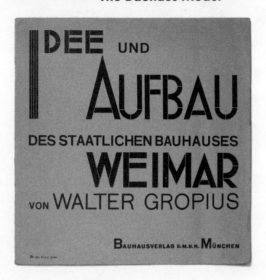

the bauhaus

■048 **Walter Gropius (text), Herbert Bayer (design and layout),** *Idee und Aufbau des Staatlichen Bauhauses Weimar* **[Idea and Structure of the State Bauhaus Weimar], 1923,** letterpress, 25 × 25 cm, private collection

■049 **Margit Téry-Adler (cover),** *Utopia,* **ed. Bruno Alder, Weimar 1921,** lithograph, 33 × 24.6 cm, Vitra Design Museum Collection

Idea and Structure

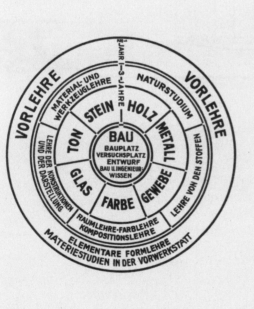

I. LEITUNG: WALTER GROPIUS

II. SYNDIKUS: EMIL LANGE

III. LEHRENDE MEISTER

A. FÜR DIE FORMLEHRE:
LYONEL FEININGER
WALTER GROPIUS
JOHANNES ITTEN
WASSILY KANDINSKY
PAUL KLEE
GERHARD MARCKS
GEORG MUCHE
OSKAR SCHLEMMER
LOTHAR SCHREYER

B. FÜR DIE WERKLEHRE:

EMIL LANGE:	Bauversuchsplatz
JOSEF HARTWIG:	I. Steinbildhauerei
ANTON HANDIK:	IIa. Tischlerei
JOSEF HARTWIG:	IIb. Holzbildhauerei
CHRISTIAN DELL:	III. Gold-Silber-Kupfer-schmiede
MAX KREHAN:	IV. Töpferei
	V. Glasmalerei
HEINRICH BEBERNISS:	VI. Wandmalerei
HELENE BÖRNER:	VII. Weberei

IV. AUSSERORDENTLICHE LEHRKRÄFTE
GERTRUD GRUNOW (Harmonisierungslehre)
ADOLF MEYER (Baulehre)
CARL ZAUBITZER (techn. Leiter d. Graph. Werkstatt)

■050 Walter Gropius, design of teaching structure at the Bauhaus, in *Satzungen Staatliches Bauhaus in Weimar, July 1922,* letterpress on paper, 20 × 29.5 cm, private collection

■051 Paul Klee, *Idee und Struktur des Staatlichen Bauhauses* [Idea and Structure of the State Bauhaus], curriculum for Bauhaus Weimar, **1922,** ink pen on thin paper, 25 × 21.1 cm, Bauhaus-Archiv Berlin
Photograph: Markus Hawlik

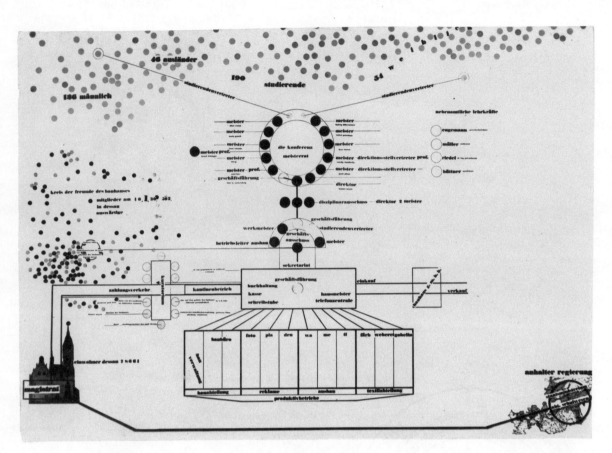

■ 052 Unknown, Bauhaus Dessau under the direction
of Hannes Meyer, 1928–30, modernist archives/bauhaus-
university Weimar

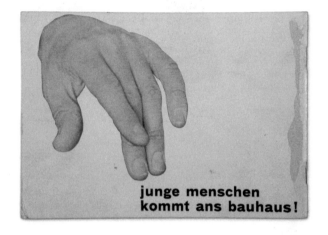

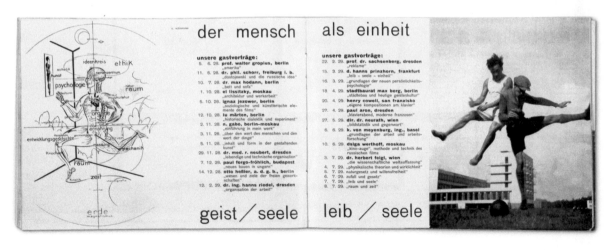

■053 **Hannes Meyer, *Junge Menschen kommt ans Bauhaus* [Young people, come to the Bauhaus!], 1929**
letterpress on paper, 14.7 × 20.9 cm, Freese Collection

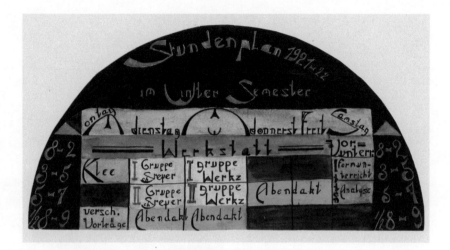

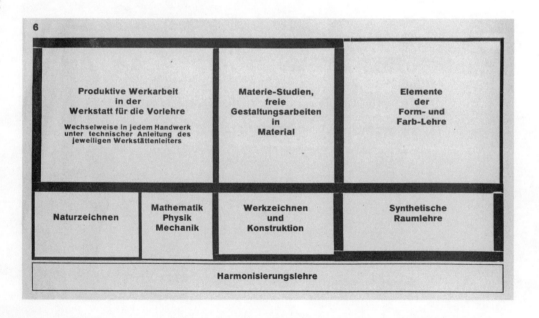

■054 **Lothar Schreyer, timetable for the winter
semester, 1921/1922,** watercolour, tempera, ink and
pencil on paper, 16.5 × 32.7 cm, Bauhaus-Archiv Berlin

■055 **Walter Gropius, study programme at the
Bauhaus 1923,** in *Idee und Aufbau des Staatlichen
Bauhauses Weimar,* **1923,** letterpress, 25 × 25 cm,
private collection

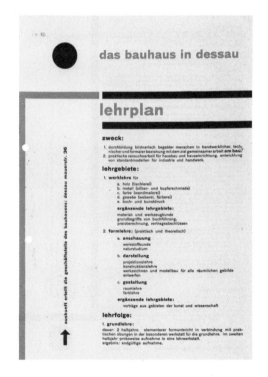

STUNDENPLAN FÜR VORLEHRE
VORMITTAG

	MONTAG	DIENSTAG	MITTWOCH	DONNERSTAG	FREITAG	SAMSTAG
8-9						
9-10	GESTALTUNGS·STUDIEN MOHOLY REITHAUS	WERKARBEIT ALBERS REITHAUS				GESTALTUNGS·STUDIEN MOHOLY REITHAUS
10-11						
11-12						
12-1		GESTALTUNGSLEHRE FORM·KLEE·AKTSAAL			GESTALTUNGSLEHRE FARBE·KANDINSKY·	

2-3			WERKZEICHNEN GROPIUS·LANGE·MEYER RAUM 39			
3-4						
4-5	WISSENSCHAFTL·FÄCHER·MATH·PHYS·etc. AKTSAAL	ZEICHNEN KLEE RAUM 39			ANALYTHISCH ZEICHNEN— KANDINSKY. R39	
5-6						VERSCHIEDENE VORTRÄGE
6-7						
7-8		ABENDAKT·KLEE OBLIGATORISCH FÜR VORKURS			ABENDAKT.	
8-9						

AN DEN GELB UMRANDETEN UNTERRICHTSSTUNDEN KÖNNEN ALLE GESELLEN UND LEHRLINGE TEILNEHMEN.

das bauhaus in dessau

lehrplan

zweck:
1. durchbildung bildnerisch begabter menschen in handwerklicher, technischer und formaler beziehung mit dem ziel gemeinsamer arbeit **am bau.**
2. praktische versuchsarbeit für hausbau und hauseinrichtung. entwicklung von standardmodellen für industrie und handwerk.

lehrgebiete:

1. **werklehre** für
 a. holz (tischlerei)
 b. metall (silber- und kupferschmiede)
 c. farbe (wandmalerei)
 d. gewebe (weberei, färberei)
 e. buch- und kunstdruck

 ergänzende lehrgebiete:
 material- und werkzeugkunde
 grundbegriffe von buchführung,
 preisberechnung, vertragsabschlüssen

2. **formlehre:** (praktisch und theoretisch)
 a. **anschauung**
 werkstoffkunde
 naturstudium
 b. **darstellung**
 projektionslehre
 konstruktionslehre
 werkzeichnen und modellbau für alle räumlichen gebilde
 entwerfen
 c. **gestaltung**
 raumlehre
 farblehre

 ergänzende lehrgebiete:
 vorträge aus gebieten der kunst und wissenschaft

lehrfolge:

1. **grundlehre:**
 dauer: 2 halbjahre. elementarer formunterricht in verbindung mit praktischen übungen in der besonderen werkstatt für die grundlehre. im zweiten halbjahr probeweise aufnahme in eine lehrwerkstatt.
 ergebnis: endgültige aufnahme.

auskunft erteilt die geschäftsstelle des bauhauses: dessau mauerstr. 36

■056 Designer unknown, State Bauhaus Weimar, sketch of timetable for the preliminary course at **Bauhaus Weimar, 1924** (reproduction from the 1960s), Bauhaus-Archiv Berlin

■057 **Herbert Bayer, Bauhaus Dessau currriculum (circulation 500), 1925,** letterpress on art paper, 29.7 × 21 cm, Freese Collection

bauhaus dessau
hochschule für gestaltung

september 1930

I. lehr- und arbeits-gebiete
die ausbildung der bauhaus-studierenden erfolgt in theoretischen
und praktischen lehrkursen und in den werkstätten des bauhauses.

1. allgemein
werklehre
gegenständliches zeichnen
darstellende geometrie
schrift
mathematik
physik
mechanik
chemie
materialkunde
normenlehre
einführung in die künstlerische gestaltung
vorträge über
psychologie
psychotechnik
wirtschafts- und betriebslehre
farbenlehre
kunstgeschichte
soziologie
2. bau und ausbau
rohbau-konstruktion
ausbau-konstruktion
konstruktives entwerfen
heizung und lüftung
installationslehre
beleuchtungs-technik
veranschlagen
festigkeitslehre
statik
eisen- und eisenbetonkonstruktion
gebäudelehre und entwerfen

städtebau
ausbau-seminar
praktische werkstatt-arbeit in der tischlerei, metall-
werkstatt und wandmalerei
3. reklame
typografie
druck- und reproduktionsverfahren
schrift, farbe und fläche
kalkulation von drucksachen
fotografie
werbegrafische darstellung
werbevorgänge und werbsachengestaltung
werbsachen-entwurf
werbe-plastik
praktische werkstattarbeit in druckerei und reklame-
werktatt
4. foto
belichtungs-entwicklungs-nachbehandlungstechnik
abbildungsvermittlung
tonwertwiedergabe und tonfälschungen
farbwiedergabe
struktur-wiedergabe
das sehen, helligkeitsdetails und schärfendetails
materialuntersuchungen
spezifische anforderungen der reklame u. reportage
5. we rei
bindungslehre
materialkunde
webtechniken auf schaftstuhl
schaftmaschine
jaquardmaschine
teppichknüpfstuhl
gobelinstuhl
kalkulation
dekomposition
patronieren
stoffveredelung
entwurfszeichnen
warenkunde und warenprüfung
färberei
praktische arbeit in der weberei
6. bildende kunst
freie malklasse
plastische werkstatt

■058 Unknown, first curriculum under the direction of
Mies van der Rohe, September 1930, paper printed in black,
20.9 × 29.5 cm, Bauhaus-Archiv Berlin

II. lehrkörper

ludwig mies van der rohe, architekt, direktor des bauhauses
josef albers, werklehre, gegenständliches zeichnen
lfre arndt, ausbau–werkstatt
otto büttner, herrengymnastik und herrensport
friedrich engemann, gewerbe-oberlehrer, darstellende geometrie, berufs-fachzeichnen, technische mechanik
carla grosch, damengymnastik und damensport
wassily kandinsky, professor, künstlerische gestaltung, freie malklasse
paul klee, professor, freie malklasse
wilhelm üller, studienrat, chemie, technologie, baustofflehre
walter peterhans, fotografie, mathematik
h rle i, dr. ing., psychotechnik, betriebswissenschaft, mathematik
alc r rudelt, bauingenieur, bauwissenschaft, festigkeitslehre, höhere mathematik, eisenbau, eisenbetonbau.
hinnerk scheper, wandmalerei, (z. zt. beurlaubt).
joost schmidt, schrift, reklame, plastische werkstatt.
fra gunta sharon-stölzl, weberei–werkstatt.
ludwig hilberseimer, architekt, baulehre.

III. aufnahmebestimmungen

als ordentlicher studierender kann jeder in das bauhaus aufgenommen werden, dessen begabung und vorbildung vom direktor als ausreichend erachtet wird und der das 18. lebensjahr überschritten hat. je nach dem grad der vorbildung kann aufnahme in ein entsprechend höheres semester erfolgen.

anmeldung.
die anmeldung in das bauhaus muß schriftlich erfolgen.
dem antrag sind folgende anlagen beizufügen:
a. lebenslauf, (vorbildung, staatsangehörigkeit, persönliche verhältnisse und unterhaltsmittel, bei minderjährigen unterhaltserklärung durch eltern oder vormund).
b. polizeiliches leumundszeugnis.
c. ärztliches gesundheitszeugnis (ausländer impfschein).
d. lichtbild.
e. etwaige zeugnisse über handwerkliche oder theoretische ausbildung.
f. selbständige zeichnerische oder handwerkliche arbeiten.

aufnahme.
die aufnahme gilt als vollzogen, wenn
1. das schulgeld und sämtliche gebühren gezahlt,
2. die satzungen, sowie die haus- und studienordnung durch unterschrift anerkannt sind.

gebühren.
an gebühren werden erhoben:
1. einmalige aufnahmegebühr rmk. 10.—
2. lehrgebühren: I. semester „ 80.—
für inländer: II. „ „ 70.—
III. „ „ 60.—
IV. „ „ 50.—
V. „ „ 40.—
VI. „ „ 30.—
ausländer zahlen das eineinhalbfache.
3. allgemeine obligatorische gebühren für unfallversicherung und duschenbenutzung pro semester rmk. 5.—.

IV. studiendauer und -abschluß

die ausbildung dauert normal 6 semester.
der abgang vom bauhaus erfolgt nach beendigung des studiums. austritt aus dem bauhaus ist der leitung schriftlich mitzuteilen.
studierende, deren leistungen nicht befriedigen, können auf beschluß der konferenz zum austritt aus dem bauhaus veranlaßt werden:
erfolgreicher abschluß der studien wird bestätigt durch das bauhaus-diplom.
teilstudien werden durch zeugnis bestätigt.

das wintersemester 1930/31 beginnt am 21. oktober 1930.
schluß des wintersemesters 1930/31 am 31. märz 1931.

die studierenden benötigen für den lebensunterhalt in dessau durchschnittlich mindestens rmk. 100.— pro monat.
einfach möblierte zimmer sind in den siedlungen nahe beim bauhaus von rmk. 25.— monatlich an zu haben.
die kantine des bauhauses verabreicht zu selbstkostenpreisen frühstück, mittagessen, nachmittagskaffee, abendessen.
das bauhaus-sekretariat steht für jede spezialauskunft zur verfügung.

117

■ 059 Ragnar Kjartansson, *Bauhaus and me*, 2015
drawing on paper, 29.7 × 21 cm, courtesy Ragnar Kjartansson

Das Programm des Staatlichen Bauhaufes ftellt einen Plan dar, der allmählich verwirklicht werden foll. Die Lehrwerkftätten find erft teilweife vorhanden und werden nach und nach ergänzt und ausgebaut.

Bewerber haben als Grundlage für die Aufnahme einzufenden:

1. Selbftgefertigte Arbeiten (Zeichnungen, Bilder, Entwürfe, Modelle, Photos).
2. Selbftgefchriebenen Lebenslauf.
3. Polizeiliches Leumundszeugnis.

Bei Aufnahme für die Architekturabteilung des Bauhaufes wird außerdem der Nachweis mehrjähriger handwerklicher Tätigkeit (möglichft Gefellenbrief) und Abfchluß einer Baugewerkenfchule verlangt, jedoch kann Architekten, die diefe Vorbildung noch nicht befitzen, auch Ausbildung im Handwerk am Bauhaus felbft oder in hiefigen Privatbetrieben und technifch-theoretifcher Unterricht (als Vollfchüler oder als Hofpitanten) an der Weimarer Baugewerkenfchule erteilt werden, mit der das Bauhaus in ergänzender Verbindung fteht.

Sämtliche Aufnahmen erfolgen grundfätzlich auf ein Probefemefter, erft nach deffen Ablauf wird über endgültige Aufnahme entfchieden.

Die Leitung des Staatlichen Bauhaufes.

■ 060 **Karl-Peter Röhl (signet), Walter Gropius (text),**
Programm des Staatlichen Bauhauses Weimar
[Programme of the State Bauhaus Weimar], 1921
29.2 × 19.5 cm, Freese Collection

■061 Oskar Schlemmer, *Satzungen und Lehrordnungen des Staatlichen Bauhauses in Weimar* [Statutes and Regulations of the State Bauhaus in Weimar], 1923, cover and interior view, letterpress on letterpress paper, 20 × 29.4 cm, private collection

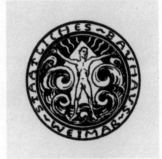

■062 **Students´competition for the signet of the Bauhaus Weimar, 1919,** different artists, ThHStAW, Staatliches Bauhaus Weimar no. 78

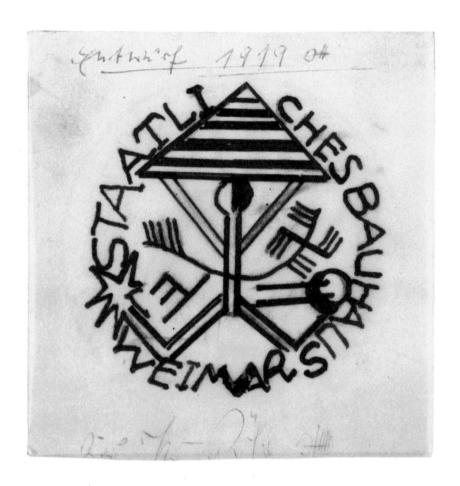

■063 **Karl-Peter Röhl,** *Sternenmännchen* **[Star Manikin],**
Bauhaus Weimar signet competition, 1919, pen, black ink on
paper, 9.8 × 9.8 cm, Karl-Peter Röhl Estate, Freese Collection

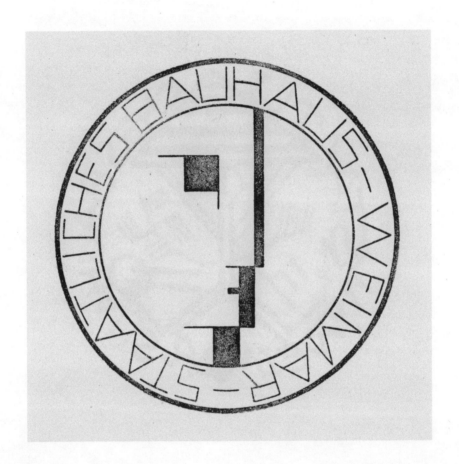

■ 064 Oskar Schlemmer, **State Bauhaus Weimar signet as a stamp, 1922,** blue stamping ink on paper, Ø 4.4 cm, Bauhaus-Archiv Berlin

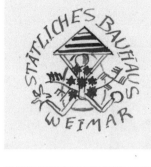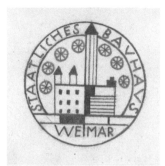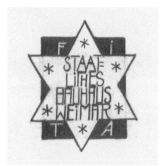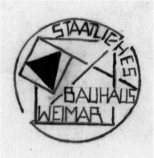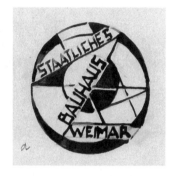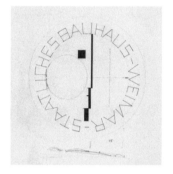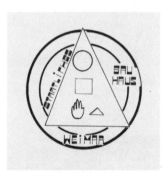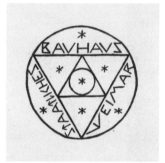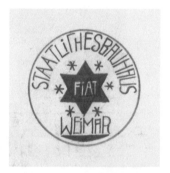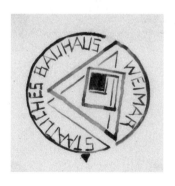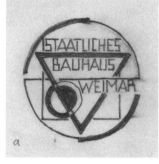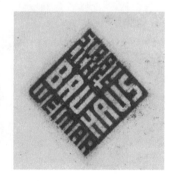

#createcontext

■065 **Sketches of signets for the Bauhaus Weimar, different artists 1921–22,** Bauhaus-Archiv Berlin

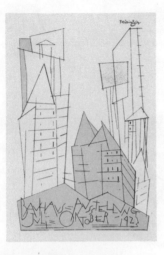
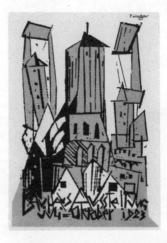
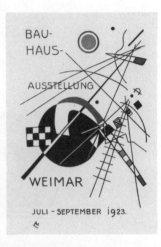

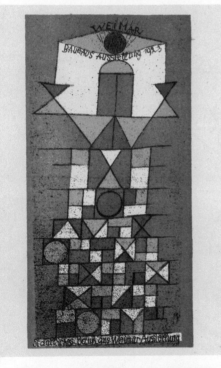

■066 **Lyonel Feininger, postcard no. 1 for the** *Bauhaus-Ausstellung* **in Weimar, summer 1923,** colour lithograph on cardboard, 14.8×10.5 cm, Freese Collection

■067 **Lyonel Feininger, postcard no. 2 for the** *Bauhaus-Ausstellung* **in Weimar, summer 1923,** colour lithograph on cardboard, 15×10.7 cm, Freese Collection

■068 **Wassily Kandinsky, postcard no. 3 for the** *Bauhaus-Ausstellung,* **summer 1923,** colour lithograph on cardboard, 15.1×10.5 cm, Freese Collection

■069 **Paul Klee, postcard no. 4 for the** *Bauhaus-Ausstellung* **in Weimar, summer 1923,** colour lithograph on cardboard, 15×10.6 cm, Freese Collection

■070 **Paul Klee, postcard no. 5 for the** *Bauhaus-Ausstellung* **in Weimar, summer 1923,** colour lithograph on cardboard, 10.5×15 cm, Freese Collection

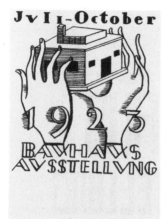

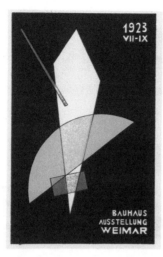

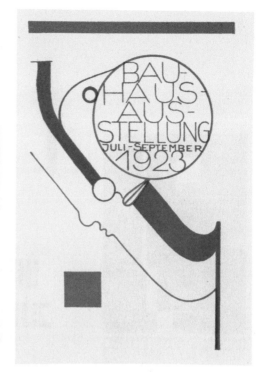

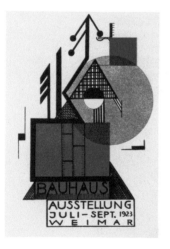

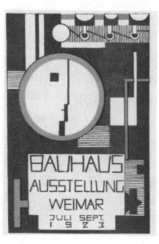

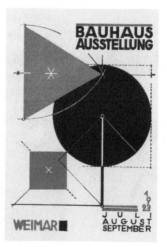

■071 **Gerhard Marcks, postcard no. 6 for the** *Bauhaus-Ausstellung* **in Weimar, summer 1923,** lithograph on cardboard, 15 × 10.5 cm, Freese Collection

■072 **László Moholy-Nagy, postcard no. 7 for the** *Bauhaus-Ausstellung* **in Weimar, summer 1923,** colour lithograph on cardboard, 14.3 × 9.5 cm, Freese Collection

■073 **Oskar Schlemmer, postcard no. 8 for the** *Bauhaus-Ausstellung* **in Weimar, summer 1923,** colour lithograph on cardboard, 15.1 × 10.4 cm, Freese Collection

■074 **Rudolf Baschant, postcard no. 9 for the** *Bauhaus-Ausstellung* **in Weimar, summer 1923,** colour lithograph on cardboard, 15.1 × 10.6 cm, Freese Collection

■075 **Rudolf Baschant, postcard no. 10 for the** *Bauhaus-Ausstellung* **in Weimar, summer 1923,** colour lithograph on cardboard, 15 × 10.5 cm, Freese Collection

■076 **Herbert Bayer, postcard no. 11 for the** *Bauhaus-Ausstellung* **in Weimar, summer 1923,** colour lithograph on cardboard, 15.4 × 10.4 cm, Freese Collection

#createcontext

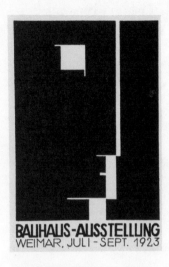

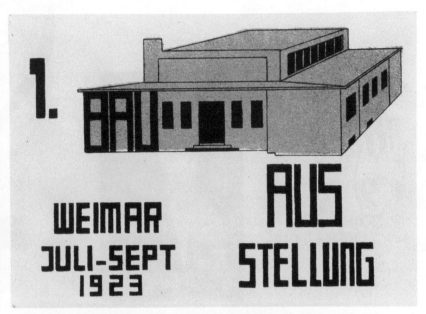

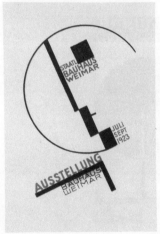

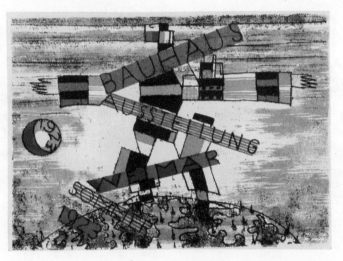

■ 077 **Herbert Bayer, postcard no. 12 for the** *Bauhaus-Ausstellung* **in Weimar, summer 1923,** colour lithograph on cardboard, 15.1 × 10.1 cm, Freese Collection

■ 078 **Paul Häberer, postcard no. 13 for the** *Bauhaus-Ausstellung* **in Weimar, summer 1923,** colour lithograph on cardboard, 10.5 × 15.2 cm, Freese Collection

■ 079 **Dörte Helm, postcard no. 14 for the** *Bauhaus-Ausstellung* **in Weimar, summer 1923,** colour lithograph on cardboard, 15.1 × 10.4 cm, Freese Collection

■ 080 **Ludwig Hirschfeld-Mack, postcard no. 15 for the** *Bauhaus-Ausstellung* **in Weimar, summer 1923,** colour lithograph on cardboard, 11 × 15.3 cm, Freese Collection

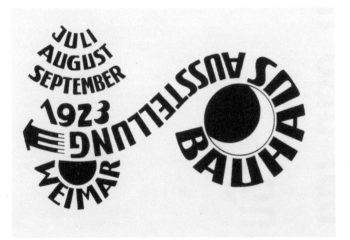

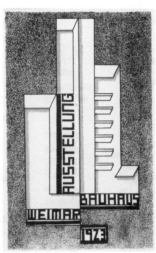

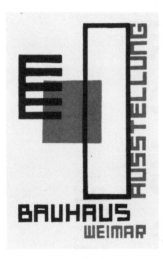

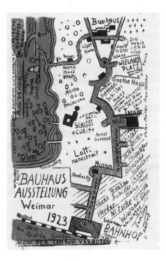

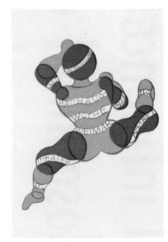

■081 **Ludwig Hirschfeld-Mack, postcard no. 16 for the** *Bauhaus-Ausstellung* **in Weimar, summer 1923,** lithograph on cardboard, 10.4 × 15.1 cm, Freese Collection

■082 *Farkas Molnár,* **postcard no. 17 for the** *Bauhaus-Ausstellung* **in Weimar, summer 1923** colour lithograph on cardboard, 14.4 × 9.4 cm, Freese Collection

■083 **Kurt Schmidt, postcard no. 18 for the** *Bauhaus-Ausstellung* **in Weimar, summer 1923,** colour lithograph on cardboard, 14.3 × 9.4 cm, Freese Collection

■084 **Kurt Schmidt, postcard no. 19 for the** *Bauhaus-Ausstellung* **in Weimar, summer 1923,** colour lithograph on cardboard, 14.1 × 9.4 cm, Freese Collection

■085 **Georg Teltscher, postcard no. 20 for the** *Bauhaus-Ausstellung* **in Weimar, summer 1923,** colour lithograph on cardboard, 15.1 × 10.3 cm, Freese Collection

I do not feel influenced, I feel inspired. It is the philosophical conceptual side that interests me rather than the final existence of the object. But also the connection to art is strong.

ARIK LEVY, DESIGNER

The Bauhaus was the catalyst for what we call "design" today. It saw industrial production and artistic creation as one seamless condition, and was instrumental at the beginning of the democratization of design.

KARIM RASHID, DESIGNER

The idea of collaboration is still its strongest idea. The Bauhaus was founded on collaboration: even though all the collaborators were respectable and reputable artists in their own right, they wanted to come together to change the world of design. This principle of collaboration inspired me.

YINKA ILORI, DESIGNER

#learnby doing

"The school serves the workshop and one day they will merge into one another. This is the reason why we do not have teachers and students but rather masters, journeymen and apprentices," wrote Gropius in March 1919. The entirety of the Bauhaus training was based on the duality of theory and practice, of design and crafts, of art and technology. Students were taught the basics of design in artistic and theoretical subjects, and were able to try out chromatics and spatial theory on concrete objects in the workshops.

The workshops were divided into teaching workshops, experimental workshops and production workshops. It was in the teaching workshops that the students were taught a craft. In the production workshops, small-scale production of outstanding designs took place, which would later be sold, as well as the manufacturing of external commissions. A dual education meant that designers who trained at the Bauhaus were equally competent in both design and production, meaning that they were able to develop reproduction-ready models for industrial series production.

■086 **Josef Albers, *Park*, c. 1923/1924,** glass,
paint, wire, metal in a wooden frame, 49.5 × 38 cm,
The Josef and Anni Albers Foundation

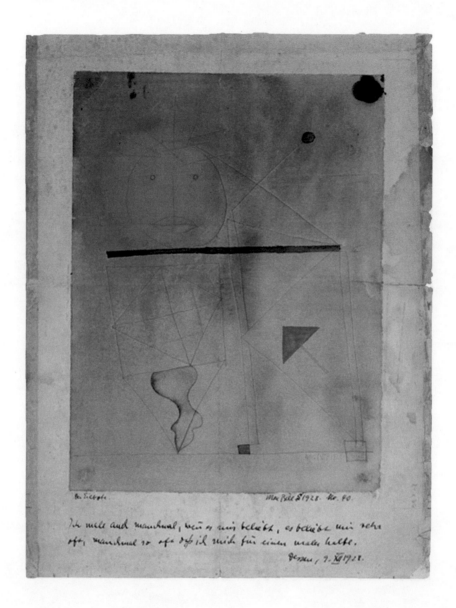

■087 **Max Bill, *Der Eilbote*, 1928,** watercolour,
42.6 × 30.6 cm, Christine and Volker Huber Collection,
Offenbach am Main

■088 **Lothar Schreyer,** *Erde* **[Earth], huge mask for the play**
Mann, **1921,** colour lithograph on cardboard, 31.3 × 24.3 cm,
Lothar Schreyer Estate, Freese Collection

The Bauhaus is a very potent idea. Its objectives became widely diffused and sustained and continue their influence even today.

Perhaps the most innovative concepts were experimentation and a new approach to learning by doing, trust in technology and strong ideas rooted in integrating artists and craftsmen, art and industry, leading to unification of the disciplines of painting, sculpture, design and architecture. This unique approach was more a philosophy of life, which could be summed up as "Design not as a profession but an attitude." What I appreciate most in these ideas is the fresh take on *Gesamtkunstwerk* by innovating each aspect and critically questioning it and not taking traditions as they are but creating and inventing new ones without nostalgia. The ideas initiated by the Bauhaus are still relevant today.

The first international exhibition of the Bauhaus was presented in 1922 at the Society of Oriental Art in Calcutta. One could say that modernity arrived in India — unfortunately just as visual modernity in design and architecture. India's project of modernism is merely a castle on a dung heap, because the democratic framework is not rooted in social modernity, without which there cannot be real modernity in society.

I grew up as a designer studying at the IDC, the Industrial Design Centre at the Indian Institute of Technology, Bombay. IDC was founded on Ulm design methodology, and the

critical questioning of the legendary Ulm model within an Indian context shaped my design thinking. So Bauhaus ideas arrived somewhat indirectly via Ulm to the IDC.

It is difficult to say which of these ideas influenced me — their effect has perhaps been implied rather than direct. Making models and building one's ideas and thinking through models and prototypes was the Bauhaus method which perhaps influenced me most.

However, by the time these ideas came through to my generation, the word "Bauhaus" suggested "conformist, dogmatic fixed notions of modernity which are considered modern all around the world". These images were filtered in the Asian part of the world. Just like many design collectives and schools such as the Bauhaus and Ulm, Memphis and Droog give a kind of caricatured projection of their initial intent.

The perceived notion of the Bauhaus for me then was nothing but a pure mechanical-rational-functionalist approach to design, devoid of any emotions or feelings. That's not to say that we do not need rationalism, but sensoriality and poetics are equally essential. Towards the late nineties, while setting up my design practice in Amsterdam, I continued a critical understanding and questioning of the issues related to functionalism, and cultivated my design approach going deeper into sensoriality and materiality by focusing on the industrial as well as socio-cultural perspectives.

During the late nineties, I decided to quit and work with the Muria community in

central India. I was eager to experience and understand the non-industrial way of making and living with such objects. I went to the Bastar region in the central state of Chhattisgarh. The Muria are one of the oldest indigenous peoples of India and what fascinated me most was their amazing democratic social structure and the socio-ethical educational system. An amazing level of creativity seems to go into their culture of making things.

During my stay in the Bastar region I discovered a wonderful object, a stick used by the Muria to take care of their herds. It is bamboo, hollowed inside, with an ingenious design idea and a delightful poetic innovation: two metal washers placed inside at a particular distance transform it into a flute! What I experienced with the Muria people is evident in this exemplary everyday object: empathy for materials and the desire to infuse everyday objects with a natural, unpretentious yet poetic beauty.

I am curious about such cultural conditions and the kind of modernity that creates this combination of poetry and utility. We need to seek such amazing cultural contributions all around the world in various communities and cultivate such features in industrial design.

Looking back now at the Bauhaus ideas, the notion of good design permeating socially inclusive cultures is what we need today more than ever. The fundamental belief based on the tenet that good design is the birthright of all citizens implies that design

has to be recognized not only as an integral part of daily life but also as a means of effecting social change with wider cultural awareness. In this regard I consider the Bauhaus ideas to be still valid today: the investigation and nurturing of a plural approach to design, which seeks the enhancement of quality of life through appropriate and affordable products and an aesthetic culture which is the result of a shared desire for a social ideal.

SATYENDRA PAKHALÉ, DESIGNER

141

■ 089 Muria people, India, bamboo stick-cum-flute for herding, 2015, courtesy Satyendra Pakhalé Associates

When teaching started at the Bauhaus in 1919, the school was
in a desolate state. The workshops were rudimentary and there was
a lack of tools and materials. The weaving looms were owned by
workshop teacher Helene Börner; in the metal workshop, students
worked with tools belonging to a traditional silversmith; bookbinding
was taught privately by teacher Otto Dorfner, and pottery was
taught in the workshop of master Max Krehan in Dornburg.

Despite these difficult circumstances, the Bauhaus was at least
partially successful in developing its own production facilities in
addition to the teaching workshops where work was experimental
and more art-orientated. The aim was for production to provide
the Bauhaus with additional income and for high-quality models for
series production to enable the industry to become more profitable
in a global market that had been severely affected by war.

At the beginning, while the Bauhaus was still in Weimar, many
objects were designed that had a long-term impact on the history
of design, due to their uncompromising stance and new aesthetic
– despite the fact that many of them were barely functional and the
small quantity meant that they were more luxury items than cheap
industrial products. It was not until the Bauhaus moved to Dessau in
1925 that the school experienced its first successful collaborations
with industry which brought moderate financial success.

The limited company Bauhaus GmbH was founded in 1925 to
deal with the sale of the items produced but it never operated
successfully. A sample catalogue designed by Herbert Bayer shows
which Bauhaus products were available for purchase at that time.
The situation greatly improved once the Bauhaus was in Dessau.
The sale of Bauhaus products was then no longer driven by the GmbH
but by the school itself, and Bauhaus members began to protect
their designs against plagiarism using licences and patents.

the bauhaus

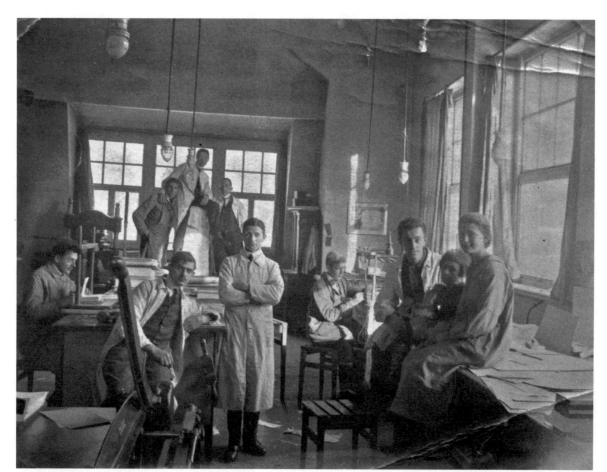

■090 **Unknown, Otto Dorfner's bookbinding workshop,
Bauhaus Weimar, 1920,** photograph, 12 × 9 cm,
private collection

Bauhaus Production

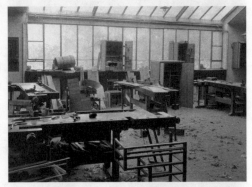

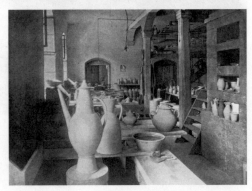

■091 **Unknown, stone sculpting workshop, Bauhaus Weimar, 1923,** silver gelatin print, 16.7×22.5 cm, modernist archives/bauhaus-university Weimar

■092 **Unknown, print shop, Bauhaus Weimar, 1923,** silver gelatin print, 21.5×16.6 cm, modernist archives/bauhaus-university Weimar

■093 **Unknown, working space of metal workshop, Bauhaus Weimar, 1923,** silver gelatin print, 16.8×22.5 cm, modernist archives/bauhaus-university Weimar

■094 **Unknown, carpentry workshop, Bauhaus Weimar, c. 1923,** silver gelatin print, 16.7×22.5 cm, modernist archives/bauhaus-university Weimar

■095 **Unknown, pottery workshop, c. 1920/1921** silver gelatin print, c. 16.7×22.5 cm, modernist archives/bauhaus-university Weimar

#learnbydoing

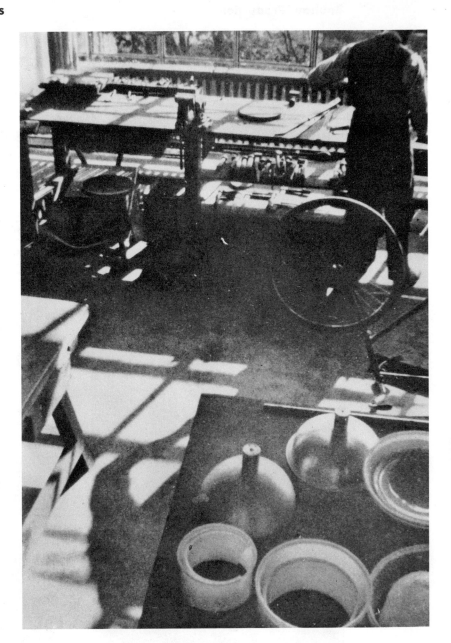

■096 **Unknown, metal workshop, Bauhaus Dessau**
photograph, modernist archives/bauhaus-university Weimar

Bauhaus Production

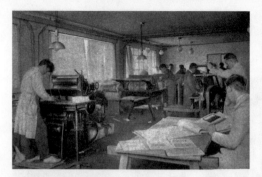 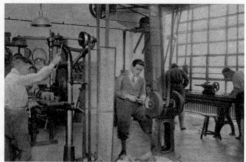

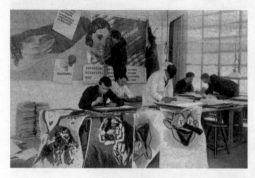 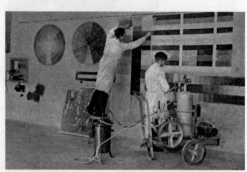

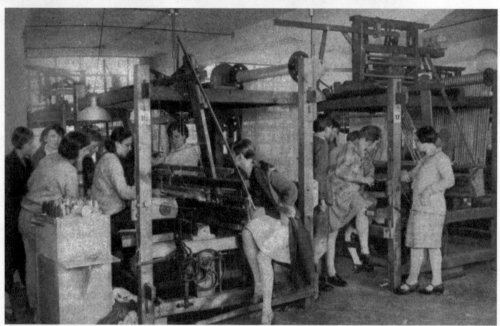

■ 097 **Unknown, printing workshop, Bauhaus Dessau, 1926,** in *Arbeiter-Illustrierte Zeitung*, Berlin, no. 16, 1929, pp. 8f., Bibliothek der Friedrich-Ebert-Stiftung

■ 098 **Unknown, working space of the metal workshop, Bauhaus Dessau, 1926,** in *Arbeiter-Illustrierte Zeitung*, Berlin, no. 16, 1929, pp. 8f., Bibliothek der Friedrich-Ebert-Stiftung

■ 099 **Unknown, advertising workshop, Bauhaus Dessau, 1926,** in *Arbeiter-Illustrierte Zeitung*, Berlin, no. 16, 1929, pp. 8f., Bibliothek der Friedrich-Ebert-Stiftung

■ 100 **Unknown, working space for the wall painting workshop, Bauhaus Dessau, 1926** in *Arbeiter-Illustrierte Zeitung*, Berlin, no. 16, 1929, pp. 8f., Bibliothek der Friedrich-Ebert-Stiftung

■ 101 **Unknown, workshop for the weaving mill, Bauhaus Dessau, 1926,** in *Arbeiter-Illustrierte Zeitung*, Berlin, no. 16, 1929, pp. 8f., Bibliothek der Friedrich-Ebert-Stiftung

arbeitsplan der druckerei

das bauhaus in dessau

druckerei. leitung: herbert bayer

a. **lehrwerkstatt:** in der druckerei des bauhauses werden schöpferisch befähigte menschen ausgebildet.

die aufnahme in die lehrwerkstatt der druckerei erfolgt probeweise nach erfolgreicher halbjähriger teilnahme an der grundlehre des bauhauses, die für alle in das bauhaus eintretenden studierenden obligatorisch ist. die probezeit in der werkstatt dauert ein halbes jahr. nach endgültiger aufnahme verpflichtet sich der studierende mindestens zwei jahre lang an der werkstattlehre teilzunehmen.

in der lehrwerkstatt werden die studierenden in das wesen der graphischen reproduktion eingeführt und genießen eine gründliche fachliche ausbildung in theorie und praxis:

1. in der setzerei
2. in der buchdruckerei (an hand- und kraftpressen)
3. in der lithographie
4. in der steindruckerei
für die schöpferische weiterentwicklung der studierenden sorgen:

1. der werkstattleiter, der die aufgaben stellt und sie mit den einzelnen eingehend bespricht, unter weitgehender berücksichtigung der forderungen der zeit und des individuellen entwicklungstadiums.
2. die im bauhaus eingerichteten kurse. die angehörigen der lehrwerkstatt sind verpflichtet, an den allgemeinen obligatorischen kursen des bauhauses teilzunehmen. (werkzeichen, mechanik u. a.)
nach zweijähriger tätigkeit in der lehrwerkstatt muß eine prüfung entweder

in setzerei und buchdruckerei
oder in lithographie und steindruckerei

abgelegt werden.

nach erfolgreicher prüfung kann die aufnahme in die versuchs- und ausführungswerkstatt oder in die baulehre erfolgen.

b. **versuchs- und ausführungswerkstatt:** die formale und technische ausbildung wird in erweiterter form in allen anderen graphischen fächern fortgeführt.

#learnbydoing

147

■ 102 **Herbert Bayer, work plan for print shop, 1925**
letterpress, double-sided printing, front, 29.6 × 20.9 cm,
Vitra Design Museum Collection

die angehörigen der versuchs- und ausführungswerkstatt sind durch das erworbene handwerkliche können befähigt, ihre schöpferischen und experimentellen absichten in gesteigertem maße zu verwirklichen. sie verfertigen muster zur handwerklichen und industriellen produktion. sie nehmen an den praktischen arbeiten der werkstatt und an den für sie obligatorischen kursen des bauhauses teil.

buchdrucker, setzer oder graphiker, die außerhalb des bauhauses schon eine handwerkliche lehre durchgemacht haben, können nach erfolgreichem besuch der grundlehre sofort in die versuchs- und ausführungswerkstatt aufgenommen werden.

die angehörigen der versuchs- und ausführungswerkstatt erhalten nach mindestens einjähriger erfolgreicher tätigkeit in dieser werkstatt ein **amtliches zeugnis des bauhauses** als nachweis, daß sie befähigt sind auf dem gebiete der graphischen reproduktion eine tätigkeit von einfluß auszuüben, die den heutigen künstlerischen und technischen forderungen entspricht.

von diesem zeitpunkt an kann entweder die arbeit in der versuchs- und modellwerkstatt fortgeführt werden oder bei eignung und neigung die ausschließliche übernahme des studierenden in die **baulehre** erfolgen unter der voraussetzung, daß er schon während der lehrzeit an allen vorbereitenden fächern (werkzeichnen, statik, konstruktionslehre u. a.) regelmäßig teilnahm. (s. arbeitsplan der baulehre).

das bauhaus besitzt das eigentumsrecht auf sämtliche in der werkstatt hergestellte arbeiten.

von der endgültigen aufnahme in die lehrwerkstatt ab werden die arbeitsleistungen der studierenden nach erfolgter verwertung entsprechend entlohnt.

angegliedert ist eine **reklame-abteilung,** in der angehörige der wandmalerei und der druckerei nach mindestens zweijähriger tätigkeit in ihrer lehrwerkstatt aufnahme finden. während der probezeit (dauer: ein halbes jahr) erfolgt dort spezielle ausbildung in schriftzeichnen und reklamegestaltung. nach erfolgreicher teilnahme an dieser ausbildung kann endgültige aufnahme in die reklameabteilung erfolgen. die studierenden nehmen sodann an den praktischen aufgaben der abteilung teil; ihre arbeitsleistung an diesen aufgaben wird nach erfolgter verwertung entsprechend entlohnt. sind sie zu selbständiger arbeit gelangt, worüber schriftliches zeugnis des instituts erteilt wird, tragen die von ihnen verfertigten reklamearbeiten neben dem zusatz „bauhaus" ihren namen bzw. ihre signatur. jedoch besitzt das bauhaus eigentumsrecht auf sämtliche in der abteilung hergestellten arbeiten. an die selbständigen mitglieder der werkstatt wird nach erfolgter verwertung der arbeiten eine entsprechende entwurfsgebühr nach vorher festgesetzter vereinbarung gezahlt.

die verteilung der arbeiten erfolgt durch den abteilungsleiter, gegebenenfalls im einvernehmen mit dem leiter der wandmalerei.

die leitung des bauhauses

■ 103 **Herbert Bayer, work plan for print shop, 1925**
letterpress, double-sided printing, back, 29.6 × 20.9 cm,
Vitra Design Museum Collection

Work Plans

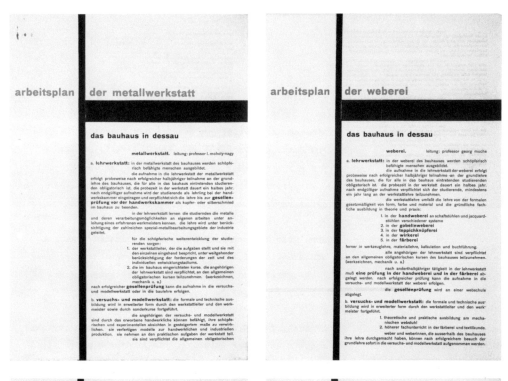

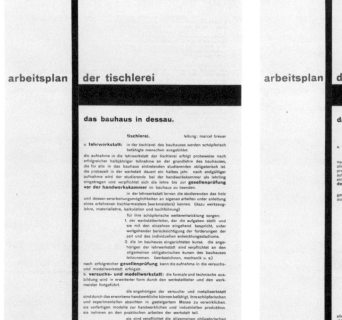

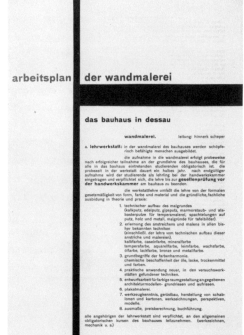

■ 104 **Herbert Bayer, work plan for metal workshop, 1925,** letterpress, double-sided printing, 29.6 × 20.9 cm, Freese Collection

■ 105 **Herbert Bayer, work plan for weaving mill, 1925,** letterpress, double-sided printing, 29.6 × 20.9 cm, Freese Collection

■ 106 **Herbert Bayer, work plan for carpentry workshop, 1925,** letterpress, double-sided printing, 29.6 × 20.9 cm, Freese Collection

■ 107 **Herbert Bayer, work plan for wall painting, 1925** letterpress, double-sided printing, 29.6 × 20.9 cm, Freese Collection

Zwischen der Leitung des Staatlichen Bauhauses in Weimar
und Herrn Kunstgewerbelehrer und Buchbindermeister Otto D
D o r f n e r in Weimar ist vorbehaltlich der Genehmigung
der Staatsregierung von Sachsen - Weimar folgender Vertrag
geschlossen worden.

1.

Herrn Otto Dorfner werden für seine Buchbindereiwerk-
statt die Räume Nr. 1,2 und 3 des Kunstgewerbeschulgebäudes
vom 1. Oktober 1919 ab bei freier Miete, Heizung und Be-
leuchtung zur Verfügung gestellt.

2.

Er verpflichtet sich keine Privatschüler mehr anzuneh-
men, sondern in seiner Werkstatt für Studierende des Staat-
lichen Bauhauses acht Lehrstellen einzurichten und zwar vier
für Lehrlinge und vier für Fachschüler und ferner jährlich
Kurse für Hospitanten nach Vereinbarung mit der Leitung des
Bauhauses abzuhalten.

3.

Für seine Lehrtätigkeit erhält Herr Dorfner eine jähr-
liche Vergütung von 4000.- Mark, die in Monatsraten zur Aus-
zahlung gelangt.

4.

Herr Dorfner erklärt sich bereit alle seiner Buchbinder-
werkstatt durch Vermittlung des Staatlichen Bauhauses zugehen-
den Aufträge dem Bauhaus zum Herstellungspreis mit einem
Höchstaufschlag von 10% zu berechnen.

5.

Solange das Staatliche Bauhaus keine eigenen Materiali-
en für Unterrichtszwecke und zur Ausführung von Aufträgen zur
Verfügung stellen kann, wird Herr Dorfner diese Materialien

■ 108 **Labour agreement between Otto Dorfner and
Bauhaus Weimar, 1 December 1919,** typed on paper,
32.5 × 21 cm, private collection

aus seinen Vorräten vorhalten.

6.

Dieser Vertrag hat Gültigkeit bis zum 31. März 1923.
Ueber eine weitere Verlängerung muss spätestens bis zum
1. April 1922 Beschluss gefasst werden.

7.

Das Verkaufrecht auf alle von Schülern ausgeführten
Arbeiten bleibt dem Bauhaus vorbehalten.

Weimar, den 1. Oktober 1919.

Staatliches Bauhaus:

Vorstehender Vertrag wird genehmigt.
Weimar, den 3. November 1920.
Kultusministerium.
Abteilung KW. I.

KW. I. 571.

BAUHAUS DESSAU

GRUNDSÄTZE DER BAUHAUS-PRODUKTION

Das Bauhaus will der zeitgemäßen Entwicklung der Behausung dienen, vom einfachen Hausgerät bis zum fertigen Wohnhaus.
In der Überzeugung, daß Haus- und Wohngerät untereinander in sinnvoller Beziehung stehen müssen, sucht das Bauhaus durch systematische Versuchsarbeit in Theorie und Praxis — auf formalem, technischem und wirtschaftlichem Gebiete — die Gestalt jedes Gegenstandes aus seinen natürlichen Funktionen und Bedingtheiten heraus zu finden.
Der moderne Mensch, der sein modernes, kein historisches Gewand trägt, braucht auch moderne, ihm und seiner Zeit gemäße Wohngehäuse mit allen der Gegenwart entsprechenden Dingen des täglichen Gebrauches.

Ein Ding ist bestimmt durch sein Wesen. Um es so zu gestalten, das es richtig funktioniert — ein Gefäß, ein Stuhl, ein Haus — muß sein Wesen zuerst erforscht werden; denn es soll seinem Zwecke vollendet dienen, d. h. seine Funktionen praktisch erfüllen, haltbar, billig und „schön" sein. Diese Wesensforschung führt zu dem Ergebnis, daß durch die entschlossene Berücksichtigung aller modernen Herstellungsmethoden, Konstruktionen und Materialien Formen entstehen, die, von der Ueberlieferung abweichend, oft ungewohnt und überraschend wirken (vgl. beispielsweise den Gestaltwandel von Heizung und Beleuchtung).
Nur durch dauernde Berührung mit der fortschreitenden Technik, mit der Erfindung neuer Materialien und neuer Konstruktionen gewinnt das gestaltende Individuum die Fähigkeit, die Gegenstände in lebendige Beziehung zur Überlieferung zu bringen und daraus die neue Werkgesinnung zu entwickeln:
Entschlossene Bejahung der lebendigen Umwelt der Maschinen und Fahrzeuge.
Organische Gestaltung der Dinge aus ihrem eigenen gegenwartsgebundenen Gesetz heraus, ohne romantische Beschönigungen und Verspieltheiten.
Beschränkung auf typische, jedem verständliche Grundformen und -farben.
Einfachheit im Vielfachen, knappe Ausnutzung von Raum, Stoff, Zeit und Geld.

Die Schaffung von Typen für die nützlichen Gegenstände des täglichen Gebrauchs ist eine soziale Notwendigkeit.
Die Lebensbedürfnisse der Mehrzahl der Menschen sind in der Hauptsache gleichartig. Haus und Hausgerät ist Angelegenheit des Massenbedarfs, ihre Gestaltung mehr eine Sache der Vernunft, als eine Sache der Leidenschaft. Die Typen schaffende Maschine ist ein wirksames Mittel, das Individuum durch mechanische Hilfskräfte — Dampf und Elektrizität — von eigener materieller Arbeit

■ 109 **Walter Gropius (text), Herbert Bayer (design), principles of Bauhaus production, 1926,** letterpress on sketch paper, 28.8 × 21.1 cm, Freese Collection

M. Brandt

nettopreisliste juni 1929
der metallgeräte des bauhauses

blatt nr. 1

			preis für das stück bei abnahme von					
			1	5	10	20	50	100
		die mit * versehenen gegenstände können auf wunsch zu entsprechender berechnung auch größer resp. kleiner geliefert werden. änderungen vorbehalten.						
2	me 3	**teekugel mit tropfschale,** ca. 15 cm lang						
		messing vernickelt	3,50					3,20
		neusilber versilbert	5,—					
		silber 900/1000 gestempelt						
	me 5 b	**teebüchse,** ca 14 cm hoch						
		messing vernickelt	11,90		9,95			
		neusilber versilbert	13,70		11,40		10,30	
		silber 900/1000 gest.						
	me 8	**tee-extraktkännchen,**						
		messing, innen verzinnt	55,—					
	me 11	**ascher,** ca. 11 cm hoch,						
		messing, deckel vernickelt	4,—					3,60
	me 17 l	**mokka-service,** 4–teilig, kanne 4/10 liter inhalt						
		messing vernickelt	105,—	89,—				
		neusilber versilbert	115,—	100,—				
		silber 900/1000 gest.						
	me 18 a	**fischkocher,** für ca. 0,75 kg fisch *						
		messing vernickelt	78,50	71.—				
		neusilber versilbert	89,60	82,—				
	me 18 b	**tablett zu me 18 a,**						
		messing vernickelt	19,—	17,40				
		neusilber versilbert	23,70	21,50				

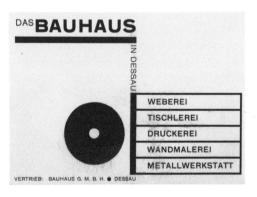

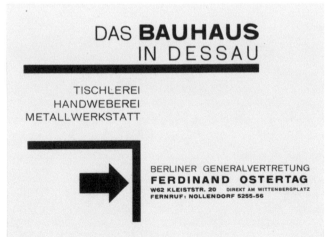

■ 110 **Unknown, net price list for Bauhaus metal devices (front), June 1929.** Five numbered pages, tacked, handwritten additions, signed by Marianne Brandt, Marianne Brandt Estate, Freese Collection

■ 111 **Joost Schmidt, primary distribution, advertisement card for workshops in Dessau, 1926,** letterpress, 10.1 × 14.4 cm, Freese Collection

■ 112 **Bauhaus distribution, general agency, 1926** letterpress, 10.4 × 14.4 cm, Freese Collection

■ 113 **László Moholy-Nagy, invoice, State Bauhaus Weimar, 1923,** letterpress on paper, 28.6 × 22.4 cm, Sörensen-Popitz Estate, Freese Collection

■ 114 **Herbert Bayer, Bauhaus GmbH letterhead, 1925** photo-mechanical print, 29.8 × 20.9 cm, Harvard Art Museums/ Busch-Reisinger Museum, gift of the artist, BR48.69.G

hochschule für gestaltung **bauhaus dessau**

ihre zeichen	ihre nachricht vom	unsere zeichen	tag
	10.3.32	**ms/r**	**17.3.32**

das bauhaus ist an einer auswertung der früher in der me-
tallwerkstatt hergestellten gegenstände nicht interessiert,
und wir geben ihnen hiermit die von ihnen entworfenen
modelle frei.
die auf anliegender liste zusammengestellten gegenstände
befinden sich noch auf unserem lager. wir würden bereit
sein, sie ihnen zu einem vorzugspreis zu überlassen.
wir erwarten hierzu ihre stellungnahme.

hochachtungsvoll
BAUHAUS IN DESSAU.

postanschrift: bauhaus dessau

frau anbei: 1 liste
marianne brandt

g o t h a
kaiserstraße 34a/1

sammel-nr. 3136 bankkonto: städt. kreissparkasse dessau 2634 postscheck. magdeburg 13701

■ 115 Unknown, Bauhaus Dessau letter to Marianne Brandt
on the occasion of the exploitation of her designs, 1932
typed on paper, 40.8 × 21 cm, Freese Collection

000001

das eigentumsrecht der form besitzt in der metallwerkstatt:
--

L T 2a grosse stehlampe pap. *199*

L T 2 leuchter siebenarmig julius pap.

L T 7 mokkamaschine w. wagenfeld

L T 8 tischlampe "

L T 15 sauciere (fett u. mager) "

L T 26-32 kannen "

L T 40-43,45 kaffee-service und teekanne "

L T 50 sauciere (fett u. mager) "

L T 38-39 teebüchsen "

L T 59 teekugeltropfschälchen einteilg. "

L T 56 speisezimmerbeleuchtung a. meyer

L T 11 teekugel w. tümpel.

L T 20-23 teekugelständer w. tümpel u. o. rittweger

L T 35 aschenschale m.beweglicher
 schale m. brandt

L T 36 aschenschale m. deckel "

L T 49 extraktkännchen "

L T 50-55,55a service m. wasserkanne u. kessel "

L T 57 messingschale

L T 58 teeglashalter krajewski.

L T 59 teewärmer gropius

L T 33 likörkanne marby

L T 1 samowar j. jucker

 b.w.

Inhalt
33 beschriebene Blätter
Datum: 17.1.78
Staatsarchiv Weimar

■ 116 **List of models, copyright of a form, metal
workshop, 1925.** ThHStAW, Staatliches Bauhaus Weimar
no. 199 f. 1r

000096

in der tischlerei (möbelabteilung) des staatlichen bauhauses zu weimar
--

verfertigte gegenstände. 1921 - 1925.

 von marcel breuer.

	photo
lehnstuhl (bunt, mit gobelinsitz und lehne von gunta stölzl)	II. 1
tisch (quadratisch,schwarz poliert und teakholz für diele sommerfeld)	II. 4
klubsessel (teakholz, rotes und schwarzes saffian)	II. 5
stuhl (schwarz poliert mit farbigem gurtgewebe von gunta stölzl)	II.7
teetisch (schwarz poliert,rund)	II.8
stuhl für wohnzimmer (mit stoffsitz,kreuz und rückenlehne aus gurt) variationen I-VIII,	II.10
schrank (aus ahorn, grauem vogelahorn und schwarz poliert)	II.12
schreibtisch (mit sichtbarem schubkasten-laufrahmen aus rot ge- beiztem kirsch und ahorn)	II.17
schrank für wohnzimmer (paduk,ahorn,esche und glas)	II.22
toilettentisch für eine dame (zitrone,nuss,nickel,glas)	II.23
damenbett (zitrone und nuss mit gebogenem fussende)	II.24
lehnstuhl (mit rosshaarpolster,aus eiche)	II.25
küche (farbig lackiert) schrank	II.29
tisch	II.28
bank	II.27
stuhl	II.27
schreibtisch kombiniert mit bücherregal (aus 8 mm sperrholz, schleiflack,linoleumsockel)	II.37,38
kinderstuhl (farbig lackiert, variationen I -III. 29,35,42 cm sitzhöhe)	II.46.
kindertisch (rund,farbig lackiert)	II.41
kindertisch (viereckig,farbig lackiert,variationen I.II. platte 50 x 50, 100 x 50)	
kinderstuhl (mit stoffsitz und lehne, buche)	II.41
bücherschrank (mit glaswänden,glasschiebetüren,ahorn,paduk)	II.43
tisch für wohnzimmer (quadratisch,paduk,ahorn,zargen und füsse mit quadratischem querschnitt)	XII.6
	b.w.

■ 117 **List of items manufactured at Bauhaus Weimar, carpentry workshop, 1921–25,** ThHStAW, Staatliches Bauhaus Weimar no. 199 f. 6r

158

103856

RÉPUBLIQUE FRANÇAISE.

MINISTÈRE DU COMMERCE ET DE L'INDUSTRIE.

DIRECTION DE LA PROPRIÉTÉ INDUSTRIELLE.

BREVET D'INVENTION.

Gr. 9. — Cl. 4.

N° 640.760

Meubles en tubes métalliques.

M. Marcel BREUER résidant en Allemagne.

Demandé le 12 septembre 1927, à 14ʰ 12ᵐ, à Paris.
Délivré le 3 avril 1928. — Publié le 21 juillet 1928.

(2 demandes de brevets déposées en Allemagne les 13 septembre 1926 et 25 mars 1927. —
Déclaration du déposant.)

La présente invention se rapporte aux sièges, aux lits, aux divans, aux casiers à dessins, etc.

L'invention est essentiellement caractérisée
5 en ce que, pour la construction des meubles, on utilise, de manière particulière, des tubes d'acier dits tubes de précision. Par suite de l'épaisseur uniforme des parois et en raison des propriétés de résistance des tubes d'acier
10 de précision, on peut utiliser des tubes de faible épaisseur. On peut notamment renoncer à l'adjonction du coefficient de sécurité dont il faut tenir compte en cas d'emploi de tubes métalliques ordinaires en raison de l'inégalité
15 de l'épaisseur des parois, de sorte qu'on réalise une économie de poids considérable.

Les cadres ou châssis pour des sièges et des lits peuvent être élastiques; ils jouent le
20 rôle de ressort lors de leur utilisation et remplacent ainsi en totalité ou en partie un rembourrage coûteux. Pour augmenter encore le caractère économique, il est avantageux d'établir les meubles de manière que toutes
25 les courbures d'angle aient le même rayon.

Pour faciliter le transport et pour réduire l'encombrement des articles, les cadres des meubles ne sont montés de préférence qu'au lieu d'utilisation par assemblage de parties
30 séparées et on évite, dans la mesure du possible, tout soudage, en se servant d'une simple liaison par insertion au moyen de broches et de vis transversales.

Les surfaces d'utilisation disposées entre
35 les tubes peuvent être fabriquées de manière très simple en bois, tissu, etc., et peuvent être vissées sur le cadre en tubes, ou peuvent être insérées en position avant l'assemblage, ou encore être reliées d'autre manière
40 convenable quelconque. Dans certaines conditions, ces surfaces peuvent, aux points où s'exercent des efforts, remplacer des barres de cadre.

D'autres caractéristiques de l'invention ap-
45 paraîtront dans la description suivante en se reportant au dessin ci-joint, qui représente à titre d'exemple, plusieurs formes d'exécution de l'invention.

La fig. 1 montre un tabouret.
La fig. 2, un genre de siège de club.
50
La fig. 3, un fauteuil pliant pour théâtre.
La fig. 4, un support pour planches de dessins, etc.
La fig. 5, une simple chaise.
La fig. 6, une chaise avec accoudoir.
55
La fig. 7, une chaise pliante.
La fig. 8 est une vue latérale du siège de la fig. 7.
Le tabouret de la fig. 1 se compose de deux parties en ⊔ 1 et 2 en tubes métalliques
60

Prix du fascicule : 5 francs.

25' 25
23

75

■ 118 Marcel Breuer, Brevet d'Invention à M. Marcel
Breuer pour meubles en tubes métalliques, 1928, print
on paper, 31.5 × 23.5 cm, Vitra Design Museum Collection

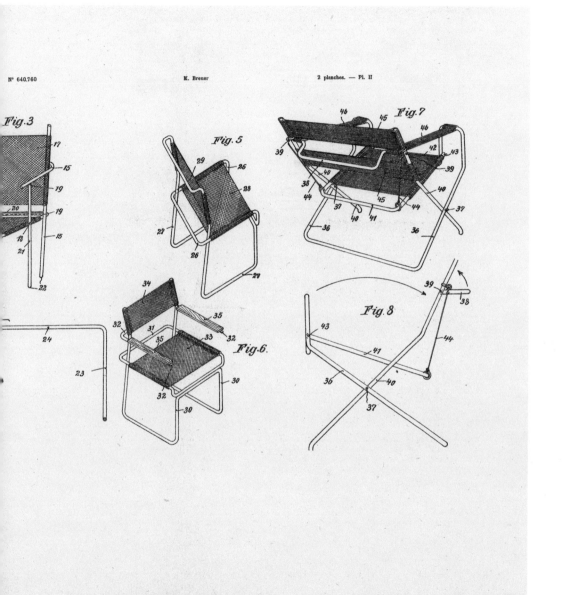

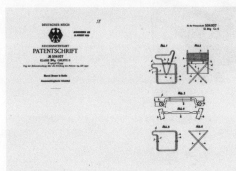

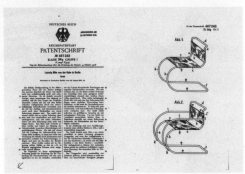

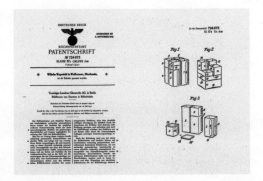

■ 119 **Wilhelm Wagenfeld, electric table lamp, patent document no. 441 438, 1925,** German Reich, Reich Patent Office, courtesy Deutsches Patent- und Markenamt (DPMA)

■ 120 **Ilse Fehling, round stage for string puppet plays, patent document no. 387 832, 1922,** German Reich, Reich Patent Office, courtesy Deutsches Patent- und Markenamt (DPMA)

■ 121 **Marcel Breuer, collapsible chair, patent document no. 468 736, 1928,** German Reich, Reich Patent Office, courtesy Deutsches Patent- und Markenamt (DPMA)

■ 122 **Ludwig Mies van der Rohe, chair, patent document no. 467 242, 1927,** German Reich, Reich Patent Office, courtesy Deutsches Patent- und Markenamt (DPMA)

■ 123 **Wilhelm Wagenfeld, set of trays for refrigerators, patent document no. 724 673, 1939,** German Reich, Reich Patent Office, courtesy Deutsches Patent- und Markenamt (DPMA)

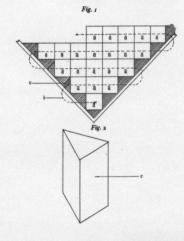

■ 124 **Kurt Kranz, process for the manufacture of raster images, patent document no. 568 606, 1932**
German Reich, Reich Patent Office, courtesy Deutsches Patent- und Markenamt (DPMA)

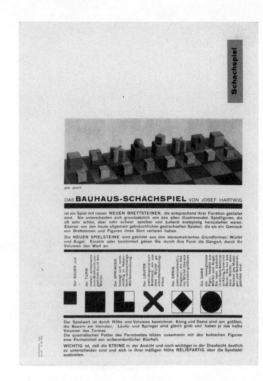

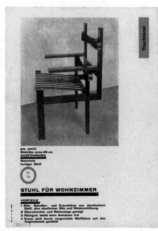

■ 125 Herbert Bayer, *Katalog der Muster* [sample catalogue], **cover sheet, 1925,** letterpress on art paper, 29.5 × 21 cm, Stiftung Bauhaus Dessau

■ 126 **Herbert Bayer,** *Katalog der Muster* [sample catalogue], **insert sheet, chess, 1925,** letterpress on art paper, 29.5 × 21 cm, Freese Collection

■ 127 Herbert Bayer, *Katalog der Muster* [sample catalogue], **insert sheet, ME5, 1925,** letterpress on art paper, 29.5 × 21 cm, Stiftung Bauhaus Dessau

■ 128 **Herbert Bayer,** *Katalog der Muster* [sample catalogue], **insert sheet, TIa1, 1925,** letterpress on art paper, 29.5 × 21 cm, Stiftung Bauhaus Dessau

Sample Catalogue

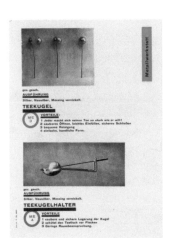

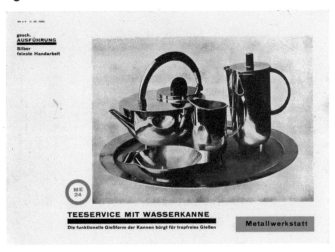

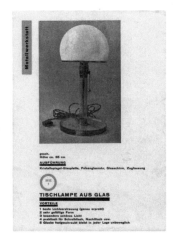

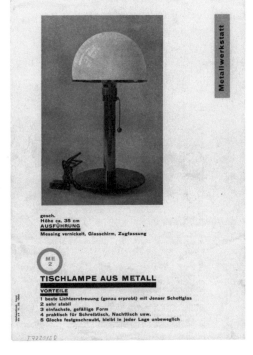

#learnbydoing

■ 129 Herbert Bayer, *Katalog der Muster* [sample catalogue], insert sheet, ME3 and ME4, 1925 letterpress on art paper, 29.5 × 21 cm, Stiftung Bauhaus Dessau

■ 130 Herbert Bayer, *Katalog der Muster* [sample catalogue], insert sheet, ME24, 1925, letterpress on art paper, 29.5 × 21 cm, Stiftung Bauhaus Dessau

■ 131 Herbert Bayer, *Katalog der Muster* [sample catalogue], insert sheet, ME1, 1925, letterpress on art paper, 29.5 × 21 cm, Stiftung Bauhaus Dessau

■ 132 Herbert Bayer, *Katalog der Muster* [sample catalogue], insert sheet, metal table lamp, ME2, 1925, letterpress on art paper, 29.5 × 21 cm, Stiftung Bauhaus Dessau

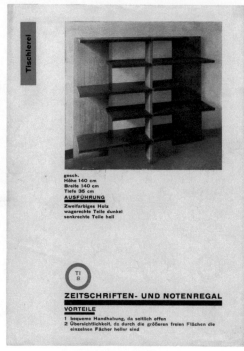

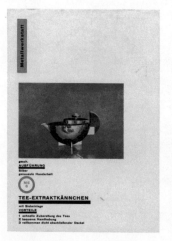

■ 133 **Herbert Bayer,** *Katalog der Muster* **[sample catalogue], insert sheet, nursery furniture, 1925,** letterpress on art paper, 29.5 × 21 cm, Stiftung Bauhaus Dessau

■ 134 **Herbert Bayer,** *Katalog der Muster* **[sample catalogue], insert sheet, TI8, 1925,** letterpress on art paper, 29.5 × 21 cm, Stiftung Bauhaus Dessau

■ 135 **Herbert Bayer,** *Katalog der Muster* **[sample catalogue], insert sheet, ME8, 1925,** letterpress on art paper, 29.5 × 21 cm, Stiftung Bauhaus Dessau

■ 136 **Herbert Bayer,** *Katalog der Muster* **[sample catalogue], insert sheet, TI23, 1925,** letterpress on art paper, 29.5 × 21 cm, Stiftung Bauhaus Dessau

#learnbydoing

■ 137 Herbert Bayer, *Katalog der Muster* [sample catalogue], double page, terms of delivery, **1925,** letterpress on art paper, 29.5 × 42 cm, Stiftung Bauhaus Dessau

■ 138 Herbert Bayer, *Katalog der Muster* [sample catalogue], **back page, 1925,** letterpress on art paper, 29.5 × 21 cm, Stiftung Bauhaus Dessau

The first Bauhaus designs were manufactured using traditional craft skills and were shaped by the Expressionism of the early Weimar years. With the design of Marcel Breuer's bar stool in 1922, the carpentry workshop completed its U-turn towards modular furniture, leading to the development of Erich Dieckmann's designs, which were assembled from standardized components and manufactured in small batches in the Bauhaus workshops. In Dessau, contact with industry was developed further and, with the support of the Dessau firm Junker, Marcel Breuer designed the first modern furniture made out of steel tubing: the famous B3 club chair, later named Wassily, followed by the B5 chair and the B9 series of stools and (side) tables.

The tension between the avant-garde demand for new designs and the bourgeois ideas in which the Bauhaus remained caught could be clearly seen in the small objects produced in the metal workshop. These were exemplified by the expensive single copy items – such as tea caddies, ashtrays and mocha services – made from valuable materials. They were only partly suitable as designs for industry at that point – but now, however, some of them are produced by Alessi with great success. In contrast, the ceramic workshop quickly became successful and was the only workshop that provided the Bauhaus with a small income from the beginning.

What all the objects had in common was that they attempted to connect the world of everyday objects with the search for a radical renewal of design. The aim was to discover the potential of new material and new methods of production and to use these two aspects to create a contemporary aesthetic. Today, designers are again confronted with the same challenge as digitization brings with it radical changes in production methods and industry structure. New synthetic and composite materials, computer- and internet-based methods of design, production and sales – all these changes prompt similar questions as those which were discussed at the Bauhaus. Which designs need which manufacturing process? Which aesthetic requires the use of which material? Where is the boundary between industry and craft? Where is the boundary between design and art? What is more important in a design – the individual designer or a functioning collective?

■139 **Ludwig Mies van der Rohe, designs for steel tube furniture, 1930,** pencil on paper, 27 × 20.8 cm, Vitra Design Museum Collection

Some generations are more linked to the Bauhaus than others. For my generation, which went through the 1968 movement, its socio-political vision was an important reference. The message it was trying to bring to a wide audience about the social function of architecture and design tied in perfectly with my initial studies in the field. It's difficult to identify which ideas did or didn't have an impact on me. Being the Bauhaus transdisciplinary, we have all been fascinated

somehow by their accomplishments. When I think of Oskar Schlemmer's theatrical costumes, however, I find them both fascinating and distant at the same time.

To me the Bauhaus represents a moment when some industrial processes (such as the use of seamless steel tubing) brought revolutionary developments in the design field. Revolutions in design are often driven by advancements in material and technology.

170

Abstraction and a holistic approach to art and design are surely the most important ideas brought by the Bauhaus as well as the theoretical foundation of an architect/designer who works for society as a whole. What we lack most nowadays is the "heroic" attitude of that time.

ANTONIO CITTERIO, DESIGNER

I think the Bauhaus is more about an attitude. It's their way of thinking and their way of doing which is still of great influence.

BENEDETTA TAGLIABUE, ARCHITECT

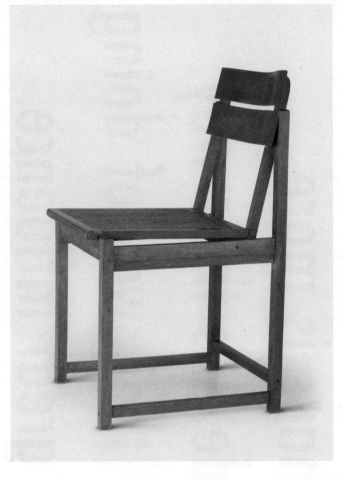

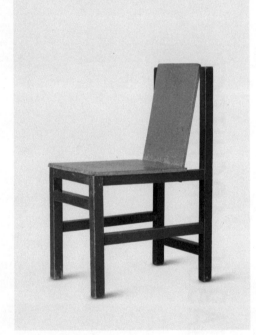

■ 140 **Marcel Breuer, children's chair TI3a, 1923**
lacquered wood, lacquered plywood, 53.2 × 26 × 34.5 cm,
Vitra Design Museum Collection

■ 141 **Erich Dieckmann, modular chair,**
c. 1926/1927, wood, basketwork, 79.7 × 42 × 52 cm,
Vitra Design Museum Collection

#learnbydoing

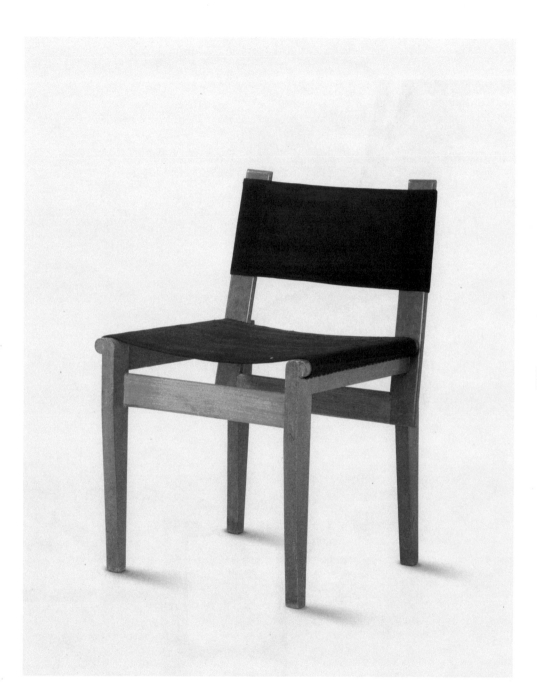

■142 **Marcel Breuer, TI2, 1924,** wood, fabric,
75.5 × 48.5 × 51 cm, Vitra Design Museum Collection

■ 143 **Jerszy Seymour, workshop chair, 2009,** wood, synthetic material, 76 × 50 × 49.5 cm, Vitra Design Museum

■ 145 **Front Design, sketch furniture, AP 2, 2005,** polyamide, 76 × 47.5 × 49.5 cm, Vitra Design Museum Collection

■ 144 **Studio Minale-Maeda, Keystones, 2014,** 3D printed polyamide, ash, laminated birch wood, Vitra Design Museum Collection

■ 146 **Clemens Weisshaar, R18 Ultra Chair, 2012,** carbon fibre micro sandwich, carbon NR composite, aluminium alloy, 84 × 39.5 × 45 cm, Vitra Design Museum Collection

From Experiment to Series Production

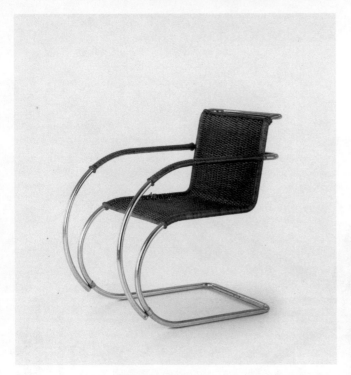

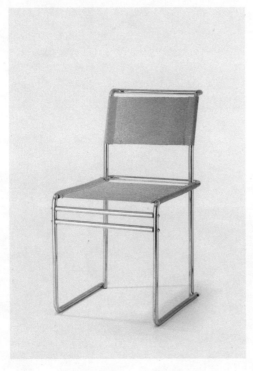

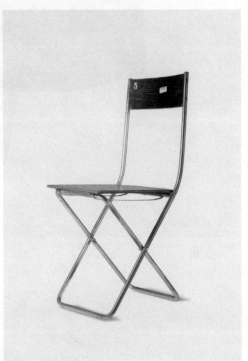

■ 147 **Ludwig Mies van der Rohe, armchair MR20/3, 1927,** cane seating, chromium-plated steel tube, 82.5 × 56.5 × 82.0 cm, Vitra Design Museum Collection

■ 148 **Marcel Breuer, chair B5, 1926,** chromium-plated steel tube, fabric, 83.5 × 45 × 64 cm, Vitra Design Museum Collection

■ 149 **Alfred Arndt, folding chair, 1929/1930** nickel-plated steel tube, stained plywood, 92 × 41 × 51 cm, Vitra Design Museum Collection

#learnbydoing

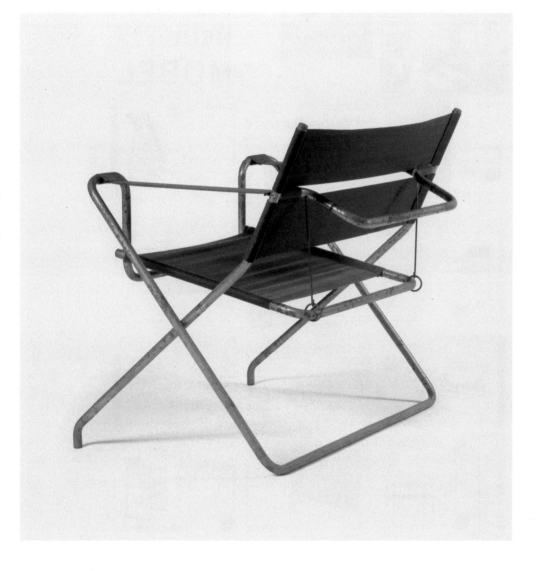

■ 150 **Marcel Breuer, B4, 1926/1927**
nickel-plated steel tube, fabric, 71.3 × 78.1 × 65 cm,
Vitra Design Museum Collection

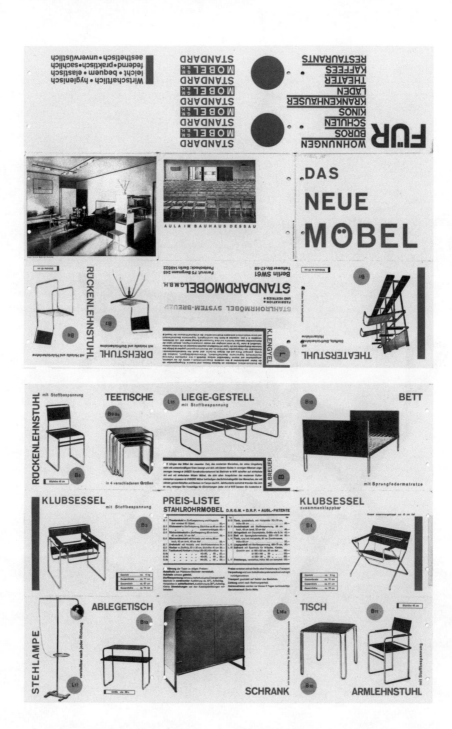

■ 151 Hajnal Lengyel-Pataky, *Das neue Möbel* [The new furniture], folding sales leaflet for furniture offered by **Standard Möbel, 1928,** lithograph on paper, 98 × 65 cm, Alexander von Vegesack Collection, Domaine de Boisbuchet, www.boisbuchet.org

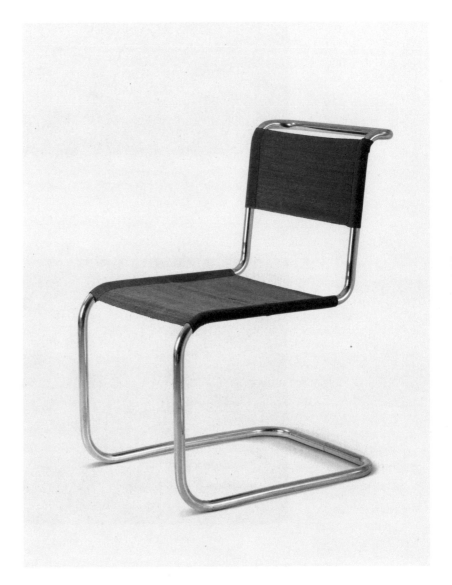

■ 152 **Marcel Breuer, chair B33, 1927/1928**
chrome-plated steel tube, fabric, 82 × 50.3 × 65.3 cm,
Vitra Design Museum Collection

■ 153 **Grete Reichardt, sample item, 1928–30**
polished yarn, seat 37.5 × 42 cm, back 20 × 44.5 cm,
Grete Reichardt Estate, Freese Collection

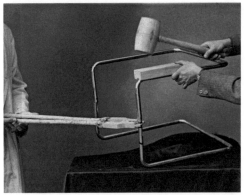
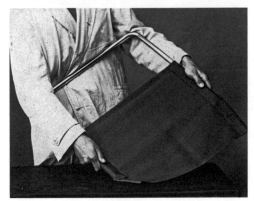
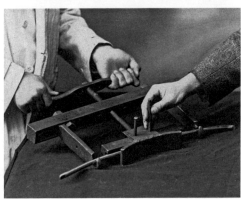

■ 154 Unknown, **compression of adapter sleeve by means of a pair of tongs, 1935,** photograph, 12.5 × 29.5 cm, Alexander von Vegesack Collection, Domaine de Boisbuchet, www.boisbuchet.org

■ 155 Unknown, **fitting of compressed adapter sleeve in two tube elements, 1935,** photograph, 12.5 × 29.5 cm, Alexander von Vegesack Collection, Domaine de Boisbuchet, www.boisbuchet.org

■ 156 Unknown, **mounting of fabric on tube element, 1935,** photograph, 12.5 × 29.5 cm, Alexander von Vegesack Collection, Domaine de Boisbuchet, www.boisbuchet.org

■ 157 Unknown, **fitting and bending of tension bracket by means of a tension jack, 1935,** photograph, 12.5 × 29.5 cm, Alexander von Vegesack Collection, Domaine de Boisbuchet, www.boisbuchet.org

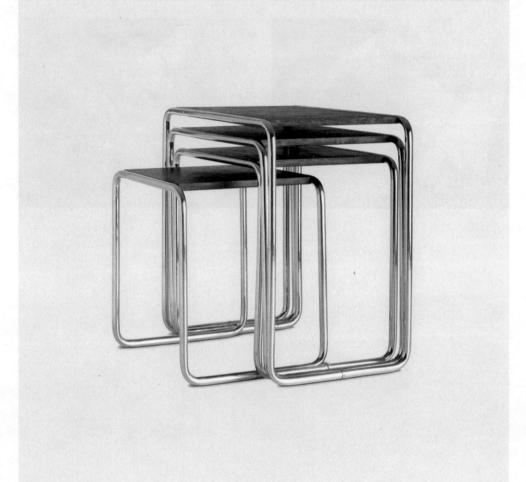

■158 **Marcel Breuer, set of tables B9, 1926/1927**
chrome-plated steel tube, lacquered wood,
60.5 × 74.7 × 45.5 cm, Vitra Design Museum Collection

■ 159 **Konstantin Grcic, Pipe, 2009,** steel tube, MDF,
chair 71 × 51 × 55.5 cm, table 72 × 120,9 × 62 cm,
Vitra Design Museum Collection
Photograph: Florian Böhm

■ 160 **Marianne Brandt, ashtray with eccentric opening and holder for cigarettes, 1924,** bronze, nickel brass, 6 × Ø 10.8 cm, private collection, courtesy Galerie Ulrich Fiedler

■ 161 **Josef Albers, tea glass, 1926,** heat-resistant glass, chrome-nickel steel, ebony, porcelain, saucer with Meissen stamp, 4.7 × 8.7 × 8.7 cm, private collection, courtesy Galerie Ulrich Fiedler

■ 162 **Marianne Brandt, MT35, ashtray with tilting device, 1924,** bronze, nickel brass, 6.7 × Ø 8 cm, private collection, courtesy Galerie Ulrich Fiedler

Metal Objects

#learnbydoing

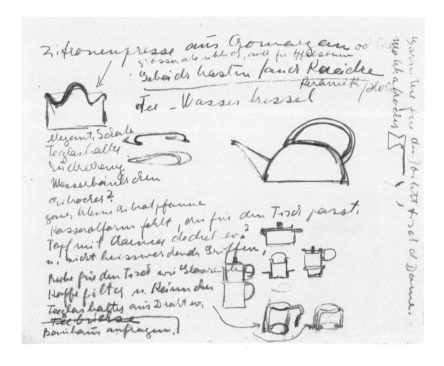

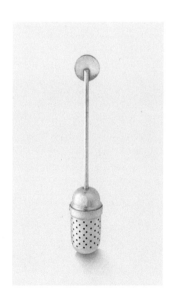

■ 163 **Marianne Brandt, design drawing of bowls and spoon, undated,** pencil on paper, 39.2 × 39.3 cm, Marianne Brandt Estate, Freese Collection

■ 164 **Wolfgang Tümpel, design drawings for tea infusers and tray, 1924,** pencil and ink on paper, five individual sheets mounted on cardboard, Museum für Kunst und Gewerbe Hamburg Collection, reproduction

■ 165 **Christian Dell, tea egg, 1924,** silver plated brass, 13 × 2.8 cm, Sebastian Jacobi Collection
Photograph: Thomas Naethe

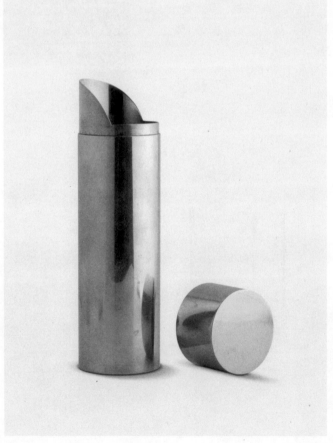

■ 166 **Wilhelm Wagenfeld, MT39, small tea caddy, 1924,** nickel brass, 14.5 × Ø 5 cm, private collection, courtesy Galerie Ulrich Fiedler

■ 167 **Hans Przyrembel, tea caddy, 1926,** nickel brass, 20.8 Ø × 6 cm, private collection, courtesy Galerie Ulrich Fiedler

#learnbydoing

■ 168 **Unfold and Kirschner3d, in collaboration with Penny Webb, Of Instruments and Archetypes, 2014,** courtesy Unfold

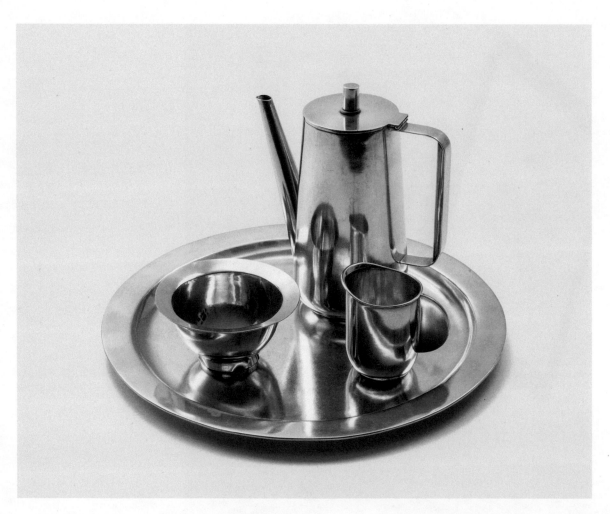

■ 169 **Otto Rittweger, coffee service, 1924,** silver,
tray Ø 26.5 cm, coffee pot H 15 cm, milk jug H 7 cm,
sugar bowl Ø 9.5 cm, courtesy Ulfstedt-Rittweger

#learnbydoing

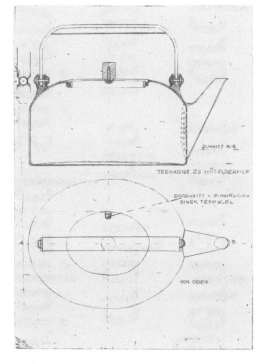

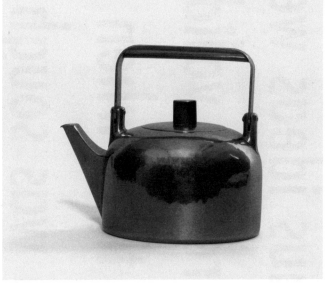

■ 170 **Hans Przyrembel, Marianne Brandt, teapot design for a hotel set (ME47), c. 1926/1927,** photostat, 29.7 × 21.2 cm, Klassik Stiftung Weimar, Direktion Museen, Graphische Sammlungen DK 125/91

■ 171 **Hans Przyrembel, Marianne Brandt, small teapot for a hotel set (ME47), after 1924,** brass, ebony, height with bracket c. 13,3 cm, width with spout 15,2 cm, body Ø 11,5 cm, Germanisches Nationalmuseum Nuremberg

Bauhaus ideas were revolutionary and are still valid today. At a time when a new way of life was sought, Walter Gropius brought together art, architecture, design and craft. He reconciled art with industrialized society.

EVA EISLER, ARCHITECT, DESIGNER

■ 172 **Eva Eisler, *Table for Father and Son*, 2013**
MDF panel, white paint, 300×110×78 cm,
courtesy Eva Eisler

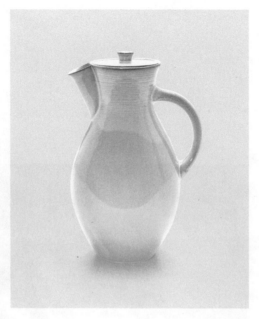

■ 173 **Otto Lindig, milk jug, c. 1925,** light glazing on fired clay, 12.2 × Ø 11.6 cm, Vitra Design Museum Collection

■ 174 **Otto Lindig, hot chocolate jug, c. 1923,** die-set turned to size, light glazing on fired clay, 22.9 × Ø 12.5 cm, Vitra Design Museum Collection

■ 175 **Otto Lindig, small green vase, c. 1940** green glazing on light fired clay, 26.8 × Ø 13.8 cm, Vitra Design Museum Collection

Ceramics

#learnbydoing

■ 176 **Marguerite Friedlaender, bowl, c. 1929**
dark brown overflow glazing on grey-brown fired clay,
7.1 × Ø 15.3 cm, Vitra Design Museum Collection

■ 177 **Theodor Bogler, prototype for combination
teapot, 1923,** cast stoneware, 11.8 × 21.5 × 15.5 cm,
private collection, Berlin

■ 178 **Otto Lindig, place setting, c. 1930,** clay, cup
Ø 10 cm, saucer Ø 14 cm, Vitra Design Museum Collection

The objects that made the new design language and aesthetic of the Bauhaus accessible to the wider public were often not the stools, lights and small objects that are now so iconic. Instead, it was the lesser known, anonymous industrial products, designed or reworked by past Bauhaus members, which succeeded in this task. Companies such as Körting & Mathiesen (Kandem), Ruppelwerke Gotha, Jenaer Glas, Lausitzer Glaswerke, Polytex and others manufactured the products, sometimes with great and long-lasting success. Successful items included Wilhelm Wagenfeld's Kubus crockery, which soon found a home in many kitchens; his tea service; his reworked version of Gerhard Marck's Sintrax coffee machine, but also Marianne Brandt's designs for Ruppelwerke, which ranged from ashtrays to napkin holders. These objects were successful not because they were sold under the label of the Bauhaus but because they were functional. As Gropius said, "They need to serve their purpose perfectly, that is, they must fulfil their function usefully, be durable, economical, and 'beautiful'."

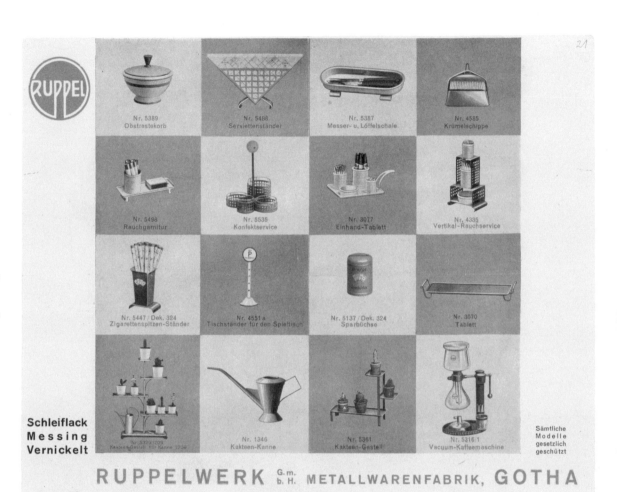

■ 179 **Marianne Brandt, folder *Ostergeschenke werden***
dann am liebsten genommen, wenn sie während des
***ganzen Jahres Freude machen*, 1950,** letterpress, 28 × 21.5 cm,
Alexander von Vegesack Collection, Domaine de Boisbuchet,
www.boisbuchet.org

■ 180 **Marianne Brandt, ashtray for Ruppelwerke, 1932–34,** metal, glass, 6.4 × Ø 9.2 cm, private collection

■ 181 **Marianne Brandt, ashtray, 1930–32**
painted brass, chrome-plated metal, 8 × 10.5 × 10.5 cm,
Vitra Design Museum Collection

■ 182 **Marianne Brandt, blotter and inkwell
for Ruppelwerke, 1930–33,** enamelled sheet metal,
6 × 15 × 7.2 cm, Vitra Design Museum Collection

■ 183 **Marianne Brandt, Hin Bredendieck, bedside lamp no. 702 for Kandem, 1928/1929,** enamelled sheet metal, 24 × 14 × 25 cm, Vitra Design Museum Collection

■ 184 **Kandem lamps list no. 80, 1935,** letterpress, 29.6 × 21 cm, Alexander von Vegesack Collection, Domaine de Boisbuchet, www.boisbuchet.org

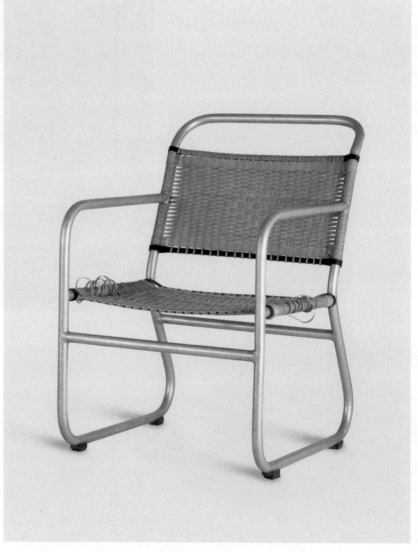

the bauhaus

■ 185 **Junkers company brochure** *NEA 38 – Aufstieg,*
Fortschritt, Qualität, **1929,** letterpress, 21 × 14.8 cm,
Freese Collection

■ 186 **Junkers Werkstatt, armchair factory draft,**
Dessau, 1930, aluminium, basketwork, 83 × 57.5 × 65.4 cm,
Vitra Design Museum Collection

■ 187 **Workers of Junkers-Werke on Junkers
aluminium chairs, 1930,** photograph, 6.6 × 10 cm,
Vitra Design Museum Collection

■188 **Wilhelm Wagenfeld, Kubus crockery, 1938/1939,** pressed glass, 22 × 27.5 × 18.5 cm, Vitra Design Museum Collection

■189 **Wilhelm Wagenfeld, tea service, 1930–34** oven-proof Jenaer glass, 13 × 50 × 40 cm, Vitra Design Museum Collection

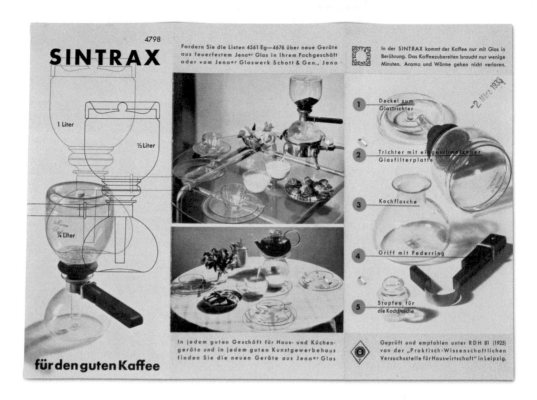

■ 190 **Wilhelm Wagenfeld, Sintrax coffee machine, 1930,** fireproof glass, wood, metal, 30 × 22 × 15.5 cm, Vitra Design Museum Collection

■ 191 **László Moholy-Nagy, brochure *Sintrax. Für den guten Kaffee* [Sintrax. For good coffee], c. 1930** letterpress, c. 21 × 29.7 cm, Vitra Design Museum Collection

■ 192 **Dokter and Misses, 2008**, Johannesburg, South Africa

203

The Bauhaus has always been regarded as a revolutionary model in art, architecture and design. Today, we still perceive the Bauhaus idea as timeless and modern, driven by constant effort to shape the future. Reducing everything to essentials and striving for innovation is precisely what our design has in common with the Bauhaus idea.

GORDEN WAGENER, HEAD OF DESIGN DAIMLER AG

■ 193 Mercedes-Benz F015 Luxury in Motion

#thinkabout
space

Essential "places" in which Bauhaus artists could envision spatial ideas and develop spatial concepts were the dance, the play, the stage and, naturally, the building site. However, this had very little to do with architecture per se; it was rather about the relationship between man and space, and therefore about the "power of Lebensraum" of every single person. Hence spatial concepts emerging in that way should be understood as life world models and social strategies of Bauhaus protagonists, for it was their intention to shape and reshape society and its structures, too.

Since "modernity" defined architecture and life form plus technology and art as a unity, the highest level of creative ambition was required which, ultimately, only a collective would be able to offer. In that sense, then, reflecting the intentions of Walter Gropius, a building would become a total work of art if it evolved from interaction between different arts and techniques. The avant-garde of modernity believed that architecture should take social responsibility, for space is created according to human will. Today, it is social design that addresses this issue.

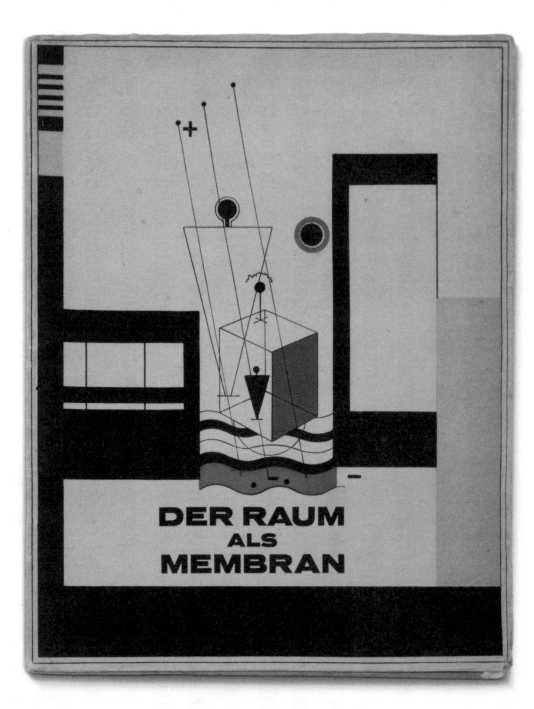

■ 194 **Siegfried Ebeling,** *Der Raum als Membran*
[The Space as membrane], 1926, letterpress, 27 × 22 cm,
Hans Wittwer Estate, Freese Collection

The Bauhaus movement endeavoured to re-imagine the world through a unity of all the arts, to bridge the gap of art and industry, in a longing, according to Oskar Schlemmer, "to find the form appropriate to our times". His statement is as poignant today as it was back then, and we felt a detailed construction drawing of Dark Matter, one of our sculptures, might illustrate that thought. Dark Matter is a sculpture that explores the dynamics of perception and reality by appearing variously as a perfect circle, a hexagon and a square depending on the position of the viewer whose presence activates the work. A suspended black entity, Troika's sculpture poses questions about the nature of knowledge and being.

The work questions a purely mechanistic world view in which all material form is reduced to simple geometric entities that fit the rational mind's natural geometry. It reflects on subjective experience and personal reality, and implies that subjective experience can be true, but all such experience is inherently too restricted to account for a total truth. One model or view alone can never form an accurate image of the whole unless it is through the lens of the particular.

TROIKA, ARTISTS

■ **195 Troika, Dark Matter, 2014**
construction drawing, courtesy Troika

Space and Man

Functionality in the Bauhaus sense of the word not only allowed emotion and intuition to flow freely, but also made way for speculative irrationality and visionary imagination. The diversity of human physical and mental expression of life was regarded as the focal point of space – both in its design and in its aesthetic acquisition.

The Bauhaus pays tribute to this ideal, not only in the essence of its products and buildings, but also in its intensive focus on space and man; in Paul Klee's drawings, Josef Albers's spatial concepts and Moholy-Nagy's composition studies, for instance, but ultimately also in Oskar Schlemmer's dances and Roman Clemens's stage designs.

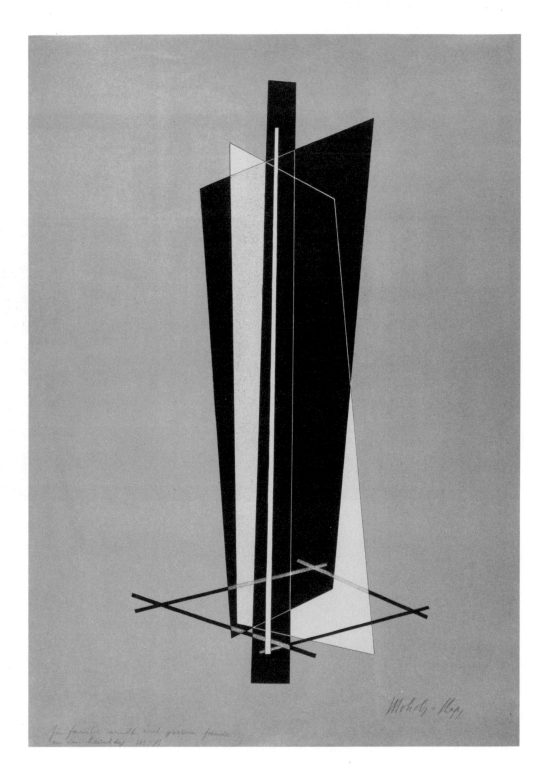

■ 196 **László Moholy-Nagy, *Konstruktion IV*, c. 1927**
sheet no. 6 from Kestner Folder, colour lithograph, 60 × 44 cm,
with dedication "On your wedding anniversary 1927",
Alfred and Gertrud Arndt Estate, Freese Collection

■ 197 **Josef Albers, Interior a, c. 1929,** sandblasted opaque glass, 24.8 × 20.6 cm, The Josef and Anni Albers Foundation

■ 198 **Josef Albers, Interior b, c. 1929,** sandblasted opaque glass, 27 × 23.2 cm, The Josef and Anni Albers Foundation

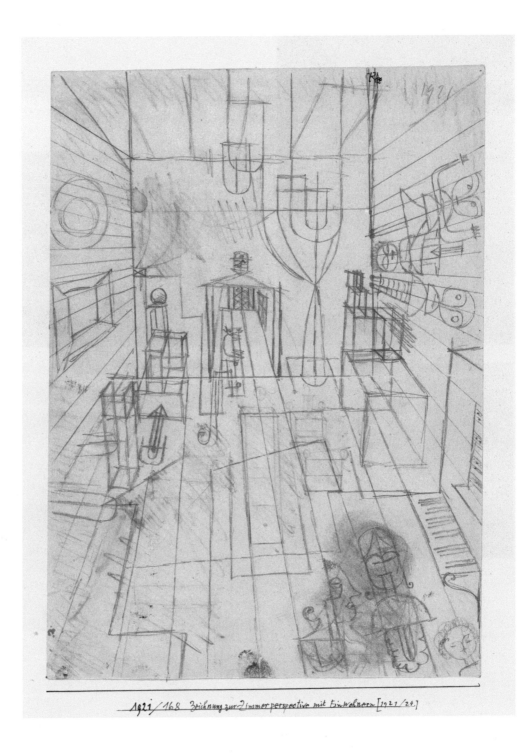

1921/168 Zeichnung zur Zimmerperspective mit Einwohnern [1921/24]

■ 199 Paul Klee, *Drawing of Room Perspective with inhabitants* [1921/1924], **1921,** 168, pencil on paper on cardboard, 33.6/33.8 × 25/24.7 cm, Zentrum Paul Klee, Bern

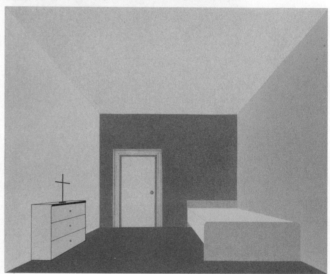

■ 200 **Roman Clemens,** *Faust – Eine Tragödie,* **Studierstube, 1928,** pencil, tempera, spray technique, 40 × 32 cm, Klassik Stiftung Weimar, Direktion Museen, Graphische Sammlungen KHz/01063

■ 201 **Roman Clemens,** *Faust – Eine Tragödie,* **Osterspaziergang, 1928,** pencil, tempera, collage, paper, 32.2 × 40.3 cm, Klassik Stiftung Weimar, Direktion Museen, Graphische Sammlungen KHz/01064

■ 202 **Roman Clemens,** *Faust – Eine Tragödie,* **Auerbachs Keller, 1928,** pencil, tempera, 40 × 32 cm, Klassik Stiftung Weimar Direktion Museen, Graphische Sammlungen KHz/01066

■ 203 **Roman Clemens,** *Faust – Eine Tragödie,* **Gretchens Kammer, 1928,** pencil, tempera, spray technique, 40.2 × 32.1 cm, Klassik Stiftung Weimar, Direktion Museen, Graphische Sammlungen Khz/01065

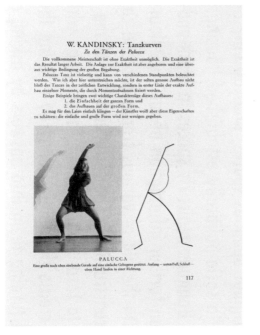

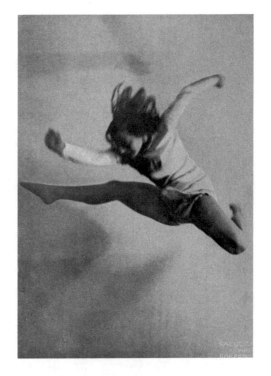

■204 **Marianne Brandt** *Palucca tanzt* [Palucca dances], **1929,** cut-and-pasted newspaper clippings with ink, photograph, 17.5 × 13 cm, Marianne Brandt Estate, Freese Collection

■205 **Wassily Kandinsky,** *Tanzkurven. Zu den Tänzen der Palucca,* **in** *Das Kunstblatt,* **no. 3/1925,** letterpress, c. 29 × 21 cm, Vitra Design Museum Collection

■206 **Hugo Erfurth,** *Palucca tanzt,* **1929,** photograph, 14.8 × 10.4 cm, Freese Collection

Space for Everyone
Wilfried Kuehn and Adrian Sauer

Time is more clearly evident in architecture for housing than for public buildings: such architecture changes as a result of being used by changing occupants; by means of appropriation and wear, the original condition of a flat becomes a fiction. Housing was at the heart of Bauhaus architecture. Despite being familiar with the Bauhaus's living spaces, we do not truly know them. The idea of preserving spaces in the style of a museum also runs counter to the Bauhaus's goal of changing the lives of as many people as possible. Although the originals still exist, the Bauhaus show houses cannot be experienced in three dimensions, as originals, in view of physical changes to their surfaces and appointments. What we can see in Weimar and Dessau, then, are spaces or partial museum-style reconstructions that have changed as a result of use. We must rely on accompanying documents to gain a comprehensive notion of the original Bauhaus spaces, and can only develop an understanding of them by seeing them in relation to socio-politically established housing practice.

Historical photographs of the Bauhaus depict its spaces in black-and-white and only rarely in colour, from text documents we can glean further information about the colours and patterns not revealed by the photographs available. With the aid of various fragments and circumstantial evidence we can draw conclusions and attempt reconstructions. The reconstruction of the defunct situations can be pieced together on a case-by-case basis to form a three-dimensional image which is, however, not a living space. It remains an image. We create this image today by relating the heterogeneous pieces of information to each other and turning them into answers by asking our questions. We accept the

distance of this spatial experiment from the original and recognize the advantage, compared with the historical document, of subjective appropriation from a perspective that we determine autonomously. We view the Bauhaus spaces as artists: instead of a historical documentation or museified presentation of fragments, we present a series of photographic pairs posing a specific question about space by means of two contrasting images. The image pairs unite to create an exhibition installation in which the Bauhaus spaces leave the demonstrative form of master houses and show flats.

The open form of the spatial experiment allows us to approach the Bauhaus living space from a different angle. Wallpaper structures, patterns, ornaments and material-heavy surfaces can be assigned to the more abstract black-and-white photographs based on selective research. This creates new images that update our idea of the Bauhaus spaces by means of a different perspective and test the possibility of experiencing the Bauhaus living spaces. Although derived from photographs, they are not photographs; nor are they photo-realistic images. They approach the flats depicted in them in a manner similar to painting: they present spaces.

■ 207 **Adrian Sauer, *Lady´s Chamber,* 2015**
digital C-print, 124×90 cm, courtesy Adrian Sauer and Klemm's Berlin

Space for Everyone

221

■ 208 Image 4 Adrian Sauer, *Volkswohnung, 2015*
digital C-Print, 100×125 cm, courtesy Adrian Sauer and Klemm's Berlin

209 **Adrian Sauer, *Gropius Director´s House*, 2015**
digital C-print, 120×169 cm, courtesy Adrian Sauer and Klemm´s Berlin

Wilfried Kuehn and Adrian Sauer

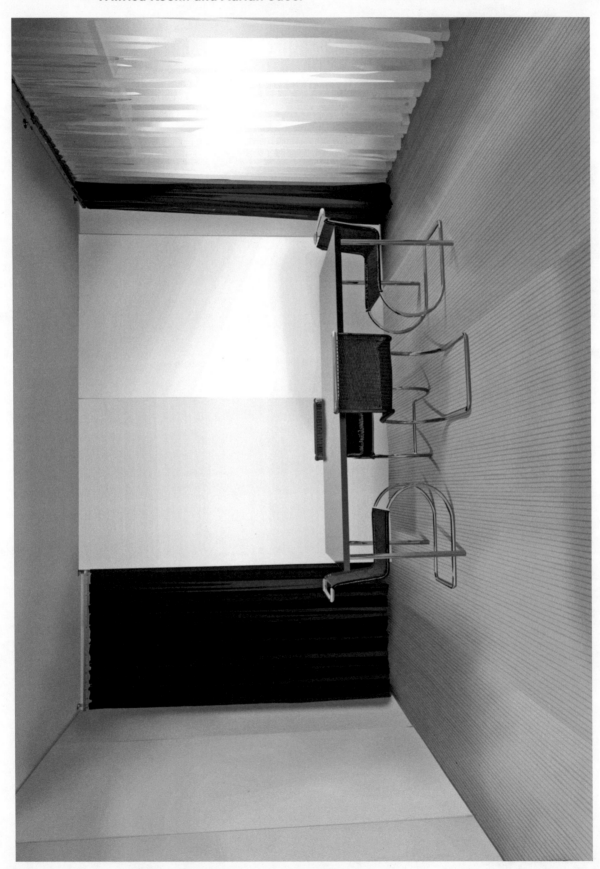

210 Adrian Sauer, *Mies van der Rohe Director´s House*, 2015
digital C-print, 150 × 209 cm, courtesy Adrian Sauer and Klemm´s Berlin

Residential buildings remained one of modernity's main challenges. Industrialization had not only altered demands on living space, but also led to an enormous housing shortage for poorer people. Healthy and economical buildings were therefore paramount – including the question of modern living space – since modern architects were convinced that built structures had an effect on the social behaviour and actions of those living inside them.

In order to provide economical yet high-quality living space, it was planned to transfer the advantages of serial production of commodities to architecture. In 1910, Walter Gropius had already developed an initial proposal to "rationalize building" in the form of a system of industrially manufactured building elements and flexibly extendable room clusters that would combine the greatest possible variability with standardization. This "Baukasten im Großen" [large-scale construction kit] was reworked by Fred Forbát and tried out for the first time in 1923 by Georg Muche as the Haus Am Horn.

While Gropius remained true to solid construction, Marcel Breuer developed a typological series of prefabricated metal houses in 1927, and Georg Muche and Richard Paulick built a steel house in Dessau-Törten in 1929. The owner of Junkers Aircraft Company, Hugo Junkers, hoped that Gropius would collaborate with him to develop a metal house concept that would combine the expertise of Junkers engineers with the Bauhaus approach. Finally, a smaller-sized building set system composed of profiled metal sheet lamellas went into serial production in 1928, albeit without Bauhaus cooperation.

#thinkaboutspace

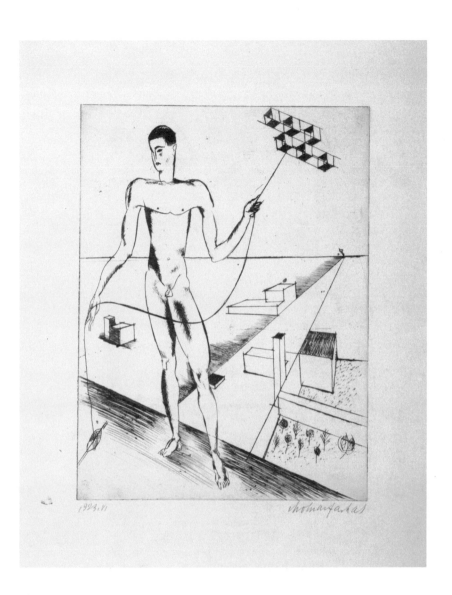

■211 **Farkas Molnár,** *Der Drachensteiger,* **1923,** etching, signed, 39.8 × 30.6 cm, Freese Collection

STILRHYTHMIK
NACH
DR. GEORG G. WIESZNER

prof. l. moholy-nagy

■212 **László Moholy-Nagy,** *Stilrhythmik,* **photomontage, in Georg Gustav Wieszner,** *Der Pulsschlag deutscher Stilgeschichte,* **part 1, 1929,** letterpress, c. 29.7 × 21 cm, Vitra Design Museum Collection

Jirí Pelcl

The Bauhaus is a "school to express the modern age", the age of machines and industry.

I was interested primarily in the Bauhaus period after 1928 under the leadership of Hannes Meyer, when the focal point of thinking definitively shifted towards rational principles of creative work, and mass production processes determined the form of products.

I was influenced by the philosophy of respecting the authenticity of the material and seeking the logic of its use in an intelligible construction. Another important aspect of design for me was the moral aspect represented by a standardized product accessible to the broader masses.

I regard as the greatest innovation the promotion of new thinking that reflected the nascent modern society. New ideas in architecture and design are rarely disseminated or promoted in the textual form of manifestos. The Bauhaus demonstrated them in tangible objects and products that people could directly observe in a physical way. It was a pioneer in the new concept of education; its ideas reflected the intellectual spark of the European avant-garde.

Czechoslovakia (in the interwar period) was one of the first countries in which Bauhaus ideas were directly applied in production, especially in the furniture manufacture of the Spojené umeleckoprumyslové závody [United Applied Art Company, UP], founded in Brno in 1922 by the architect Jan Vanek. It was one of the first manufacturers in Europe to introduce modular furniture systems with individual components that could be variously combined. A prominent figure who determined the concept of the design was the architect Jindrich Halabala.

I see the legacy of the Bauhaus in how the visual form of buildings and objects is derived, not from artificially created visual, aesthetic trends, but from the level of advancement of society's manufacturing and technological capabilities. That situation determines the spiritual dimension of the shaping of both physical and virtual matter.

JIRÍ PELCL, DESIGNER

Lord Foster, what comes to mind when you hear the word "Bauhaus"?
One of the birthplaces of the modern world — a utopian vision.

In which way would you say the ideas of the Bauhaus have had an influence on you?
Perhaps there are beliefs passed on to me through generations of teachers or maybe a conscious personal selection of some inspirations which happen to coincide with those of the Bauhaus. For example, I have a passionate interest in the links between architecture, design and art which was at the core of Bauhaus teaching. There is also my driving curiosity about how things are made.

In another sense, our practice is like a school in the way that I have designed Foster + Partners as a creative entity. Within our studios, engineers work alongside architects, researchers, industrial and urban planners, and specialists in many more disciplines. We also encourage collaborations with artists. Like a school, this model has also spawned a new generation of architects — many of whom have since gone on to develop their own work.

Walter Gropius wrote the Bauhaus Manifesto in 1919 and Paul Rudolph studied under him at Harvard. I was taught by Rudolph at Yale, so there is a direct lineage.

However, Rudolph had a far greater conviction in the autonomy of the individual architect than Gropius — he disagreed that architecture is a cooperative art. I have a greater affinity with Gropius here, as I believe architecture must be a team activity albeit with the strong leadership of an individual. A building is always a focus of energies, from the extremes of a small core team to a veritable army of constructors spread out across continents.

What do you consider the most important innovations, merits, ideas of the Bauhaus? The Bauhaus school operated during turbulent times, but their philosophy was essentially idealistic — a belief in the power of architecture and industry to change society for the better. Some of our early buildings, such as Willis Faber and the Sainsbury Centre, were born out of tough economic and social circumstances. But you could describe them as similarly utopian, in the sense that they did not express any of the negatives of their age — instead they offered a vision for a brighter future.

How are they being transmitted?

Our renovation of a 1934 house in London is an example of how domestic architecture from that era has stood the test of time. In the early 1990s, we were commissioned to restore and extend a house by Eric Mendelsohn and Serge Chermayeff, which was originally designed for the playwright Dennis Cohen. Together with the neighbouring house by Maxwell Fry and Walter Gropius, it forms an enclave of idealistic, émigré modernism in the heart of Queen Anne-era Chelsea. Along with repairs to the fabric, our main task was to replace a faux-Victorian conservatory, added in 1963, with a contemporary glass enclosure that responded more directly to the spirit of the original architecture. The house once again epitomizes civilized urban living without compromising its original progressive architectural ideals, demonstrating the relevance of the formal and functional ideals of the Bauhaus today.

Are there any ideas of the Bauhaus that are still relevant today?

Gropius envisioned a time when buildings would be mass-produced in factories, and their component parts assembled like toy bricks – he designed cars, trains and, with Konrad Wachsmann, experimented with modular systems for housing.

As technology and materials have advanced, this thinking is even more relevant. We frequently utilize prefabricated components and we have worked at the scale of prefabricating entire buildings, with the development of a new, innovative system for the large-scale production of individual homes. The potential for the 3D printing of a building is arguably an extension of the Bauhaus philosophy. I am particularly interested in how these methods could be used to improve the quality of life in some of the world's poorest communities.

LORD FOSTER, ARCHITECT

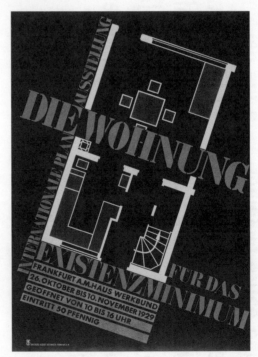

■ 213 **Humboldt-Film GmbH, Berlin-Wilmersdorf, recording manager: Ernest Jahn, filmstill from:** *Wie wohnen wir gesund und wirtschaftlich?* [How do we live healthily and economically?], **1926–28** Bauhaus-Archiv Berlin, total duration c. 55 min.

■ 214 **Carl Burchard,** *Gutes und Böses in der Wohnung in Bild und Gegenbild. Grundlagen für neues Wohnen,* **1933,** letterpress, 19 × 25.5 cm, Vitra Design Museum Collection

■ 215 **Hans Leistikow, poster** *Die Wohnung für das Existenzminimum,* **1929,** offset printing, 117 × 84 cm, Staatliche Museen zu Berlin, Kunstbibliothek

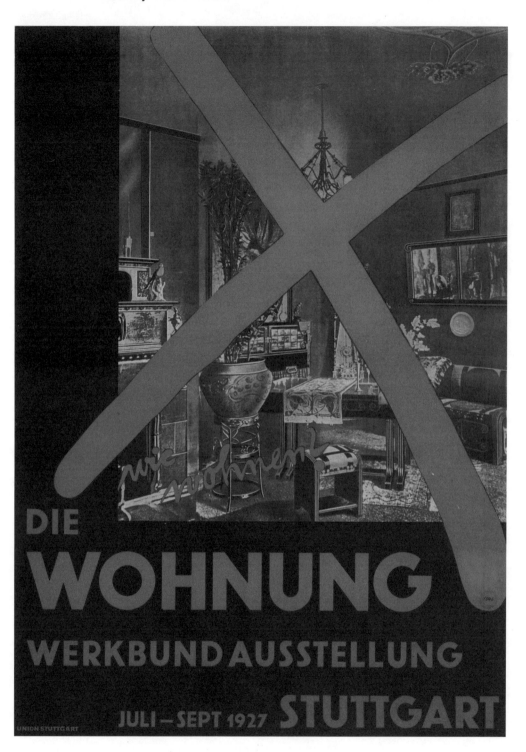

■216 Willi Baumeister, Werner Graeff, Ludwig Mies van der Rohe,
poster *Die Wohnung, Werkbund exhibition Stuttgart,* **1927,** lithograph,
115 × 81 cm, Staatliche Museen zu Berlin, Kunstbibliothek

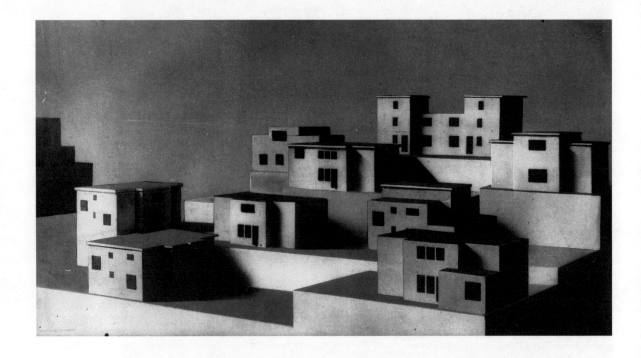

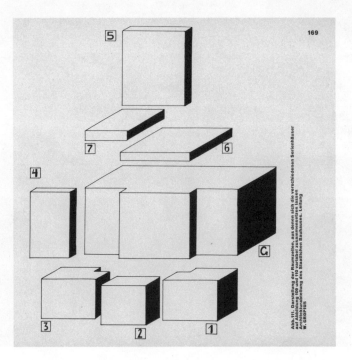

■217 **Walter Gropius, Fred Forbát, Bauhaus Housing Development Am Horn, Weimar, 1920–22:** models, photograph, 53.5 × 99 cm, Harvard Art Museums/Busch-Reisinger Museum, Gift of Walter Gropius, BRGA.12.4

■218 **Walter Gropius, Fred Forbát, honeycomb system: schematic representation of modules, 1922** in *Staatliches Bauhaus Weimar 1919–1923*, 1923, p. 169, Vitra Design Museum Collection

Industrialized Building

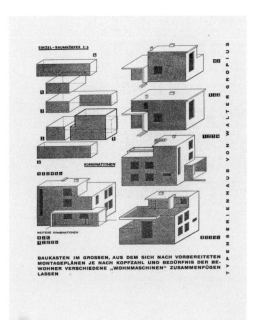

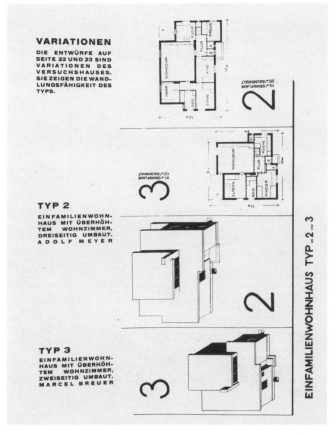

■ 219 Walter Gropius, *Baukasten* [modular prefabricated building system], **1923,** in Aldolf Meyer, *Ein Versuchshaus des Bauhauses in Weimar. Haus am Horn* [An experimental house by the Bauhaus in Weimar: Haus am Horn], Bauhausbücher, vol. 3, Albert Langen Verlag, Munich 1925, p. 8, letterpress, 23 × 18,3 cm, Bauhaus-Archiv Berlin

■ 220 Marcel Breuer, Adolf Meyer, Farkas Molnár, **variations on the basic form of Haus Am Horn exhibition house, 1922,** in *Walter Gropius. Der Architekt und Theoretiker,* 1985, p. 99, Vitra Design Museum Collection

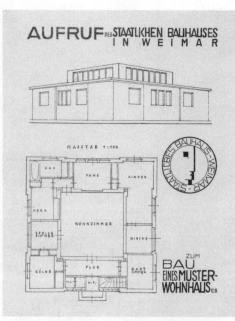

DAS STAATLICHE BAUHAUS IN WEIMAR WIRD IN EINER ERSTEN AUSSTELLUNG IM SOMMER 1923 DAS ERGEBNIS SEINER BISHERIGEN TÄTIGKEIT DER ÖFFENTLICHKEIT ZEIGEN.

DIE AUFGABE DES STAATLICHEN BAUHAUSES IN WEIMAR WAR VOM ERSTEN TAGE SEINES BESTEHENS AN DIE AUSBILDUNG BILDNERISCH BEGABTER MENSCHEN ZU SCHÖPFERISCH GESTALTENDEN HANDWERKERN, BILDHAUERN, MALERN, ARCHITEKTEN. DIE ZUSAMMENFASSUNG ALLER DIESER **IM HANDWERK, IN DER TECHNIK UND IN DER FORM** DURCHGEBILDETEN MENSCHEN ZUR GEMEINSAMEN ARBEIT **AM BAU** ALS EINHEITLICHER GRUNDLAGE WAR DAS ZIEL.

DAS STAATLICHE BAUHAUS SUCHT BEWUSST DIE VEREINIGUNG JENER FÜR DIE VOLKSWIRTSCHAFT GLEICHBEDEUTENDER DREI GRUPPEN: DER KÜNSTLER, DER TECHNIKER UND DER KAUFLEUTE. DIESE ERSTREBTE VEREINIGUNG KÜNSTLERISCHER, TECHNISCHER UND WIRTSCHAFTLICHER ARBEIT ABER KOMMT IM **BAU** AM HERVORRAGENDSTEN ZUM AUSDRUCK. DENN HIER IST DAS PROBLEM EIN DREIFACHES. KEINS SEINER TEILE IST ENTBEHRLICH: HIER MUSS IN VERSTÄNDNISVOLLER ARBEITSVERBINDUNG GLEICHZEITIG DER KÜNSTLER NACH DER BESTEN FORM, DER INGENIEUR NACH DER BESTEN TECHNIK, DER KAUFMANN NACH DER BESTEN ÖKONOMIE DES GANZEN SUCHEN.

DAHER WIRD DAS STAATLICHE BAUHAUS IN DER KOMMENDEN AUSSTELLUNG NEBEN DEN EINZELERZEUGNISSEN SEINER WERKSTÄTTEN [STEIN U. HOLZBILDHAUEREI, GOLD-SILBER-KUPFERSCHMIEDE, WANDGLASMALEREI, KUNSTDRUCKEREI, WEBEREI, TÖPFEREI, TISCHLEREI] EINER INTERNATIONALEN GEMÄLDESCHAU U.S.W. DEN HAUPTWERT AUF EIN ZU ERRICHTENDES MUSTER-WOHNHAUS LEGEN IN DEM ZUM ERSTEN MAL - UNABHÄNGIG VON DER TENDENZ DER ZEITNOT DIE ERFINDUNGEN UND NEUERUNGEN DER INDUSTRIE UND WIRTSCHAFT MIT DER FORMALEN SCHÖPFERARBEIT DES KÜNSTLERS IN EINHEITLICHER WEISE ZUSAMMENGEFASST SIND.

ES IST VON WEITTRAGENDSTER BEDEUTUNG, DASS DER PLAN DES

BAUHAUSES ZUR AUSFÜHRUNG GELANGT. DER REICHSKUNSTWART HERR DR. REDSLOB SCHREIBT HIERÜBER: VON DER DIREKTION DES STAATLICHEN BAUHAUSES AUFGEFORDERT, EINE ÄUSSERUNG ÜBER EINEN MIR VORGELEGTEN HAUSENTWURF FÜR DIE IN WEIMAR 1923 GEPLANTE AUSSTELLUNG ABZUGEBEN, BESTÄTIGE ICH, DASS ICH UNTER DEN GEGENWÄRTIGEN VERHÄLTNISSEN KAUM EINEN AUSSTELLUNGSPLAN FÜR LOHNENDER ZUR VERWIRKLICHUNG HALTEN WÜRDE ALS DIESEN. IM ALLGEMEINEN BIN ICH SKEPTISCH GEGENÜBER HAUSBAUTEN FÜR AUSSTELLUNGEN, ABER HIER HANDELT ES SICH UM DIE AUFSTELLUNG EINES NEUEN BAUTYPS, DER OHNE ZWEIFEL FÜR DIE KOMMENDE ZEIT VON MASSGEBENDER BEDEUTUNG WERDEN WIRD UND DESSEN VERWIRKLICHUNG DAHER WEITGEHENDE KULTURELLE UND WIRTSCHAFTLICHE FOLGEN HABEN DÜRFTE. DIE NOTWENDIGKEIT EINER SPARSAMEN BAUWEISE UND DIE ÄNDERUNGEN UNSERER LEBENSFORMEN SCHEINEN EINE BAUEINTEILUNG VORZUBEREITEN, DIE DAS EINFAMILIENHAUS NICHT MEHR ZU EINER REDUZIERTEN IMITATION DER VILLA MIT GLEICHMÄSSIG VERKLEINERTEN ZIMMERN MACHT. ES SCHEINT, ALS OB SICH EINE BAUWEISE HERAUSBILDETE, DIE MEHRERE KLEINERE RÄUME ORGANISCH UM EINEN GROSSEN FÜGT UND DIE DAHER IN DER FORMGEBUNG UND IN DER WOHNKULTUR EINE VÖLLIGE VERÄNDERUNG BRINGT. VON ALLEN MIR HIERZU BEKANNT GEWORDENEN ENTWÜRFEN ERSCHIEN MIR KEINER SO GEEIGNET, DAS PROBLEM ZU VERANSCHAULICHEN UND ZU MEISTERN WIE DER MIR VOM BAUHAUS VORGELEGTE. ICH MÖCHTE MICH DAHER MIT ALLEM NACHDRUCK FÜR DIE VERWIRKLICHUNG EINSETZEN. SELBST WENN DER BAU IN EINZELHEITEN DER FORMALEN LÖSUNG UMSTRITTEN WERDEN SOLLTE, WIRD ER DOCH ALLEN VERANTWORTUNGSVOLL UND VOR ALLEM AUCH WIRTSCHAFTLICH DENKENDEN MENSCHEN EINE GANZ ENTSCHEIDENDE ANREGUNG GEBEN UND DADURCH FÜR WEIMAR WERBENDE KRAFT HABEN. DENN DER BAU DOKUMENTIERT, DASS DIE NOTLAGE, IN DIE WIR GERATEN SIND UNS AUCH DAZU BRINGT ZUERST VON ALLEN VÖLKERN DIE LÖSUNG NEUER BAUPROBLEME ZU BETREIBEN UND SOMIT WEGBEREITER ZU WERDEN.

GEZ. DR. REDSLOB

DER PLAN IST FERTIG, DER PLATZ AUF DEM SIEDLUNGSGELÄNDE DES BAUHAUSES IST DA. DER STAAT ABER, DER ALS ERSTER BERUFEN WÄRE, SICH DER LÖSUNG DIESES FÜR DIE GESAMTE BAUWELT SO ÜBERAUS WICHTIGEN, JA GRUNDLEGENDEN PROBLEMS ANZUNEHMEN, KANN DIE NOTWENDIGEN MITTEL NICHT ZUR VERFÜGUNG STELLEN.

DAHER WENDET SICH DAS STAATLICHE BAUHAUS AN ALLE DIEJENIGEN, WELCHE DIE WICHTIGKEIT DIESES PROBLEMS ERKENNEN UND FORDERT SIE ZUR TATKRÄFTIGEN MITARBEIT AUF. BEDEUTENDE INDUSTRIEN HABEN UNS BEREITS IN GROSSZÜGIGER WEISE DIE ERZEUGNISSE IHRER WERKE, WELCHE SICH DEM PLAN DES GANZEN EINFÜGEN FÜR DIE DAUER DER AUSSTELLUNG ÜBERLASSEN, IN DER RICHTIGEN EINSICHT, DASS SICH HIER DIE BESTE MÖGLICHKEIT BIETET, IN DEM RAHMEN EINES RICHTUNGGEBENDEN BAUES MODERNE ERZEUGNISSE DER ÖFFENTLICHKEIT ZU ZEIGEN. ES FEHLT ABER NOCH AN BARMITTELN, UM DEN BAU ZUR AUSFÜHRUNG ZU BRINGEN.

UM NUN DENEN, DIE DURCH GELDSPENDEN DIE HERSTELLUNG ERMÖGLICHEN, IHRE AUSGABEN ZURÜCK ERSTATTEN ZU KÖNNEN, WIRD DAS HAUS, DAS MASSIV UND DAUERHAFT AUSGEFÜHRT UND ALS WOHNUNG EINGERICHTET WIRD, NACH VERLAUF DER AUSSTELLUNG IN EINER VERSTEIGERUNG VERKAUFT WERDEN.

DIE BEITRÄGE ERBITTEN WIR AUF DAS BAUKONTO DES STAATLICHEN BAUHAUSES, DEUTSCHE BANK IN WEIMAR, ZU ÜBERWEISEN.

DAS STAATLICHE BAUHAUS, WEIMAR

■221 Georg Muche, *Aufruf des Staatlichen Bauhauses in Weimar zum Bau eines Musterwohnhauses, 4-page brochure, 1923*, print, 29.2 × 22.8 cm, Wilhelm Flitner Estate, Freese Collection

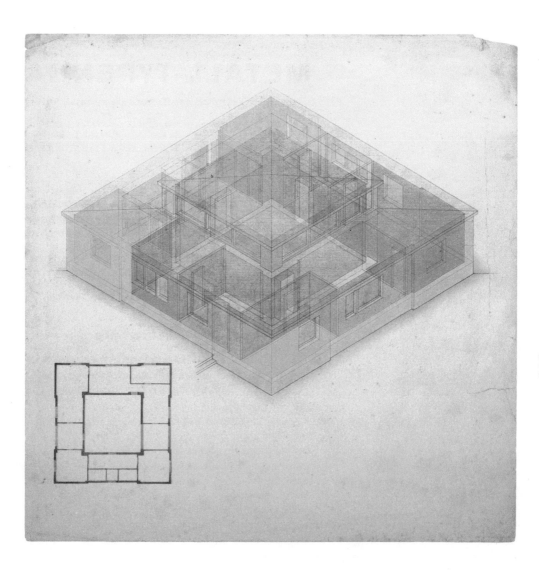

#thinkaboutspace

■222 **Benita Koch-Otte,** *Haus Am Horn, Isometrie,*
1923, colour lithograph, 25.5 × 25.5 cm, Freese Collection

METALL-TYPENHAUS

errichtet zur Eröffnung des Bauhauses in Dessau November 1926

Architekten: MUCHE und PAULICK Dessau
Burgkühnauer Allee 4
Hersteller: CARL KÄSTNER A.G. Leipzig

D. R.-Patente a. und D. R. G. M.

Wohnhäuser nach variablen und anbaufähigen Grundrissen jeder Größe und Raumanordnung

Siedlungshäuser — anbaufähige Klein- und Kleinstwohnungen

Weekend-Häuser mit und ohne Garage

Weekend-Hotels

Schnellbauwohnungen (in vollwertiger Ausführung) für Arbeiter an den Arbeitsplätzen

werden in 10–20tägiger Bauzeit in trockenem, sofort beziehbarem Zustand hergestellt.

Das Metalltypenhaus, Konstruktion 1927 (mit atmenden, in jeder beliebigen Stärke isolierten Außenwänden und Decken), kann mit denselben Normteilen jederzeit und ohne irgendwelche Zerstörung von Bauteilen in wenigen Stunden beziehungsweise Tagen in der Raumanordnung des Grundrisses verändert oder erweitert werden.

■ 223 Unknown, metal standardized house, 1926,
letterpress, 29.8 × 21 cm, Eckhard Neumann Estate,
Freese Collection

DAS „KLEINMETALL-HAUS TYP 1926"

Aufgabe: Gestaltung eines kleinen Hauses, einer Wohnung für zwei bis drei Menschen, den heute aktuellen Familientyp.

Konstruktion: Im allgemeinen hat eine Wand zu tragen (sich selbst, das Dach, die Menschen, die Einrichtung) und zu isolieren (gegen Wärme, Kälte, Feuchtigkeit und Unsicherheit). Die übliche Steinmauer trägt und isoliert gleichzeitig. Bei dem „Kleinmetallhaus Typ 1926" ist ein anderer Weg eingeschlagen: tragen und isolieren; diesen zwei verschiedenen Funktionen entsprechend sind zwei verschiedene Konstruktionselemente angewendet:

1. ein selbständiges Eisengerüst,
2. die an diesem Eisengerüst montierten isolierenden Teile, also sämtliche Außen- und Innenwände, Türen und Fenster.

Durch dieses Konstruktionsprinzip sind folgende Resultate zu erreichen:

1. Ein Ausdruck größter Leichtigkeit. Weder Säulen, Pfeiler, noch dicke Mauern. Die tragenden Konstruktionsteile sind Linien — je näher sie im Ausdruck zu ihrem statischen Sinnbild, der absoluten Linie, kommen, desto besser. Die isolierenden Leicht-

MARCEL BREUER
Montage-Kleinhaus aus
Stahl (1926)

371

platten sind keine Mauerkörper mehr — je näher sie im Ausdruck zu ihrem praktischen Sinnbild, der absoluten Fläche, kommen, desto besser. Die Monumentalität der Massen, dieses bis heute noch geltende Architektenprinzip, wird durch ein mutiges Spiel der gespanntesten Kräfte, durch die Monumentalität des Geistes überholt. Statt der Pyramide: der Eiffelturm.

2. Das Montagehaus ist in zwei bis drei Wochen zu errichten. Die zur Montage vollkommen vorgerichteten Einzelteile des Baues muß man an Ort und Stelle bloß zusammensetzen, da der größte Teil des Arbeitsvorganges sich in der Fabrik abspielt. Eine Vereinfachung, Verbilligung und Beschleunigung der Baumethode.

Bei der Aufgabenstellung sind folgende FORDERUNGEN an einen Kleinhaustyp gestellt worden:

a) Billigkeit, trotzdem aber: großer Wohnraum, zwei Schlafräume, Küche, Bad, Dachgarten.

b) Großer Wohnraum, in dem man sich keineswegs beengt fühlen soll; kurz: es sollen sechs Paare bequem darin tanzen können.

Das „Kleinmetallhaus Typ 1926" enthält folgende LÖSUNGEN der nebenstehenden Forderungen:

54 Quadratmeter Baufläche, 233 Kubikmeter umbauter Raum. Für zirka 9000 Mark zu bauen.

In der einen Richtung neun, in der anderen sechs Meter Ausdehnung. Die zu den Schlafräumen und dem Dachgarten führende Metalltreppe und das Geländer sind leicht, durchbrochen, sie verkleinern den Raum nicht. An zwei Seiten große Fenster, im Treppenhaus nach dem Dachgarten zu auch. Von vier verschiedenen Richtungen kommt Licht in die-

372

MARCEL BREUER
Montage-Kleinhaus aus
Stahl (1926)

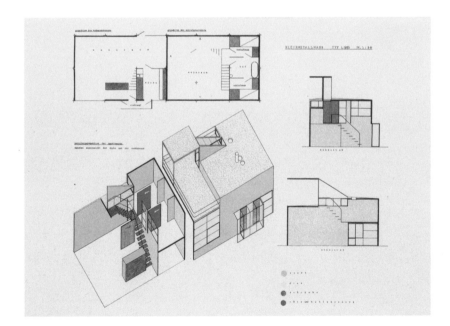

■224 Marcel Breuer, *Kleinmetallhaus Typ 1926* [small prefabricated steel house], in *Offset Buch- und Werbekunst*, issue 7, special issue on Bauhaus, 1926 offset print on cardboard, 30.9 × 23.5 cm, Vitra Design Museum Collection

■225 Marcel Breuer, small prefabricated steel house, ground plan, sectional view, isometric drawing, in *Offset Buch- und Werbekunst*, issue 7, special issue on Bauhaus, **1926**, offset print on cardboard, 30.9 × 23.5 cm, Vitra Design Museum Collection

Living Space for Everyone

In 1928, Hannes Meyer took over the management of the Bauhaus from founding director Walter Gropius. While architectural and artistic ideas had played a significant role for Gropius, Meyer geared teaching and workshops more towards his own left-wing political beliefs, placing greater emphasis on collective work. Meyer believed in the idea of a collective design process, calling this principle "co-op". Hence he concentrated on creating a tiny flat for poorer people, i.e. a dwelling for people living on or below the breadline, making the Volkswohnung into a subject of research.

Today, both the search for maximum economy in terms of form, material and construction as well as the principle of collaborative design have been rediscovered in sharing communities, open design and co-operatives. In that context, many designers of the DIY movement such as Van Bo Le-Mentzel with his Hartz-IV furniture refer to Italian designer Enzo Mari and his principle of *autoprogettazione*. As designers, they wish to avoid providing users with ready-made furniture, but rather deliver instructions for DIY construction of their own simple furniture – with the aim of helping users to understand the idea behind furniture design and thus enabling them to create their own furniture.

Cooperative

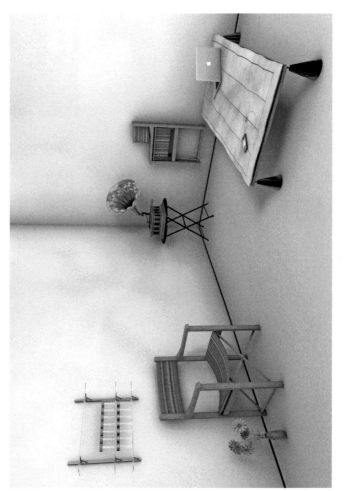

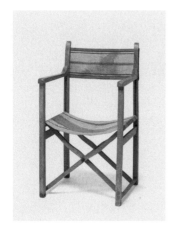

■226 **Hannes Meyer, Co-op.Interieur, Basel, 1926**
gta Archive/ETH Zurich (Hannes Meyer Estate)

■227 **Unknown (design), folding chair Co-op.Interieur,**
c. 1925, beech wood, cotton, 92 × 49 × 52 cm, Museum für
Gestaltung Zurich, design collection, Zürcher Hochschule der
Künste, donation of Ruggero Tropeano

■229 **Enzo Mari,** *Proposta per un'autoprogettazione chair,* **1973,** wood, 85.5 × 50 × 53 cm, Vitra Design Museum Collection

■230 **Enzo Mari,** *autoprogettazione?,* **1974,** letterpress, 16.4 × 24.6 cm, Vitra Design Museum Collection

■231 **Van Bo Le-Mentzel, 24 Euro Chair, in Van Bo Le-Mentzel,** *Hartz IV Moebel.Com, Build More Buy Less! Design instead of consume,* 2013, pp. 28f.

■232 **Van Bo Le-Mentzel, Hartz-IV furniture series collection: 24-Euro Chair,** wood, cushions, 2014 60 × 60 × 66 cm, Vitra Design Museum Collection

■ 233 Jesse Howard, Thomas Lommée, OpenStructures
kettle, exploded view, 2013
Photograph: Kristof Vrancken

I associate the Bauhaus academy with several protagonists who played significant roles in shaping the development of art, architecture and design in the first half of the twentieth century — Mies, Gropius, Kandinsky, Breuer, Moholy-Nagy. Many of them later led important academic programmes in the US, further spreading the impact of the doctrines cultivated at the Bauhaus.

Mies van der Rohe was appointed to lead IIT Chicago's College of Architecture in the late thirties and his legacy was palpable during my studies at the university from 1997 to 2000. There was absolutely no way of discussing modern architecture without touching upon his influence.

The curriculum developed by Mies at IIT's College of Architecture was influenced by his "Less is More" ethos as well as his directorship at the Bauhaus in the early thirties (following the closure of the Bauhaus in 1933, Moholy-Nagy also moved to the US and founded the New Bauhaus on IIT's Chicago campus in 1937). During the first three years of undergraduate study, the curriculum geared students towards developing a sound grasp of materials in relation to design and building technologies, before progression into advanced design studios for a further two years. This interplay between materiality and technology remains an important facet in the development of my designs.

After moving to London to study at the Architectural Association and later to Columbia University in New York, I observed that the investigative approach prevalent at these academic environments shared resonances with what I had learned about the Bauhaus. It was my observation that a number of elements at the core of these academic test beds, such as the significant role played by technology and the encouragement of interdisciplinarity, were traceable to the experimental spirit championed at the Bauhaus.

During my first postgraduate design studio at Columbia, I had the opportunity to propose an extension to Mies van der Rohe's iconic Farnsworth House. By retaining little more than the structural elements of Mies's Farnsworth House I envisioned a programmatic transformation from a dwelling into a pavilion. The proposal aimed to break away from the inherited distinctions between structure and surface by bringing both aspects to a level of equivalence.

IFEANYI OGANWU, ARCHITECT AND DESIGNER

■ 234 **Ifeanyi Oganwu,** *Autonomous Rex,* **2006,** 3D visualization, 2006, courtesy Ifeanyi Oganwu

Material and Colour

Unlike the widely held, stereotypical opinion, modernity was not "white". One of its major achievements was an in-depth focus on colour, not as a decorative element, but as a means of spatial design, thus also as a "tool" for influencing physical and mental wellbeing. Colour was seen to be an essential part of a building's overall concept. Colours in interiors and on external walls were used to emphasize architecture, transcending it at the same time by creating new colour spaces.

Although the Bauhaus did not develop its own colour theory, master artists would nevertheless develop their own based on existing concepts such as Goethe's theory of colours or Wilhelm Ostwald's mathematical colour system. These colours were not only discussed in theoretical instruction and applied in free painting classes, but also tried out in practice in interior and textile design, or realized as economically successful wallpaper for Rasch.

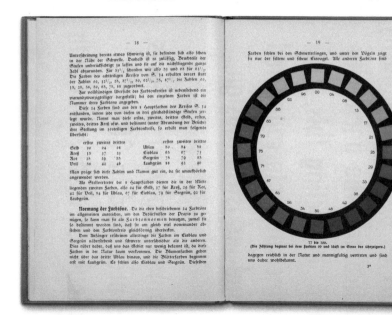

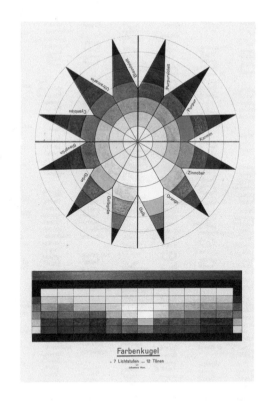

■235 **Wilhelm Ostwald, 24-part chromatic circle, hand-painted in watercolours, in Wilhelm Ostwald, *Die Farbenfibel*, Leipzig, 1921,** 6th revised edition, p. 19 (1st edition 1916), 22.5 × 16.6 cm, Freese Collection

■236 **Johannes Itten, color sphere in 7 light values and 12 tones, in Bruno Adler, *Utopia*, Dokumente der Wirklichkeit, Weimar, 1921,** lithograph, 47.4 × 32.2 cm, Vitra Design Museum Collection

The black-and-white photograph of the Dessau building is so striking – that is what immediately comes to mind when I hear the word Bauhaus. Bauhaus design was created through an artistic sensibility and it is impossible not to think of Wassily Kandinsky, Paul Klee, Joseph Albers and Johannes Itten and their influence on design.

The philosophy of Bauhaus teaching, with its focus on multi-disciplinarity, is at the heart of the British art school system, particularly the university foundation year, which we have both benefited from. Reflecting this, our studio consists of a triple structure housing distinct but interconnected disciplines: furniture and product design, research and industrial design, and architecture and spatial design.

This painting of the blue wheel connects early foundation year projects, the theories of Itten and Albers and our Iris tables produced in 2008; the myriad hues of anodized aluminium reference Bauhaus theory, but with a deliberate disregard for the formality.

Much of our work is rooted in the rationalism, pragmatism and experimentation of the Bauhaus, also in the notion of learning by making, and Walter Gropius's emphasis on skill and craftsmanship.

JAY OSGERBY AND EDWARD BARBER, DESIGNERS

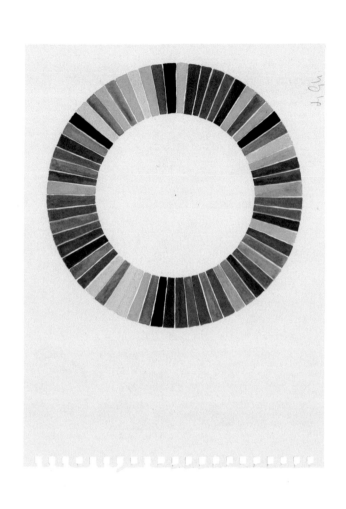

■ 237 **Jay Osgerby, Edward Barber, untitled, 2015,** drawing, 21 × 29.7 cm, courtesy Jay Osgerby and Edward Barber

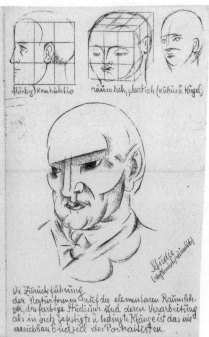

■ 238 **Johannes Itten, drafts on colour theory, 1931**
various techniques on paper, 42 × 59.4 cm, Vitra Design
Museum Collection

■ 239 **Johannes Itten, drafts on colour theory, 1931**
various techniques on paper, 40 × 52.5 cm, Vitra Design
Museum Collection

■ 240 **Johannes Itten, drafts on colour theory, 1931**
various techniques on paper, 32 × 38.5 cm, Vitra Design
Museum Collection

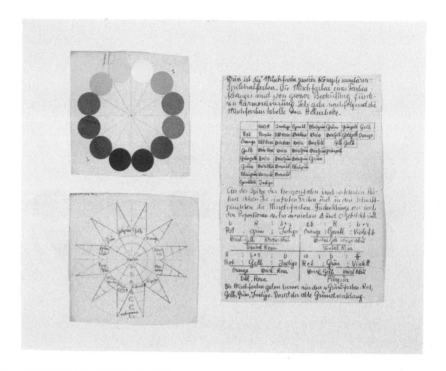

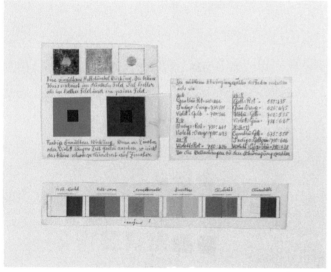

■241 **Johannes Itten, drafts on colour theory, 1931**
various techniques on paper, 40 × 50 cm, Vitra Design
Museum Collection

■242 **Johannes Itten, drafts on colour theory, 1931**
various techniques on paper, 40 × 50 cm, Vitra Design
Museum Collection

#thinkaboutspace

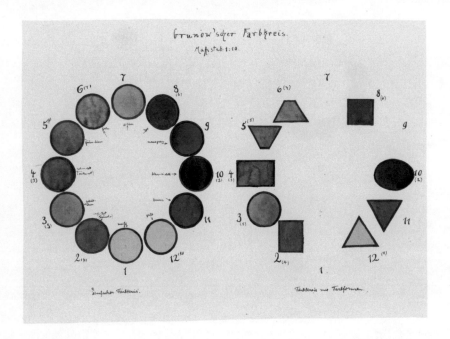

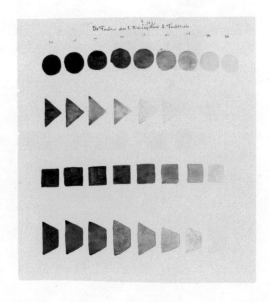

■243 **Ilse Bettenheim-Hornecke, from Gertrud Grunow's teaching: Grunow's chromatic circle, 1924,** black ink, watercolour, pencil on paper, 29.5 × 41.1 cm, Klassik Stiftung Weimar, Direktion Museen, Graphische Sammlungen Gr-2010/618

■244 **Ilse Beckenheim-Hornecke, from Gertrud Grunow's teaching: Grunow's chromatic circle, 1924** watercolour, pencil on paper, 32.5 × 34.7, Klassik Stiftung Weimar, Direktion Museen, Graphische Sammlungen Gr-2010/620

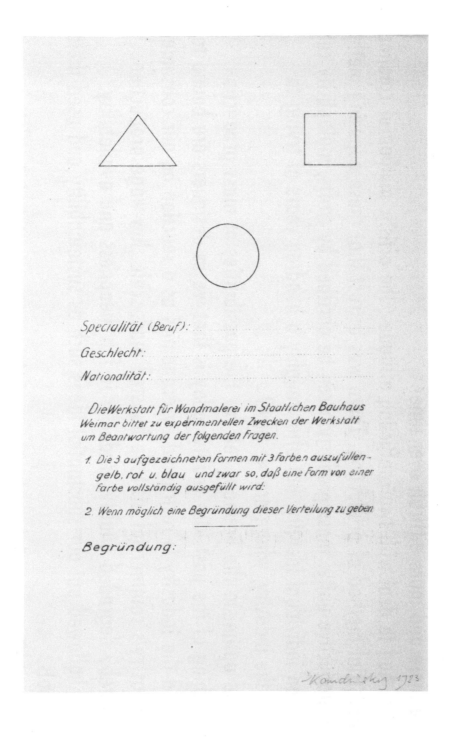

■245 Questionnaire campaign by Wassily Kandinsky, mural painting workshop to explore the connection between primer, paint and form, 1923, paper, 24.1×15.1 cm, Freese Collection

The Bauhaus design ideals are very similar to mine. Although my approach on how to reach these ideals is different, I share the ambition to make high-quality products available for a large audience. But could the people at the Bauhaus ever have imagined this mission would become more and more difficult over time?

The Bauhaus had to deal with two conflicting attitudes: the artistic method of creation versus the industrial method of production. There was a trust that these opposing methods could form a productive unity: mass production can be enriched by crafts, multiplicity can be united with an individual identity. But after roughly a hundred years of trying to harmonize with the industry, where are we now?

The trust and optimism the Bauhaus felt for the possibilities of mass production is clearly something of the past. Our reality today is that we as designers are bound to the industry. And the industry is restrained by economics as a reaction on our consumerist society. The industry's commercial attitude boosted mass-scale, low-wage production methods. It thereby degraded quality, traded it in for cheapness and availability. Commerce even hollowed out our substantial ideas such as sustainability and used them as marketing tools.

I do, however, believe in serial production, and the great potential of the industry. But we lost the connection between the three values where the Bauhaus started from: cultural awareness, social responsibility and practical economics.

It is no longer a holistic industry, and we as designers have a responsibility here. I believe we have to think about what to make, and how to make it. I focus on the actual relationship between user and object as a reaction to this overconsumption. Maybe we need to give a product some more values than just its newness or cheapness.

Solving these problems requires a careful and holistic approach. In contrast to most of the mass-produced goods of our time, why does a piece of art never age, why does it never get boring? Good art will trigger the imagination over and over again. Good art keeps openness for the imagination of the viewer. Good art continues to evoke sensations that embrace the spectator as a whole human being. Because good art is holistic, it always contains many values. Now, this is a feature that design seems to have lost.

I rely on a few basic principles that I deploy in my design process. These are heavily influenced by the Bauhaus, but there are also differences, which reflect the vast changes our society has been through since the early modernism of the twentieth century. I will explain how some of my topics relate to the Bauhaus, covering my hands-on approach, my material-focused design attitude and my self-initiated research projects.

Intelligent hands

I never stop drawing, sketching, making models. No matter how complex the product is or how far we are in the design process: intelligent hands know more than the head. The mind works

in a circular way, and tends to revolve around what we already know. New ideas appear when I cannot fully control the process, while experimenting with materials, colours and techniques. It's an attitude that was taught in the Bauhaus, where they offered basic "Former" courses and provided hands-on material workshops, which all served the centre of the Bauhaus education: the Bauplatz. Having architecture as a focus, the ideal was that all these models would be converted to something industrial, clean of traces of handwork and crafts.

This is where I see a difference with my work. Through the process, traces of the human hand are inscribed in the products that result from it. It's these imperfections that I cherish and that I want to preserve: they can resemble the human scale in a product that has passed through all stages of production. Up until that moment, I want to allow imperfections and traces of the making to be part of the product.

The signature of my products is not based in modernism, so from the aesthetic point of view my work has a different outcome from the Bauhaus objects.

This is also a method to show a certain authorship. Where the Bauhaus eliminated much of the individual character and handwriting of its students, I notice now that even the industry longs for more specificity, to create products with stories and character. In our complex society, the subjectivity of recognizable authorship allows people to identify themselves with an object.

Always start with designing the yarn

Closely linked to this hands-on approach is my focus on working from within the material, exploring its potential and experimenting with possible uses. Out of the material, we can truly connect to the user through sensibility and tactility resulting in real quality.

In the case of weaving, I always start with designing the yarn, working on a hand-loom. Weaving was one of the first manual processes to be fully mechanized for large-scale industrial production. There are countless numbers of different automated looms. So why are we still working manually in the studio? The answer can be found in the Bauhaus weaving workshop.

The point at which weaving became an industrial process, the designing of fabrics became an intellectual task and moved away from the loom, straight to the drawing board. There, patterns and colours were drawn out as diagrams, blueprints, formulas and calculations. The weavers from the Bauhaus did not agree with this development.

They strongly believed that the person operating the loom should also be the person to construct the fabric. Manual weaving enables you to understand fully what the effects of the 2D pattern will be in a 3D textile. Improvization and experimentation were the essence of Bauhaus weaving research. Textiles were explored by concentrating on the weaving as a medium itself.

261

It is this setup that I share with the Bauhaus weaving workshop: we begin with the yarn, develop the idea on a hand-loom, and try to bring the essence of the discoveries all the way through the mechanized production methods to the final product. This is even one step further than the Bauhaus weavers. I never romanticize the craft, but celebrate this quality within serial production.

Question the questions

Next to my responsibilities as an art director for multiple companies and my commissioned work, I always work on self-initiated research projects. These projects start with questions, but never result in definitive answers. A long-running investigation into colour is one example of this approach. When I look at my work on colour in relationship to the Bauhaus, I see a clash between two opposing views.

Johannes Itten soon discovered that every student of his had a different sense of colour harmony. He told them to forget about their subjective preferences, and to study the true nature of colour, to find objective knowledge to base their designs on. His overview of different colour effects, together with the work of Josef Albers, forms a rich index of how colour can be designed. I still profit from their work. But it is the subjective aspect they rejected that interests me the most – not the final answers, but the question that triggers the journey we undertake to understand something.

Colour touches on so many different aspects of design: words, shapes, materials, physics, spaces, light. Through colour, I want to relate to the user, so the subjectivity of the colour experience is my starting point. I don't want to educate people in colour harmony. My goal is to design colours that are made from high-quality recipes, which celebrate shape and surfaces – objects people will cherish and want to keep around for some time, because they have values other than only being new.

In the Bauhaus, I see a clear mission. There was general consensus on what design could achieve and how it should be practised. The pure goodwill of modernism triggered an urge to break with the old: they strived for the best through making the new. But I never start with an empty sheet of paper. I believe in working with already existing ingredients, embracing traditions and revitalizing design classics. Whenever I start a project, I relate to the archives, our common heritage. Standing on the shoulders of great authors and thinkers, I try to build higher on the foundations that are already there. The Bauhaus is such a foundation.

HELLA JONGERIUS, DESIGNER

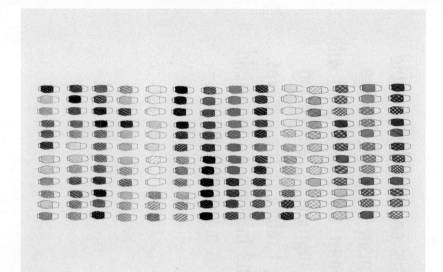

■ 246 **Detail from the installation** *Colour Recipe Research,* **2014,** 6 paintings
on canvas, 25 lacquered metal sheets, various colour samples, 300 × 600 cm,
commissioned by MAK (Museum of Applied Arts, Vienna) for the exhibition *Exemplary,*
Hella Jongerius/Jongeriuslab

■ 248 **Coloured vases (series 3), series of 300 unique vases, 2010,** porcelain,
41 × ∅ 16 cm, Hella Jongerius/Jongeriuslab

■ 247 **Sketch for** *Vases wabric,* **2012**
Hella Jongerius/Jongeriuslab

■249 **Fritz Kuhr, wall-painting scheme for the studio of Paul Klee's Master House, Dessau, 1926,** tempera, silver bronze, pencil on paper, 24×34 cm, Bauhaus-Archiv Berlin

Wall Paint

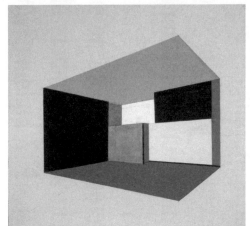

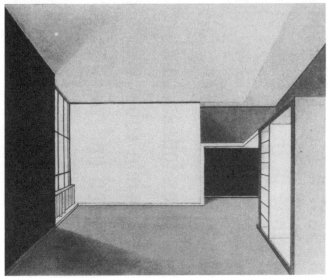

■ 250 **Wassily Kandinsky, Vladas Svipas, wall-painting scheme for the studio of Wassily Kandinsky's Master House, Dessau, 1927,** reproduction 2005, Bauhaus-Archiv Berlin

■ 252 **Heinrich Koch, wall-painting scheme for the studio of Oskar Schlemmer's Master House, Dessau, 1926** tempera pencil on paper on card, 32.5 × 35.3 cm, Bauhaus-Archiv Berlin

■ 251 **Peter Keler, wall-painting scheme for László Moholy-Nagy's Master House, Dessau, 1925,** gouache, silver bronze powder on paper, 30.2 × 49.8 cm, Klassik Stiftung Weimar, Direktion Museen, Graphische Sammlungen KK 7818

■ 253 **Werner Isaacsohn, wall-painting scheme for a studio in the Masters' Houses, Dessau, 1926,** in special Bauhaus issue of *Offset* magazine, Bauhaus-Archiv Berlin

During the seven years that it took to design and construct the Federal Environmental Agency (UBA) in Dessau, we often asked ourselves in what way our project would differ from the Dessau buildings designed by Walter Gropius. The building surely had to present a complete antithesis to the Bauhaus.

The first impression does indeed confirm this assumption. On one side of a railway embankment, white cubes rise proudly above the site. On the other side, a curved, coloured and wooden structure nestles against the topography of the townscape. There are also numerous other differences. The energy footprint of the Bauhaus is undoubtedly much higher than that of the UBA. One detail that demonstrates their lackadaisical attitude to the climate and use of resources is the large glass facade on the west side, which has no working form of sun protection. It would be unthinkable to include such a detail today.

Despite these clear differences, we are no strangers to many of the Bauhaus concepts. The unique way in which members of the creative community came together, contributing to the 1927 building (which incidentally took only

two years to design and build), is an almost unachievable goal for architects following a holistic, integrated design approach. The aesthetic and sensual power of the buildings still provide a (secretly envied) benchmark. Despite all the differences, it is easy to identify with the general aim of the Bauhaus — that of confronting the everyday with the sensitivity and quality of art. In fact, it only seems possible to implement Gropius's intention of "switching off the disadvantages of the machine, without sacrificing any of its advantages" in this age of computer-controlled mass customization.

The Bauhaus can teach us a lot about sustainability; there is hardly a single building in "Bauhaus Town" that has a more sustainable appearance. This impression is not because of its solid building materials or economy, but its aura and elegance.

In contrast to our parents' generation, we do not want to demonstrate the weaknesses of Modernism. No, just like the Modernist architects, we are convinced that it is possible to solve contemporary problems by making the correct use of design and technical knowledge.

The difference between then and now is that the focus no longer lies in dominating the environment but in creating a symbiotic relationship with both the natural and the artistic surroundings. Art and technology are both of equal importance in this context: ecological building can be measured quantitatively by looking at the tonnes of CO_2 emissions and measuring kilowatts of renewable energy. In addition, a tangible environment has to be created where architecture – i.e. space and material – is used to influence people's wellbeing in a positive way.

MATTHIAS SAUERBRUCH AND LOUISA HUTTON, ARCHITECTS

Revised extracts from Matthias Sauerbruch and Louisa Hutton,
"enkel und großeltern", in umweltbundesamt dessau review, Berlin 2014

■ 254 Sauerbruch Hutton, colour and context, Federal
Environment Agency, Dessau, 1998, courtesy Sauerbruch Hutton

■ 255 Hinnerk Scheper, colour scheme for the treatment
of the walls, director's office in the Bauhaus building
Dessau, 1926, tempera, pencil, bast, ink on cardboard,
45.5 × 42.5 cm, Scheper Estate

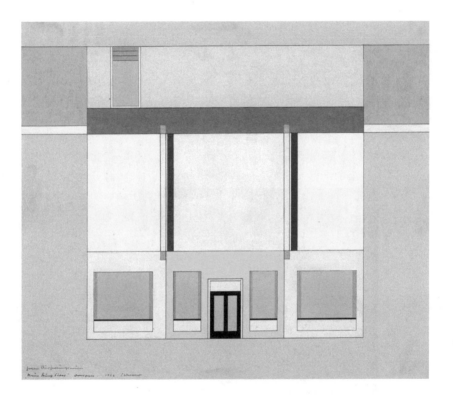

■ 256 **Hinnerk Scheper, Galerie Neue Kunst Fides,
Dresden, colour scheme for main exhibition hall, 1926**
ink, tempera on cardboard, 55 × 64.5 cm, Scheper Estate

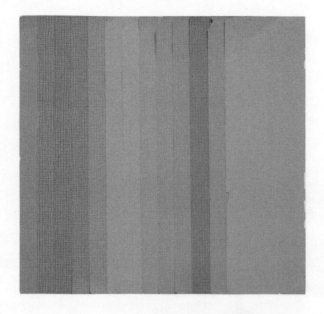

■ 257 **Bauhaus wallpaper, series b23 A-O, 1931**
32.5 × 34 cm, Rasch-Archiv, Bramsche, Tapetenfabrik
Gebr. Rasch GmbH & Co. KG

■ 258 **Sample originals, 1931,** 48.5 × 38 cm, Rasch-Archiv,
Bramsche, Tapetenfabrik Gebr. Rasch GmbH & Co. KG

#thinkaboutspace

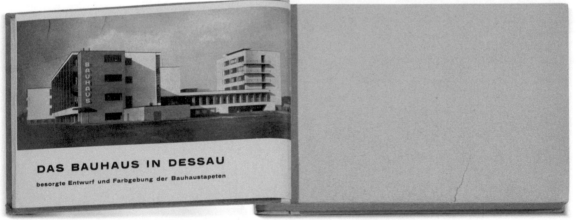

■259 **Bauhaus wallpaper, sample book with 145 cards, 1930,** card, linen-covered, book nails, 16 × 24 cm, Rasch-Archiv, Bramsche, Tapetenfabrik Gebr. Rasch GmbH & Co. KG

■ **260 Rasch, Bauhaus Dessau, modification of contract, commission and advertising budget, 13 September 1930** paper sheet Bauhaus Dessau, 29.7 × 21 cm, Rasch-Archiv, Bramsche, Tapetenfabrik Gebr. Rasch GmbH & Co. KG

■ **262 Rasch, Bauhaus Dessau, last commission account, 14 May 1934,** flimsy paper, 29.3 × 23 cm, Rasch-Archiv, Tapetenfabrik Gebr. Rasch GmbH & Co. KG

■ **261 Mies van der Rohe, Emil Rasch, termination of contract and cession of rights, 27 April 1933,** neutral paper, 29.5 × 20.8 cm, signatures ppa. Dr Rasch, Mies van der Rohe, Rasch-Archiv, Bramsche, Tapetenfabrik Gebr. Rasch GmbH & Co. KG

Wallpaper

■263 **Verlag Scherl Berlin (design), Bauhaus advertisement, 1932,** 14×10 cm, photograph, tempera, Rasch-Archiv, Bramsche, Tapetenfabrik Gebr. Rasch GmbH & Co. KG

■264 **Joost Schmidt, catalogue *der bauhaustapete gehört die zukunft* [The future belongs to Bauhaus wallpaper], 1931,** 12 pages, 10 original Bauhaus wallpapers, letterpress on paper (with cut-outs), 14.7×21.3 cm, Rasch-Archiv, Bramsche, Tapetenfabrik Gebr. Rasch GmbH & Co. KG

I've always been aware of the Bauhaus: I think it had such a pivotal impact on twentieth-century design across all disciplines that it's impossible to be a creative and not know the movement, or be influenced by it in some way. The appeal of the Bauhaus is its purity, its rigour and its precision — all elements that easily translate to BOSS fashion. Indeed, for me, those

elements are the DNA of the house.

JASON WU, ARTISTIC DIRECTOR BOSS WOMENSWEAR

■ 265 Jason Wu, high-waisted pixel tweed
pencil skirt, BOSS Women's Collection
Fall/Winter 2014, courtesy HUGO BOSS

■266 **Josef Albers, study for glass construction** *Pergola,*
1929, ink and pencil on squared paper, 31.1 × 50.8 cm,
The Josef and Anni Albers Foundation

■267 **Anni Albers, Domberger (study for DO II),**
1973, gouache on paper, 46.4 × 47 cm,
The Josef and Anni Albers Foundation

Fabrics

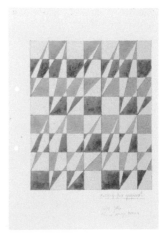

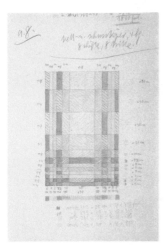

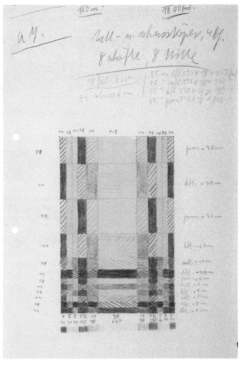

■268 **Lena Meyer-Bergner, designs for woven pieces,
1928–29,** watercolour, pencil, 2 sheets of paper 30 × 20.7 cm,
3 sheets of paper 29.8 × 21.1 cm, Lena Meyer-Bergner Estate,
Freese Collection

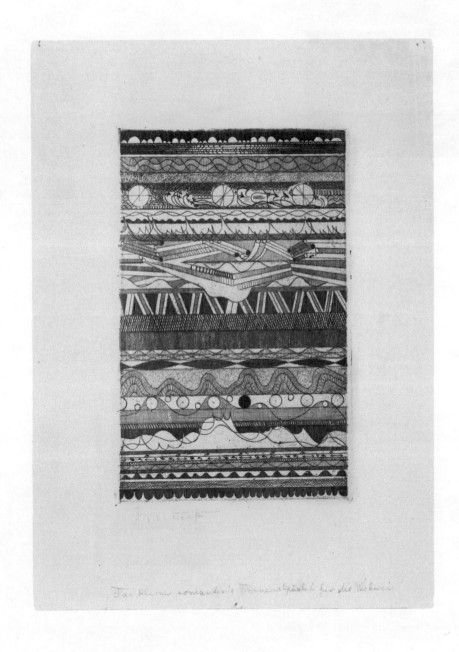

■ 269 Georg Muche, *Das kleine romantische Formenalphabet*
für die Weberei, **1922,** print, 37.1 × 27.4 cm, Gunta Stölzl Estate,
Freese Collection

Fabrics

■270 **Gunta Stölzl, drapery specimen, c. 1925**
cotton, wool, rayon, 6×15 cm, Gunta Stölzl Estate,
Freese Collection

■271 **Gunta Stölzl, drapery, 1928–30,** polytex,
17×14.5 cm, Gunta Stölzl Estate, Freese Collection

284

After I got myself a little deeper into the Bauhaus movement, I embraced their vision to create a new culture concerning architecture, furniture, visual arts, graphic design, typography, fashion, performance, etc. Since then I have discovered how essential the interplay of all creative disciplines has become for branding — in terms of corporate communication, the Bauhaus gang were very much ahead of their time.

The idea of following an inspiring manifesto can be a challenge. It took me years to free myself from the (aesthetic) burden. Maybe in the beginning you need radical rules, but life is a permanent evolving flow and you need to be able to adjust — otherwise the power of creation can change over time into a struggle against the beauty and diversity of life.

I guess as much as I adored the masters of style in the beginning, I started to question them later on.

One day many years ago I went into my factory — took an ordinary, supposedly ugly, monoblock chair and wrote all those names, buzz words, mission statements on it, like "Heroic Modernism", "Utopia", "Art" and

"Revolution" ... it was a kind of revenge. I wanted to step beyond this dictatorial bound of design theory and compliant execution.

MIKE MEIRÉ, DESIGNER

■ 272 **Mike Meiré, Bauhaus, 2008,** kitchen towel on canvas frame, 54.5 × 54.5 cm, courtesy Bartha Contemporary, London

Playful Appropriation of Space

Toys were not only the most economically successful Bauhaus products, but they also made an important contribution to the discussion about aesthetic education and the development of a child's identity, which evolved from art education and the Arts and Crafts movement around 1900. For the pioneer of early childhood education, Friedrich Fröbel, play was one of the central issues in that context: he believed that children express themselves in play, learning about themselves while doing so. In that way, children continually learn new things and take possession of their surroundings.

Fröbel developed *Spielgaben* – Fröbel Gifts or Play Gifts – to help children understand the principles of the world. His pedagogical approaches influenced the avant-garde of the time – from Bruno Taut to Theodor Winde as well as many other Bauhaus protagonists such as Walter Gropius, Paul Klee and Alma Buscher, whose small ship building toy had already become very popular and is still available today. Now, coloured building block sets are increasingly replaced by digital open-world games such as Minecraft. However, Minecraft contains many similar elements from its predecessors, such as small geometrical self-designed basic modules with which players can build their own virtual worlds and therefore also learn how spatial and social relationships work.

■273 **Alma Buscher,** *design for ship building toy,* **small version, 1923,** watercolour, pencil on paper, 16 × 42 cm, Klassik Stiftung Weimar, Direktion Museen, Graphische Sammlungen. Gift of Lore and Joost Siedhoff

■274 **Alma Buscher,** *Bauspiel Schiff* [ship building toy], **1923,** wood, painted in different colours, 13.8 × 27 × 3 cm, Donation Naef (reproduction 2015), Vitra Design Museum Collection

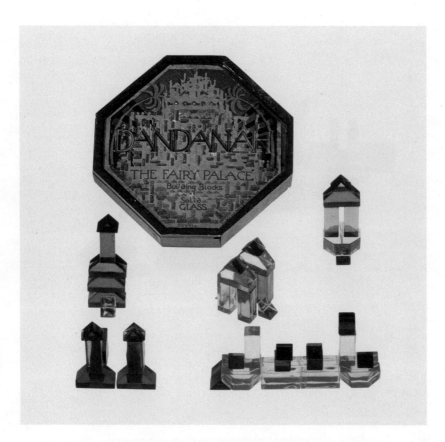

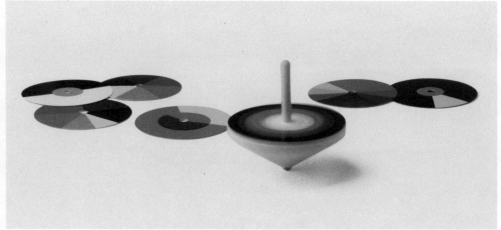

the bauhaus

■ 275 Bruno Taut, *Dandanah* glass building blocks, design 1920/1921, manufactured 1925–26, glass, wooden box with instructions, 4.1 × 25.5 × 25.5 cm, Deutsches Spielzeugmuseum, Sonneberg

■ 276 Ludwig Hirschfeld-Mack, *Optischer Farbmischer*, 1924, wood, Ø 10 cm, Donation Naef (reproduction 2015), Vitra Design Museum Collection

Bauhaus Toys

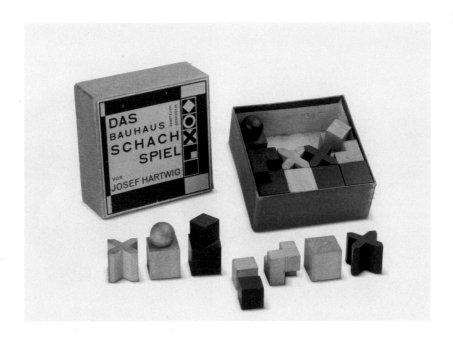

■ 277 Unknown, *Die Revolution des Schachbretts*
[The chessboard revolution], in *Leipziger Tagblatt*,
21 September 1924, printed material, 29.5 × 21 cm,
Freese Collection

■ 278 Josef Hartwig, Joost Schmidt [cardboard box]
Das Bauhaus Schachspiel model XVI, 5.3 × 12.3 × 12.3 cm,
private collection, courtesy Galerie Ulrich Fiedler

■279 **Friedrich Fröbel, first *Fröbelgabe*, 1837–1900**
fabric, wood, 6 × 26 × 7 cm, Museen der Stadt Nürnberg
Spielzeugmuseum

■280 **Friedrich Fröbel, second *Fröbelgabe*, 1837–1900**
wood, 6 × 21 × 7.5 cm, Museen der Stadt Nürnberg
Spielzeugmuseum

■281 **Friedrich Fröbel, third *Fröbelgabe*, c. 1900,** wood,
sawn and stuck together, 9.3 × 9.8 × 9.8 cm, Museen der Stadt
Nürnberg Spielzeugmuseum

Bauhaus Toys

■ 282 **Theodor Artur Winde, *14 Kinderspielzeuggebäude,
before 1933,*** wood, sawn, stamped, painted, pasted,
9 × 15.2 × 15 cm, Staatliche Kunstsammlungen Dresden,
Museum für Sächsische Volkskunst

Blockchain
A film by Space Caviar

The building block system was popularized on the international design scene by Alma Siedhoff-Buscher, who in 1923 designed the *Bauspiel Schiff* [ship building toy], the most successful of the *Bauhaus Baukästen* at the Bauhaus school. The *Bauspiel Schiff* is the embodiment not only of a broad educational philosophy recognizing the importance of play in early childhood development, it is the expression of the Bauhaus ethos, the school's philosophy on aesthetics, formal and technical terms, as well as standardization and mass production. By encouraging children to explore form and texture, Alma Siedhoff-Buscher's toy encourages them to develop a sense of inventiveness and creativity, as well as recognize colour combinations and shapes in their imaginative play. Through the building block, they entwined play and creative work.

Markus "Notch" Persson's 2009 video game Minecraft, a native of the present era of digital technology and post-digital culture, gives children access to a further evolution of building blocks. This "digital Baukasten" drops the players into a randomly generated world made of digital cubes, allowing them to start building the world they will play in, giving the possibility to be connected in a community platform, with unlimited, self-perpetuating opportunities for single and multiplayer play. Blocks can represent any material, shape, colour or texture, and can also be crafted in a multiplicity of ways. Minecraft is a production set of design, engineering, architecture and computation resulting in a common tool for recreating any artefact, real or imaginary, crafted or engineered (from dragons and ships to trains and buildings, from functioning computers and calculators to hard

drives and 3D printers). Importantly, the creation of worlds requires the investment of time and effort, since only one block can be placed at a time; many of the game's most ambitious environments required over two years of collaborative effort to build.

Combining the logic of digital image composition in video games, the logic of child creativity and learning, and the logic of collaborative digital media, Minecraft worlds effectively constitute a never-ending laboratory of unbridled creativity whose defining philosophy can be traced back to Walter Gropius's workshops. Nearly one century after the founding of the twentieth century's most renowned school, Minecraft servers have – consciously or unconsciously – become one of the most powerful historical expressions of its influence, developing into a platform of multiple social formations and archetypes, from traditional game play to laboratories of experimental digital production for millions. In Minecraft, the creative impulse in Alma Siedhoff-Buscher's building block system becomes a digital interactive reality, offering an interesting opportunity for reflection on the taxonomy of the building block.

■ 283 *Titan City by ColonialPuppet, 2014*
http://www.planetminecraft.com/project/modern-city-megabuild---titan-city

■ 284 *Giant Controllable Walking Battle Robot – Mega Gargantua*
by Cubehamster, 2014
http://www.planetminecraft.com/project/mega-gargantua---giant-controllable-battle-robot

■ 285 *The Dropper by Bigre, 2012*
http://www.planetminecraft.com/project/advpuzz-the-dropper-2-new-levels

■286 Bauwelt Archive, *Walter Gropius. 3 Talks about Architecture*. **1978**, vinyl record, Bauwelt, Berlin

#commu
nicate

The attention that the Bauhaus has attracted across the world is closely connected to the characteristic way in which it communicated its ideas to the public. Like no other institution before, the Bauhaus succeeded in presenting its ideas and products to the wider public and made subsequent generations familiar with its views on all things and non-things. In order to do so, the Bauhaus made use of all available means of communication. Through manifestos and programmes, lectures, journals and advertising brochures, press releases, special editions, exhibitions and, last but not least, its own series of publications, the Bauhaus gained international acclaim. It became an important contributor to the contemporary debate on architecture, urban design, interior and graphic design, art and typography.

Although this cannot be described as a targeted communications strategy, the Bauhaus none the less managed to develop its own corporate identity over the years. A revolutionary breakthrough at the time, its successful campaigning strategy continues to be exemplary today. Complex content and conflicting tendencies gave the Bauhaus its unique momentum, but they needed simplifying. Over the years, the Bauhaus was increasingly reduced to one particular style, which finally became a myth that has lost none of its fascination. Cheap plagiarisms and expensive re-editions of its products as well as continuing debate on its ideas are ample proof of that.

■ 287 **Herbert Bayer, design for a multi-media trade fair stand for Regina toothpaste, 1924,** gouache, photocopy, 45 × 37.7 cm, Eckhard Neumann Estate, Freese Collection

Programme and Propaganda

One of the most important and influential tools that the Bauhaus used to disseminate ideas was its own series of publications consisting of fourteen books which also included contributions by non-Bauhaus authors such as Piet Mondrian, Theo van Doesburg and Kasimir Malevich. Sources suggest that many other books had been planned but were never published, including "Die neue Lebenskonstruktion" [The new construction of life], "Spezialfragen in der Wirtschaft 1908–1923" [Special issues in economy], "Organisation (als eine der wichtigsten Fragen)" [Organization (as one of the most important questions)], "Utopisches" [Utopian] and "Paul Klee: Statik und Dynamik" [Paul Klee: statics and dynamics].

In addition, an in-house magazine, appearing from 1926 to 1931, was devised to confront increasing criticism of the Bauhaus and, at the same time, to inform the public about Bauhaus activities and teachings and its opinions on architecture and art. Further tools that the Bauhaus used to spread ideas included special editions of renowned professional journals such as *Offset* as well as the Bauhaus's own exhibitions ranging from the first exhibition in 1923 in Weimar, Hannes Meyer's travelling exhibition *Volkswohnung* [The people's apartment] in 1929, to Walter Gropius's and Herbert Bayer's (unsuccessful) exhibition in exile at New York's MoMA in 1938.

■288 **László Moholy-Nagy, Bauhausbücher [Bauhaus books] prospectus, 1924,** letterpress on chamois cardboard, 23.1 × 18 cm, donated by Hattula Moholy-Nagy, Freese Collection

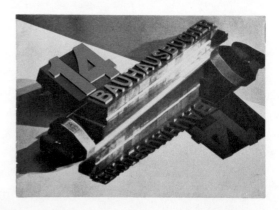

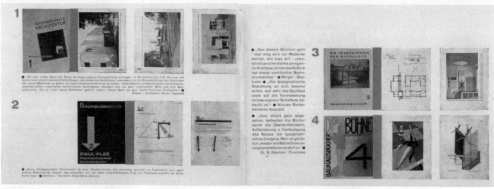

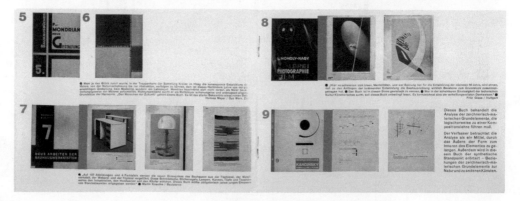

the bauhaus

■289 **László Moholy-Nagy, Bauhausbücher [Bauhaus books] sales catalogue, 1929,** letterpress on art paper, 14.8 × 21 cm, Freese Collection

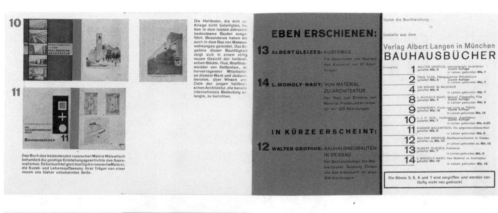

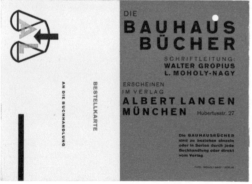

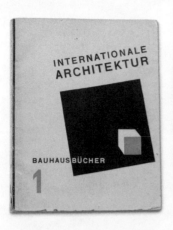
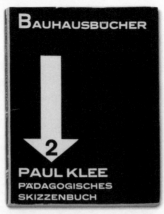
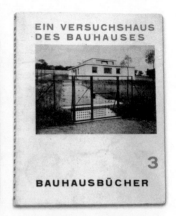

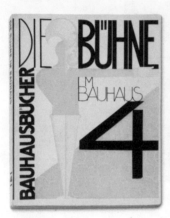
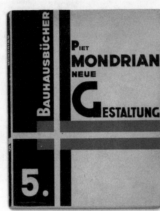
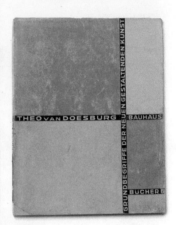

■ 290 Walter Gropius, *Internationale Architektur*, Bauhausbücher, vol. 1, **1925,** letterpress, 23.1 × 18.2 cm

■ 291 Paul Klee, *Pädagogisches Skizzenbuch*, Bauhausbüchers, **vol. 2, 1925,** letterpress, 30 × 21.5 cm

■ 292 Walter Gropius, László Moholy-Nagy, *Ein Versuchshaus des Bauhauses*, Bauhausbücher, **vol. 3, 1925,** letterpress, 30 × 21.5 cm

■ 293 Oskar Schlemmer, László Moholy-Nagy, *Die Bühne am Bauhaus*, Bauhausbücher, **vol. 4, 1924,** letterpress, 23 × 18 cm

■ 294 Piet Mondrian, *Neue Gestaltung*, Bauhausbücher, vol. 5, **1925,** letterpress, 30 × 21.5 cm

■ 295 Theo van Doesburg, *Grundbegriffe der neuen gestaltenden Kunst*, Bauhausbücher, vol. 6, letterpress, 1925, 23 × 18 cm

Bauhaus Books

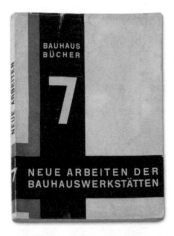
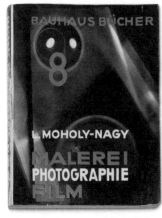
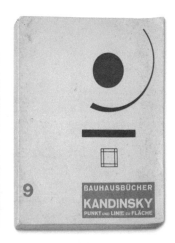

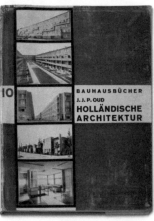
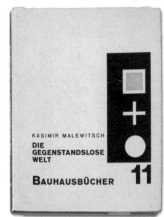
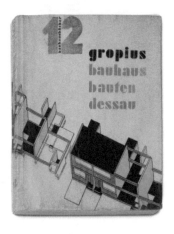

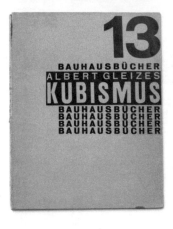

■ 296 Walter Gropius, *Neue Arbeiten der Bauhauswerkstätten*, Bauhausbücher, vol. 7, 1925
letterpress, 30 × 21.5 cm

■ 299 J. J. P. Oud, László Moholy-Nagy, *Holländische Architektur*, Bauhausbücher, vol. 10, 1926
letterpress, 30 × 21.5 cm

■ 302 Albert Gleizes, *Kubismus*, Bauhausbücher, vol. 13, 1928
letterpress, 30 × 21.5 cm

■ 297 László Moholy-Nagy, *Malerei, Fotografie, Film*, Bauhausbücher, vol. 8, 1924
letterpress, 23 × 18 cm

■ 300 Kasimir Malevich, *Die gegenstandslose Welt*, Bauhausbücher, vol. 11, 1927
letterpress, 30 × 21.5 cm

■ 303 László Moholy-Nagy, *Von Material zu Architektur*, Bauhausbücher, vol. 14, 1929
letterpress, 30 × 21.5 cm

■ 298 Wassily Kandinsky, Herbert Bayer, *Punkt und Linie zu Fläche*, Bauhausbücher, vol. 9, 1926
letterpress, 30 × 21.5 cm

■ 301 László Moholy-Nagy, *Bauhausbauten Dessau*, Bauhausbücher, vol. 12, 1930
letterpress, 23 × 17 cm

All images:
Vitra Design Museum Collection

violett [violet] *based on wassily kandinsky*
Olaf Nicolai

"violett, a stage-composition with introduction and scenery" by Wassily Kandinsky is one of those titles from a series of Bauhaus books that was repeatedly announced, but never published.

Over fifty titles were announced in various advertising brochures and notices for the series devised by László Moholy-Nagy and Walter Gropius, but only fourteen were actually published. Moholy-Nagy, who supervised both the editing and design of the series, envisioned nothing less than "collecting together everything that is modern" – as he described it in a letter to Alexander Rodchenko shortly before Christmas in 1923. [1] While that letter anticipates a brochure rather than a series of books, the programme was already fixed: in thirty points, Moholy-Nagy listed the themes that were intended to include "all creative areas", beginning with the debate around "Constructivism" (point 1) through to "New Inventions (Practical Things)" (point 29) and "Utopian" (point 30). This ambitious programme also shaped the later series of books in which artists, musicians, architects, physicists and doctors were to present for discussion not only their theories but also their practical experiences.

Apart from a concentration on architecture, design and material issues as one would expect, there is also a surprising focus on film and stage. Five of the editions planned were to be devoted to these two themes alone. The first book published in the Bauhaus series by László Moholoy-Nagy in 1925 was *Die Bühne am Bauhaus* – a joint work by Oskar Schlemmer and Farkas Molnár. Two years later issue 3 of the *bauhaus magazine* was devoted entirely to *Bühne* [the stage].

Here, on the last page, alongside Moholy-Nagy's article "wie soll das theater der totalität verwirklicht

werden?" [how should the totality of theatre be realized?], readers found a brief excerpt from "violett, a romantic stage-composition by kandinsky", followed by the note: "this section of 'violett' was written in the summer of 1914." This is the only trace of the Bauhaus book that had been advertised — yet a significant one, in that it shows Kandinsky's particular approach to his material. He published a text that he had produced either before or at the beginning of the First World War in an issue devoted to experiments on the Bauhaus stage in the 1920s. The editorial comment seems to imply that only this section of "violett" existed and the announcement of the play as a Bauhaus book makes it seem doubtful that the published section would have appeared like this. It is quite possible that it would have been further modified or it may have completely disappeared, just as the word "romantic" vanished from the title.

According to this logic of a "work in progress", which repeats, re-uses, reformulates and productively speculates, the existing insert of Kandinsky's text "violett" is staged as a possible guide to the production. Moholy-Nagy finished the letter to Rodchenko with the sentence: "Of course, we expect ideas and work from all sides that concern a life design principle for today." The interpretation begun here of the excerpt announced by Kandinsky of a stage-composition that was never completed continues at the exhibition in the format of performance.

CONCEPT: OLAF NICOLAI

DESIGN: OLAF NICOLAI AND PASCAL STORZ

1 Letter from Moholy-Nagy to Alexander Rodchenko, 18 December 1923, Weimar/Staatliches Bauhaus, quoted in Krisztina Passuth, Moholy-Nagy, VEB Verlag der Kunst, Dresden 1987, p. 392.

violett

[violet]

two choirs alternate—
simple and heartfelt:

men:

don't look at the trees.

don't look at the trees in the air.

but look at the trees in the water.

how their branches, leaves, needles turn

and what a tangle is born—

arches, curves, zigzags.

and beside these arches, curves, zigzags

other arches, curves, zigzags.

but in between blueish, greenish, whitish,

rosy and … white small, smaller,

very small little specks are curling.

5" 3" 12" 3" 10"

women:

don't look at the boat

and not at the person on the boat

and also not at the … rudders.

look at the little hill of water

that is born out of the water with the rudder's stroke.

all that is necessary is to look at the little hill of water.

what ribs and sides he has—

ribs are especially important!

on ribs and sides are gullets

that climb up the ribs and sides.

it is important to see, how the ribs and gullets

are pliant and hard,

and sharp and alas! soft.

you cannot squash them,

20"

3"

12"

but pierce them with your finger—

that is very important!

on the little hill of water

sits a peak of pricks—

the pricks are partly coalescent with the peak,

partly they have grown out of the little hill,

partly over the little hill,

hanging in the air,

which is very important.

men:

don't look at the boat.

don't look at the deep blue,

at the dark green water.

not at the

12" 2" 3" 10"

white,

1"

Olaf Nicolai

pink-coloured,

1"

Olaf Nicolai

blue-coloured,

1"

Olaf Nicolai

violet-coloured,

1"

Olaf Nicolai

red,

1"

Olaf Nicolai

black,

1"

purple-coloured,

1"

olive-coloured,

1"

brown

water.

2"

5"

women:

also not at the violet-coloured—

we really ask you not to!

4"

men:

don't look at the hard water

and not at the airless water.

3"

12"

but only, only and only at the light green water,

that should be stroked,

that could be licked,

into which the hand by all means wants to dip,

that should be brought home,

whereby breathing seems possible,

violet

(the words "violet-coloured" drawn out)

"violet-coloured"

(very underlined)

Olaf Nicolai

which stays in the chest,

young, fresh, clear, light, cool, funny, safe,

which smells of eternity,

which only, only, only under the boat is to be seen.

who can believe that this light green water

is carrying the boat?

hence, the mind is silent.

... appearing on stage:

alto

soprano

tenor

bass

child

16"

bauhaus 4
1927

die zeitschrift erscheint vierteljährlich / bezugspreis: jährlich mk. 2.—. / preis dieser nummer 60 pfennig /
mitglieder des „kreis der freunde des bauhauses" erhalten die zeitschrift kostenlos /
schriftleitung: w. gropius und l. moholy-nagy /
verlag und geschäftsstelle: dessau, lange gasse 21, telefon 2064 und 2224 /

**an die bezieher
der bauhauszeitschrift!**

da die herstellungskosten bei dem überaus billigen
verkaufspreis nicht zu decken sind, sehen sich die
herausgeber und der verlag genötigt, den abonne-
mentspreis der zeitschrift jährlich auf rm 4.– zu er-
höhen. preis des einzelheftes rm 1,20.

die zeitschrift erscheint im zweiten jahrgang in hand-
licherem format und zwar: 210 × 297 mm (din a 4),
und in umschlag.

k. von meyenburg

**kultur von
pflanzen, tieren, menschen**

letztes jahr strömten erforscher der toten und lebenden
natur zur „gesolei" nach düsseldorf, um ihre interessen
anthropozentrisch zu richten auf den „mensch in der mitte",
in der mitte einer dem forscher selbst täglich komplexer,
funktionell verwobener und feiner konstruiert erscheinen-
den natur, die nach sonnenschein hascht, auf — und im
rhythmus unserer erdkugel, wie sie im eisigen weltall um
die sonne tanzt.
zweck dieses haschens ist zunächst das „nichtsterben",
dann das „allen gewalten zum trotz sich erhalten". schließ-
lich das möglichst gute, sichere, dauernde, gehaltvolle,
wirkungsvolle leben einzelner; oder ganzer zweckverbände
der gleichen spezies (herden, völker, wälder usw.); oder
vielseitigerer notverbände sich ergänzender spezies des-
selben „reiches" (völkerbund, mischwald, wiese); oder der
drei reiche: kohlenblumen, w. landwirtschaft, d. h. alles
menschenlebens überhaupt.
die „gesolei" ist vielseitig, groß, interessant, aber biolo-
gisch gesehen, kann sie keine klarheit geben, weil sie ein
zu kleines gesichtsfeld beleuchtet.
sie ist die revolte des menschen gegen die früchte des
18. jahrhunderts; den unbezähmten menschlichen egois-
mus und die unbezähmte maschine. sie ist noch nicht die
selbstbezwingung der technik. noch singen unsere arbeiter:
„wir schmieden, wir schmieden die rüstung der zeit, die
uns einst befreit."

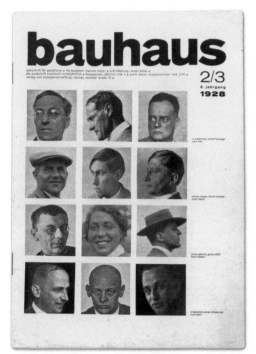

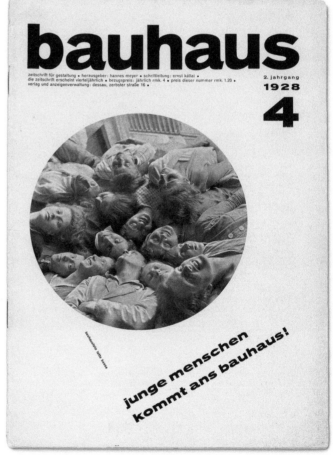

■305 **Hannes Meyer,** *Bauhauszeitschrift,* **no. 2/3, 2nd year, 1928,** 29.7 × 21 cm, Vitra Design Museum Collection

■306 **Hannes Meyer,** *Bauhauszeitschrift,* **no. 4, 2nd year, 1928,** 29 × 21.0 cm, Vitra Design Museum Collection

■307 **Staatliches Bauhaus Weimar,** *Kundgebungen für das Staatliche Bauhaus Weimar* **[rallies for Staatliches Bauhaus Weimar], 1924,** letterpress, 22.5 × 14.5 cm, private collection

■308 **László Moholy-Nagy, design for the title page** of *Pressestimmen für das Staatliche Bauhaus Weimar* **[media reports on the State Bauhaus Weimar], signed by Walter Dexel, 1924,** letterpress, 23.1 × 15.9 cm, Walter Dexel Estate, Freese Collection

■309 **Joost Schmidt, title page of the journal** *Offset Buch- und Werbekunst,* **issue 7, special issue on Bauhaus, 1926,** offset on cardboard, 30.9 × 23.5 cm, Vitra Design Museum Collection

■310 **Karel Teige, magazine** *RED,* **special issue on Bauhaus, no. 5, 1930,** 21 × 15 cm, Vitra Design Museum Collection

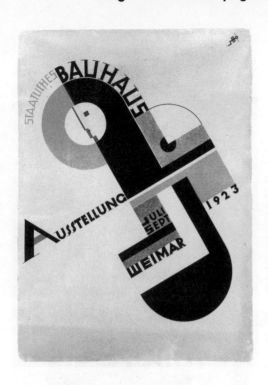

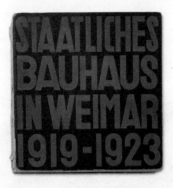

DIE AUSSTELLUNG 1923

DIE SCHULE
zeigt Erziehung und Bildung des Menschen auf dem Wege von Handwerk und Kunst. Die Schule will den bildnerisch Begabten aus dem naiven Basteln und Werken zu der Erkenntnis seiner Mittel und ihrer Gesetze und daraus zur Freiheit schöpferischen Gestaltens führen. An Schulbeispielen solcher Art mit besonderer Einstellung auf das Werkmässige werden Lehrgänge gezeigt, die von programmatischer Bedeutung für den Kunstunterricht sind.

AUSSTELLUNG VON NATUR-STUDIEN FORM- FARB- UND MATERIE-STUDIEN MATERIALKOMPO-SITIONEN

DIE WERK-STÄTTEN
zeigen selbständige und auf den Bau bezogene Werkarbeit der Tischlerei, Holz- und Steinbildhauerei, Wandmalerei, Glas- und Metallwerkstätten, Töpferei und Weberei. Die Kenntnis des Materials, seine Gesetze und Möglichkeiten, die Durchdringung des Handwerklichen und Formalen (künstlerische Phantasie) soll aus dem Zusammenbruch des zunftmässigen Werkens von einst und geistloser Maschinenarbeit von heute jene Synthese herstellen, die ein Gebilde schön, neu und zweckmässig macht. Auf dem Wege solcher Gestaltung ist das Handwerk im alten Sinne heute Uebergang, das vollendete Maschine nicht ausschliesst, sondern erstrebt. Die Ueberleitung der Schulwerkstätten in produktive ist eine Frage aber auch ein Gebot der Zeit.

AUSSTELLUNG VON EINZELERZEUGNISSEN DER WERKSTÄTTEN FÜR STEIN, HOLZ, METALL, TON, GLAS, FARBE, GEWEBE

DER BAU
zeigt das einfache Haus und seine Einrichtung. Denn Sinn und Wesen der Bauhausarbeit ist der Bau und unser unmittelbares Ziel die Gestaltung unserer Wohnstätte nach den Bedürfnissen und Möglichkeiten heutigen Lebens. Der Zusammenschluss aller zweckmässigen Gestaltens im Dienste einer Idee, der Bau- und Hausidee, die Zweckbeziehung und Bindung aller Teile macht kollektive Arbeit zur Notwendigkeit und damit den Bau zum Gemeinschaftswerk. Das Siedlungsgelände des Bauhauses soll einem weitgefassten Siedlungsplan dienen, der Einzelhäuser, Bad, Spielplatz und Gärten umfasst. Das weitgesteckte Ziel des Bauhauses schliesst den metaphysischen Bau nicht aus, der über die Schönheit des Zweckvollen hinaus als wahrhaftes Gesamtkunstwerk die Verwirklichung einer abstrakten monumentalen Schönheit erstrebt.

EIN HAUS UND SEINE EINRICHTUNG SIEDLUNGSPLÄNE UND HAUSMODELLE UTOPISCHES AUSSTELLUNG INTERNATIONALER ARCHITEKTEN

MALEREI UND PLASTIK
zeigen Einzelwerke und ihre Vereinigung und Bindung durch Architektur. Die Aufgabe der bildenden Kunst war zu allen Zeiten grossen Stils eine ethische und sie wird es fernerhin sein. Stoff und Ideen der Darstellung haben sich gewandelt ebenso wie ihre Darstellungsmittel. Mit der Heraufkunft einer neuen Baukunst ist die monumentale Kunst heute wieder im Werden, vorweggenommen oder vorbereitet im Einzelbild, das sich von architektonischen Vorstellungen leiten lässt oder auch über jegliche Beziehung sich hinwegsetzt. Solche Unabhängigkeit schafft ihm weitesten Spielraum und lässt es die Grenzen bildnerischen Gestaltens kühn erweitern.

INTERNATIONALE KUNSTAUSSTELLUNG AUSSTELLUNG VON EINZELWERKEN DER BAUHAUSANGEHÖRIGEN, MALEREI UND PLASTIK IN RÄUMLICHER BINDUNG

DIE BÜHNE
zeigt Schau-Spiele, Spiele zum Schauen verschiedener Art, in denen die Ursprünge theatralischer Kunst zum Ausdruck kommen und zu neuen Wegen der Gestaltung führen. Sie sollen einer neuen Festlichkeit zum Siege helfen, die das Leben durchdringt. Die Bühnenkunst gleich der Architektur eine synthetische Kunst ist als Welt des Spiels und des Scheins Zufluchtsort des Irrationalen.

AUFFÜHRUNGEN DER BAUHAUSWOCHE AUSSTELLUNG VON ENTWÜRFEN, MODELLEN, FIGURINEN

DIE BAUHAUSWOCHE
bringt Vorträge über Bauhausbestrebungen, über Architektur, Kunst, Handwerk, Technik, Industrie, Schule, Erziehung; Aufführungen der Bühnenwerkstatt, Spielgänge, Tänze, Marionetten- u. Lichtspiele, Kino; Musikalische Veranstaltungen; ein Fest der Bauhäusler im Park von Weimar oder Umgebung

■311 **Joost Schmidt, exhibition poster** *Staatliches Bauhaus, Ausstellung Juli–September*, **Weimar 1923** lithograph, 68.5 × 48.5 cm, Klassik Stiftung Weimar, Direktion Museen, Graphische Sammlungen DK 346/92

■312 **Herbert Bayer, cover of exhibition catalogue** *Staatliches Bauhaus in Weimar 1919–1923,* letterpress, 25.5 × 25.5 cm, Vitra Design Museum Collection

■313 **Oskar Schlemmer, brochure** *Programm zur Bauhaus-Ausstellung,* **1922,** letterpress, double-sided printing, 20.2 × 30 cm, Vitra Design Museum Collection

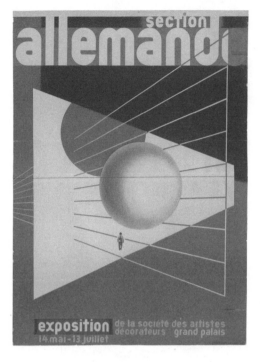

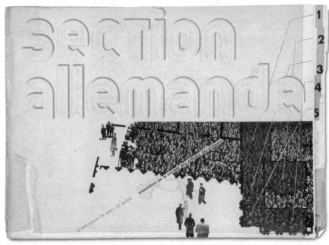

■314 **Herbert Bayer, exhibition poster** *Section allemande für die Werkbundausstellung Paris,* **1930** lithograph, 158 × 115 cm, Staatliche Museen zu Berlin, Kunstbibliothek

■315 **Herbert Bayer, exhibition catalogue for Werkbund exhibition in Paris 1930,** Societé des Artistes Décorateurs, Paris: Section Allemande, 15 × 21 cm, letterpress, Alexander von Vegesack Collection, Domaine de Boisbuchet, www.boisbuchet.org

■316 **Herbert Bayer, apartment house, communal rooms for Werkbund Exhibition, Paris, 1930,** interior perspective, bar: gouache, ink, pencil on paper, 42 × 57.1 cm, Harvard Art Museums/Busch-Reisinger Museum, gift of Walter Gropius, BRGA.45.1

■317 **Herbert Bayer, apartment house, communal rooms for Werkbund Exhibition, Paris, 1930,** interior perspective, ink and gouache over pencil on paper, 55.3 × 48.2 cm, Harvard Art Museums/Busch-Reisinger Museum, gift from Walter Gropius, BRGA.45.2

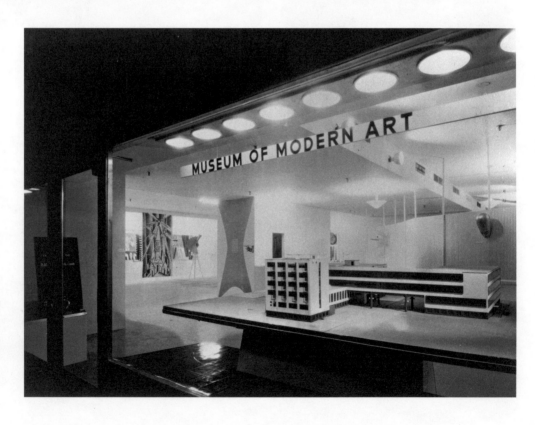

■318 **Herbert Bayer, *Bauhaus 1919–1928,*** 7 December 1938 – 30 January 1939, exhibition floor plan in the Museum of Modern Art, New York, 1938, ink, gouache and cut-and-paste coated papers, 51.3 × 45.2 cm, purchase, acc. num. 252.1986, Museum of Modern Art, New York

■319 **Soichi Sunami, *Bauhaus 1919–1928,*** installation view of exhibition in the Museum of Modern Art, New York, designed by Herbert Bayer, 1938, silver gelatin print, 17.9 × 24.6 cm, Harvard Art Museums/Busch-Reisinger Museum, gift of Lydia Dorner, BR58.112

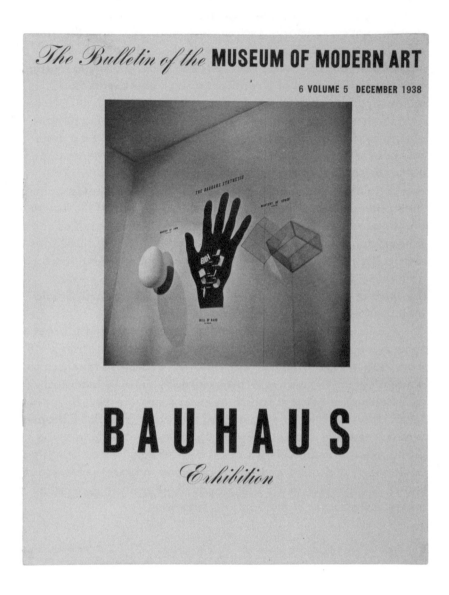

■ 320 **Herbert Bayer, The Bulletin of the Museum of Modern Art, Bauhaus Exhibition, vol. 6, December 1938**
letterpress, 23.4 × 18.7 cm, Eckhard Neumann Estate,
Freese Collection

"New vision" was a 1920s concept that radically broke with the prevailing authoritative view of the world. New photography increasingly distanced itself from the conventional image, instead showing unusual pictorial sections and motifs and adopting new perspectives in an attempt to capture epochal momentum in a picture. It thus revolutionized visual habits and came to express a modern perception of a reality that was now dominated by the media.

Thousands and thousands of photographs showing people, objects and architecture prove that the camera played a major role in everyday Bauhaus life. Walter Peterhans, who was head of the Dessau Bauhaus photography class established in 1929, and Lucia Moholy are among the most well-known photographers. Their photographs came to dominate the perception of the Bauhaus and its products. Furthermore, film as a technical medium connecting art and technology also greatly fascinated Bauhaus artists. Right from the beginning, there was a profound focus on both these media which, like no others, were able to capture the spirit of modernity. Nevertheless, despite his efforts, László Moholy-Nagy failed to establish a film class.

Bauhaus owes its unmistakable appearance to the concept of "new typography". With his appointment to the advertising workshop in 1923, Moholy-Nagy began to focus on typeface as a major communication tool, using already existing fonts such as Schelter-Grotesk and Futura as letter forms; Herbert Beyer and Josef Albers additionally developed new fonts from basic shapes such as the circle and square. The use of lower-case letters and printed matter in the DIN standard from 1925 onwards shows the influence of Walter Porstmann, a vehement advocate of lower-case letters and inventor of the DIN standard, who was honoured by a note in the footer of the Bauhaus letterhead.

■ 321 Benny Au, *A way of seeing things that projects into my own imaginary*, 2015, digital print, courtesy Benny Au

■322 **Fritz Schleifer, untitled, 1926/1927,** vintage print, gouache, 17.9 × 24 cm, Galerie Berinson, Berlin

■323 **Iwao Yamawaki, untitled, 1932,** vintage print, 22.9 × 16.5 cm, Galerie Berinson, Berlin

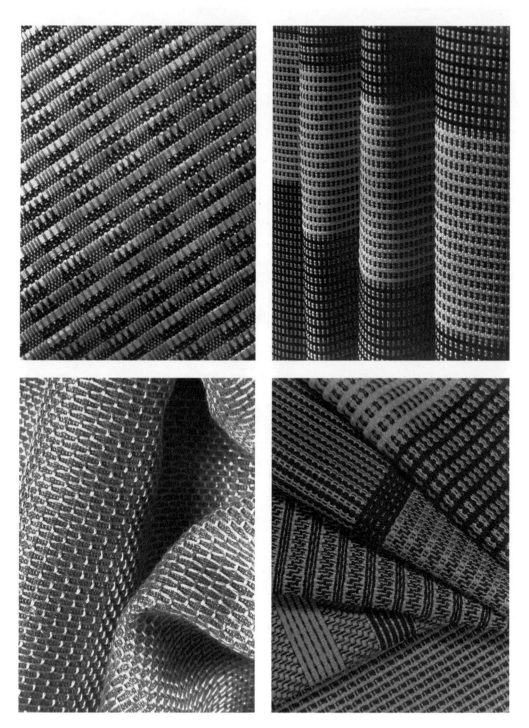

■324 **Heinrich Koch, Gunta Stölzl, wall covering, 1930,** photograph, 24×18.5 cm, v. Bodelschwinghsche Stiftungen Bethel, Bielefeld

■325 **Heinrich Koch, decoration fabric, 1930** photograph, 24×18.5 cm, v. Bodelschwinghsche Stiftungen Bethel, Bielefeld

■326 **Heinrich Koch, decoration fabric, 1930** photograph, 24×18.5 cm, v. Bodelschwinghsche Stiftungen Bethel, Bielefeld

■327 **Heinrich Koch (photograph), Gunta Stölzl (fabric), divan blankets, 1930,** photograph, 24×30 cm, v. Bodelschwinghsche Stiftungen Bethel, Bielefeld

■328 **Heinrich Koch, silk fabric, 1929,** photograph,
24 × 18.5 cm, v. Bodelschwinghsche Stiftungen Bethel,
Bielefeld

■329 **Ladislav Foltyn,** *Stilleben mit Glas,* **1929,** vintage print, 37.9 × 29 cm, Vitra Design Museum Collection

■330 **Albert Hennig, fabric, feather, net, glasses, pebble stone, a photographic class of Walter Peterhans, 1933** vintage print, 30 × 20.5 cm, Vitra Design Museum Collection

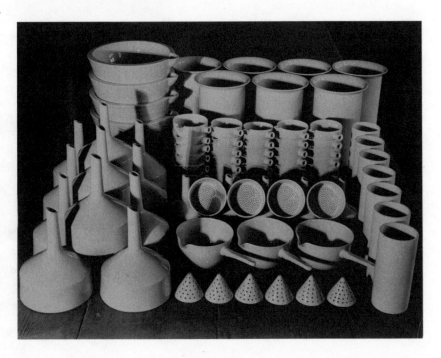

■ 331 **Walter Peterhans, untitled (three tea bowls, II), 1932,** silver bromide gelatin, 29.1 × 39.8 cm, Museum Folkwang, Essen

■ 332 **Walter Peterhans, untitled (labware), c. 1935** silver bromide gelatin, 29.6 × 23.3 cm, Museum Folkwang, Essen

■333 **Walter Peterhans, untitled (glass table), c. 1930**
silver bromide gelatin, 17.1 × 22 cm, Museum Folkwang, Essen

Interestingly, "Bauhaus" is also a popular name in Hong Kong as it belongs to a local denimwear brand. I hope the spirit of the Bauhaus could be as "everyday" as denim jeans are to a contemporary generation.

More than a school or institution, the Bauhaus was an environment that allowed artists and designers to experiment with their ideas, where people from different disciplines and cultural backgrounds could learn from and influence each other. More importantly, it went beyond a utopian playground for designers, because they were able to bring their efforts into public use. It is always easier said than done, but the Bauhaus successfully put

its experiments into practice. Not only did it bring designs to mass production and popularize the importance of typographic design, but many of its ideas are still influential in the design world today.

The Bauhaus was also proactive in presenting its creative outcomes through exhibitions which enhanced public access and understanding, and it left important documentation for future research.

ALAN CHAN, DESIGNER

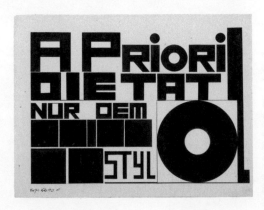

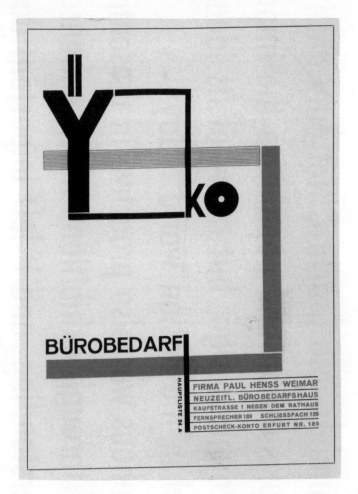

■334 **Karl Peter Röhl, poster design** *A Priori Die Tat nur dem Styl,* **1922,** 39.7 × 52 cm, Freese Collection

■335 **Joost Schmidt, advertisement for Paul Henss, Weimar, 1924,** letterpress, 11.4 × 8.2 cm, Freese Collection

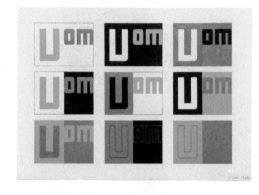

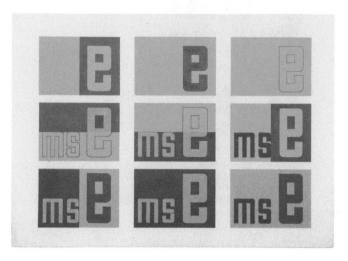

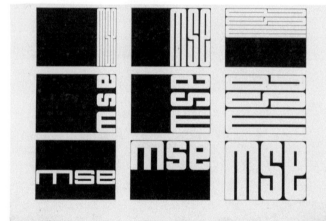

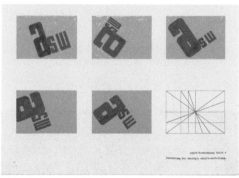

■336 **Theo Ballmer, untitled, arrangement of letterings,** **1930,** print, 29.7 × 42 cm, Freese Collection

■337 **Theo Ballmer, untitled, arrangement of letterings,** **1930,** print, 29.7 × 42 cm, Freese Collection

■338 **Theo Ballmer, untitled, arrangement of letterings,** **1930,** print, 27.2 × 42 cm, Freese Collection

■339 **Theo Ballmer, untitled, arrangement of letterings,** **1930,** print, 29.5 × 42 cm, Freese Collection

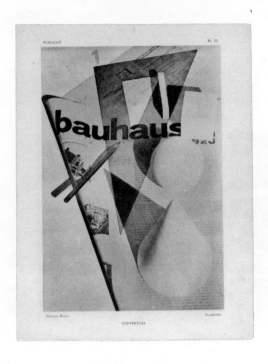

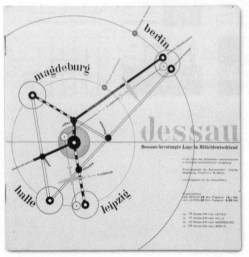

■ 340 **Herbert Bayer, design for an advertisement brochure, 1927,** letterpress, 29.7 × 21 cm, Vitra Design Museum Collection

■ 341 **Xanti Schawinsky, advertisement leaflet *Barasch ... der grosse Erfolg*, 1934,** letterpress, c. 29.7 × 21 cm, Vitra Design Museum Collection

■ 342 **Joost Schmidt, brochure of the City of Dessau, 1930,** letterpress on art paper, 23 × 23.5 cm, front and back covers, Vitra Design Museum Collection

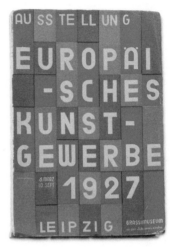

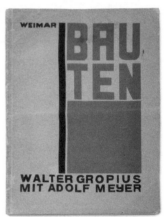

■343 **Joost Schmidt, title page**
Die Form, **year 1, issue 15, 1926**
letterpress, 29.7 × 21 cm,
Vitra Design Museum Collection

■344 *László Moholy-Nagy*, **title**
page *i10*, **no. 1, year 1, 1927**
letterpress, c. 29.7 × 21 cm,
Vitra Design Museum Collection

■345 **Herbert Bayer, exhibition**
catalogue *Europäisches*
Kunstgewerbe, **Leipzig 1927**
letterpress, c. 21 × 14.8 cm,
Vitra Design Museum Collection

■346 **László Moholy-Nagy**
(cover), Carl August Emge (text),
Die Idee des Bauhauses, Kunst
und Wirklichkeit, **1924,** letterpress,
cardboard, 22.8 × 15.6 cm, Alma
Buscher Estate, Freese Collection

■347 **László Moholy-Nagy (cover),**
Ernst Kállai (text), *Neue Malerei in*
Ungarn, **Leipzig 1925,** letterpress,
collage, 22.4 × 16.5 cm, Freese
Collection

■348 **Walter Gropius, Adolf Meyer,**
Bauten, **1925,** letterpress, 28 × 21.2 cm,
Lily Hildebrandt Estate, with dedication
"Der Protektorin!, Walter" [„To the
Protector, Walter!"], Freese Collection

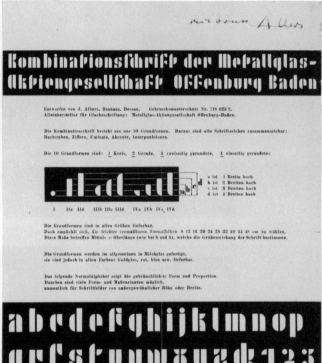

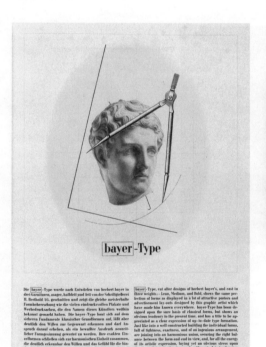

■349 **Herbert Bayer, font sample of Bayer-Type, 1936**
letterpress, 32.1 × 24.8 cm, Vitra Design Museum Collection

■350 **Josef Albers, brochure on combination lettering made of glass, 1930,** letterpress, 29.7 × 21.2 cm, with a dedication by Josef Albers, Walter Porstmann Estate, Freese Collection

Typography

#communicate

■351 **László Moholy-Nagy (letter paper), Herbert Bayer, letter to Dr Porstmann, Fabriknorm, 26 June 1925,** Walter Porstmann Estate, Freese Collection

■352 **Walter Porstmann, *Sprache und Schrift*, *Fundamente der Organisation* [Language and writing. Its fundaments and organization], ed. Dr Ing. Richard R. Hinz, 1920,** letterpress, c. 29.7 × 21 cm, Vitra Design Museum Collection

■ 353 **Hiroshi Sugimoto, MoMA, Bauhaus Stairway, 2013**
silver gelatin print, 61 × 50.8 cm, courtesy the Artist and Pace Gallery

PERCHÈ LA BAUHAUS E' COSÌ IMPORTANTE?

1) Perchè ebbe il coraggio di accettare la macchina come strumento degno dell'artista.

2) Perchè valorizzò il problema della "Forma Buona" per la produzione in serie.

3) Perchè il suo corpo insegnante fu composto da un numero di artisti eccezionali più che in qualsiasi altra scuola d'arte moderna.

4) Perchè creò il ponte sull'abisso che separa artisti ed industria.

5) Perchè eliminò la differenza di livello fra le arti libere e quelle applicate.

6) Perchè distinse nettamente fra ciò che si può imparare (capacità tecnica) e ciò che non si può imparare (il dono dell'invenzione creativa).

7) Perchè il suo edificio a Dessau fu l'opera architettonica più importante nella decade 1920 - 30.

8) Perchè giunse, dopo parecchi tentativi ed errori, a sviluppare una nuova concezione della Bellezza.

9) Perchè infine la sua influenza nel mondo intero è ancora attuale soprattutto in Inghilterra ed in U.S.A.

Citato da: "BAUHAUS 1919 - 1928 - Edizione III a 1953 VERLAG ARTHUR NIGGLI & WILLY VEREAUF - TEUFEN (SCHWEIZ).

PERCHÈ LA HOCHSCHULE FUR GESTALTUNG DI ULM NON E' UNA NUOVA BAUHAUS?

9) Perchè l'effetto delle sue dottrine si indebolisce di giorno in giorno per essere rimpiazzato da un eclettismo immobile ed empiristico.

8) Perchè la loro concezione della Bellezza è noiosa e senza alcun rapporto col desiderio di sensazionalità e sensorialità della nostra epoca.

7) Perchè l'edificio della scuola di Ulm è orientato verso i vecchi sistemi di costruzione senza aprire alcuna direzione nuova.

6) Perchè considera l'attività creativa come un dono divino ed individuale e non come volontà sperimentale.

5) Perchè sostituisce, al livellamento delle arti libere con le applicate, un rifiuto assoluto del diritto d'esistere all'arte libera.

4) Perchè vuol fare dell'artista il servo dell'industria invece di rendere l'industria mezzo di libertà artistica ed umana.

3) Perchè essa scuola è incapace di legare artisti eccezionali al suo carro.

2) Perchè i suoi maestri sono stati, dal problema della Forma Buona, resi ciechi a quello della Forma Nuova.

1) Perchè gli stessi furono incapaci di restituire agli artisti le macchine che sono i loro strumenti evidentemente giustificati, richiedendo una istruzione tecnica a chi voglia entrare nella loro scuola.

PERCHÈ IL MOVIMENTO INTERNAZIONALE PER UNA BAUHAUS IMMAGINISTA E' NECESSARIO

1) Perchè abbiamo il coraggio di chiedere le macchine come strumento e gioco per gli artisti liberi.

2) Perchè abbiamo, per la prima volta, risolto in maniera razionale il problema del rapporto fra la creazione individuale e la produzione in serie.

3) Perchè siamo in grado di attrarre più artisti eccezionali nella nostra direzione di qualsiasi altro movimento artistico dopo la guerra.

4) Perchè sostituiamo le tradizioni artigianali morenti con creazioni tecniche (artistiche) libere ed imponiamo i problemi artistici direttamente all'industria.

5) Perchè abbiamo svelato l'inutilità di molte arti ed usi applicati e la necessità e funzionalità psichica delle arti libere.

6) Perchè consideriamo l'attività creativa non come un dono divino ma come una capacità, rinforzata dalle esperienze nuove ed inattese, metodologicamente indirizzate.

7) Perchè i risultati delle esperienze dell'Incontro internazionale della ceramica ad Albisola nel 1954 hanno già dimostrato la nostra capacità di trovare nuove prospettive nel nostro dominio.

8) Perchè abbiamo creato una nuova teoria estetica, superiore a quelle esistenti, mediante la considerazione che il non - estetico non è il Brutto e il Ripugnante ma l'Insignificante ed il Noioso.

9) Perchè il Movimento internazionale per una Bauhaus immaginista è la sola tendenza artistica che è stata capace di riunire differenti forze creative della nostra epoca (Cobra - Nucleari - Lettristi - ecc.) nella direzione iniziale di prospettive lungimiranti ed effettive.

COSA NOI VOGLIAMO

Nel 1951 fu inviato ad un gran numero di Università, Biblioteche, Istituti e Musei di tutto il mondo, un invito firmato dal Direttore dell'Università di Columbia - USA - il generale attualmente presidente Eisenhower. In questo invito si richiedeva di partecipare ad una indagine internazionale sulle "condizioni di libertà della ricerca e dell'espressione scientifica". Si indicava come la libertà della ricerca e dell'espressione scientifica sia considerata "fondamentale per la libertà e il benessere dell'Umanità"; ciò accadendo, per i popoli civilizzati, da parecchi secoli e come "questa libertà subisca oggi attacchi seri e sistematici in molti paesi".

La libertà ed il benessere sono concezioni molto vaghe ma la libertà di ricerca ed espressione scientifica è cosa ben precisa. Noi siamo arrivati, nello studio di questa questione, ad uno sconfortante risultato: *che la più grande minaccia contro la libertà della ricerca e dell'espressione scientifica è presente a partire dall'esperienza dello stesso perfezionamento dell'appato scientifico - e dal pregiudizio professionale che impone l'impianto delle facoltà scientifiche.* Ciò accade sotto non importa quale regime politico.

La debolezza del metodo di "obiettività scientifica", sta nel fatto ben noto che la pagliuzza nell'occhio del prossimo è assai più visibile che non il trave nel proprio.

Probabilmente è per questo motivo che noi aspettiamo ancor oggi, nel 1956, la risposta a quel problema, attualissima ed importante, che avrebbe dovuto esser data e pubblicata in occasione del cinquantenario dell'Università di Colombia nel 1954.

Noi abbiamo in quell'occasione inviato a questa Università le nostre riflessioni su quel problema: la secolare libertà dell'espressione scientifica - che in sé, in quanto metodo, non può portare al benessere dell'Umanità altro che tramite le bombe atomiche - è seriamente minacciata se non la si completi col suo metodo inverso "la libertà della ricerca e della espressione artistica".

Noi siamo consapevoli che il metodo della ricerca soggettiva (artistica) soffre di una debolezza altrettanto grave - per lo più ignorata - di quella dell'obiettivazione scientifica; ciò è causato dal fatto che una piccola spina nel proprio sedere è più dolorosa che non il colmo del letto sulla testa del proprio vicino. E' tuttavia nostra convinzione che i due metodi si completino. E' per proporre questo metodo della ricerca artistica che noi abbiamo fondato il Movimento per una Bauhaus immaginista.

Noi esigiamo gli stessi mezzi e possibilità economiche e pratiche delle quali già si servono le ricerche scientifiche naturali con formidabili risultati.

La ricerca artistica è identica alla "scienza umana", ciò che per noi è la scienza "interessata" non la scienza puramente storica. Questa ricerca deve essere condotta dagli artisti coadiuvati dagli scienziati.

Il primo Istituto costituito a questo scopo nel mondo intero è il laboratorio sperimentale per ricerche artistiche libere fondato ad Alba il 29 Settembre '55. Tale laboratorio non è un Istituto d'insegnamento, esso non serve che ad offrire nuove possibilità al Maestro nel suo campo di esperienza.

I Direttori dell'antica Bauhaus erano grandi maestri, di capacità "eccezionali, ma pessimi pedagoghi. Le opere degli allievi, non erano se non scimmiottature pietose sui modelli dei loro maestri. L'influenza di questi fu indiretta, occasionata dalla forza dell'esempio: Ruskin per V. d. Velde, V. d. Velde per Gropius.

Ciò che diciamo non è per nulla un criticare, soltanto una constatazione da cui si possono trarre le conclusioni seguenti:

- Il trasferimento diretto dei doni artistici è impossibile, l'adattamento artistico si opera attraverso una serie di fasi contraddittorie: SBALORDIMENTO - MERAVIGLIA - IMITAZIONE - PROTESTA - TENTATIVO - ADEGUAZIONE.

Nessuna di tali fasi può essere evitata benchè non sia necessario che esse siano tutte attraversate da un individuo solo.

La nostra conclusione interessata: noi abbandoniamo ogni tentativo di azione pedagogica per orientarci sull'attività sperimentale.

COS'È LA BAUHAUS? MAR-00094

La Bauhaus è una risposta alla domanda:
Quale "educazione" è necessaria per l'artista, affinchè egli possa occupare il suo posto nell'età della macchina.

COME E' SORTA L'IDEA DELLA BAUHAUS?

Essa è sorta come una "scuola" in Germania; prima a Weimar in seguito a Dessau, fondata dell'architetto Walter Gropius, nel 1919 - distrutta dai nazisti nel 1933.

COS'E' IL MOVIMENTO INTERNAZIONALE PER UNA BAUHAUS IMMAGINISTA?

E' la risposta alla domanda DOVE E COME trovare un posto giustificato per l'artista nell'età della macchina.
Questa risposta dimostra che l'educazione data dall'antica Bauhaus è falsa.

COME E' NATA L'IDEA DI UN MOVIMENTO INTERNAZIONALE PER UNA BAUHAUS IMMAGINISTA?

Esso è nato come movimento di protesta, fondato dal pittore Asger Jorn nel 1953 a Villars - Svizzera, contro il programma di una nuova Bauhaus ad Ulm - Germania, dell'architetto Max Bill. Esso si è realizzato nel "laboratorio sperimentale", per una Bauhaus immaginista ad Alba sotto la direzione tecnica del Dott. G. Gallizio e attraverso la pubblicazione del periodico "ERISTICA", redatto da P. Simondo - Alba (Italia) Via XX Settembre 2.

■ 354 **Mouvement international pour un Bauhaus imaginiste,** *Perché la Bauhaus e cosi importante?*, **1956,** letterpress, 22 × 30 cm, Vitra Design Museum Collection

What do you consider the most important innovations/merits/ideas of the Bauhaus?

It recognised the potential of design as a political tool

■ 355 **Thomas Lommée, Bauhaus interview, 2015**, handwriting on paper, 29.7 × 21 cm, courtesy Thomas Lommée, Intrastructures

Are there any ideas of the Bauhaus that are still/again relevant today?
(in celebration with Carsten Höffner.)

YESTERDAY
(BAUHAUS)

- as a reaction to the emergence of new technologies that are introducing the mechanical era.
- democratisation of the industrial product
- design for the owner
- the design is grey anonymous
- the designer as a genius
- Montagne!
- the customer as a consumer
- the home as a "living & habitat"

- designing from a belief in the future.

A.

TODAY.

- as a reaction to the emergence of new technologies that are introducing the digital era.
- democratisation of the industrial future
- design by the owner.
- the designer is asking questions
- the designer as researcher
- Dialogue

- the customer as a participant
- the home as an "Atelier & habitat"

- designing from a reflection about / the future

B.

- linear (static), vertical and closed designs

- design for 'eternity'! (i.e. timeless design)

- production of 1000 identical copies of the same design

- expiring (sudden) revolution

- cyclical (dynamic), horizontal and (new) open designs

- design for change (integrating time within design)

- production of 1000 different versions of the same design.

- expiring continuous evolution!

B.

THOMAS LOMMÉE – 2018

My engagement with the Bauhaus can be likened to the gradual development of a relationship from acquaintance to friendship — one that involves the sharing of values, aspirations, desires and goals every step of the way.

Knowledge of the Bauhaus was not a salient feature in my art/design education at the Yaba College of Technology in Lagos, Nigeria. I don't recall the lecturers talking about the Bauhaus or what it stood for. My first engagement with it was through a classmate for whom it represented an ideal — the highest level of technical excellence in design. His enthusiasm wasn't backed up by any deep knowledge, but was largely derived from his perception of what is good and beautiful — he had a part-time job at an architectural firm where he had seen some Bauhaus images. His fascination was contagious and I made a mental note to find out more.

My second engagement with the Bauhaus was in April 2006, with Jeremy Aynsley's book *A Hundred Years of Graphic Design: Graphic Design Pioneers of the 20th Century*. In a brief history of the Bauhaus, it presented biographies of László Moholy-Nagy and Herbert Bayer and images of their work. I was fascinated by its timeless quality.

While my first engagement with the Bauhaus presented it as an ideal, my second made me realize it was a school and also made me aware of the importance it gave to craft, making through experimentation, self-promotion, connection with industry and the value of a philosophy guiding the creation of work. I had become really interested in framing a philosophy for my work and a book I got from my parents was helpful in this regard. *100% Cotton: T-Shirt Graphics by Tim Fletcher and Helen Walters* introduced me to a world of urban contemporary art and some of the artists shaping the culture: Shepard Fairey, Dave Kinsey, Takashi Murakami, etc. The book made me see drawing as a tool, a means to an end; the importance of collaboration, and the benefits of engaging with industry to make work accessible and visible. This multidisciplinary, collaborative approach to creating was also one that the Bauhaus accommodated. In this sense, the Bauhaus has been a reinforcer of known ideals and a major indirect influence in my life as a designer.

The Bauhaus has been like that "behind the scenes" person who has a pervasive influence on your life but without your being deeply conscious of the impact they are having on you. I say this because my most memorable engagement with the Bauhaus happened while researching material for the writing of this essay.

I came across a thesis by Miette Bretschneider, "The Bauhaus: Understanding its History and Relevance to Art Education Today". She highlighted how the Bauhaus's approach was quite similar to the education she had received at East Tennessee State University. As I read, I realized that the Bauhaus approach, specifically the Vorkurs, was also quite similar to the method of training at Yaba College.

Our introduction consisted of a two-year general arts programme in which students were exposed to different disciplines – textile design, graphic design, basic design, ceramics, sculpture, general drawing, life drawing, technical drawing and painting. There was a heavy focus on craft and the development of technical skills. After the first year, students had to engage with industry via an internship for three months, then return to college for another year before a second industrial training programme, this time for a year. They then had the option of going back to college for a two-year diploma in a specialized course of study in fine arts, graphic design, fashion or textile design.

Students also took "non-art" courses in cost estimation, international relations, psychology, entrepreneurship development, etc. I believe that the Bauhaus has remained relevant because of its unique, inclusive approach to education that favours

a connection between academia and the real world of industry, a connection between expressiveness and functionality. It is an education that recognizes the importance of collaboration, independence and interdependence. This approach fits well in the current climate, which favours the blurring of lines between disciplines, the free flow of ideas and the democratization of making. The documentation of the output of the Bauhaus via archives, books and exhibitions has also lent a lot of weight to its continued relevance through the years.

When I think about the Bauhaus, I think about an attitude that encourages the formation and cultivation of possibilities within the context of everyday living. It has now become the friend I look forward to knowing better in as many capacities as possible.

KARO AKPOKIERE, GRAPHIC DESIGNER

363

We shouldn't limit ourselves to the Bauhaus style, but think Bauhaus.

MIRO, DESIGNER

■ 356 **MIRO**, still life *Square and Circle*, 2015
digital print

■ 359 **MIRO**, still life *Look and See*, 2015
digital print

■ 357 **MIRO**, still life *Intersection and Destination*,
2015, digital print

■ 360 **MIRO**, still life *Square and Circle*, 2015
digital print

■ 358 **MIRO**, still life *Stars and Stripes*, 2015
digital print

All Images: courtesy MIRO

#communicate

365

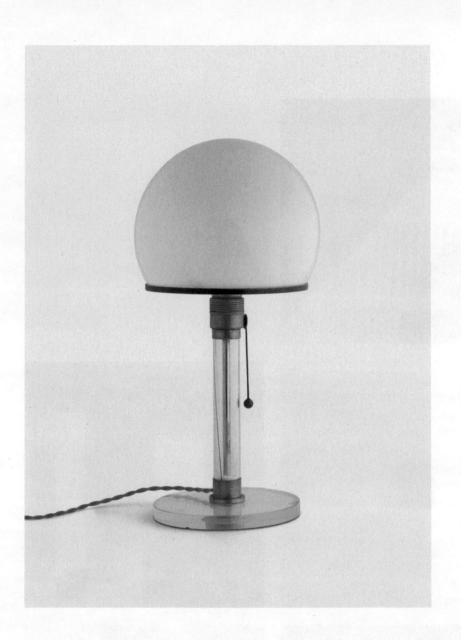

■361 **Wilhelm Wagenfeld, table lamp ME1/MT9,
1923/1924,** brass, glass, 39.3 × 20 cm, private collection,
courtesy Galerie Ulrich Fiedler

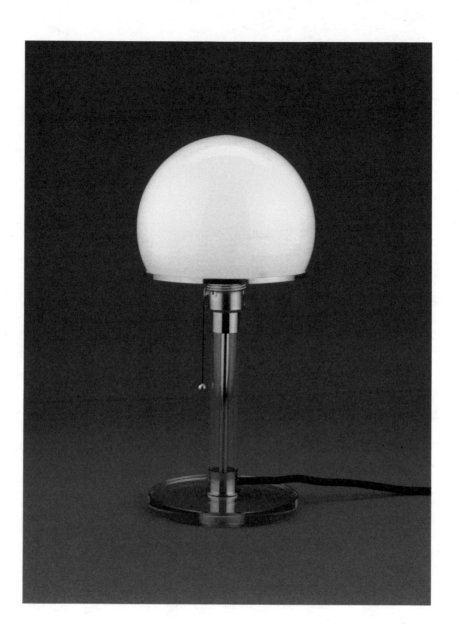

■362 **Wilhelm Wagenfeld, table lamp ME1/MT9, table lamp, 1923/1924,** glass, brass, 36×18×18 cm, (reproduction Tecnolumen), Vitra Design Museum Collection

The *Bauhaus Paradox*
Philipp Oswalt and Julia Meer

For many people, the Bauhaus lamp is a perfect embodiment of the Bauhaus concept — a modern, functional and well-designed utility object of the Industrial Age. And yet closer inspection reveals that this impression is, in fact, deceptive.

1. The Bauhaus lamp is not modern: unlike its contemporaries, it did not make use of the new options for electric lighting available at that time. Light bulbs allow more targeted illumination since flames and fire residues are eliminated, and so light no longer has to face upwards but can also be directed downwards; added to which, electric lamps are movable ■363 ■364. As a modern restyling of the oil and paraffin lamps of the nineteenth century, the Bauhaus light was therefore an anachronism ■365. Even its glass stand is a reference to classic form — but without purpose, since you no longer needed to be able to look through the glass to find out how much paraffin remained.

2. The Bauhaus lamp is not functional: The Bauhaus advertised it as a work and bedside lamp, and presented it within these settings at exhibitions ■366. However, due to its small light beam, which shines only downwards on to its base, it is unsuitable for those purposes; it is instead employed chiefly as decorative mood lighting. It is therefore not surprising that the Bauhaus advertisement depicts an unlighted lamp — not in use, but virtually in the form of a sculpture ■367.

3. The Bauhaus lamp is not an industrial product: it was made by hand. The intention was that its practicality should embody the unity of art and technology, serving as a symbol of a new industrial culture. However, in actual fact not only was the prototype produced by hand but indeed the whole first series of around 100 saleable items were carefully crafted at the metal workshop of Bauhaus in Weimar ■368. The almost medieval-looking workshop was equipped as a silversmith's with tools from the Weimar Court Jeweller Theodor Müller; it did not even have an electric drill.

Even today the design of the lamp requires individual production by hand, which is also why it costs so much. Only fake replicas can be manufactured on an industrial scale, selling at a tenth of the price ■369.

Owners of the lamp are well aware of all this, and yet it does not detract from their enjoyment of it. The lamp has – as soon became apparent when it first appeared – quite another purpose. Its forerunner was designed as a showpiece for the first Bauhaus exhibition in 1923 in Weimar. Following initial critical reviews it was redesigned, then displayed widely in museums, at trade fairs and in show apartments ■370. As an exhibit, it was intended to represent the Bauhaus's work and a modern conception of design.

To this day, scarcely a single Bauhaus exhibition (or indeed any aspiring interior design shop) would fail to include the Bauhaus lamp. In contrast, the Kandem light designed just a few years later by the Bauhaus met with far less interest, although its industrial manufacture makes it functional and inexpensive, thus fulfilling Bauhaus ideals ■371. And yet this is not the point. No one expects the Bauhaus lamp to be a practical work or reading lamp. It is instead an avowal of the Bauhaus concept and the notion of "good design" – and thus its ideational significance assumes greater importance than its mundane everyday function. As a pleasing, illuminated sculpture it symbolizes a way of thinking,

The Bauhaus Paradox

fits into many contexts and does not take up a lot of space. Its practical value lies in a symbolic function, and as such it is highly effective. As a classic it is firmly inscribed into our consciousness and has developed a second life as a media icon. Film clips, advertisements and pictograms effectively convey its symbolic function — even without any kind of physical materialization ■372 ■373.

■ 363 **Table lamp pointing downwards**, as depicted in Géza von Boleman, "Über elektrische Schreibtischlampen", in *Licht und Lampe*, 1928, no.16, p. 560

■ 364 **Flexible table lamp pointing downwards**, as depicted in Géza von Boleman, "Über elektrische Schreibtischlampen", in *Licht und Lampe*, 1928, no.16, p. 560

371

■ 365 **Franz Seraph Stirnbrand, portrait of Karl Seydelmann, 1830**, oil on canvas, 109 × 91 cm, Kunsthalle Bremen – Der Kunstverein in Bremen, photograph: Lars Lohrisch

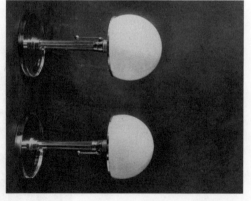

Philipp Oswalt and Julia Meer

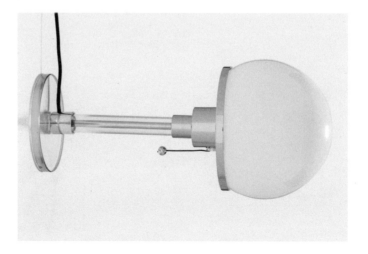

373

■ 366 **Deutsche Bauausstellung Berlin 1931**, in *Die Form*,
1931, p. 244, photograph: Berliner Bildbericht

■ 368 **Unknown, work rooms of metal workshop,
Bauhaus Weimar, 1923**, silver gelatin print, 16.8 × 22.5 cm,
modernist archives/bauhaus-university Weimar

■ 367 **Lucia Moholy, photographs of the Bauhaus
lamp, 1924–1925**, silver gelatin print, 17.1 × 12.5 cm,
Bauhaus-Archiv Berlin

■ 369 **Plagiarism of the Bauhaus lamp,
ikarus Design Handel,** www.ikarus.de,
photograph: Peter Porst

Philipp Oswalt and Julia Meer

■ 370 **Showcase with products of the metal workshop at the exhibition** *Europäisches Kunstgewerbe,* **Grassi-Museum, Leipzig 1927**

■ 372 **Ott + Stein, Jucker/Wagenfeld Lampe, 1995,** Kunstsammlungen zu Weimar, Poster DIN A1, courtesy Ott + Stein

■ 371 **Marianne Brandt, Hin Bredendieck, bedside lamp no. 702 for Kandem, 1928/1929** enamelled sheet metal, 24×14×25 cm, Vitra Design Museum Collection

■ 373 **Bauhaus lamp as a bonus for subscription to** *Die Zeit,* courtesy Die Zeit

Jucker · Wagenfeld

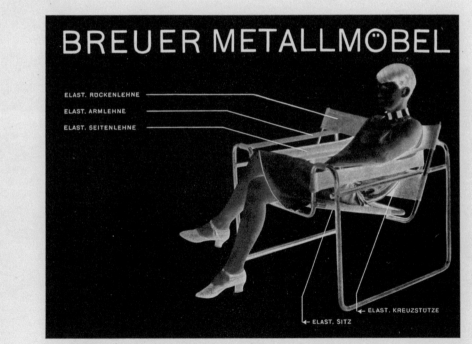

■ 374 Unknown, magazine *Das Zelt, Blätter für gestaltendes Schaffen,* **1930,** letterpress, c. 29.7 × 21 cm, Vitra Design Museum Collection

■ 375 Marcel Breuer, lounge chair B3, **1925,** chromium-plated steel tube, polished yarn, 73 × 77.7 × 71 cm, Vitra Design Museum Collection

■ 376 Herbert Bayer, brochure *Breuer Metallmöbel,* **1927,** letterpress, 21 × 14.8 cm, Vitra Design Museum Collection

■ 377 **Alessandro Mendini, Wassily chair from serie,**
Redesign di sedie del movimento moderno, 1978
leather, chrome-plated steel tube, 80 × 87 × 65 cm,
Vitra Design Museum Collection

377

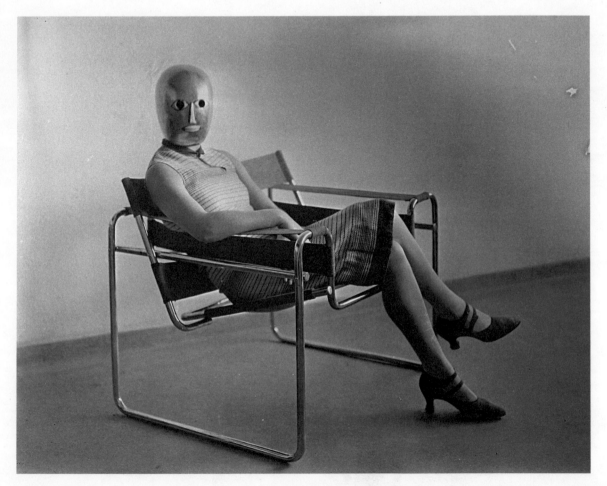

■378 **Erich Consemüller, Woman in B3 club chair by Marcel Breuer wearing a mask by Oskar Schlemmer, 1926,** photograph, 9 × 12 cm, Bauhaus-Archiv Berlin (reproducion c. 1967)

The Bauhaus has been one of the most radical, changing, aesthetic concepts. Probably ever.

TOBIAS REHBERGER, ARTIST

I like to think that I have not in any way been influenced by the Bauhaus — apart from the knowledge that it exists in a space very far removed from where I am.

LUCINDA MUDGE, DESIGNER

Essays

the bauhaus

Everything is Designed
Bauhaus ideas in context
Jolanthe Kugler

Essay

383

"I am increasingly convinced that anyone wishing to begin something completely new nowadays must come to terms with the totality of life,"[1] concluded Walter Gropius some six months after the Bauhaus had started as a school. With this, he yet again underlined in red, so to speak, what moved him and what he believed to be the essence of his new art school ■379.

The Staatliche Bauhaus emerged from the fusion of two academies: the Grand Ducal Art School and the Grand Ducal School of Arts and Crafts, founded by Henry van de Velde in 1907. On 11 April 1919, Walter Gropius signed a contract, backdated to 1 April, by which the Lord Steward of the Household, Hugo Freiherr von Fritsch, appointed him director of the Grand Ducal Art School from the summer semester of 1919 ■380. On 12 April 1919, the provisional Republican government authorized the new name proposed by Gropius: Staatliches Bauhaus or the State Bauhaus. The Bauhaus, however, had not been Gropius's initial intention, for he had originally planned to establish a masons' guild, then a masons' round table.[2]

According to the 1926 State Directory of Thuringia, the school's purpose was to provide "higher education to artisans and architects on a joint basis with regard to technical as well as artistic aspects."[3]

The Staatliches Bauhaus thus strove to train a new type of designer who would learn a handcraft in the school's workshops while also receiving tuition on basic artistic work with forms, colours, materials and perception. This was intended to enable students to develop a feeling for contemporary aesthetics in close cooperation with industry and, at the same time, encourage them actively to shape society by designing items ranging from daily commodities to houses and housing developments.

Barely six years later, in 1925, the Weimar Bauhaus had to close down owing to political pressure; it reopened in the industrial city of Dessau. For Gropius, however, Dessau was just a brief intermezzo ■381. In 1928 he left the school, now known as the School of Design, handing over his post to the Swiss architect Hannes Meyer, who had been appointed the previous year to organize the long-planned architecture department ■382.

The focus of the Bauhaus changed considerably under Meyer's directorship, now concentrating on "mass requirements instead of luxury", process standardization, standardization, serial and mass production. Meyer was also politically active and sympathetic towards left-wing ideologies which, in the end, brought about his downfall. He was dismissed from his post in 1930 due to a right-wing shift among leading government

Jolanthe Kugler

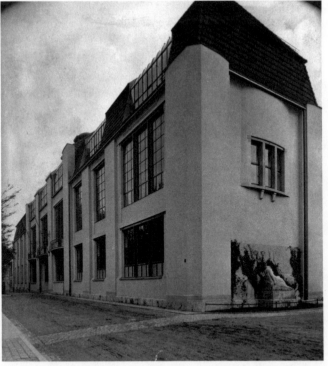

■379 **Lucia Moholy, portrait of Walter Gropius, 1925**
silver gelatin print, 23.7 × 18.2 cm, reverse signed by
Lucia Moholy, Freese Collection

■380 **Henry van de Velde, Kunsthochschule Weimar,**
c. 1912, modernist archives/bauhaus-university Weimar

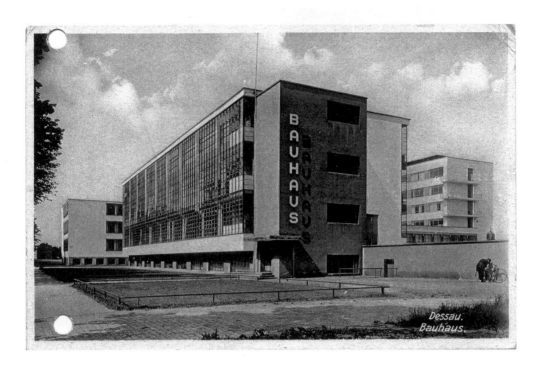

■ 381 **Unknown, Bauhaus Dessau, c. 1927**
photograph, 9.1 × 14 cm, Stiftung Bauhaus Dessau

■ 382 **Umbo, portrait of Hannes Meyer, 1924,** vintage
silver gelatin print, 17 × 23.1 cm, Freese Collection

Jolanthe Kugler

■383 **Fritz Schreiber, portrait of Ludwig Mies van der Rohe, farewell excursion of the Bauhaus members on the Havel, 15 July 1933,** silver gelatin print, 14.1×10.2 cm, Bauhaus-Archiv Berlin

■384 **Howard Dearstyne, Bauhaus Berlin (building of a former telephone factory in Berlin-Steglitz), 1932–33,** silver gelatin print, 12.7×17.9 cm, Bauhaus-Archiv Berlin

officials in Dessau. Mies van der Rohe was appointed the Bauhaus's third and last director ■383 who deliberately tried to keep the Bauhaus out of politics. Due to temporary financial hardships during his leadership, the workshops' agency and productivity became increasingly limited. Consequently, the Bauhaus became a school of architecture without any social or political ambitions. None the less, some two years later, increasing pressure from the Nazi government forced the Dessau Bauhaus to close down. After relocating to Berlin, Mies van der Rohe attempted to run the school as a private institute, but to no avail ■384. Only months after Hitler seized power in Germany, the Bauhaus was forced to close for good.[4] It is all the more astonishing, therefore, that the Bauhaus was able to achieve so much in such a short time under such unfortunate conditions, not only in terms of its amazing productivity, but also in view of its influence on twentieth-century design issues. Moreover, the Bauhaus continues to fascinate us to the present day.

The end and a new beginning

Essentially, the Bauhaus stood at the end of one development and at the beginning of a new one. Developments had come to a temporary close with the concepts that Walter Gropius defined and laid down in the 1919 founding manifesto (■026 p. 98). This sheds light on the numerous efforts of artists (including architects) who, since the mid-nineteenth century, had been searching for novel, adequate ways to face the challenges of industrialized mass production and to create a new type of artist-designer who would be a creative shaper and former. It was only later on that a distinction was made between "architect" and "designer".[5] At first, the Bauhaus tried to realize the concepts of its precursors such as the Arts and Crafts movement, established by Ruskin and Morris, who firmly believed that "to endow daily commodities with quality ... is surely a question of social conscience before it can become a matter of design."[6] The manifesto clearly reveals the ideas of the art school reform as well as of the Deutscher Werkbund (German Association of Craftsmen), and above all of the Arbeitsrat für Kunst (Workers' Council for Art), for whom Walter Gropius had already compiled a paper in March 1919. Most parts of that paper's text correspond to the manifesto and programme of the Bauhaus published one month later.[7] All of them strove to unite art and handcrafts, demanding that art should break free from its isolation and return to people's daily lives. "First and foremost we declare that art and the people should unite to form a whole. Art should no longer be a privilege of the few, but the happiness and reality of the masses."[8]

Just as contemporary Walter Dexel had critically noted in the 1920s, the Bauhaus did not spark the "architectural and creative development that had commenced almost simultaneously in many European countries", but rather had itself been "carried away by that development".[9] Aware of that fact, Walter Gropius stressed that the Bauhaus had nothing to do with a revolution and breaking with traditions. On the contrary, the Bauhaus intended to continue to foster existing developments that had begun so promisingly before the First World War had interrupted them. The Bauhaus was not to be understood as a utopian experiment or "original concept",[10] but as a concrete effort to enhance existing tendencies. In his speech to the Thuringian State Diet on 9 July 1920 as an appointed government representative in his capacity as "government commissioner",[11] Gropius justified the educational philosophy of the Bauhaus, arguing that numerous other institutions and prominent individuals had made similar demands on art education or had themselves attempted to implement them.[12]

In 1919, however, the Bauhaus was the first school to put those ideas vehemently into practice. As a workshop school with dual methods (theory and practice, basic artistic

education and training in handcrafts), it was the first to build art education upon the foundation of handcrafted work, with architecture at the top as a synthesis of all the arts. At the same time, the Bauhaus strove to renew society by means of design, providing a whole range of artistically valuable products and even shaping people's everyday lives.

Words that had been familiar in the Middle Ages such as apprentice, journeyman and master were used to replace professor and student, thus breaking with the academic self-conception of the past.[13] By placing free and applied arts, master and apprentice, master craftsman and master designer equally side by side, Gropius envisioned an egalitarian society that would develop new solutions in a democratic collective.[14] At the same time, both arts would remain independent and eventually reunite as a greater whole beneath the roof of architecture. Lyonel Feiniger's woodcut on the cover of the manifesto illustrates those ambitions, with the cathedral representing handcrafts as a foundation. Three stars crown its three towers, the two lower ones symbolizing free and applied arts, the third star representing architecture appearing high above them in the centre of the image.

Gropius's reference to medieval symbols and words was by no means out of the ordinary. Quite a number of theories and publications testify to in-depth study of medieval ideals such as Oswald Spengler's *The Decline of the West*, which depicts the Middle Ages as the cradle of German culture. That epoch was regarded as exemplary with its anti-materialism, cultural synthesis (cathedral building) and (alleged) social harmony. Seen as a contrast to the failed imperial ambitions and expansive policy of the Wilhelmine period, which finally culminated in the First World War, that perspective became extremely popular.

Nevertheless, despite existing similarities and the will to continue a tradition, the Bauhaus still differed from its precursors and contemporaries. The English Arts and Crafts movement, for instance, was more restorative. Its founder William Morris, one of the fathers of design and among the last so-called utopian socialists, advocated a return to handcrafts and rejected industrial methods. On the other hand, the Dutch Artists Association De Stijl, founded in 1917 by Theo van Doesburg and Piet Mondrian among others, regarded itself as an aesthetic and social utopia, rejecting handcrafts in favour of the machine ■385. Constructivists such as El Lissitzky, Kasimir Malevich and Wladimir Tatlin, by contrast, chiefly developed social-aesthetic theories with the goal of satisfying the basic needs of the wider population.[15] What they had in common with the Bauhaus, though, was their belief that architecture was the mother of all arts ■386.

The Bauhaus rejected neither industrial manufacture nor handcrafts, nor did it favour one over the other. It saw the "machine as a shaping tool"[16] and – in a relationship between handcrafts and industry and the reconciliation of art, technology and science – as a suitable means of applying highly qualitative traditional handcrafts to industrial methods, thus fulfilling the social necessity to provide well-designed products for everyone.

However, the following statement by Hannes Meyer, the second director of the Bauhaus from 1928 to 1930, shows that its chosen direction had not always met with approval. Meyer, who established a new architecture department at the Dessau Bauhaus in 1927 based on sound systematic and scientific educational methods, firmly believed that, on a social level, architecture and design should cater to the needs of ordinary people: *"What did I find upon my appointment? The Bauhaus had a reputation that by far surpassed its productivity, the former being the object of an unprecedented advertising campaign. A school of design that transformed simple tea glasses into a problematic constructivistelizing thing. One lived in the coloured sculptures of houses. Their floors were spread with the emotional complexes of young girls like carpets. Art is strangling life everywhere."*

[17] As a consequence, he sacrificed the "art for art's sake" experiments and artistic self-gratification of the Bauhaus's initial phase in favour of a stronger focus on process

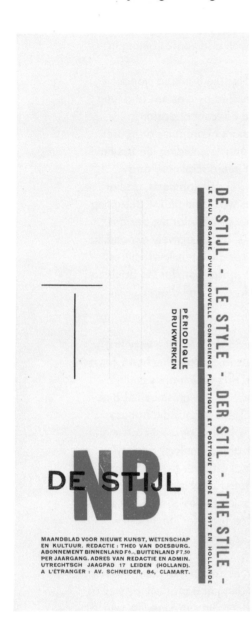

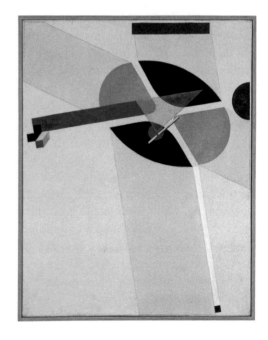

■385 **Theo van Doesburg, adhesive tape by the artist group De Stijl, c. 1920,** letterpress, 15.7 × 36.9 cm, Vitra Design Museum Collection

■386 **El Lissitzky, *Proun G 7, 1923,*** distemper, tempera, paint and pencil on canvas, 77.2 × 62.2 × 2.3 cm, bpk/ Kunstsammlung Nordrhein-Westfalen, Düsseldorf/Walter Klein

standardization, standardization of types, serial and mass production, thus largely relinquishing the Bauhaus's original concept of an art school with additional training in handcrafts.

At the same time, with its comprehensive design philosophy, the Bauhaus stood at the beginning of a development that was temporarily interrupted by closures and long belittled, but that was called for time and again: an "extended concept of design". A concept that not only grasped the idea of designers as creators of products or houses, but as protagonists of social change. Central figures of modernity – including the Bauhaus – were convinced that design (*Gestaltung* in German) was an interdisciplinary and multidimensional process, bound to both technological and social developments, and active shaper of the latter. Hence the power to shape social structures was connoted to designing objects, resulting in a far-reaching professional and ethical responsibility for the designer. His or her role was not meant to be confined to shaping objects, but by actively expanding it into the realms of shaping organizations, institutions, political and economic structures, the designer would become an agent of social change. In that sense, then, for the Bauhaus all socially relevant issues were a matter of shape – and therefore, "it's all design".

A volatile design concept

"Design" as a word has always been in a state of flux. Leonardo da Vinci, the very first designer, if you like, embodied the inventor-designer. Giorgio Vasari, on the other hand, forged the artistic idea of *disegno*, thus becoming "father of the three arts, which are painting, sculpture and architecture". English encyclopaedias have specified design since 1588 as a "plan or scheme of something that is going to be realized". The Bauhaus did not use the terms "design" or "designer", but spoke of shaper, shaper of forms or artist-craftsman. By providing education that would enable designers to master art, technology and style, the Bauhaus laid "the foundations for transforming professional practice from traditional craftsmanship to industrial design".[18] The name "industrial designer" that is in use today is said to have been coined in 1948 by Mart Stam. It was attributed to designers who worked for industry, i.e. it defined the role of the designer as a "service provider" to industry. Hence, according to Sigfried Giedion, design also represented styling, reducing the designer to a mere shaper who let technology disappear into a box.[19]

In 1977, the Berlin Designzentrum formulated a definition of design that pleaded for the visualization of the specific character, function and handling of a product, as well as for the consideration of technical developments and issues concerning sustainability and ergonomics. In his speech at the 1987 documenta 8, Michael Erlhoff called for design to be "socially functional, significant and representational, in contrast to art". Design theorist Bernhard Bürdek was in favour of concentrating more on defining tasks instead of just defining terms[20] – thus coming close to the concept of the Bauhaus: "Our efforts aimed to find a new attitude that would allow participants to develop creative awareness, and finally lead them to a new philosophy of life."[21] The designer was therefore not to be drilled to fulfil a certain role, but to identify himself with his work and create his very own professional role.

Understood in its capacity as an all-embracing shaping assignment, design, according to Walker, is "a form of politics in the most general sense [...]: the human race is constantly struggling to shape environment and society in such a way that its needs are satisfied. Hence we can legitimately conclude that design also encompasses shaping political structures and economic systems."[22] In this sense, "politics" can be understood as active participation in social reform and not the doctrine of a party programme. It also means that everyone can become a shaper – whether he or she does it consciously (expert design), or subconsciously

(diffuse design).[23] When "humankind [transforms] the earth in an alloplastic way, until it fulfils all needs and desires", it is time for the designer to step in to take "responsibility for the task of shaping and reshaping it."[24]

Extended design concept

When the Bauhaus closed, its comprehensive understanding of design initially narrowed. The designer became a service provider within an industry that was focused purely on using design to increase the market value of its products. Over the decades, and above all after the Club of Rome's report on the "Limits to Growth" (1972), numerous well-known personalities began to fight against this approach, attempting to place a renewed focus on social issues.

Viktor Papanek called for designers to focus "on planning an environment fit for all people". [...] In an age of mass production [...], design has become the most powerful tool with which man shapes his tools and environments (and, by extension, society and himself). This demands high social and moral responsibility from the designer [...] and more insight into the design process by the public."[25] He was convinced that "it is crucial for designers to understand clearly the social, economic, and political background of what they do"[26] and that design "can and must" become a way to "change society"[27] ■387.

In 1980, Lucius Burckhardt published his essay "Design ist unsichtbar" [Design is invisible], a manifesto on post-industrial society. He made the criticism that "designers divide the world into products instead of problems", thereby becoming "deliverers of ideas who are free from responsibility". He was convinced that design had to take into account primarily the "system of relationships between people" because "interpersonal systems are designed partially by history and tradition but also by people living today."[28] He used workplaces as an example, as these are "designed, not only by a designer in the traditional sense, but also by the way in which some activities are removed from the workplace, competences are divided up or taken away and cooperation is promoted or prevented." Invisible design refers to "the design of tomorrow, which is capable of consciously taking into account an invisible overall system consisting of objects and interpersonal relationships".[29]

Enzo Mari's *autoprogettazione* did not criticize the term "design" itself or the role of the designer, but rather the attitude of the consumers. As consumers usually do not have any design training, it is difficult for them to judge good design. With *autoprogettazione*, he provides consumers with the tools needed to learn about the principles of design and quality, thereby giving them the skills needed to design themselves in a small way, meaning that they are able to recognize and appreciate good design ■388.

Ezio Manzini's publication is a recent contribution.[30] For him, design is primarily a process during which unconscious *diffuse* or conscious *expert* design emerges. Like Papanek, he believed that this would ensure that all people would participate in design, although his "all" also referred to organizations, companies, public administration, towns, regions and nations. While it was possible to concentrate on physical products during the beginnings of industrial design, designers today work on organizational structures, interaction services and experience design. Many of these tasks involve complex social and political questions and require designers to be able to deal with these topics ■389.

Papanek, Burckhardt, Mari and Manzini therefore called and still call for a new definition of design which does not allow designers to restrict themselves to creating new versions of "thing(s) with such a high level of symbolic value and such a low level of imagination involved as cutlery".[31] Instead, they need to become aware of their power "to change, abolish, alter or bring entirely new forms into being".[32] Of course, beautiful forks and chairs are also

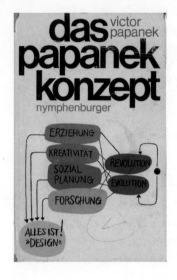

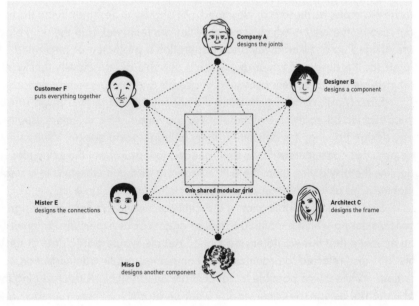

■387 **Victor Papanek, "Das Papanek Konzept", 1972**
Greif-Poppen (cover), Nymphenburger Verlagshandlung,
Munich

■388 **Enzo Mari, Sedia 1 for Artek, 2010**, 31.7 × 47.5 cm,
courtesy Artek, photograph: Juoko Lehtola

■389 **Thomas Lommée, Open Structures diagram**
© Thomas Lommée

important as we should not forget that "satisfying the human psyche through beauty [...] is as important, perhaps even more important, for a fulfilled and civilized life as the fulfilment of our material needs for comfort."[33] Art, architecture and design are not, however, to pay homage to aestheticism as an end in itself, but are to be seen in relation to people and their environment. After all, "tool, shelter, clothing, and breathable air and usable water are not only the job but also the responsibility of the industrial designer."[34]

Is everything design and every person an artist?

If design is planning and design, it is also the basis of every human activity.[35] From Gropius to Papanek and from Joseph Beuys to Manzini, architects, designers and artists remain convinced that every individual has creative powers; they just need to be discovered.

The Bauhaus training focused on individual free artistic expression. Lessons in the theory of harmony provided a space for unconscious sensations, teaching students to use them as creative energy. Free art and the students' work with materials served the purpose of activating the creative powers that are present in all of us. Gropius believed that the most important task was "to use general education to reawaken the lost skills of understanding and designing form that reside in every individual" and to develop the individual personality rather than just professional skills.[36] This approach remains relevant today, although proof still needs to be found that these skills do always exist.

The Bauhaus lives on – to a large part in Joseph Beuys's oft-quoted sentence of "everyone's an artist" and in Viktor Papanek's "all men are designers and all that we do is design". Let's wait and see what the next few years bring!

1 Walter Gropius, letter to Gustav Wyneken, 12 December 1919, ThHStAW, Staatliches Bauhaus Weimar, no. 25, sheet 51.

2 Annemarie Jaeggi, "Ein geheimnisvolles Mysterium: Bauhütten-Romantik und Freimaurerei am frühen Bauhaus", in Christoph Wagner, ed., *Das Bauhaus und die Esoterik*, exhibition catalogue Kerber, Bielefeld/Leipzig 2005, pp. 37f.

3 Volker Wahl, "Das Staatliche Bauhaus in Weimar 1919–1925. Zur Institutionengeschichte und zur Überlieferung seiner Registratur", in ibid., p. 21.

4 For further historical details, please see Volker Wahl, ed., *Das Staatliche Bauhaus in Weimar*, Böhlau, Weimar 2009; Ute Ackermann in Volker Wahl, ed., *Meisterratsprotokolle des Staatlichen Bauhauses in Weimar 1919–1925*, Hermann Böhlaus Nachf. Weimar, Weimar 2001; Georg W. Költzsch and Margarita Tupitsyn, ed., *bauhaus – Dessau, Chicago, New York*, DuMont, Cologne 2000; Peter Hahn: *Bauhaus Berlin*, Weingarten 1985; www.bauhaus-online.de.

5 Walter Gropius uses the word in his essay "Concept for the Education of Architects", based on his 1939 essay "Education of Architects". Published in Walter Gropius, *Architecture*, Fischer Library, Frankfurt am Main 1956, pp. 44f.

6 Nikolaus Pevsner on Morris, in Nikolaus Pevsner, *Der Beginn der modernen Architektur und des Designs*, DuMont, Cologne 1972, p. 24.

7 In *JA! Stimmen des Arbeitsrats für Kunst in Berlin*, Berlin 1919, pp. 30f.

8 Leaflet of the Workers Council for Art, 1 March 1919.

9 Walter Dexel, *Der Bauhausstil, ein Mythos: Texte 1921–1965*, Keller, Starnberg 1976, p. 17.

10 Walter Gropius, speech to the Thuringian State Diet, 9 July 1920, printed in Volker Wahl, *Das Staatliche Bauhaus in Weimar*, Böhlau, Weimar 2009, p. 348.

11 Please refer to Wahl, op. cit., p. 344 or Volker Wahl, in Christoph Wagner, ed., *Das Bauhaus und die Esoterik*, op. cit. 2005, p. 25.

12 For instance, Hans Poelzig in Wroclaw, Bruno Paul and Albert Reimann in Berlin, Richard Riemerschmid and Wilhelm Debschitz in Munich; also relating to Otto Bartning's ideas, later director of Bauhaus's successor school, the Staatliche Bauhochschule in Weimar, and Bruno Taut was deeply obliged to Gropius. Please see John V. Maciuika, *Before the Bauhaus. Architecture, Politics and the German State*, Cambridge University Press, Cambridge 2005, p. 290.

13 Ibid., p. 289.

14 Ibid., p. 290.

15 For more details please see Bernhard E. Bürdek, *Geschichte, Theorie und Praxis der Produktgestaltung*, 3rd edition, Birkhäuser, Basel/Boston/Berlin 2005, pp. 28f.

16 Walter Gropius, *Architecture*, Fischer Library, Frankfurt am Main, 1956, p. 17.

17 http://www.deutschlandfunk.de/architekt-hannes-meyer-ein-erfinder-der-politischen.871.de.html?dram:article_id=303382.

18 For more details on the development of definition of design, see Bürdek, op. cit., 2005, pp. 13ff.

19 Ibid., p. 15.

20 Ibid., p. 16.

21 Gropius, op. cit., 1956, p. 17.

22 John A. Walker, *Designgeschichte. Perspektiven einer wissenschaftlichen Disziplin*, Scaneg, Munich 1992, p. 46.

23 To distinguish between *diffuse* and *expert* design, see Ezio Manzini, *Design, When Everybody Designs*, Massachusettes Institute of Technology, Massachusetts 2015, pp. 37ff.

24 Viktor Papanek, *Das Papanek Konzept*, Nymphenburger Verlagsbuchhandlung, Munich 1972, p. 149. Original title, *Design for the Real World*, published 1970.

25 Ibid., p. 9.

26 Ibid., p. 10.

27 Ibid., p. 13.

28 Lucius Burckhardt, "Design ist unsichtbar", in *Design ist unsichtbar*, exhibition catalogue, Löcker, Vienna 1981, p. 18.

29 Ibid., p. 20.

30 Manzini, *Design, When Everybody Designs*, op. cit., 2015.

31 Burckhardt, op. cit., 1981, p. 18.

32 Papanek, op. cit., 1972, p. 149.

33 Gropius, op. cit., 1956, p. 65.

34 Papanek, op. cit., 1972, p. 149.

35 Ibid., p. 17.

36 Gropius, op. cit., 1956, p. 132.

Two Kinds of Bauhaus
The "industrial product" in discussion
from 1919 to 1933
Arthur Rüegg

What may well have been the most radical manifesto of a new product culture ever emerged in the bourgeois-democratic milieu of Switzerland in 1926: this was the so-called Co-op. *Interieur* representing an extreme counter-position to the received spatial work of art ■390 ■391. Hannes Meyer, a member of the Basel group of architects ABC aligned with the avant-garde,[1] decked a corner of his office with paper webs to do away with traditional spatial limitations, thus providing a spectacular premiere for a few products that implied industrial production in enormous piece numbers. The point of departure for this installation with its self-consciously improvized effect was a conceptual approach – like the "environments" of the 1960s. In the spirit of Russian Agitprop, Meyer arranged a couple of elementary furnishing items for the "semi-nomadic pattern of the new economic life",[2] which, thanks to their symbolic form, conveyed the message of "the mechanization of our daily life"[3] – such as the expressive horn gramophone, which could in no way have been replaced by the newly emerging portable box model.[4] Meyer's folding chairs, the iron portable side table, the mattress supported on black cones and the improvized glass shelf were the epitome of those modern consumer goods that at the time could not yet be purchased. Together with 33 further images, photographs of the Co-op.*Interieur* illustrated a staccato-like, poetic text by Meyer with the programmatic title "The New World".[5] The standardization of all "living, clothing, nutritional and intellectual needs",[6] the eradication of luxury goods and conveyor-belt mass production were intended to meet the requirements of rapid changes in living conditions and to help people finally achieve "the freedom essential to life".[7]

Meyer's poetic conjuring of a "new" world cannot be seen in isolation. His composition and the accompanying images were "part of a culture of high-pitched manifestos in various keys", as Hans Ulrich Gumbrecht rightly asserts: "On the one hand a growing sense of progress and acceleration in the changing of the world as this had spread through the nineteenth century was now gone, pushed aside by a sense of dramatic loss since the end of the First World War. All the values and principles of the traditional world that had been the foundation of collective and individual existence appeared to have evaporated completely, with the result that the longing for a new firm basis of existence soon began to make itself felt."[8] The Bauhaus established in Weimar in 1919 through the merging of the Saxon-Grand Ducal Art School and the Grand Ducal School of Arts and Crafts founded by Henry van de Velde was also dedicated to a search for new forms of expression in every area of social life. The ideas held by the various avant-garde groups about what these

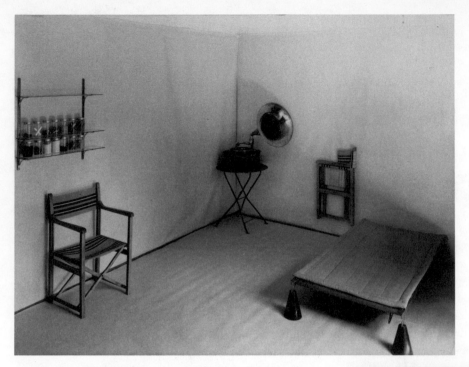

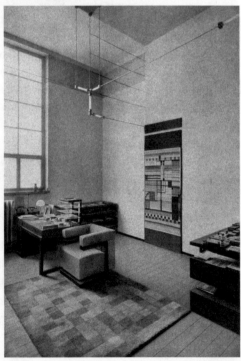

■ 390 **Hannes Meyer, *Co-op.Interieur*, Basel 1926**
gta Archive/ETH Zurich (Hannes Meyer Estate)

■ 391 **Lucia Moholy, Walter Gropius's director's office at Bauhaus Weimar, 1923,** photograph, 23 × 17.7 cm, offset print on art paper, Bauhaus-Archiv Berlin

should be were, however, in no way congruent. When Hannes Meyer replaced the founding director of the Bauhaus, Walter Gropius, on 1 April 1928, the path ahead was blocked in his view by "incestuous theories preventing any access to the right path ahead for designing life."[9] Every tea glass was being turned into "a problematic constructivistelizing thing", he polemicized. "The cube is trumps, and its sides are yellow, red, blue, white, grey, black. [...] The square was red. The circle blue. The triangle yellow. People sat and slept on the coloured geometries of furniture. One lived in the coloured sculptures of houses. Their floors were spread with the emotional complexes of young girls like carpets. Art is strangling life everywhere. This is how my tragi-comic situation emerged: as Bauhaus director I took up the fight against Bauhaus style."[10] The outcome is well known: Meyer established the scientific foundations of design as the objective of his teaching and he changed the pedagogical structure of the institution in the process: the engineer was joined by the business manager, a number of new Bauhaus masters were called in and were to be encountered as they developed the guest course on "The dangers of pseudo-scientific activity".[11]

Is there such a thing as "Bauhaus style"?

Meyer's disparaging description of what he found illustrates the difficulty he faced in bringing the work of the Bauhaus into a single line. The Basel art historian Georg Schmidt – like Meyer a committed advocate of a normative view of history oriented towards social and artistic progress – already described the Bauhaus in 1930 as "possibly the most concentrated breeding ground for those famous or perhaps infamous bacilli that are entitled 'New Objectivity'."[12] When such a thing as a "Bauhaus style" is recognizable at all, Schmidt continued, then it must go through the usual courses of change: "insanity, fashion, style". The products of the early Bauhaus were indeed "insane" in the sense of being unbalanced, since they had to unbalance the traditional notions of the house, its furniture and equipment. These products were not only extreme, but also unique, meaning they were not repeatable. Despite this, they were repeated and became "what is known as fashion: an outwardly directed playfulness, formalism". In the first period of enthusiasm, fashionable play was made with new forms at the Bauhaus. Yet simultaneously a phase of self-contemplation emerged. Now the issue was no longer that of a new style, "but quite the contrary: it was no less than the fundamental overcoming of style!" The form which things take should be exclusively "the result of the consideration given to how they can best perform their natural functions."[13]

Bauhaus research in the years following the Second World War also differentiated between various clearly discernible development phases. According to Lothar Lang's early study *Idee und Wirklichkeit* on ideas and reality at the Bauhaus (1965),[14] an initial "romantic" phase of seeking to reform art and life linked with the development of Bauhaus teaching concepts was followed after 1925 by the conversion of the Bauhaus workshops into laboratories for industry. The profession of product designer slowly began to acquire a profile. Lang also pointed to a formalistic rigidity, which was also overcome in this second phase under Hannes Meyer. Social relevance and scientific working methods gained ever more prominence. In a third phase, however, the sociological disciplines vanished altogether from the curriculum and under Ludwig Mies van der Rohe between 1930 and 1933 the Bauhaus was transformed into a purely educational establishment.

Both Schmidt and Lang describe the Bauhaus as a normative project, developing in a logical way step by step towards a classless, everyday aesthetic, before the experiment was stopped by political pressures. Object design had followed a course moving from unique handcrafted items to the artistic design of consumer goods for inexpensive mass

production. Normalization, rationalization and mechanization characterize the last phase of Bauhaus design and it is still regarded today as an essential pillar of modern material culture. The "formalistic" Bauhaus experiments have also long been rehabilitated. Whenever Bauhaus (style) is discussed today, it is the Gropius period that is usually meant. A number of principles and procedures of those development phases that had seemingly been pushed aside as irrelevant are regarded today with boundless – rapt, even – enthusiasm by architects, designers and collectors. This alone is reason enough to examine the nature and the topicality of the contrary positions taken by Gropius and Meyer.

Industrial catharsis and artistic ability

In 1910 Walter Gropius, Ludwig Mies van der Rohe and Le Corbusier, three of the most influential designers of the twentieth century – and two of them future Bauhaus directors – were employed almost simultaneously by one of the central figures in the reform of the applied arts in Germany. Coincidence? Peter Behrens, originally a painter, had in the years before the First World War become a pioneer of the objective style in architecture and modern industrial design. As an architect, product designer and typographer he was responsible for the striking corporate identity of Allgemeinen Elektricitäts-Gesellschaft (AEG), a company with 60,000 employees at that time. The young Le Corbusier greatly admired what he termed the "aspect modeste, sobre, presque impersonnel" in the design of the AEG heating and lighting equipment with their "intervention artistique autoritaire".[15] Like his colleagues he immediately dropped all involvement with individually handcrafted items and forthwith concerned himself exclusively with the economically and socially more relevant discipline of series production.[16] But how is a standardized product arrived at in the first place? In contrast to the trend of the times, Le Corbusier had scarcely any interest in the design of industrial products. Instead of designing "period machine products" (Muthesius) he deliberately picked out those products which had consistently proved their suitability for use through a continuous process of reworking and which had already arrived at perfection of form. His concern was with the symbolic and archetypal prototypes of a particular category of man-made objects. As a furniture designer, he practised with notable success the redesign of the formal and strikingly impressive luxurious furniture of the late French dix-huitième, before turning away from it in favour of the anonymous, manufactured chairs of the nineteenth century and ultimately beginning to focus on the idea of linking the formal perfection of consumer goods with their commercial and industrial production. The artist-architect established new aesthetic rules as he did so, as a means of both justifying his decisions and managing the further development and arrangement of anonymous industrial products. In the course of his crusade against the decorative arts, which reached its peak at the Paris Exposition Internationale des Arts Décoratifs Industriels Modernes of 1925, he put all of this to the test in the L'Esprit Nouveau pavilion with the arrangement of his ready-mades selected for their resonantly iconic nature-based on principles of composition he had developed in painting since 1918.[17]

Hannes Meyer adopted a similar approach one year later. Working for the Swiss Consumer Association (VSK) he had not only built a pioneering communal housing project,[18] but had also put new forms of design to the test working with the propaganda theatre Théatre Co-op in 1924 for EIKOS, the International Exhibition of Co-operatives and Social Welfare in Ghent. Meyer pushed aside the conventional images of Switzerland with "cows, chalets, chocolate, shooting-ranges and picturesque Alpine costumes"[19] to bring scenic presentations of social issues instead – including Arbeit Co-op, Traum Co-op, Kleid Co-op and Handel Co-op. In the centre of the signal red theatre auditorium he placed an oversized

glass presentation case, also in signal red – the *Vitrine Co-op* – with an exciting display of highly varied "standard co-operative association consumer articles".[20] He also produced photographs and graphic work together with the *Co-op.Interieur* presentation under the pseudonym co-op in the years between 1926 and 1930. If there was a connection between the objects presented and their widely varying form and design, it was without doubt the ideology of "the people's needs" that they were intended to represent.

Both Le Corbusier and Meyer used "industrial Darwinism"[21] as their point of reference – a term coined by Stanislaus von Moos and also derived from Adolf Loos: "but revolutions always come from below. And what is 'below' is the workshop."[22]

Le Corbusier expressed himself in almost identical terms in his review of the opulent publication produced for the 1923 Bauhaus Exhibition: "The art of the well-made develops in the course of the industrial tasks of the worker in successive stages [...]. The well-made originates at the basis to emerge and break the surface as a result of its qualities [...]. The perfectly made is the standard [...]. The standard is a resultant fact." And referring to Bauhaus Weimar: "An art school is absolutely incapable of improving industrial production and establishing standards: there is no input of new standards."[23] Le Corbusier advised Gropius to close the workshops and concentrate fully on education and training for architecture.

While the design of everyday objects was not artistic work for Le Corbusier and Meyer, Gropius took a completely opposite view. In 1925 – during the second phase – he defined the Bauhaus workshops as artist-inspired "laboratories, in which ripeness for the mass production of devices typical for contemporary times would be carefully developed and continuously improved as models."[24] As a means of equipping students to manage the balancing act between art and technology, he aimed to establish a polytechnic, but above all a poly-artistic education, to be provided by outstanding personalities. They were to have "equal mastery of technique and form",[25] yet for Gropius there was, despite this, no question of challenging the hierarchy of the Bauhaus masters responsible for shaping artistic ability in form and the workshop managers who were in charge of the technical issues. He found unusually harsh words for the latter in 1922 when they demanded a seat and a voice on the council of masters with no limitations: "The workshop managers are without question not in a position to take any responsibility whatsoever for the decisions of a council of masters, which are largely made from an artistic perspective. [...] It is simply an aspect of the fields of activity in the Bauhaus for the artist to penetrate more readily the secrets of those crafts that can be learned than it can ever be for craftspeople to find their way in questions of art, which have nothing to do with a profession, but are a vocation. [...] The composition of the council of masters represents the historic development of the Bauhaus, the initiative behind this thinking and its implementation originated from artists and not from craftspeople."[26]

While Le Corbusier and Meyer thus evaluated the manufacture of industrial products in terms of their ideological, technical and aesthetic standards, the Bauhaus people attempted "to force through industrial production from above, by the artists and to a specific, geometrically fixed type."[27] The Bauhaus under Gropius thus followed the bottom-up movement with a top-down exclusivity principle.

Theory and practice

How were these conflicting views reflected in practice? In 1931 the French architect and later politician Roger Ginsburger[28] still knew how to distinguish fine differences in the area of lighting fixtures that he traced back to their provenance: "If we take, for instance,

the standard lamp: German standard lamps often display a detail on the join between the reflector and tube or on the curve of the tube, a purely formal detail, even if this is not acknowledged, so in fact an unconscious effort to make it 'beautiful'. Indeed in Germany the lamp is usually designed by a man who comes from an arts and crafts background, who does not simply think in the material and follow a particular practical objective, but rather always has a notion of form in mind. If, on the other hand, we take a look at the lamp produced by Didier des Gachons & Ravel [...], then we immediately recognize that the ball pivot foot is intended as a casting mould [...], that the arms of the lamp – which are punched metal sheet folded together into tubes, their flat ends forming the disc joints – are flat not because this corresponded to the formal ideal of the inventor, but rather because this was the cheapest and most practical means of production."[29]

It is a well chosen example – not least since the Didier lamp, as it was called in the Zurich Wohnbedarf store in around 1932, was highly regarded by the whole of the French avant-garde as the epitome of the perfect industrial product.[30] None the less, of all the models, it was in fact this one that was not the result of a collective, long-term design process but rather a brilliant idea created by a small circle of gifted tinkerers and inventors – ardent individualists, in other words, who like Thomas Alva Edison at times are able to change the life of society. In 1921 a certain Bernard Albin Gras (1886–1943) lodged a patent application for a "lampe articulée à usage industriel" ■392.[31] Alongside other, sometimes bizarre, projects he had attempted to invent an adjustable lamp for factory work – somewhat earlier than the German engineer Curt Fischer, the creator of the Midgard articulated light. It was the Comte Maurice Brunetau de Sainte-Suzanne – a wealthy count from Champagne with homes in Paris, Normandy and the Riviera as well as a mechanical workshop in the 16th Arrondissement of Paris – who was enthusiastic about Gras's invention and became involved in a small-scale industrial venture. By 1922 he had already sold his company to Louis-Didier-Théodore Peyrot des Gachons, who primarily manufactured equipment for presenting postcards and went on to make the Gras lamp into a success.

This footnote on the genesis of a "typical industrial product" shows that collective development process over a longer period of time was by no means always typical. This statement should be supplemented by a critical comment on the actual manner in which "standards from below" were dealt with, not only by Le Corbusier and Meyer, but also by artists such as Theo van Doesburg.[32] They were not content with the simple selection of ready-mades, but produced the designs for the serial production of specific models themselves, or took a controlling hand from above in the development of industrial standards. Meyer had the anonymous folding chair as presented at Co-op.Interieur developed further in the Bauhaus under the motto "in search of a new standard" in 1928, which was worked into the Bauhaus Model TI206 in the joinery workshop.[33] Le Corbusier and Pierre Jeanneret designed modular storage system furniture (the Casier standard) in 1925 and processed historic furniture types together with the interior designer Charlotte Perriand in 1928 (this was the steel tube furniture presented at the Salon d'Automne in 1929), without concerning themselves about the technical production details.[34] It was no surprise that French industry showed little interest or attraction to the luxury models produced by these or other "artistes décorateurs".[35] The classic counter-example to the Gras Lamp is the "glass lamp with a milk-glass bell shade; and electric cable lead in a nickel tube", begun in 1923 in the Bauhaus metal workshop of Carl Jucker under the temporary management of Oskar Schlemmer and completed by Wilhelm Wagenfeld under László Moholy-Nagy, which has become an icon of Bauhaus design ■393.[36] The decisively modern effect is the result of an aesthetically motivated composition, together with the transparency of the material and the boldly visible

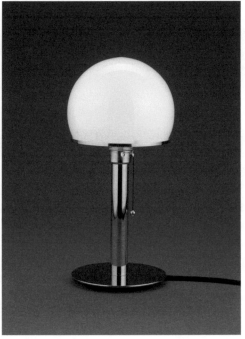

■392 **Atelier Bernard-Albin Gras, Mod. 202, Lampe Gras, 1921,** nickel-plated metal, aluminium, 72×43×14 cm, Vitra Design Museum Collection

■393 **Wilhelm Wagenfeld, MT8/ME2, 1924,** glass, metal, 36×18×18 cm, Vitra Design Museum Collection

cable routing in the context of the stereometric and reduced basic form of this lamp – with its hemispherical shade and also the cylinder and disc of the lamp base. Despite all of this, however, the lamp belongs typologically to the old-established oil and petroleum lamp family, which had already achieved consummate elegance in the Biedermeier period.[37] It was similar in this respect to the reclining chair designed by Le Corbusier, Jeanneret and Perriand, the *fauteuil à dossier basculant* of 1928 – not least in the transfer of an existing type, the standard colonial armchair, into a contemporary structural and design logic.

The situation was thus abundantly complicated. Roger Ginsburger's characterization of lighting production according to country is not least unfair towards the Bauhaus. Prior to his departure in 1928, Marcel Breuer had already followed the entire track from the unique Expressionist item (such as the African chair of 1921, ■394) through to the artistically motivated "type" (the lattice chair of 1924, ■008 p. 82) down to the Bauhaus model suitable for industrial production (the nesting table B9 of 1925/1926, ■158 p. 182). Marianne Brandt, who joined in 1924, concentrated at first on clear and stereometric metal vases and lamps produced as unique items.[38] ■395 She was only to initiate a cooperation with the Leipzig firm Körting & Mathiesen (producing lamps under the brand name Kandem Leuchten),[39] in 1928 when – still under Gropius – she was the deputy head of the metal workshop. This was work that to some extent included advice to and training for the students and which left clear traces in the product language ■183 p. 197. Since she had sought to break through the limitations of the top-down development, Brandt and her colleague Hin Bredendieck[40] have earned a special place in the first generation of industrial designers in the contemporary sense of the term. Hannes Meyer succeeded during the brief term of his work from 1927 to 1930 in bringing the Bauhaus into cooperation with companies and in establishing an industrial design committed to the "needs of the people". Under his aegis outstanding Bauhaus wallpapers, the fruits of a cooperation with the company Gebrüder Rasch of Hanover, achieved remarkable success in both ideal and commercial terms: over six million rolls of pastel-coloured wall coverings were sold within six years.[41]

And today?

Today, the glass lamp can still be admired side by side with the Gras lamp in the display windows of upmarket furnishing stores. Although both models require specialized suppliers, their series production faces no insurmountable barriers. The same is true for the metal furniture of Le Corbusier/Jeanneret/Perriand and Mies van der Rohe, which was rejected by the Italian re-edition specialist Dino Gavina as late as 1964 with the pejorative remark, "They would never obtain a pass grade at any design high school."[42]

Today, in the wake of the third industrial revolution of digitization, the myth of a manufacturing process with a determining effect on form appears to have moved into the background. It is true that the dialogue between designers and manufacturers as proclaimed by the Bauhaus is now a matter of course and that an industrial design based on technical innovation and industrial standards established itself in the post-war period as a concept and a vocational principle. But the repertoire of the moderns exhausted itself in the boom-time building frenzy, while the commitment to a normative design practice wilted along with it. During the 1970s the informal lifestyle of the hippies introduced a new approach to furnishing, as they simply turned away from conventional behaviour and production methods. An alternative reaction to functionalism emerged, questioning with humour and irony the social and functional significance of the historic, against which the moderns had once so bitterly struggled. Space as total art shifted once again into the centre of interest.

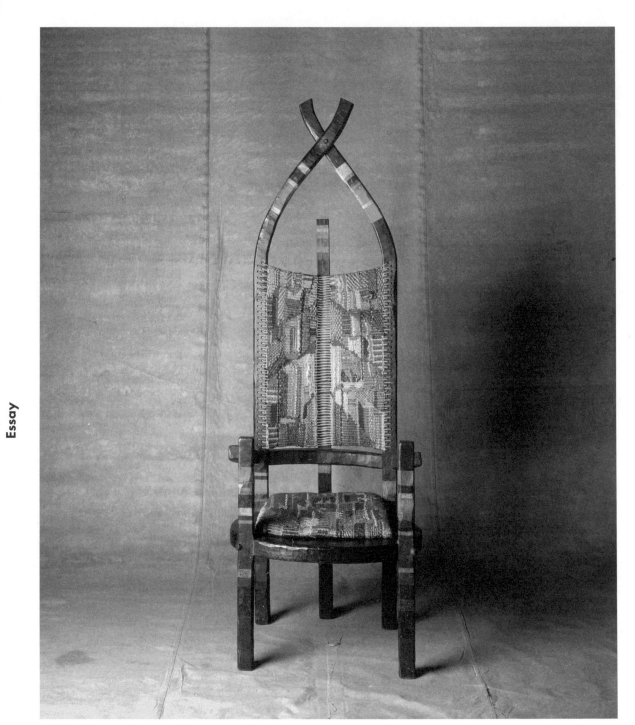

■394 **Marcel Breuer, Gunta Stölzl,** *African chair,* **1921**
179.4×65×67.1 cm, different types of painted wood,
different fabrics, Bauhaus-Archiv Berlin/photograph: Hartwig
Klappert/purchased with the support of Ernst von Siemens
Kunststiftung

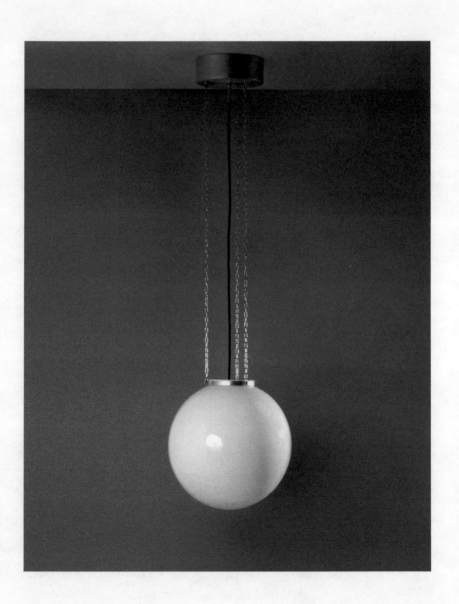

■395 **Marianne Brandt, ceiling light with opal glass sphere on chain suspension, ME104b, 1926,** 165 cm, Ø 40 cm, yellow brass (nickel-plated), opal glass, Bauhaus-Archiv Berlin

Two Kinds of Bauhaus

Paradoxically, the most important designs of the pre-war era were now once again rediscovered, by the postmodern generation, raised to the status of classics and produced for the first time in large numbers.[43] Ever since then, the red/blue chair and the zic-zac chair by Gerriet Rietveld, the Jucker/Wagenfeld lamp, the Wassily chair by Marcel Breuer, the Barcelona chair by Mies van der Rohe and the furniture by Corbusier/Jeanneret/Perriand have enjoyed higher popularity, despite the fact that they are all based on entirely different concepts of product design. That the most radical of manifestos, which struck expressly at the heart of historicism with its renown addiction, should now have found its place among the prestigious must-haves has most certainly much to do with the exhaustion of every possibility for understanding an item of furniture as being in any way a powerful symbol. While numerous designers must continue to concern themselves with the serial and inexpensive possibilities of "needs of the people" production, a boundless passion has been manifested up to today for the "classics" and for all those unique pieces which have occupied the border territories of art, with which one can give expression to individuality and social status. This much appears to be certain: the discussion of design will thus continue until further notice to be an essential aspect of everyday culture – if only under quite different premises from those of the "heroic period"[44] of the moderns.

1 The journal ABC, Beiträge zum Bauen, published in Basel by Hans Schmidt, Mart Stam and Emil Roth and influenced by El Lissitzky, appeared in nine editions between 1924 and 1928. A reprint with a commentary volume was brought out by Lars Müller Publishers, Baden, in 1993.

2 Hannes Meyer, "Die neue Welt", in Das Werk, year 3, no. 6, July 1926, pp. 205–24; p. 223.

3 Ibid.

4 See Arthur Rüegg, "Kunstgewerbe, Kunstindustrie, Maschinenkunst: Vom Möbeltyp zum Typenmöbel", in Christian Brändle, Renate Menzi and Arthur Rüegg, ed., 100 Jahre Schweizer Design, Lars Müller Publishers, Zurich 2014, p. 54.

5 Meyer, op. cit. 1926, pp. 205–24.

6 Ibid., p. 223.

7 Ibid.

8 Hans Ulrich Gumbrecht, "Rationale Ungeduld mit der Vergangenheit: Hannes Meyers Co-op.Interieur, 1926", in 100 Jahre Schweizer Design, op. cit., p. 83.

9 Hannes Meyer, "Mein Herauswurf aus dem Bauhaus. Offener Brief an Herrn Oberbürgermeister Hesse, Dessau", in Lena Meyer-Bergner and Klaus-Jürgen Winkler, ed., Hannes Meyer: Bauen und Gesellschaft. Schriften, Briefe, Projekte, VEB Verlag der Kunst, Dresden 1980, p. 68.

10 Ibid.

11 Ibid., p. 69.

12 Georg Schmidt, "Zur Einführung", in Bauhaus-Wanderschau 1930, Wegleitung 34, Kunstgewerbemuseum der Stadt Zurich, 1930, p. 5. On Georg Schmidt see Roger Fayet, "Georg Schmidt und die Frage der künstlerischen Werte", in RIHA Journal 0097, September 2014

13 Ibid., pp. 8ff.

14 Lothar Lang, Das Bauhaus 1919–1933 – Idee und Wirklichkeit, 2nd expanded edition, Zentralinstitut für Gestaltung, Berlin 1966.

15 Charles-Edouard Jeanneret, Étude sur le mouvement d'art décoratif en Allemagne, Haefeli, La Chaux-de-Fonds 1912, p. 43.

16 See Arthur Rüegg, "Kunstgewerbe, Kunstindustrie, Maschinenkunst: Vom Möbeltyp zum Typenmöbel", op. cit. 2014, p. 53.

17 Ibid., pp. 53f.

18 The Freidorf housing settlement in Muttenz bei Basel – a model cooperative housing form – was built from 1919 to 1921 as an initiative of Bernhard Jaeggi, President of the management commission of the Swiss Co-operatives Association VSK (today Co-op). The Co-op headquarters building was completed in 1924.

19 Hannes Meyer and Jean Bard, "Das Propagandatheater Co-op", in Bauhaus, year 1, no. 3, 1927, p. 5 (Kraus reprint, Nendeln, in cooperation with Bauhaus-Archiv Berlin, 1976).

20 Ibid.

21 See Stanislaus von Moos, "Le Corbusier und Loos", in Stanislaus von Moos, ed., L'Esprit Nouveau. Le Corbusier und die Industrie 1920–1925, Wilhelm Ernst & Sohn, Berlin 1987, p. 124.

22 Adolf Loos, "Schulausstellung der Kunstgewerbeschule" [1897], in Adolf Loos, Ins Leere gesprochen 1897–1900, Editions Crès et Cie., Zurich 1921, p. 10.

23 Le Corbusier, "Pédagogie", in L'Esprit Nouveau. Revue internationale illustrée de l'activité contemporaine, no. 19, December 1921, n.p.

24 Walter Gropius, "Grundsätze der Bauhausproduktion", in Walter Gropius, ed., Neue Arbeiten der Bauhaus-werkstätten, Albert Langen Verlag, Munich 1925, p. 7.

25 Ibid.

26 Letter from Walter Gropius to the works master, 21 April 1922, in Volker Wahl, ed., Die Meisterratsprotokolle des Staatlichen Bauhauses Weimar 1919–1923, Verlag Hermann Böhlaus Nachfolger, Weimar 2001, p. 185.

27 See Winfried Nerdinger, "Le Corbusier und Deutschland. Standard und Typ", in L'Esprit Nouveau. Le Corbusier und die Industrie 1920–1925, Wilhelm Ernst & Sohn, Berlin 1987, p. 48.

28 Ginsburger had himself made an attempt at being a furniture designer: see his adjustable reclining chair, in Roger Ginsburger, *Junge französische Architektur*, Meister der Baukunst, Geneva 1930, pp. 108f.

29 See Roger Ginsburger, "Kunstgewerbe und Industrie in Frankreich", in *Französische Ausstellung*, Wegleitung 98, Kunstgewerbemuseum der Baukunst, Geneva 1930, pp. 108ff.

30 Gras lamps in various models were to be found in numerous interiors by Le Corbusier, Robert Mallet-Stevens and Eileen Gray as well as Maurice Barret, Georges Braque, Cassandre, Sonia Delaunay, Henri Matisse, Michel Roux-Spitz, Jacques Emile Ruhlmann and others.

31 On Gras lamps, see Didier Teissonnière, *La lampe Gras*, Norma Editions, Paris 2008.

32 See Matthias Noell, *Im Laboratorium der Moderne. Das Atelierwohnhaus von Theo van Doesburg in Meudon – Architektur zwischen Abstraktion und Rhetorik*, gta, Zurich 2011, pp. 54–60.

33 Roger Ginsburger, "Kunstgewerbe und Industrie in Frankreich", op. cit., p. 15.

34 On Le Corbusier's furniture, see Arthur Rüegg, *Le Corbusier – Möbel und Interieurs 1905–1965*, Scheidegger & Speiss, Zurich 2012.

35 See Roger Ginsburger, "Die jungen Innenarchitekten, denen Standardleistungen ernsthaft Ziel sind, können kaum auf die Zusammenarbeit mit der Industrie rechnen", in *Junge französische Architektur*, op. cit., 1930; "Kunstgewerbe und Industrie in Frankreich", op. cit., p. 7; also Charlotte Perriand, "Le négoce du meuble n'était pas prêt . . .", in *Une vie de création*, op. cit., 1998, p. 34.

36 See Arthur Rüegg, "Notizen zur Glaslampe", ed. Meike Noll-Wagenfeld, in Joan Billing and Samuel Eberli, ed., *Wilhelm Wagenfeld*, Katalog 10, Design und Design, Baden 2010, pp. 16ff.

37 See Naum Gabo, "Gestaltung", in *Bauhaus*, year 2, edition 4, 1928, p. 4 (Kraus reprint, Nendeln, in co-operation with the Bauhaus-Archiv Berlin, 1976): "Was hat sich an diesen Gebrauchsgegenständen geändert, seit man sie zu 'gestalten' anfing: Dem Wesen nach gar nichts. [...] Das Wesen des Gegenstandes hat sich nicht geändert, es hat sich nur in andere Formen verkleidet."

38 See Hans Brockhage and Reinhold Lindner, *Marianne Brandt*, Chemnitzer Verlag, Chemnitz 2001, also Klaus Weber, ed., *Die Metallwerkstatt des Bauhauses*, for the Bauhaus-Archiv, Kupfergraben Verlagsgesellschaft, Berlin 1992, biographies of Brandt and Bredendieck, p. 315.

39 See Justus A. Binroth et al., *Bauhausleuchten? Kandemlicht! Die Zusammenarbeit des Bauhauses mit der Leipziger Firma Kandem*, Arnoldsche Art Publishers, Stuttgart 2002, pp. 159ff. Over 50,000 Bauhaus lamps were sold by 1931 alone (ibid., p. 53).

40 Bredendieck was responsible for the cooperation with Körting & Mathiesen in summer 1929 after the departure of Brandt. In June 1932, on the recommendation of Moholy-Nagy, he joined the company BAG Turgi, CH-Turgi, where together with the engineer and art historian Sigfried Giedion he developed the Indi-Lamps family. This standard lamp was characterized simply by the optimal use of light it made with a specific metal reflector type. See Arthur Rüegg, "Das neue Licht", in *100 Jahre Schweizer Design*, op. cit., pp. 118ff.

41 On the Bauhaus wallpapers, see Burckhard Kieselbach, Werner Möller and Sabine Thümmler, *Bauhaustapete. Reklame und Erfolg einer Marke*, DuMont, Cologne/ Gebr. Rasch, Bramsche 1995.

42 "Do Mies and Corbu Deserve a Passing Grade?", by Büro Dino Gavina, Simon International, translated by Liviu Dimitriu, in *Skyline, The Architecture and Design Review*, year 2, no. 5, October 1979, p. 4

43 See Arthur Rüegg, "Der Anfang – oder das Ende der Geschichte? Neo-Historismus, Re-Editionen und Hommagen", in *100 Jahre Schweizer Design*, op. cit., pp. 300ff., and also Gerda Breuer, *Die Erfindung des modernen Klassikers. Avantgarde und ewige Aktualität*, Hatje Cantz, Ostfildern 2001.

44 The term is from Alison and Peter Smithson: see *The Heroic Period of Modern Architecture 1917–1937*, special issue of *Architectural Design AD*, year 35, December 1965.

Of Copyrights and Licences
Sebastian Neurauter

Rights management is one of those aspects of the Bauhaus that has rarely ever been researched. The few surviving documents on this issue provide a diffuse picture.[1] The working method resembled an ideas bazaar rather than the coordinated building of a cathedral, a metaphor which is frequently applied elsewhere in the context of the Bauhaus and its work.[2] A planned rights management was lacking and this is the reason why such a very broad field has been open for copyright disputes both during the Bauhaus period and since. An additional problem is that the legal framework available to protect Bauhaus productions from being copied was remarkably confused and differences of opinion were expressed even on the issue of suitability for copyright protection.

Instruments
The same protective instruments for works of art and products of the applied arts existed during the Bauhaus period as those we have today: copyright law[3] and design copyright law.[4] Technical developments were also protected at the time by patent law[5] and by the utility model law.[6] In theory these four instruments made possible a comprehensive protection of aesthetically designed articles of daily use – a situation which in practice, however, required both legal expertise and a very high standard of corporate organization. The easiest and at the same time most long-term protection, since it could be obtained without registration, was provided by the German law of 1907 regulating copyright for art, protecting not only pictures and sculptures, but also objects created by the applied arts. Productions of modern functionality were also, in principle, covered by copyright. In a judgement of 14 January 1933, the German courts ruled for the copyright protection of a steel tube cantilever chair ■396 designed by Mart Stam, and referred to "the stringently austere and consistently clear lines, avoiding the use of any unnecessary part and embodying modern functionality in the most reduced form with the simplest of means."[7] One year later it was significantly more critical in reference to the simple and functional door handle developed by Gropius in 1922 ■397: The "Puritanical abandonment of any decorative addition to the basic forms, the stringent modern functionality of the cylinder and the square" were "clearly an expression of the modern feeling for art", yet it was lacking "the individuality essential for the protection of art in the given case".[8] It can be clearly seen from this legal tangle in the courts that the question of which Bauhaus designs could receive copyright protection was difficult to determine, not only for lay persons with little legal experience. This is why it was considered important for the Bauhaus to provide its most promising designs with the additional protection of rights that could be assured by means of registration.

The creator principle and serviceable works

The question of who actually held the rights to Bauhaus productions is not something to which there is a single simple answer. This was and still is today the occasion for argument in a great many separate cases.

According to the creator principle, the original owner of the copyright is the person who first originated the individual intellectual creative act.[9] The rights of exploitation under copyright are transferable up to the present day. Productions which specifically came into existence in the course of an employment relationship could and can be the subjects of rights which are directly transferable to the employer.[10] Since many of the Bauhaus people – teachers, trainees and also people who were employed to carry out production work – had employment relationships with the Bauhaus, or with the controlling legal entities above it, the rights to numerous productions were transferred to the Bauhaus as an institution.

During the Weimar Bauhaus period, specific rules were adopted in various contracts with works masters, as for example with Carl Zaubitzer (printing press), by the terms of which all work produced was to be "property of the Bauhaus".[11] This clause was absent from the contracts of the design masters. They all had permission to do private spare-time work in their creative domains as artists, and they were also permitted to do so at the Bauhaus. The greater part of their work was thus not regarded as Bauhaus property.

The German court which had concerned itself with the legal order in force at the Bauhaus in the case of the door handle (referred to above) sought to differentiate the scope in which the items from the "productive operation" of the Bauhaus were to be attributed, and thus to establish whether the rights for the door handle were to be regarded as the property of the German State of Thuringia as the operating authority of the Bauhaus:

"Precisely this disputed door handle belongs to the model design work carried out in the scope of the productive operations of the Bauhaus. [...] To the extent that designs [...] may be provided with art copyright protection, the copyright must fall to the state and not to the director of the operation employed by the state, because the business utilization of products of the kind derived from arts and crafts would not be possible except through possession of the copyright, the purpose of employing the Bauhaus director as the head of a productive operation of this kind thus goes hand-in-hand with the requirement for the copyrights to be assigned to the state."[12]

This judgement was the trigger behind an attempt made by the City of Dessau to obtain the copyrights from the last Bauhaus director Mies van der Rohe in 1934. The public works inspector Konrad Nonn attempted on behalf of the city, by this time under National Socialist governance, to prove breach of trust and embezzlement of Bauhaus productions against Gropius and Fritz Hesse, former Mayor of Dessau and Bauhaus friend, under the terms of copyright law. He saw the use made of the door handle by Gropius as a "plain case of embezzlement of design licences".[13] In addition to this, the judgement also inspired him with the idea of establishing a claim to all "Bauhaus pattern designs". He suggested:

"It would be possible by means of an injunction to have all the Bauhaus pattern designs, which are known as such in the business world, claimed by Dessau and that the payment of licences by manufacturing companies to any persons whatsoever would be prohibited, and that all payments of this kind together with the associated agreements from which they arise would be awarded by injunction to the Dessau Municipal Authority. In this context separate objects which appear to be of special value, such as the Bauhaus wallpaper, could be given special treatment, in that one would intervene directly with the companies involved. The new Bauhaus of Mies van der Rohe would then be immediately prohibited from using the trademark 'Bauhaus'."[14]

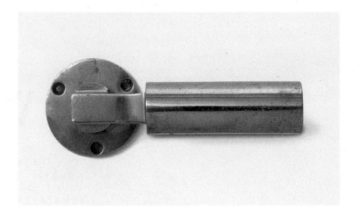

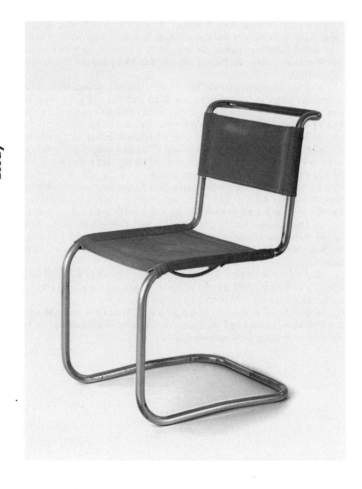

■ 396 **Mart Stam, stool ST12, 1926**
nickel-plated steel tube, sail cloth, 84 × 47 × 64 cm,
Vitra Design Museum Collection

■ 397 **Walter Gropius, door handle, 1922**
6 × 14 × 11.5 cm, Vitra Design Museum Collection

WERKSTAT

1. Die im jeweiligen Stundenplan festgesetzte Arbeitszeit ist pünktlich einzuhalten.

2. Fehlen ohne Erlaubnis der Werkstattleitung oder ohne Entschuldigung ist unstatthaft. Längere Abwesenheit als drei Tage ist sowohl der Werkstattleitung, als auch dem Sekretariat des Bauhauses begründet schriftlich mitzuteilen.

3. Die Einrichtungsgegenstände, die Maschinen und Geräte müssen schonend behandelt werden. Für selbstverschuldete Beschädigungen jeder Art haftet der Einzelne und, sofern dieser nicht festgestellt werden kann, die Gesamtheit der Unterrichtsteilnehmer.

4. Die Lehrlinge haben die nötigen Aufräumungsarbeiten in der Werkstatt, sowie die Reinigung der Maschinen und der Werkzeuge selbst zu erledigen.

5. Den Anordnungen des Werkstattleiters oder dessen Stellvertreters ist unbedingt Folge zu leisten; grobe Verstösse gegen die Werkstattordnung ziehen den Ausschluss aus der Werkstatt bezw. aus dem Bauhaus nach sich.

6. Jeder Studierende, der in einer Werkstatt arbeitet, ist verpflichtet, jede einzelne Arbeit, die in der Werkstatt ausgeführt wird, sowol vor wie während der Herstellung mit seinen beiden Meistern fortlaufend zu besprechen, also sowol mit seinem Werkstattleiter, als auch mit seinem ihm Formunterricht erteilenden Meister. Nur so kann die Verbindung zwischen künstlerischer und handwerklicher Arbeit geknüpft werden.

7. Das Bauhaus stellt jedem Lehrling und Gesellen für seine handwerklichen Arbeiten das erforderliche Material. Für jede Materialentnahme ist der Werkstattleitung Quittung auszustellen.

8. Jeder haftet für das ihm anvertraute Material. Fortgesetzte Materialverschwendung zieht Ausschluss aus der Werkstatt nach sich.

9. Für jede Arbeit ist grundsätzlich ein Material- und Arbeitszettel zu führen, der von der Werkstattleitung oder deren Stellvertretung zu unterzeichnen ist.

■398 **Workshop rules 1920,** ThHStAW, Staatliches Bauhaus Weimar 14 f. 29v/30r

2-v

000030

ORDNUNG

10. Jede mit dem Material des Bauhauses hergestellte Arbeit gehört dem Bauhause.

11. Jede fertige Arbeit ist mit dem Arbeitszettel der Werkstattleitung alsbald abzuliefern, diese leitet die Arbeiten gesammelt an das Sekretariat.

12. Vom Bauhause endgültig übernommene Arbeiten werden dem Verfertiger bezahlt. Der Leiter des Bauhauses berät gemeinsam mit den beiden Meistern des Verfertigers, ob der Gegenstand vom Bauhaus übernommen und welche Summe dem Verfertiger für seine Arbeit vergütet werden soll.

13. Dem Verfertiger kann unter besonderen Umständen (schriftliche Begründung) gestattet werden, vom Bauhaus übernommene Arbeiten, die er behalten oder verschenken will, zurückzukaufen. Diese Absicht entbindet jedoch nicht von der einstweiligen Verpflichtung der Ablieferung (Ausstellungszweck). Entsprechender Vermerk ist auf dem Arbeitszettel einzutragen. Material und allgemeine Unkosten sind in diesem Falle von dem Verfertiger bar zu bezahlen.

14. Rückkauf der vom Bauhaus übernommenen Arbeiten mit der Absicht freihändigen Verkaufs würde gegen das Interesse der Gesamtheit verstossen uud kann in keinem Falle zugelassen werden.

15. Die nicht vom Bauhaus übernommenen Arbeiten darf der Verfertiger freihändig verkaufen oder verschenken nach barem Ersatz der Material- und allgemeinen Unkosten.

16. Vor der Annahme von Aufträgen hat jeder seine beiden Meister zu Rate zu ziehen und jeden Auftrag törmlich durch das Sekretariat zu leiten. Das Bauhaus ist dem Auftraggeber gegenüber künstlerisch und wirtschaftlich verantwortlich.

Weimar,
Oktober 1920

LEITUNG UND MEISTERRAT
DES STAATLICHEN BAUHAUSES.

411

richtlinien für die werkstätten vom 1.11.1928

I. allgemein: zur erzielung möglichster wirtschaftlichkeit
ist organisatorisch eine gewisse trennung
zwischen pädagogischer und versuchswerkstatt
einerseits und der produktivabteilung anderer-
seits anzustreben. die leitung der gesamt-
werkstatt liegt in den händen des werkstatt-
leiters, der sich im einzelnen möglichst pä-
dagogischen und gestalterischen fragen widmen
soll, während für die ausführung von aufträgen
sowie für die eigentliche fachliche lehrlings-
ausbildung der werkmeister verantwortlich ist.

zur förderung des gedankens der selbstverwal-
tung jeder zelle und erzieherisch gesehen ist
in jeder werkstatt die stellung eines mitar-
beiters wünschenswert, weil sie gelegenheit
gibt, die befähigsten studierenden mit der
werkstattleitung vertraut zu machen und werk-
stattleiter und werkmeister in ihren aufgaben
zu unterstützen.

solange die jetzige wirtschaftliche lage an-
hält, muß die lösung in den einzelnen werkstät-
ten verschieden gehandhabt werden gemäß den
folgenden vorschlägen. wichtige allgemeine
fragen z.b. über annahme von aufträgen ent-
scheiden leiter, meister und mitarbeiter ge-
meinsam, unter endgültigem entscheid des leiters.

um einen möglichst reibungslosen arbeitsab-
lauf zu gewährleisten, ist es notwendig, die
arbeitsgebiete der verschiedenen werkstattange-
hörigen und ihrer funktionen nach möglichkeit
festzulegen. es ist aufgabe der werkstätten
dies unter berücksichtigung der vorschläge der
verwaltung vorzunehmen und die richtigkeit der
getroffenen maßnahmen laufend zu kontrollieren.

rechnung für
fräulein otti berger
im hause.
27.6.30 lfd.nr. 492

sie erhielten aus unserer weberei:
B 104a rm 20.--
B 104e rm 20.--
 rm 40.--

zahlbar: sofort.

■ 399 Bauhaus Dessau, Workshop guidelines from 1 November 1928, Bauhaus-Archiv Berlin

■ 400 Receipt for Otti Berger, 27 June 1930 Bauhaus-Archiv Berlin

Of Copyrights and Licences

Mies van der Rohe submitted to this pressure – or at least took a step towards compliance – and in September 1934 declared the reassignment of various rights, in reference above all to the rights on designs, but not to copyright law.[15]

Purchase

The Bauhaus students (in Weimar, Dessau and Berlin) – in contrast to the design masters – were under obligation to offer the Bauhaus the works they had created in its workshops. Against the background of the chronic under-financing of the institution, the masters decided after the first two semesters to introduce "a right of first refusal" on the free work of the students.[16] Subsequently this delivery obligation was transferred to the workshop regulations of 1920,[17] ■398 and was then entered in §7 as an integral part of the Bauhaus Articles of Incorporation of 1921.[18] Only a few months after the workshop regulations came into force, the great potential economic importance of the delivery obligation became fully clear. The student Friedl Dicker-Brandeis wished to sell a carpet she had produced elsewhere. Gropius declared at the Council of Masters session on 7 February 1921 that "we must stop the best work in particular from being lost to the Bauhaus, or it will never be in a position to establish a collection of high quality products."[19] The Council of Masters decided to purchase the carpet from the student for 200 Marks, which was less than the market value.

Despite the solution by mutual agreement, this case was highly controversial, since the students were being deprived of an important source of income. Master Itten thus made the proposal that sooner or later it must be possible to take on all potentially saleable work against a payment.[20] Even if the Bauhaus was never able to reach this objective entirely, since only a very small portion of the student work could be purchased, the implementation of a consistent purchasing practice can be demonstrated equally through all of the Bauhaus phases.

The workshop directives introduced under the second Bauhaus director Hannes Meyer on 1 November 1928 were the most precise, transparent and informative from a legal perspective:

"General. The Bauhaus has a title of ownership to all workshop products under its articles of association. In compliance with the legal provisions the rights in the design remain to a limited extent with their author. In accordance with this the Bauhaus has the priority right to the commercial exploitation of all model pattern designs or samples designed or produced in the Bauhaus workshops by members of the Bauhaus. The models may neither be offered elsewhere nor duplicated, and this also in cases where the author leaves the Bauhaus. The Bauhaus shall have the right to protect Bauhaus pattern designs under law and in its own name. The documentation required for this must be supplied by the author. The model must not be made available to the public in any manner whatsoever prior to the obtaining of copyright protection. In cases where the Bauhaus has no interest in exploiting samples, the author may have free disposal over them, but only subject to a written agreement on this matter, whereby the name Bauhaus design or model must not be retained for any further external duplication purpose."[21] ■399

Despite the Bauhaus having a "priority right" to the copyright on models and pattern designs from the outset, the assumption was not made that all rights without exception would be transferred automatically to the Bauhaus without a special transfer contract provision having first been made. The regular practice was rather the purchase of student models and pattern designs for a special fee payment – and this under the directorship of Hannes Meyer as had been earlier the case under Gropius in Weimar.[22] The archives contain numerous bills of receipt for payments made to students, for example to the weaver Otti Berger ■400,

who received a number of separate sums of between 5.50 and 20 Reichsmarks in December 1929.[23] Those designs that were never implemented as products received payments only in exceptional cases.[24]

In consequence the assumption is to be made that the power of disposal on the copyrights of work by free students required by the Bauhaus could first and only be transferred to the Bauhaus (as the representative of the Dessau Municipal Authority) by the author, and exclusively when the relevant design or model had been purchased from the author with a fee paid by the Bauhaus. The students – insofar as they were not on the staff as "employees" – received no fixed payments under which the transfer of the rights was already covered. The fact that the legal situation in respect to every product was to be regulated in the course of individual discussions is also evident from the draft of the "Contract between the Bauhaus and Mr Bauhaus member XXXX" of 1925.[25] This was presumably never used in practice. The transfer of the disposition over copyrights was made in Dessau – as was previously the case in Weimar – in each case by tacit agreement whenever a model was purchased by the Bauhaus.

The purchasing practice was also maintained in Berlin. The academic prospectus of the Berlin Bauhaus of October 1932 contained the clause "copyright on all work produced within the institute" is that of the Bauhaus.[26] Yet the Bauhaus continued to pay fees to students for designs it had taken over from them, and thus did not make unlimited use of copyright law provisions.[27]

Profit shares from mass production

In addition to purchase fees, the Dessau students also had profit shares from the income generated as a result of the use and duplication of their designs.[28] ∎401 These payments, generally referred to as "licences" at the Bauhaus, were already common before the guideline directives came into force. They were to become incomparably more important as a result of the successful industrial cooperation activities that had been set in motion under Meyer. The minutes of the advisory board meeting of 9 December 1930 contain statistics on the wage and fee payments to students in the period from April 1929 up to and including September 1930.[29] According to these a total of 64,520.29 Reichsmarks was paid out to them.

An interesting dispute in the context of copyright was that involving the weaving workshop members Otti Berger and Ilse Voigt in early 1931. Voigt had produced a textile pattern sample in cooperation with the textile company Polytex in 1930 and in doing so had kept to guideline instructions from Berger. When this design was to be paid for by the Bauhaus administration, differences of opinion arose on who was actually the author of the sample. Voigt wrote the following to the Bauhaus administration on 16 January 1931:

"During the period in question Otti Berger was the deputy workshop manager; in this position she determined the properties of the material. Even in cases where this is considered as processing, I am, as I have already informed you, still a co-worker in this process. I need only remind you of the processing for the pattern sample of Gretel Reichardt, whose design fee was reduced because of the minor input to it made by a co-worker. I have a right to a fee, since as I have informed you I had to use the material that was made available in such a manner that the effect of the new sample was the same as that of the original, and this is precisely the same situation as in the case referred to above where the two students had a share in the design fee. The wage payment is made on a separate basis in all cases."[30]

The Bauhaus management was obliged to investigate the case and decided that Voigt should have a one-third share in the fee.[31]

blatt 10

b) **festsetzung der umsatzbeteiligung**

die umsatzquote wird von jahr zu jahr auf grund der letztjährigen bilanz festgesetzt. für das laufende geschäftsjahr beträgt die versuchsweise für die

weberei	10%
metallwerkstatt	12%
tischlerei	5%
wandmalerei	5%
druckerei	5%

im umsatz nicht enthalten ist der eigenbedarf des bauhauses. für aufträge, die - wie fall piscator - keinen verdienst, sondern erheblichen schaden für das institut gebracht haben, kann ein prozentsatz vom umsatz abgesetzt werden.

c) **die berechnung**

erfolgt vierteljährlich durch die k. an hand des verkaufsbuches unter berücksichtigung etwaiger nachlässe z.b. transportschäden und material- oder fabrikationsfehler usw.

d), **die verteilung**

wird folgendermaßen vorgeschlagen:

a) werkstattleiter	10%
b) werkmeister	10%
c) werkstattangehörige	70%
d) werkstattfonds	10%

die verteilung des anteils c) ist angelegenheit der gesamtwerkstatt, die ihre entscheidung vierteljährlich durch die werkstattleitung an die k. einzureichen hat.

e) **die auszahlung**

erfolgt an hand dieser unterlagen jedesmal 8 wochen nach abschluß des quartals, also für die zeit v. 1. 4. - 30. 6. am 1. 9.
1.7. - 30. 9. " 1.12.
1.10. - 31.12. " 1. 3.
1. 1. - 31. 3. " 1. 6.

f) **vorschüsse**

auf die umsatzbeteiligung werden grundsätzlich nicht ausgezahlt.

g) **lizenzen**

nach dem ausscheiden aus dem bauhaus werden lizenzen an einzelne urheber nur für diejenigen muster und modelle ausgezahlt, deren fabrikation vertraglich durch auswärtige fabriken gegen lizenzzahlung erfolgt und zwar solange, wie tatsächlich lizenzen eingehen. von diesen lizenzen erhalten:

bauhaus	40%
urheber	50%
werkstattfonds	10% = 100%

um zweifel auszuschließen wer an diesen lizenzen zu beteiligen ist, soll vor anbahnung von fabrikationsverhandlungen für jedes vervielfältigungsreife muster oder modell festgestellt werden, wer der einzelurheber ist oder ob gemeinsame urheberschaft vorliegt.

h) **für erfindungen**

die durch patent geschützt werden, ist von fall zu fall regelung durch sonderabkommen zu treffen.

■ 401 **Workshop guidelines from 1 November 1928**
Bauhaus Weimar–Dessau–Berlin, folder 53, Bauhaus-Archiv Berlin

„Liste der Schutzfristen für Gebrauchs- und Geschmacksmuster.
die Verlängerung der Schutzfrist hat stets *vor* deren Ablauf zu erfolgen.
Naumann

Lfd. Nr.	Bezeichnung des Gegenstandes	Werk-statt	eingetragen unter Geschmacks-muster #	Gebrauchs-muster #	Schutzdauer anfang	ende	Schutzdauer, verlängert am	auf	bis
1	stuhl aus stoffsitz u. armlehne	ti	# 278 / e 1a	-	28.9.25	28.9.28	-		
2	kinderstuhl	ti	e 3a / e 3b	-	"	"	-		
3	küchenstuhl	ti	e 4	-	"	"	-		
4	küchentisch	ti	e 5	-	"	"	-		
5	küchenschrank	ti	e 7	-	"	"	-		
6	kindertisch	ti	e 6	-	"	"	-		
7	wohnzimmertisch	ti	e 9	-	"	"	-		
8	kinderliegestuhl	ti	e 12	-	"	"	-		
9	glaslampe	me?	e 1	-	"	"	[1]	7	28.9.35
10	metalllampe	me	e 2	-	"	"	-		
11	teekugel / me	me	e 3	926 828	"	"	-		
12	teekugelhalter	me	e 4	-	"	"	-		
13	teebüchse	me	e 5	-	"	"	-		
14	teeglashalter	me	e 6	-	"	"	-		
15	aschenbecher	me	e 7	-	"	"	-		
16	teekugeluntersatz	me		926 829	26.9.25	26.9.28	-		
17	armsessel	ti		926 830	"	"	-		
18	armsessel	ti		926 831	"	"	-		
19	ti 200 stuhl bücking	ti	# 289		3.9.28	3.9.31			
20	ti 200a " "	ti	"		"	"			
21	ti 200b " "	ti	"		"	"			
22	ti 201 " decker	ti	"		"	"			
23	ti 202 " hassenpflug	ti	"		"	"			
24	ti 2 rückenlehnstuhl breuer	ti	"		"	"			
25	ti 205 klapptisch hassenpflug	ti	"		"	"			
26	ti 206 klappstuhl hassenpflug	ti	"		"	"			
27	me 154 toiletten-spiegel brandt	me	"		"	"			
28	ti 240 klappliege-stuhl	ti	# 290		8.3.29	8.3.32	Schutzfrist wird nicht verlängert		
29	teeglashalter 10001	me	291		28.4.29	28.4.32	an käufer mitg.		
30	aschenbecher 10002	me	"		"	"	schriftl. wird nicht verlängert "		
31	obstschale 10003	me	"		"	"			
32	kippstuhl # 1003	me	292		5.8.29	5.8.32			
33	satz von bausteinen	bau		1115185	16.11.29	16.11.32			
34	arbeitsstuhl mit verstellbarem sitz	me							
35	teeglashalter	me		1205058	9.1.32	9.1.35			
36	elastische sitz- & lehnenfläche für sitz- & liegemöbel	aus-bau		1223915	24.6.32"				

[1] Unleserlich.

■ 402 "List of terms of copyrights for utility models and registered designs", Stadtarchiv Dessau-Roßlau, SB/18, transcript by Sebastian Neurauter, first published in Sebastian Neurauter, *Das Bauhaus und die Verwertungsrechte*, Mohr Siebeck, Tübingen 2013

Of Copyrights and Licences

Potential for conflict also arose regarding what fees former Bauhaus members should receive for their designs after their departure, insofar as these were still in production. There were differences, for example, when Marianne Brandt left the Bauhaus in 1930. Brandt had worked with Hin Bredendieck when employees of the metal workshop produced lamp designs for Körting & Mathiesen (known for their Kandem-Leuchten brand). Brandt wrote to Bredendieck in a letter of 12 June 1930:

"I find the Bauhaus offer of 800 RM payable in 4 instalments of 200 RM extraordinarily modest. In fact I find it unacceptable. When on my departure I told one of the leading personalities of my assumption that they would certainly have to amend the guidelines in order to get around the inconvenience of a licence payment, this person told me that such a course would be very difficult to achieve, and in the event of a squeeze the only course that would be open would be the law. This would, of course, be difficult for us since the party to face in our lawsuit would be the City of Dessau. And the city certainly has far more staying power than we have." [32]

In a further letter to Bredendieck on 10 July 1930 Brandt states that the Bauhaus had not until that date responded to her licence requests. [33]

Registration of intellectual property rights

With its move in the direction of pattern model-making for industrial production, the Bauhaus in Dessau was also obliged to secure the intellectual property rights for its products and turned to the patent lawyers Karsten & Wiegand. In September 1925 the lawyers registered sixteen design and utility patents for models from the cabinet making and joinery workshops ■402. [34] The majority of those in the first category were from Marcel Breuer, and the greater part of the designs from the metal workshop were by Wilhelm Wagenfeld. Since Bauhaus Dessau as an institution was not a legal entity in its own right, the registration entries were made in the name of the "Municipality of Dessau, as represented by the director of the city Bauhaus Professor Gropius, Dessau", or simply in the name of the " Municipality of Dessau". [35] When reading the surviving correspondence with the patent lawyer Wiegand, an immediately apparent point is that the authors of the various models are not named. From the start of contact through to the first registration in September 1925 each of the models dealt with was treated as an anonymous creation. This was in compliance with the marketing concept of the Bauhaus which moved in the direction of depersonalization and corporate identity. Patent rights were registered on a total of thirty-six design models until the closure of Bauhaus Dessau. [36]

After the final closure of the Bauhaus in 1933 it achieved a continuously growing worldwide fame. Business interest in its inheritance grew considerably. The design copyrights and the patents on numerous objects have long since expired, but a great many others still remain under intellectual property protection. The long extended period of protection under the copyright laws (up to seventy years after the death of an author) [37] now has the effect that the disputes and contention surrounding many Bauhaus creations will have sequels continuing into the distant future.

Sebastian Neurauter

1 This essay is based on the study "Das Bauhaus und die Verwertungsrechte – Eine Untersuchung zur Praxis der Rechteverwertung am Bauhaus 1919–1933".

2 See Lothar Lang, *Das Bauhaus 1919–1933 – Idee und Wirklichkeit,* Zentralinstitut für Gestaltung, Berlin 1965, p. 31, and Horst Claussen, *Walter Gropius, Grundzüge seines Denkens,* Olms, Hildesheim 1986, pp. 32ff.

3 Law relating to the copyright on works of art and photography 9 January 1907 (KUG 1907), and law relating to the copyright on works of literature and music 19 June 1901 (LUG 1901).

4 Law relating to the copyright of industrial designs and models 11 January 1876 (GeschmMG 1876).

5 Patent law 7 April 1891.

6 Law relating to the protection of designs 1 June 1891 (GebrMG 1891).

7 German court ruling 1 June 1932, ref. no. I 75/32, GRUR 1932, 892, 893 – Mart Stam.

8 German court ruling of 14 January 1933, ref. no. I 139/42, RGZ 139, 214, 219 f. = GRUR 1933, 323f.

9 See current version applicable today in §7 UrhG (version since 1965).

10 As an example, see German court ruling of 8 April 1925, RGZ 110, 393, 395 – employee authorship and name rights.

11 Contract of 1 October 1921, Main State Archives of Thuringia in Weimar, Staatliches Bauhaus Weimar no. 114, Bl. 271.

12 GRUR 1933, 323, 324.

13 Municipal Archives Dessau-Roßlau, SB/29, Bl. 41.

14 Ibid., Bl. 44.

15 See Sebastian Neurauter, *Das Bauhaus und die Verwertungsrechte,* Mohr Siebeck, Tübingen 2013, pp. 462–71.

16 Minutes of the Council of Masters 2 February 1920 in Volker Wahl and Ute Ackermann, *The Meisterratsprotokolle des Staatlichen Bauhauses Weimar 1919 bis 1925,* Hermann Böhlaus Nachfolger, Weimar 2001, p. 71.

17 Main State Archives of Thuringia in Weimar, Staatliches Bauhaus Weimar no. 14, Bl. 30; illustration in Rolf Bothe, *Das frühe Bauhaus und Johannes Itten,* Hatje Cantz, Ostfildern, 1994, pp. 217f.

18 Printed among others in Hans Maria Wingler, *Das Bauhaus 1919–1933,* 3rd edition 1975, p. 55.

19 Wahl and Ackermann, op. cit. 2001, pp. 117, 119.

20 Ibid.

21 Bauhaus-Archiv Berlin, Bauhaus Weimar–Dessau– Berlin, folder 53 (small print, with highlighting).

22 See "Grundsätze für die Lizenz-Verteilung an Bauhaus-Angehörige für Entwurf und Herstellung von Werkstätten-Erzeugnissen" of 22 February 1924, Main State Archives of Thuringia in Weimar, Staatliches Bauhaus Weimar no. 132, Bl. 34–35.

23 Bauhaus-Archiv Berlin, Berger, Otti, folder 16.

24 For example, a design by the student Franz Ehrlich: meeting of the business committee on 18 July 1930, minutes, Bauhaus Dessau Foundation, Engemann estate, I 8071– 8387 D (small print). In §10 it was arranged that "every single object which falls under the terms of this contract" should be the subject of "a special contract established between the Bauhaus and the Bauhaus member"; Bauhaus-Archiv Berlin, GS 7, folder 45.

25 Bauhaus-Archiv Berlin, GS 7, folder 45.

26 Peter Hahn, *Bauhaus Berlin,* Kunstverlag Weingarten, Weingarten 1985, p. 101 (small print).

27 See minutes of the advisory board meeting of 31 January 1933, Bauhaus Dessau Foundation, Engemann estate, I 8071–8387 D.

28 See the rule in the guidelines of 1 November 1928 filed under the letter g (Licences), Bauhaus-Archiv Berlin, Bauhaus Weimar–Dessau– Berlin, folder 53.

29 Ibid.

30 Bauhaus-Archiv Berlin, GS 7, folder 45.

31 Minutes, Bauhaus Dessau Foundation, Engemann estate, I 8071–8387 D.

32 Bauhaus-Archiv Berlin, Brandt, Marianne, folder 10 (small print).

33 Ibid.

34 Municipal Archives Dessau-Roßlau, SB / 18.

35 This is borne out by later confirmations of receipts and other papers and correspondence of the German Patent Office (Reichspatentamt), in the Municipal Archives Dessau-Roßlau, SB / 18.

36 See the "Liste der Schutzfristen für Gebrauchs- und Geschmacksmuster", in the Municipal Archives Dessau-Roßlau, SB/18; printed in Neurauter, loc. cit. 2013, pp. 403f.

37 This deadline is applicable under §129 para. 1 UrhG 1965 and also applies for old, existing works.

Back to the Future
How tradition inspires
contemporary *making*
Claire Warnier and Dries Verbruggen

"We have broken your business, now we want your machines!"[1] This was the tongue-in-cheek response UK writer and digital strategist Russell Davies gave when he was asked by The Guardian Media Group to talk about the implications for the newspaper industry of a company he co-founded in 2009 called Newspaper Club ■403. This is a digital web service that allows anyone to design and print their own custom newspapers on demand, from a single copy to ten thousand or more. What empowers it is the collapse of traditional print newspapers: the birth of low-threshold blogging platforms and free citizen journalism has decoupled news from the physical newspaper and subsequently ruined the industry's business model. Newspaper Club does the reverse and reclaims the deprecated newspaper medium from the news business and frees its pages up for public appropriation. By injecting the logic and methods of the internet into an age-old infrastructure, it manages to show that people would still pay for a traditional newspaper, they just don't want to pay for news any more.

This is just one example of how the digital revolution is putting pressure on current social, technological and economical models. Digitization has caused irrevocable shifts of tectonic scale, from media industries struggling with peer-to-peer music and film sharing, to computerized high-frequency trading algorithms taking over half of the US stock market, traditional stores being undercut and outrun by Amazon, citizen journalists monitoring illegal state-sponsored weapons deliveries and kids no longer having to interact face to face but able to kickstart political revolutions from their laptops. Increasingly we can see these digitally induced cracks and subsequent shifts starting to develop in the world of design and manufacturing too, with phenomena such as distributed digital manufacturing, crowd funding, open-source hardware and co-design.

It would be well to remember that this kind of dramatic change is nothing new, and more than a hundred years ago it was industrialization that played the role of the disruptor. And it is when under pressure – when the status quo isn't working any more – that people tend to reflect on the past and carve out new roles for themselves. We see this today, but we also saw it in the early 1920s – shortly after the First World War shook up our beliefs with the founding of the Bauhaus in Weimar, led by the architect Walter Gropius.

Industrious craft
In the first 1919 *Bauhaus Manifesto and Programme*, Walter Gropius wrote: "Architects, sculptors, painters, we must all return to craft skills!"[2] Gropius pleaded for the end of "art for

art's sake"[3] and a renewed focus in all artistic disciplines on materials, techniques and the making of objects. He argued that art itself cannot be learned and that education in the arts must instead be focused on the learning of a craft ■026 p. 98.

At the time of the foundation of the Bauhaus, roles and relations within the production industry were changing in major ways. Until the Industrial Revolution, most things were made by hand by craftsmen who embodied the entire making process from start to finish. These people possessed an extraordinary knowledge of the materials, tools and heritage of the things they made, transferred over centuries from master to apprentice. With the Industrial Revolution, this one-man show started to disintegrate into many different professions. Traditional activities and relations, inherently stringed together in the holistic practice of the craftsman, became separated from each other. The maker and the user became anonymous personae for each other, and designing, making and selling, once activities combined in one profession, broke up into many specialized professions.

The newly emerged designers – those responsible for the design and not the making – felt frustrated with these changes and tried to reformulate a meaningful position within the new industrial system. Some felt threatened, but all were challenged: how can we keep up standards of quality and perfection within an industrial system that is focusing merely on appearance and quantity? Many positions were taken in this debate, and all tried to reclaim some of the lost terrain, or stretch the definition of their profession. But the overall tendency was either to ignore the industrial production systems and try to preserve the artisanal past, or to embrace these new tendencies and try to face the challenges they brought.

When reading Gropius's statement about a return to the crafts, we might think his idea of craft was a romantic one, looking at the past rather than the future. At first sight, it feels as if he was rejecting the big changes in society – industrialization, mass production, and trying to go back to the old system.

According to Professor Sir Christopher Frayling, the now widely quoted "return" in Gropius's early statement is a mistranslation of the original German. Gropius's intention was a "turn" to craft in a contemporary way, rather than a "return" to a nostalgic idea of craft.[4] Gropius wanted the architects, sculptors and painters of his time to take the traditional system and make it valuable within a present-day society.[5] This interpretation is corroborated by a lecture given by Gropius to a large group of industrialists on 28 June 1919, in which he explained the intentions of the Bauhaus and asked for their support.[6] In an essay he wrote in 1925, Gropius's vision of the crafts is much more elaborated: *"The Bauhaus represents the opinion that the contrast between industry and the crafts is much less marked by the difference in the tools they use than by the division of labour in industry and the unity of the work in crafts. But the two are constantly getting closer to each other."*[7] In other words, Gropius envisioned a new kind of craft that unites both craft and industry. He tried to connect the traditional past with the unknown future, using craft as a bridge between the two.

Today we see again a renewed interest in the crafts, especially in the last decade. Design magazines and blogs have been full of stories about designers rediscovering the crafts, sometimes as a nostalgic "return", but a growing number of designers are "turning" to craft with, in their hands, the tools brought by the digital revolution. In his groundbreaking 1996 book, *Abstracting Craft: The Practiced Digital Hand,* Malcolm McCullough aimed to open up the definition of craft in order to find a place for digital technology within it: "Craft is neither the design nor the individual artifact: it is the tradition of the very production. It is the presence of many objects identical in their conception, and interchangeable in their use, but unique in their execution."[8] His words perfectly intertwine with Gropius's interpretation of craft in his second Bauhaus manifesto.

■ 403 *Newspaper Club*, **test print, 2010**
Photograph: Russel Duncan, *Newspaper Club*

Claire Warnier and Dries Verbruggen

■ 404 Dirk Vander Kooij, *Endless Chair*, 2010
Photograph: René van der Hulst

■ 405 Adrian Bowyer, initiator of the RepRap
open source 3D printer project, 2011
Photograph: Georgie Clarke

Back to the Future

What this turn to crafts in a digital context might look like can be illustrated with the work of Dutch designer Dirk Vander Kooij. In 2011 he obtained for himself a decommissioned industrial robot arm from a Chinese car factory and equipped it with a plastic extruder ■404. He installed this oversized 3D printer in his small studio and started to print out "endless" chairs with thick toothpaste-like plastic coils of various colours. Despite using industrial gear, Vander Kooij operates more like a traditional craftsman, constantly honing and improving his tools and the products he makes with them. In his process, there is no distinction between the pre-production prototype and the final – often mass-produced – object such as we see in industrial production. Every chair produced is a prototype for the next one and, as such, his production process follows more the logic of craft production. This type of feedback loop opens up the development of products to become a more public affair as opposed to the classical closed-doors design of products for industry. It is this continuous iterative design and making process that for centuries formed the heart of the craft way of manufacturing.

In Vander Kooij's re-appropriation of industrial machines, we hear echoes of Davies's statement to The Guardian Media Group. While many similarities can be drawn between today's turn to craft and the one envisioned by Gropius, this do-it-yourself attitude is in juxtaposition to the Bauhaus vision of the craftsman-designer serving industry, as today's generation rather bypasses industrial institutions altogether. And the vital information to do so isn't locked up in industry any more but can be openly found and shared online.

Distributed education

"It is only through constant contact with newly evolving techniques, with the discovery of new materials, and with new ways of putting things together, that the creative individual can learn to bring the design of objects into a living relationship with tradition and from that point to develop a new attitude towards design".[9]

The Bauhaus was first and foremost an educational institute and Gropius wanted its workshops to become the laboratory for a new kind of craftsman. The workshops in the Bauhaus were operated by masters, journeymen and apprentices and facilitated hands-on experimentation with new technologies and materials. The laboratories of today are not educational institutes: they have been superseded by an ad-hoc knowledge-sharing infrastructure of blogs, open-source instructions and wikis with their physical hubs in the form of FabLabs and hacker spaces. Contemporary design studios are nested within this structure, both benefiting from it and feeding it with new developments. As such, education has become distributed.

An interesting example of knowledge distribution in this context is the way 3D printing as a technique became popular so rapidly over the last decade. In 2005 Professor Adrian Bowyer and a tiny group of students at the University of Bath began researching a machine that could reproduce itself. This resulted in the development of the first simple, open-source 3D printer called RepRap ■405. The blueprints for the machine were published online and soon people everywhere – including our own design studio Unfold – joined its development, improving and extending every aspect of the machine and learning from each other's developments through a so-called "blog of blogs" that aggregated every individual's openly published, but disconnected, efforts into one feed of information, discussion and learning.[10] Within a few years, a cottage industry of consumer 3D printer manufacturers was born, with by-now established names such as Ultimaker or Makerbot. Today, every maker, inventor, designer, hobbyist or artist can enjoy the fruit of this platform and have a 3D printer in their studio. The lowering of the barriers into digital manufacturing triggered an

unprecedented explosion of creative experimentation with 3D printing. Just like a craftsman who would constantly improve his own tools, these machines are conceived in such a way that they are easy to hack into and alter to suit one's needs – from Royal College of Art graduate Markus Kayser's Solar Sinter ■406 ■407, a machine that turns desert sand into a glass vessel using focused sunlight, to the work in Unfold on developing ceramic 3D printing processes akin to traditional coiling and the resulting research on a distributed ceramic manufacturing network ■408 ■409.

The collaborative open learning spirit that resulted in the RepRap 3D printer continues to live in the projects it's being employed in. Richard van As, a carpenter from South Africa, lost all four right-hand fingers in a tragic accident. He soon discovered the incredibly high cost of a custom-made prosthesis but, being a maker, he created a provisional solution in his own workshop. But his life really changed through a chance encounter on YouTube with American puppeteer Ivan Owen. Together the two men designed a fully functional prosthesis, first from aluminium and later using 3D printing, which allowed them to work unhampered even though they lived on opposite sides of the world. Files could be emailed, printed, tested and commented on in the span of a single day, allowing for rapid iterative development. Other people started noticing the Robohand project and joined in, to develop and produce a €50 prosthesis. The world took notice of this example of amateur healthcare, and today professionals are pitching in and bringing their expertise to the Robohand and e-NABLE communities that formed around the project.

Quality through transparency

"The Bauhaus workshops are essentially laboratories in which prototypes of products suitable for mass production and typical of our time are carefully developed and constantly improved. In these laboratories the Bauhaus wants to train a new kind of collaborator for industry and the crafts, who has an equal command of both technology and form."[11]

Through the education of a new breed of craftsmen, Gropius argued, the industry could be guided to produce quality products. He wrote: "The Bauhaus fights against the cheap substitute, inferior workmanship, and the dilettantism of the handicrafts, for a new standard of quality work."[12] In the Dessau period, the Bauhaus started to pay more attention to the creation of quality products and systems for an industrial society. "The machine, capable of producing standardized products, is an effective device, which, by means of mechanical aids – steam and electricity – can free the individual from working manually for the satisfaction of his daily needs and can provide him with mass-produced products that are cheaper and better than those manufactured by hand."[13] The Bauhaus philosophy was noble, and in essence it was part of a larger movement that intended to utilize industrialization to democratize production and to provide quality products to the masses. Many goods considered ubiquitous today were luxury products before industrialization. This optimistic utopia lived on until late in the twentieth century. Kaj Franck, one of the emblematic designers at Nuutajärvi, now Iittala, used the motto *"Echt gepresst – nicht geschliffen"* [genuine pressed glass – not hand cut] for his Delfoi range of pressed glass designed in 1976, a tongue-in-cheek reference to the traditional exclusive hand-cut and polished glass which went under the tagline *"Echt Kristall – handgeschliffen"* [Genuine Crystal – hand cut].[14]

But around the same time dissident voices started to emerge. While it was a noble goal to create better products, there was a growing sense that industrialization merely gave people access to more, but often inferior, products disconnected from the people they were meant to serve. Industrialization gave birth to consumerism and overconsumption.

■ 406 **Markus Kayser, Solar Sinter, Egypt 2011**
Photograph: Markus Kayser Studio

■ 407 **Markus Kayser, bowls printed with the
Solar Sinter, Morocco 2012**
Photograph: Markus Kayser Studio

Claire Warnier and Dries Verbruggen

■ 408 Unfold, 3D printer for ceramics, 2009
Photograph: Kristof Vrancken

■ 409 Unfold, 3D printed ceramic structures, 2009
Photograph: Kristof Vrancken

Back to the Future

In his collection of essays, *Small Is Beautiful*, the British economist E. F. Schumacher pleaded against the idea of economic growth, an inhumane system that requires people to buy and replace more stuff in perpetuity. "The economic calculus [...] forces the industrialist to eliminate the human factor because machines do not make mistakes which people do."[15] He called the industrial system a leftover of nineteenth-century thinking and he argued that it was time to think of a new system, a system based on attention to people rather than goods. He quoted from Gandhi's economic vision of "production by the masses" instead of "mass production".

In today's manufacturing system people are demoted to "target groups" who need to be studied with "market research" in order to understand their needs, instead of being involved directly in the process. The two-way conversation between maker and user has long since been reduced to one-way broadcasting. Modernism's elitist idea of "good taste" and a single solution for everyone surely did not help alleviate the problem,[16] but the reduction of the individual to a large generalized group was also the collateral damage of industry's necessity for economies of scale. A product always has to be produced in gigantic quantities to compensate for the high cost and complexity of starting up production. Personal manufacturing, the production of personalized artefacts for individual people, was no longer feasible nor desirable. The complexity of the industrial manufacturing system, with its long chain of marketeers, designers, investors, engineers, factory workers, retailers and distributers, also resulted in obfuscating for the user where and how stuff is being made, aspects that used to be a great deal more transparent in the short chains of craft production.

Stefano Giovannoni is an Italian industrial designer famous for his work in the eighties and nineties for Italian kitchenware brand Alessi. In a recent interview with online design publication *Dezeen*, he argued that the furniture and product brands we know today "will disappear in five years" due to the way the internet revolutionizes the way we market and distribute goods. And traditional design brands are not investing enough in new (read digital) business models. Giovannoni is referring to online platforms such as Etsy, Shapeways, Monoqi and Bezar, where designers and makers can sell directly to end-users, sidestepping the long chain with its numerous gatekeepers. The success of such platforms has been created by people looking for more personal products, created in smaller quantities and with the stories of the makers. Giovannoni draws an interesting parallel, suggesting that in the future product designers will take a page from the book of fashion designers and become their own brands, arguing that "the role of the designer is to be an entrepreneur".[17] Where Giovannoni falls short is in understanding that designers will not only become brands, managing their own marketing and distribution using online tools, but they will become manufacturers too . . .

With manufacturing going digital, industry is being scaled back to the size of the studio, and we see a merging of aspects of the pre-industrial craft economy with high-tech industrial production methods injected with the internet. If we are able to learn from the past, this combination has the potential to shift power from industrial mass producers to the entrepreneur-designer and the consumer, whose involvement in the process leads to better and more transparent production.

Due to resemblances in the spirit of the age, it is relevant to reread the Bauhaus today, but the interesting observations happen where the marked differences are. How can we learn from some of the mistakes the Bauhaus made? While we should embrace the opportunities digital manufacturing brings, we should keep a critical attitude to how our well-intentioned actions today might overshoot in the future.

Claire Warnier and Dries Verbruggen

1 Russell Davies, "Not just electronic", for the exhibition *After the Bit Rush* in art gallery MU, Eindhoven, 2011.

2 Walter Gropius, *Manifest und Programm des Staatlichen Bauhauses*.

3 Christopher Frayling, "We must all turn to the crafts", in Daniel Charny, *Power of Making. The importance of being skilled*, V&A Publishing, London, 2011, pp. 29–33.

4 Ibid.

5 Ibid.

6 Lecture given by Walter Gropius during a discussion of the Director of the State Bauhaus with tradesmen and industrialists on 28 June 1919; source: Bauhaus-Archiv Berlin, Walter Gropius Archive, GS 3/folder 12 (Design), printed in Volker Wahl, *Das Staatliche Bauhaus in Weimar. Dokumente zur Geschichte des Instituts 1919–1926*, Bühlau, Cologne/Weimar/Vienna 2009, p. 244ff.

7 Walter Gropius, "Grundsätze der Bauhausproduktion", *Bauhausbücher 7*, 1925.

8 Malcolm McCullough, *Abstracting Craft: The Practiced Digital Hand*, MIT Press, Massachusetts, 1996.

9 See note 6.

10 http://blog.reprap.org/2010/06/reprap-aggregation-pipe-v2-update.html, retrieved 17 April 2015.

11 See note 6.

12 Ibid.

13 Ibid.

14 Päivi Jantunen, *Kaj & Franck: Designs & Impressions*, WSOY Publishers, Helsinki, 2011.

15 E. F. Schumacher, *Small Is Beautiful: A Study of Economics As If People Mattered*, MIT Press, Massachusetts, 1976.

16 Paul Atkinson, "Orchestral Manoevres in Design", in Bas Van Abel, Lucas Evers, Roel Klaassen and Peter Troxler, *Open Design Now. Why design cannot remain exclusive*, BIS Publishers, Amsterdam, 2011, pp. 24–31.

17 Interview by Marcus Fairs with Stefano Giovannoni, "Most Design Brands will disappear within five years", http://www.dezeen.com/2015/02/28/stefano-giovannoni-most-design-brands-will-disappear-within-five-years-design-indaba-2015/, published February 2015, retrieved 17 April 2015.

Contemporary Exhibiting
Ute Famulla

During the short period of its existence, the Bauhaus developed impressive exhibiting activities. Internal presentations, public shows, design commissions for company exhibitions, and individual or group participations in other shows and exhibitions dealing with the institution itself followed one another at varying intervals and in different constellations, contributing to the public image of the Bauhaus. Just as the way in which the Bauhaus presented itself in printed matter was divergent, so too was the image it projected in exhibitions[1] and, like the print media, so too were the shows subject to constant revision which, in addition to refining the medium and its techniques, originated from the figures involved and their positions in terms of content and artistic aspects.[2] If one considers the way in which the Bauhaus presented itself in the context of contemporary exhibition discourse,[3] this development appears as a continuum that was always centred on building as a connecting link, and thus the struggle to realize contemporary architecture.[4]

Joseph Ganter stresses the general significance of the exhibition for Modernism in 1930 in his introduction to the booklet *Ausstellungen – Exhibitions – Expositions* ■410 when he writes: "More than ever before we need those exhibitions that are appropriate not only for the modern make-up of the people, but above all for their modern standard of living."[5] Although the importance of exhibitions for the "transformation that will change the world"[6] was repeatedly emphasized by the leading figures of the avant-garde movement, this magazine is among the few publications actually published on the subject.[7] Two key demands of the advocates of a "contemporary exhibition" were topicality and accessibility.[8] The first entailed a reference to the relevant expert discussion and thus constant revision of the presentations. The second concerned contribution to popular education and to a comprehensible solution to technical questions in the field. In order to do justice to these demands, the aim was for "the central problem of our time – the intensification of life – [to be] the theme of the exhibitions".[9] Only by demonstrating current problems urgently in need of solutions would it be possible to arouse public interest and make a productive contribution to the development of society. The aim, then, was to turn exhibitions into fields of experimentation for current debates. What is more, the intended realignment of exhibiting led to a rapprochement of temporary trade fair events pursuing commercial interests and museum presentations of a more identity-creating nature.[10]

Architecture at the centre
Despite the initial lack of a building department, architecture was from the outset at the

centre of the Bauhaus "as the ultimate goal of all creative activity".[11] The manifesto
written by Gropius in 1919, which indicates "the new building of the future"[12] as the aim of
the place of training, corresponds to the mood of new beginnings that prevailed after the
war. The first buildings associated with the Bauhaus – Haus Sommerfeld and the residential
project Am Horn – follow this tradition both conceptually and in terms of their design
expression.[13] But the ideas and ideals of the Bauhaus quickly advanced: in 1923, on the
occasion of his first major public appearance with the *Bauhaus-Ausstellung* (Bauhaus
exhibition) in Weimar, Gropius proclaimed the unity of art and technology, thus setting a
new target.[14] Not only the synthesis of the arts issuing from the community of architects and
artists, but also the machine-manufactured product in collaboration with the industry were
now presented as the basis of the Bauhaus's work. Building remained at the centre of
interest. Accordingly, the centrepiece of the exhibition was the show house Am Horn ■222
p. 239. In terms of style, this building differed starkly from Walter Determann's earlier, highly
Expressionist development plan for the residential estate of the same name.[15]
Georg Muche's design, with its plain white walls, asymmetric windows following the function
of the rooms, and cubic room units, was manifestly an example of the New Objectivity,
at the same time embodying the teamwork that the Bauhaus evinced at all times. While the
design came from Muche, it was carried out by Adolf Meyer and Walter March as members
of Gropius's construction office. Completion of the interior and the entire furnishings
were carried out "with the collaboration of German industry, the Sommerfeld company,
and the workshops of the Staatliches Bauhaus".[16]

The proximity to industry and thus the contribution to rationalization was highlighted
by Adolf Meyer in the publication about the show house when he stressed that "in choosing
the building materials and building structures [...] such materials and structures [were]
preferred which accommodate a new, synthetic concept of building; alternative modes
of building were deliberately eliminated, instead importance was attached to a harmony
of material and structure so as to [...] demonstrate a possible way forward even today".[17]

The connection between the Haus Am Horn and the current architectural debate
at that time was, however, not only part of the follow-up work after the show, it was also
communicated during the exhibition itself in the form of the signage,[18] catalogue, the house,
and above all the International Architecture Exhibition accompanying the building. As in
the publication about the Haus Am Horn, in addition to Muche's design the architecture
exhibition featured the "serial type houses" or "living machines" developed by Fred Forbát
■411, modular buildings intended to adapt to the occupants' different needs by means
of a flexible combination of various compartments.[19] Developed on Gropius's instructions,
they are based on an idea for typification that Gropius had proposed to AEG in 1910
in the form of a suggestion for a housing construction factory.[20] The exhibition of 1923 thus
spotlighted the rationalization of housing construction. What is more, the show house
Am Horn was a concrete contribution to the ongoing architectural debate.[21]

Architecture was the focus of attention once again at the next major Bauhaus event
– the opening of the Bauhaus building in Dessau in 1926, with the school building and the
Dessau-Törten residential estate.[22] In this context, Ise Gropius writes in her diary that this was
about "testing completely different methods of exhibiting than hitherto",[23] by which she
probably meant the visualization of the ideas in the building. The Dessau-Törten residential
development ■412[24] involved a discussion of current questions of housing construction
and a further refinement of the initial ideas of 1910 and 1923. The estate can be seen as a
practical experiment, with Gropius using cutting-edge construction technologies, as he
had in Weimar, although this did lead to constructional defects and thus to harsh criticism.

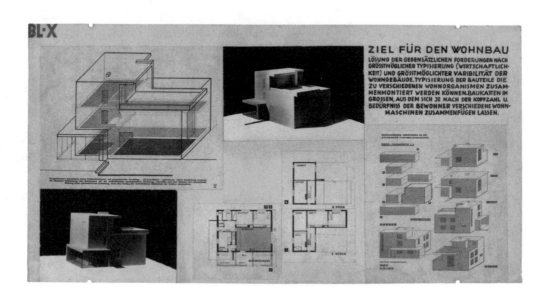

■ 410 Walter and Hans Leistikow, cover of the magazine *Das Neue Frankfurt*, **June 1930**, Frankfurt 1930, 24.3 × 26 cm, Universitätsbibliothek Heidelberg

■ 411 Fred Forbát, Bauhaus Housing Development Am Horn, Weimar, combination options: plans and model, **1920–1922**, collage, ink, silver gelatin photographs, photolithographic prints, 38.2 × 73.7 cm, Harvard Art Museums/ Busch-Reisinger Museum, Gift of Walter Gropius, BRGA.12.3

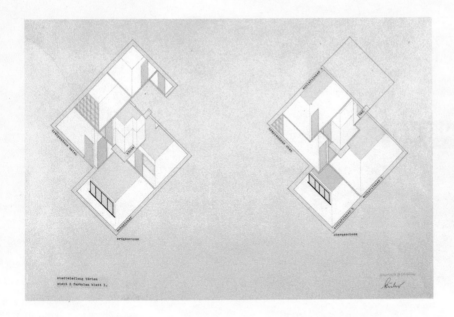

■412 **Friedrich Kuhr, Housing Development, Dessau-Törten, interior color scheme, isometric, 1926–28** graphite, black ink, gouache, collaged typewritten labels, on tan wove paper, 41.6 × 59.5 cm, Harvard Art Museums/ Busch-Reisinger Museum, Gift of Walter Gropius, BRGA.22.3

■413 **Walter Peterhans, exhibition *Die Volkswohnung*, living and sleeping room, view into kitchen, Grassimuseum Leipzig, 1929,** silver gelatin print, 15.3 × 21.2 cm, Bauhaus-Archiv Berlin

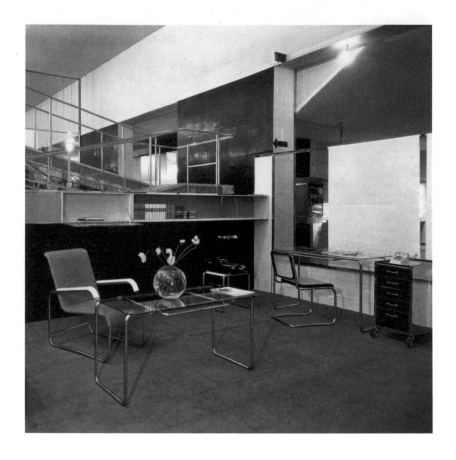

■ 414 **Marcel Breuer, floor plan of the apartments *Section Allemande* in Paris, 1930,** drawing, 52.1 × 30.5 cm, Marcel Breuer Papers, Special Collections Research Center, Syracuse University Libraries

■ 415 **Walter Gropius, Apartment House Communal Rooms for Werkbund Exhibition, Paris, c. 1930,** silver gelatin print, 16.9 × 17.4 cm, Harvard Art Museums/ Busch-Reisinger Museum, Gift of Walter Gropius, BRGA.45.9

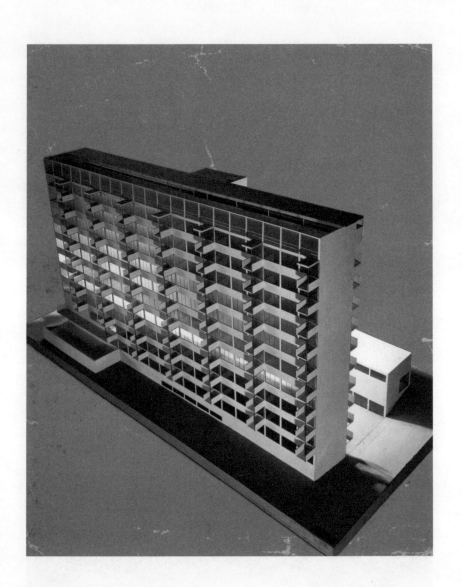

■416 **Walter Gropius, High-Rise Steel Frame Apartment
Building, 1929–30,** Harvard Art Museums/Busch-Reisinger
Museum, Gift of Ise Gropius, BRGA.44.39

Service to the people

The change of director from Gropius to Hannes Meyer entailed a realignment of the institution that was closely connected with the contemporary architecture debate: the unity of art and technology was now superseded by practical functional design as "service to the people".[25] Whereas the initial Bauhaus developments were founded on the idea of a garden city, large estates were now being built. Urban culture and city life in rationalized households came to be a contemporary architectural vision.[26]

The "minimum dwelling" was the new problem of the large estate. Not only did this subject fill all specialist magazines, it was also a topic of intense discussion at the Second International Congress of Modern Architecture. The Congress was accompanied by an exhibition entitled *The Minimum Subsistence Dwelling*. It was shown at various venues, including Zürich's Museum of Applied Arts – just a few months before the Bauhaus Travelling Exhibition organized by Meyer went on show in Basel, Breslau, Essen and Mannheim. Parts of this show were also presented in Leipzig at the reopening of the Grassi Museum in 1929. The form of the exhibition changed from venue to venue as it was constantly being refined and adapted to the exhibition sites.[27] This Bauhaus presentation also featured a "people's apartment" ■413. However, no building was constructed for the mobile show; instead, an interior was visualized as part of a larger residential complex. As before, architecture remained present here, too, not only as a historical quantity but as a current problem that the Bauhaus was instrumental in resolving. The *Neue Mannheimer Zeitung*, for example, reported on the three-room, extremely cheap people's apartment that demonstrated the potential of tasteful typification, technically and sociologically well thought out.[28] Looking at coverage of the show at the Grassi Museum in Leipzig, however, it becomes clear that this view was not shared by all visitors and the people's apartment was a topic of controversial public discussion.[29]

Despite the goal of setting the exhibition in the context of the discourse on the New Objectivity like the earlier Bauhaus shows, Meyer's presentation was above all an expression of his own understanding of architecture, a fact that becomes particularly apparent when it is compared with the "Section Allemande", which Gropius realized as part of the exhibition of the Société des Artistes décorateurs in Paris in 1930. The contrast between Meyer the pragmatist and Gropius the visionary is evident in these shows, conceived almost at the same time. Like Meyer, Gropius showcased an effort to solve the problem of the minimum dwelling, albeit not in the form of an inexpensive, practically feasible solution, but as a utopian version of a new society.[30] Alongside the apartment for a couple ■414 ■415, with one separate room each for the man and woman in keeping with ideas of restructuring society and of gender equality, Gropius presented a communal hall ■316 p. 337 that serves as the centre of a ten-storey apartment building ■416. The apartment has only a small bathroom, and instead of a big kitchen a compact kitchen – the lives of occupants in this apartment hotel would, after all, be organized collectively in the transformed society, and would take place in the communal area. Here we see a rich array of rooms with sports, sanitary, cultural and educational facilities.

The third director of the Bauhaus, Mies van der Rohe, tried to keep it out of the public discussion by exercising restraint – for one thing, in order to avoid political involvement and to reduce the risk of having the institution closed down.[31] The school nevertheless continued to contribute to the debate on modern housing construction. Accordingly, the Bauhaus featured at the Building Exhibition headed by Mies and held in Berlin in 1931. While the earlier directors had used their personal status among the architects of the New Objectivity to increase the Bauhaus's profile, Mies abstained from linking his own contribution with

that of the Bauhaus. In keeping with the contemporary debate, the Bauhaus presented a contribution to the minimum dwelling ■417.[32] What is remarkable is that this contribution was mentioned as the only example of a training facility in the magazine *Die Form*. The Bauhaus, then, continued to play a special role among the universities of art, all of which were active exhibitors, but did not receive the same level of attention in the press.[33]

Bauhaus exhibitions as "contemporary exhibitions"

Although the Bauhaus presentations differed under its various directors, it remained at all times a training facility for architecture that was devoted to the New Objectivity and was very clear in communicating this stance to the outside world – by combining exhibitions with the contemporary architecture discourse. The school always demonstrated its position with the aid of a contribution that introduced a new aspect into the current debate, putting it into practice in the form of experimental model buildings. What is more, the Bauhaus presentations not only picked up modern exhibition methods, but also helped to advance them. The topicality and experimental nature not only of the temporary, but also of the static, buildings and the simultaneous targeting of a mass audience and trade visitors are aspects of the struggle for the "contemporary exhibition" demanded by the institution. The form of this exhibition changed by degrees as mobile shows increasingly came to replace stationary presentations.[34] The aim was for small mobile presentations to reach a wide audience and also cut costs. The more or less extensive variation and reworking of the exhibition during the tour was the result of the need for topicality.

The focus on housing construction in the architectural debate in turn resulted from the circumstances of the Weimar Republic.[35] Housing construction policy was a key agenda of the workers' parties in an attempt to sway voters, which is why public sector house building was subsidized and became a central interest of architects. By focusing on the realm of housing construction, the Bauhaus – as called for by the advocates of "contemporary exhibiting" – thus picked up a central topic urgently in need of a solution.

Exhibitions in exile

Both Meyer and Gropius organized Bauhaus exhibitions while in exile. Meyer held the show *bauhaus dessau während der leitung unter hannes meyer 1928–1930* in 1931, shown in Moscow and Kharkov ■418. Gropius was jointly responsible with Bayer for the show *Bauhaus 1919–1928* ■318 p. 338 in New York in 1938. Both exhibitions were failures. The image of the Bauhaus presented in the USSR was probably too far removed from people's expectations.[36] But whereas the simplicity and partly traditional design of the presentation methods can be cited as reasons for the poor reviews in 1931, the same argument does not apply to the 1938 show at New York's MoMA. The installation, developed by Bayer, was worked out subtly and innovatively and followed the latest standards of exhibition methodology. What is more, the presentation swallowed half of the Bauhaus's annual exhibition budget ■419. Because the Bauhaus was already widely known and recognized in the US by this time, the failure came as a complete surprise to those involved. The explanation given was the cultural difference between the German exhibition-makers and the American audience, which was unable to "read" the exhibition.[37]

Apart from their shared failure, both exhibitions in exile also entailed a fundamental transformation of the Bauhaus image. The institution ceased to be an "acting subject" and became a historical paradigm: the Bauhaus did not speak up as an active contributor to the architectural debate, instead its educational approaches were staged as being exemplary. Whereas the Bauhaus was already a thing of the past in the year of the

BAUHAUS DESSAU (Bearbeiter Hans Volger). Etagenwohnung in einem Mietshaus, 62 qm, 2 Betten. Wohnzimmer, Schlafzimmer, Küche, Bad. Mit der Küche sind eine Arbeitslaibe und eine Speisekammer verbunden. Wohnzimmer nach Westen, Schlafzimmer nach Osten. Die Wohnung ist mit Serienmöbeln ausgestattet

Habitation comprenant tout un étage dans maison de rapport, 62 mètres carrés, deux lits. Chambre-salon, chambre à coucher, cuisine, salle de bain. A la cuisine se rattachent une loge de travail et un réduit servant de garde-manger. La chambre-salon prend jour à l'Ouest, la chambre à coucher, à l'Est. L'habitation est garnie de meubles fabriqués en série

Flat in tenement house, 62 sq. m., 2 beds. Living-room, bedroom, kitchen, bath. To the kitchen are attached a small workroom and a larder. Living-room faces west, bedroom east. Serial furniture

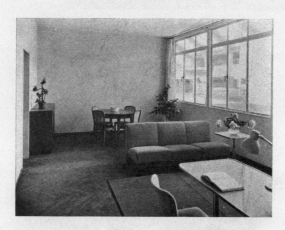

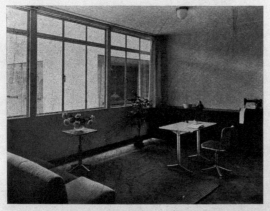

Bauhaus-Tapeten Hannoversche Tapetenfabrik Gebr. Rasch & Co., Bramsche b. Osnabrück
Möbel: Gemeinnützige Arbeitsgenossenschaft „Lübeck", Lübeck
Stühle: Gebr. Thonet A.G., Berlin / Albert Stoll Waldshut i. Baden

Fotos: C. Rehbein, Berlin

260

■ 417 **Joost Schmidt (typography), report on the contribution of the Bauhaus at the Bauausstellung, in** *Die Form,* **Berlin 1931,** letterpress, 21 × 29.7 cm, Universitätsbibliothek Heidelberg

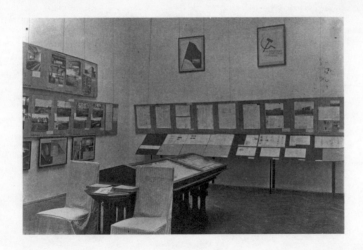

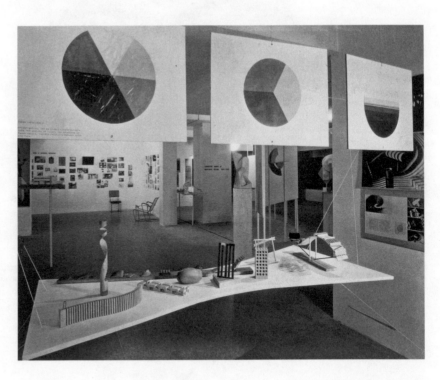

■ 418 Unknown, Bauhaus exhibition in Moscow: photo wall with Baulehre by Hannes Meyers and ADGB-Bundesschule, 1931, silver gelatin print, 13.3 × 20.3 cm, Bauhaus-Archiv Berlin

■ 419 Herbert Bayer, design for installation of the 1938 Bauhaus Exhibition at MoMA: Gallery view, 1938, silver gelatin print, 17.9 × 24.5 cm, Harvard Art Museums/Busch-Reisinger Museum, Gift of Lydia Dorner, BR58.114

New York show, making this development less surprising, the institution still existed at the time of the Soviet presentation. The exhibition-makers had deliberately enacted this change in terms of content for obvious and very similar reasons. In the USSR, Hannes Meyer was trying to set up as an architect and teacher: his "admission ticket" was not his architectural ideas but rather his educational approaches, with the system of architectural training that comprised "productive work by students on real buildings and collective work in vertical study groups".[38]

Gropius and Bayer, on the other hand, had already established themselves in America, like other Bauhaus colleagues. The Bauhaus approach to teaching had been incorporated in various educational facilities in the country. Accordingly, the New York exhibition featured the new workplaces of the Bauhaus members in the form of the Black Mountain College (North Carolina), the New Bauhaus (Chicago), and The Laboratory School of Industrial Design (New York). The show served to showcase their output and to consolidate their positions.

In neither exhibition, however, was the current architectural debate to be heard, and the Bauhaus became a historical justification in the discourse on training.

1 Ute Brüning, "Selbstdarstellung: 'Typochales und Normatives'", in Ute Brüning, ed., Das A und O des Bauhauses, Edition Leipzig, Leipzig 1995, p. 87.

2 Kai-Uwe Hemken, "'Guillotine der Dichter' oder Ausstellungsdesign am Bauhaus", in ibid., pp. 229ff.; Patrick Rössler, "Flucht in die Öffentlichkeit? Ausstellungen als Instrument zur Selbstpräsentation des Bauhauses", in Bauhaus-Archiv Berlin et al., ed., Modell Bauhaus, Hatje Cantz, Ostfildern 2009, pp. 337ff.; Dara Kiese, "Hannes Meyers Bauhaus – die 'Wanderschau' 1929–30", in Patrick Rössler, ed., bauhauskommunikation. Innovative Strategien im Umgang mit Medien, interner und externer Öffentlichkeit, Neue Bauhausbücher, vol. 1, Gebr. Mann Verlag, Berlin 2009, pp. 215–22 et pass.

3 My focus, then, is on the exhibitions dealing with the Bauhaus as an institution, staged by curators personally involved in the work of the Bauhaus.

4 Hemken, "Guillotine" 1995; Rössler, "Flucht" 2009; Kiese, "Wanderschau" 2009 et pass.

5 Joseph Ganter, "Unsere Publikation", in Das Neue Frankfurt, year 4, no. 6, June 1930, p. 141.

6 Mies Van der Rohe, "Zum Thema: Ausstellungen", in Die Form, year 3, no. 4, 1928, p. 121.

7 The editors of Die Form had planned a special issue on the topic of exhibitions as early as 1928 in order to "define quite clearly the real purpose of such exhibitions that transcend purely commercial interests [...] The idea is to identify and define the real cultural task of a major exhibition and how to find a form for this task that constitutes the best solution to the task." A publication entitled werbearchitektur. Ein bauhausbuch über ausstellungs-, schaufenster- und ladengestaltung to be published by Gropius and Moholy-Nagy was planned in England in 1936. See Ute Brüning, ed., Das A und O des Bauhauses, op. cit., p. 89.

8 Joseph Ganter, "Zusammenfassung und Thesen", in Das Neue Frankfurt, year 4, no. 6, June 1930, p. 148.

9 Van der Rohe, "Zum Thema" 1928, p. 121.

10 Anke Te Heesen, Theorien des Museums zur Einführung, 2nd edition, Junius, Hamburg 2013, pp. 14f.

11 Walter Gropius, "Bauhaus-Manifest" (1919), in Wolfgang Asholt and Walter Fähnders, ed., Manifeste und Proklamationen der europäischen Avantgarde (1909–1938), Metzler, Stuttgart/Weimar 1995, p. 173.

12 Ibid.

13 Winfried Nerdinger, Der Architekt Walter Gropius: Zeichnungen, Pläne und Fotos aus dem Busch-Reisinger-Museum der Harvard University Art Museums, Cambridge/Massachusetts und aus dem Bauhaus-Archiv Berlin, mit einem kritischen Werkverzeichnis, Gebr. Mann Verlag, Berlin 1995, p. 44.

14 Josefine Hintze and Corinna Lauerer, "Medienereignisse am Bauhaus. Die Ausstellung 1923 und die Einweihung des Bauhausgebäudes 1926", in Patrick Rössler, ed., bauhauskommunikation. Innovative Strategien im Umgang mit Medien, interner und externer Öffentlichkeit, Neue Bauhausbücher, vol. 1, Gebr. Mann Verlag, Berlin 2009, p. 186.

15 Karin Wilhelm, "Typisierung und Normierung für ein modernes Atriumhaus. Das Haus am Horn in Weimar", in Bauhaus-Archiv Berlin et al., ed., Modell Bauhaus, Hatje Cantz, Ostfildern 2009, pp. 149ff.

16 Adolf Meyer, Ein Versuchshaus des Bauhauses in Weimar, Bauhausbücher, vol. 3, Albert Langen Verlag, Munich 1924, p. 4.

17 Adolf Meyer, "Der Aufbau des Versuchshauses", in ibid., p. 24.

18 Ute Brüning, ed., Das A und O des Bauhauses, op. cit., p. 69.

19 Nerdinger, "Der Architekt Walter Gropius" 1995, pp. 58ff.

20 Hartmut Probst and Christian Schädlich, Walter Gropius, vol. 3: Ausgewählte Schriften, VEB Verlag für Bauwesen, Berlin 1987, pp. 18–25, fig. 12.

21 Karin Wilhelm, "Die Bauhaus-Ausstellung in Weimar 1923. Ein Rechenschaftsbericht", in Museumspädagogischer Dienst Berlin, ed., bauhaus weimar 1919–1924, Berlin 1996, pp. 29ff.

22 Hintze and Lauerer, "Medienereignisse" 2009, pp. 195f.

23 Ise Gropius, *Tagebuch*, p. 101 (22 January 1925), BHA Berlin, quoted in Hintze and Lauerer, "Medienereignisse" 2009, p. 192.

24 Nerdinger, "Der Architekt Walter Gropius" 1995, pp. 82f.

25 Hannes Meyer, "bauhaus und gesellschaft", in Lena Meyer-Berger and Klaus-Jürgen Winkler, ed., *Hannes Meyer: Bauen und Gesellschaft. Schriften, Briefe, Projekte*, VEB Verlag der Kunst, Dresden 1980, p. 50.

26 Annemarie Jaeggi, "Das Großlaboratorium für die Volkswohnung. Wagner. Taut. May. Gropius. 1924/25", in Norbert Huse, ed., *Siedlungen der zwanziger Jahre – heute. Vier Berliner Großsiedlungen 1924–1984*, Publica Verlagsgesellschaft cop., Berlin 1984, p. 29.

27 Christoph Zuschlag, "'ein eisenbahnwaggon ausstellungsgut'. Die Bauhaus-Wanderausstellung 1929–30 und ihre Mannheimer Station", in Peter Steininger, ed., *"als bauhäusler sind wir suchende". Hannes Meyer (1889–1954). Beiträge zu seinem Leben und Wirken*, Baudenkmal Bundesschule Bernau, Bernau bei Berlin 2014, p. 34. Among other things, the people's apartment was integrated at a later stage; facilities of the Bernau Trade Union School were presented in Zürich.

28 Ibid., p. 31.

29 Ibid., p. 33.

30 Robin Krause, "Die Ausstellung des Deutschen Werkbundes von Walter Gropius im '20E Salon des Artistes décorateurs français'", in Isabelle Ewig and Thomas W. Gaehtgens, ed., *Das Bauhaus und Frankreich – Le Bauhaus et la France*, Akademie Verlag, Berlin 2002, pp. 275–96.

31 Dara Kiese, "Bauhaus-PR unter Hannes Meyer und Mies van der Rohe", in Patrick Rössler, ed., *bauhauskommunikation. Innovative Strategien im Umgang mit Medien, interner und externer Öffentlichkeit*, Neue Bauhausbücher, vol. 1, Gebr. Mann Verlag, Berlin 2009, p. 141.

32 Ludwig Hilberseimer, "Die Wohnung unserer Zeit", in *Die Form*, year 6, no. 7, 1931, p. 260.

33 This becomes obvious, for example, by viewing the publications "Wegleitungen des Kunstgewerbemuseums Zürich" that accompanied the exhibitions and were published between 1928 and 1931: Kunstgewerbemuseum Zürich, ed., *Wegleitung des Kunstgewerbemuseums der Stadt Zürich*, nos 77–107, 1928–31.

34 The first presentations were firmly tied to their venues by the central architectural objects, with the form of the exhibition gradually evolving into a mobile show with the "Travelling Bauhaus Exhibition" and the *"Section Allemande"*. Appropriately modified and refined, the *"Section Allemande"* was Gropius's contribution to the "Building Exhibition" in Berlin in 1931.

35 Ludovica Scarpa, "Das Großsiedlungsmodell: von der Rationalisierung zum Städebau", in Norbert Huse, ed., *Siedlungen der zwanziger Jahre – heute. Vier Berliner Großsiedlungen 1924–1984*, Publica Verlagsgesellschaft cop., Berlin 1984, p. 21.

36 Phillipp Tolzinger, "Mit Hannes Meyer am bauhaus und in der Sowjetunion (1927–1936)", in Bauhaus-Archiv, ed., *Hannes Meyer 1889–1954, Architekt Urbanist Lehrer*, Wilhelm Ernst & Sohn, Berlin 1989, p. 253.

37 Mary Anne Staniszewski, *The Power of Display. A History of Exhibition Installations at the Museum of Modern Art*, MIT Press, Cambrige, Massachusetts 2001, pp. 143–52.

38 Arkadi Mordwinow, "Bauhaus k vystacke v Moskve", quoted in Klaus-Jürgen Winkler, *Der Architekt Hannes Meyer. Anschauungen und Werk*, VEB Verlag für Bauwesen, Berlin 1989, pp. 142f.

Stage Managing Media Coverage
Strategic visual communication by the Bauhaus?
Patrick Rössler

There is scarcely any doubt about the enormous significance of the Bauhaus for the artistic avant-garde of the twentieth century. The pioneer role the Bauhaus played in the development of strategic communications measures for presenting its issues to a national and international public is an area that has for a long time been far less well-known. The Bauhaus protagonists employed a broad range of PR instruments in this field, although doing so initially without any overall plan. The competences possessed by various individuals at the Bauhaus in dealing with the different media of the time first shaped the selection of these instruments.[1] Detailed analyses show how those publicity actions that achieved either a greater or a lesser success generally arose simply from the circumstances of the situation; moreover, they were distinguished by a high level of (intelligent) improvization.[2] Despite this slow beginning, the Bauhaus – and in particular its founder and first director Walter Gropius – achieved a measure of success in reaching different stakeholder groups and portions of the public.[3] In 1919, for example, he launched the first Bauhaus Manifesto in *Querschnitt*, the most popular intellectual magazine published in the Weimar Republic.[4]

A useful basis for bringing a meaningful structure to Bauhaus thinking on PR is an understanding of corporate communication in the context of the times as it emerged from an integrated corporate identity.[5] This comprises not only Bauhaus corporate design, as reflected in the printed matter produced at the in-house advertising workshop, for example, which is already sufficiently well investigated, but also corporate behaviour and corporate communications together with the public relations work that was done ■420. The concept of corporate identity can be applied usefully to the Bauhaus as an institution,[6] since in contrast to virtually all other artistic movements the Bauhaus was singled out as a state organization with a strongly institutionalized character.[7] As a counter-balance to this, however, the Bauhaus was obliged to operate from the start under permanent external pressure, which is why most of its communications measures are regarded from today's perspective as "crisis PR".[8]

The Bauhaus produced a wide range of its own publications – ranging from information brochures and advertising flyers published in very large editions,[9] or the Works of the Master reproduction folders from the in-house printing press,[10] through to the epoch-making Bauhaus Books series (from 1925) and the fourteen editions of the *Bauhaus Magazine*

Patrick Rössler

CORPORATE IDENTITY

Unternehmensleitbild: Bauhaus-Programme 1919 und 1923

CORPORATE DESIGN
visuelle Identität im Erscheinungsbild

Logo: Dienststempel 1919 und 1922

Drucksachengestaltung:
›Neue Typographie‹ ab 1923
(Schlemmer, Moholy-Nagy, Bayer)

Auftragsarbeiten:
Reklamewerkstatt (ab 1923)
z. B. Geldscheine (Bayer)

Kleinschreibung:
Standardisierung / Normierung
(Briefbogen Bayer ab 1925)

Arbeitskleidung:
Bauhaus-Tracht, Mazdaznan-Gewänder,
Monteurs-Overall

Architektur der Betriebsgebäude:
Versuchshaus ›am Horn‹,
Bauhaus-Neubau Dessau

CORPORATE BEHAVIOUR
Organisationskultur im Verhalten

Gemeinschaftsgedanke:
Feste, Bauhaustanz, Lesestunden
äußerer Druck als integrierende Kraft

Unterstützungsleistungen:
Mittagstische, Kleiderspenden,
Stipendien, Studierenden-Selbsthilfe

Auftreten der Bauhäusler vor Ort:
bohèmehaft und lebensreformerisch,
›Spießerschreck‹, moralisch zweifelhaft

CORPORATE COMMUNICATION
Kommunikationsbeziehungen zu
internen & externen Öffentlichkeiten (PR)

Grundfunktionen:
Konzeption: Gropius, Sitzungen des Meisterrats
Controlling: Presse-Ausschnittdienst Max Goldschmidt
Redaktion/Gestaltung: interne Ausführung
(Gropius, Schlemmer, Moholy-Nagy, Reklamewerkstatt)
Organisation: kollektives Engagement der Bauhäusler

Bezugsgruppen:
Internal Relations: Identität trotz Konflikten
(Richtungsstreit Gropius/Itten, Komplott C. Schlemmer)
Media Relations: Lokalpresse vs. Meinungsführer,
Agenturen, überregionale Medien
Maßnahmen: Pressemitteilungen und Bildproduktion
Community Relations: lokale Gegenpropaganda
(rechte Parteien) vs. überregionale Anerkennung
›Kreis der Freunde des Bauhauses‹
Financial/Investor Relations: Gründung Bauhaus GmbH,
Spendenaufrufe

Themen:
Krisen-PR: permanenter Ausnahmezustand (Bauhausstreit)
Public Affairs: Lobbyarbeit gegenüber Landespolitik und
Stadt (Ausstellung 1923)
Issues Management: Event-Produktion, Thematisierung
künstlerischer Positionen vs. polit. Grundsatzdebatten

Kommunikationsformen und Instrumente:
Einzelveranstaltungen: Ausstellung, Bauhaus-Abende und
-Feste, Auftritte Bauhaus-Kapelle und -Bühne
Publikationen: Info-Broschüren, Bauhaus-Mappen und
-Bücher, Zeitschrift ›bauhaus‹
Sonderhefte anderer Periodika
PR-Kampagnen:
Bauhaus-Ausstellung 1923
Eröffnung Bauhaus-Gebäude 1926

442

the bauhaus

■420 **Patrick Rössler, Bauhaus and its corporate identity**
– a survey, presentation according to Patrick Rössler

published in an edition of up to 3,000 from 1926 in Dessau.[11] In these, complete control of the content was a given and established media were being used to reach an already existing public. During the Council of Masters meeting of 24 March 1922, it was decided "to begin now with the good-quality illustrated reproduction of Bauhaus productions for publication in journals"[12] and it was thus clearly recognized that the Bauhaus idea was significantly better presented by the image than by the word. Today, the extensively illustrated special sections (or the complete special editions) of this work are recognized as a masterful achievement in communications, all of it launched by Gropius and others. It was here that the Bauhaus could present itself as it wished to be perceived by the outside world. Classic examples are the 1926 Bauhaus journal *Offset*, a specialist publication for the graphic industry and trades ■309 p. 335;[13] the 1924 special issue of the magazine *Junge Menschen*, in which all the contributions were exclusively from young people in or after training as journeymen or masters;[14] and the Bauhaus features of spring and summer 1925 in two special double issues of *Qualität*, a highly respected periodical in its circle published by the advertising graphics specialist Carl Ernst Hinkefuss.[15] These contributions to the specialist media,[16] which have been extensively discussed, reached the target groups relevant to the Bauhaus – specialists and future students. They were less suited, however, to making a broader public familiar with Bauhaus thinking.

This purpose was fulfilled by features in the mass-circulation illustrated press, which was reaching its first heights during the 1920s thanks to breakthroughs in photographic and printing techniques – the "iconic turn" that made such a significant impact on the visualization thrust of the epoch.[17] If the ideological controversies surrounding the Bauhaus were above all wars of words in the densely textual columns of the daily newspapers,[18] the illustrated magazines and the weekly photographic supplements in the newspapers were an altogether better means for achieving a presentation of the Bauhaus, using attention-grabbing audience appeal. Closer examination of these media contributions allows the identification of a number of key motifs and thus quite possibly the core of a "Bauhaus figurative trademark", establishing the visual image of the Bauhaus in its epoch.

Welcome occasions

According to the logic of event-related reporting, increased media attention is to be expected specifically in the context of the work presentations typical of artists' organizations. The Bauhaus thus made its photographic premiere in the illustrated press with the first major Bauhaus Exhibition of 1923 and also with the opening of the new Bauhaus building in Dessau in 1926. Each of these events had a special event status, offered much for illustrated feature reporting and was specifically aligned by the Bauhaus protagonists to reach the broadest possible (media) public.[19]

It is all the more disappointing in this context that although the first exhibition in Weimar was not without a certain echo in the press, photographic reporting was left out completely.[20] The market leader in this segment – the *Berliner Illustrirte Zeitung (BIZ)*, with a circulation in the millions – certainly showed interest but there was no publication, even though Adolf Behne (the influential companion of Gropius over many years) did all he could to support an illustrated article. The editor Kurt Korff refused space for it on the grounds that his readership was supposedly "without the least interest in the Bauhaus and its efforts". Ultimately only a very brief report by Behne appeared, together with a thoroughly blurred photograph of the experimental house Am Horn – and this was part of an incoherent layout which included photographs of other news events ■421.

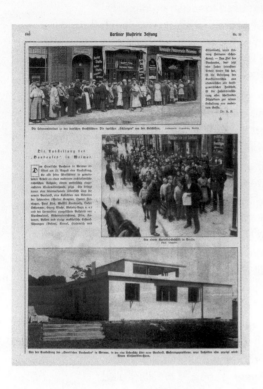

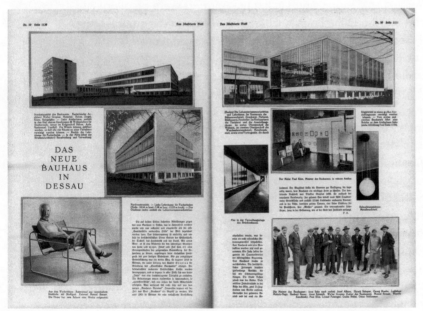

■421 Adolf Behne, house Am Horn in Weimar, illustrated feature published in *Berliner Illustrirte Zeitung*, **1923**, no. 33, Archiv der Massenpresse Patrick Rössler

■422 Berdina, "The new housing development", caricature published on the occasion of the inauguration of the new Bauhaus building. Illustrated feature in *Das illustrierte Blatt*, Frankfurt, **no. 50, 1926**, p. 1147, Archiv der Massenpresse Patrick Rössler

■423 "The new Bauhaus in Dessau", article published on the occasion of the inauguration of the Dessau Bauhaus building. Illustrated feature in *Das illustrierte Blatt*, Frankfurt, **no. 50, 1926**, pp. 1130 ff., Archiv der Massenpresse Patrick Rössler

Gropius made a further attempt with *BIZ* during the celebrations to mark the opening of the new building in early December 1926. He sought to establish contact once again through Dr Lion of the construction magazine *Bauwelt* (from the same publisher) and submitted 24 photographs for inspection.[21] This resulted in publication during the opening weekend, with two photographs and a positive report in *BIZ* – a major Bauhaus PR success. Furthermore, the first edition of the year 1927 brought a second article examining the "Experimental Theatre at the Bauhaus in Dessau" as an example of "abstract theatre". The text here provided no coverage of the opening festivities, but the illustrations referred clearly to presentations on the Bauhaus stage.

The greatest success emerged from the work done together with *Das illustrierte Blatt* magazine in Frankfurt am Main.[22] An illustrated feature in January 1926 on "Your housing interiors" made the effort to point out the "good record of previous achievement" by the Bauhaus.[23] After the topping-out ceremony for the new Dessau building, the journalist Bruno Adler, who had already written several articles on the Bauhaus,[24] wrote to Gropius again and deepened the contact.[25] In his reply of 1 April 1926 enclosing four photographs and a short text for publication, Gropius wrote, "Since there has been no published article on the new building to date, I am enclosing the first material for the illustrated edition."[26] This assurance of a publishing exclusive, however, did not bring the expected success; it is possible that the editors first began to take notice only with the opening ceremony in December. "Please remember that we have great interest in bringing a full appreciation in our publication before all the other journals," Peter Zingler, author of the later article, wrote to Gropius, adding: "the better the photographic material you can provide us with, the more space we will be able to make available for the subject."[27]

The interest of *Das illustrierte Blatt*, while not surprising from our perspective today, shows without a shadow of doubt how, unlike its prominent competitors in Berlin or Munich, it was a great deal more dedicated to a modern form of pictorial expression in the spirit of the "new way of seeing".[28] It was only logical that the picture editors of *Das Illustrierte Blatt* were eager to ensure exclusive rights to the material: "We cannot publish any photographs that have already been anticipated elsewhere. That is most important."[29] Gropius felt himself bound to this principle, and he stressed the point in his letters to other editorial teams.[30] Gropius continued to make every effort to maintain good contact with Zingler, as is shown by his invitation to the journalist to visit him at home, where he presented "beautiful and practical items [...] all of which, together with the handling of them, were completely unknown to me previously".[31] These objects were later to be presented in the women's page supplement *Für die Frau* in the *Frankfurter Zeitung*, and for which the editorial department hoped for an accompanying article written by "Gropius or one of his gentlemen" which would be "very informative, or (for the lady) very charming".[32]

The double-page spread in *Das illustrierte Blatt* finally appeared on 11 December 1926, one week after the opening, after Gropius had submitted a set of 33 photographs together with a list of captions.[33] The stylistically assured selection of the picture material for printing included numerous iconic motifs that have become key Bauhaus images today: the obligatory images of the building itself, a group photograph of the Bauhaus Masters on the roof, and the masked portrait of a lady in Marcel Breuer's steel tube chair – each an exclusive first publication. In addition, there were photographs of the spherical lamp from the in-house metal workshop, a view of the hall with window facade, and Paul Klee at work in his atelier ■423. The editorial staff could not resist using this same magazine to publish a caricature of Bauhaus architecture that criticized constructivism in a banal manner not much different to that of the hate-filled Weimar press ■422. After *Das illustrierte*

Blatt acquired the exclusive printing rights for these images, they were of only very limited interest for the competition, as was demonstrated by the reaction of *Illustrierte Zeitung* when it set the supply of "exquisite illustration material" as a condition for a "later publication".[34] Only one of the other major German publications of the time reported extensively on the opening: this was the *Leipziger Illustrierte Zeitung*, a publication strongly rooted in tradition, which brought out a double-page feature in the Christmas edition of 23 December 1926, illustrated with significantly less interesting photographic material ■425. A view of the workshop building with its characteristic glass facade was flanked by an interior and an exterior view of both the house of the Director, Gropius, and of a detached family home on the Törten Housing Estate, pictures of furnishings (including a Breuer chair, empty) plus a children's room and a kitchen facility. The static and almost lifeless effect of this layout, with no people or human interest, is in stark contrast to the presentation in the Frankfurt publication.

Reports in other periodicals are revealing about the public image of the Bauhaus in this context. A representational contribution of the regional press is, first, the weekend supplement of the *Anhalter Anzeiger*, which presented its readers with two building views from the opening weekend – an aerial photograph and a perspective of the atelier building and the workshop section, but leaving out the much-loved glass facade ■424. The monthly arts journals also published extensive reports.[35] Adolf Behne wrote an article for the 16 December 1926 edition of *Reclams Universum* (with photographs of the atelier building, the workshop wing and the Gropius house), while the highly popular monthly *Velhagen & Klasings Monatshefte* published a belated report in March 1927 (a contribution planned since August 1925 which, as a result, contained almost only pictorial material of the Weimar Bauhaus), and finally in April 1927 *Westermanns Monatshefte*, which in addition to a Gropius portrait and two typical views showing the exterior of the new building, published four photographs of the Director's house and of the Breuer chair.[36] The only lead story to include a cover picture of the glass facade for the celebrations was published in February 1927 by *Blätter für Alle*, a monthly published by Willi Münzenberg's Universum-Bücherei. The article "Only the purposeful is beautiful" examined the issue of the mass production of consumer goods and presented examples from the new building and from the Gropius house ■426. A similar line was followed by a full-page report in *Volk und Zeit*, the illustrated supplement to the Social Democratic newspaper *Vorwärts*, in late summer 1927: "The Bauhaus in everyday life" presented nine of the interior and product photographs of Lucia Moholy made for the opening in 1926, offering the so-called proletariat "the best possible in practical comfort" which was, furthermore, cheaper than in standard German industrial production.

Change of directors = change in communications

When off the beaten track of special events for public consumption, it proved difficult for the Bauhaus to draw the interest of the mass-circulation illustrated press. There were time and space for intensive reporting only in 1928 with the dramatic departure of Walter Gropius and several Bauhaus masters from Dessau, and the architect Hannes Meyer's new reign as director with a programmatic-ideological realignment. After the Munich *Illustrierte Presse* (under Stefan Lorant now in second position behind *BIZ*), the *Arbeiter Illustrierte Zeitung* of the communist Willi Münzenberg dedicated a double-page spread to the Bauhaus in spring 1927 under the title "From Dessau to Moscow" (a reference to the supposed export of Bauhaus architecture to the Soviet Union). In edition number 16 of April 1929, the text by Fritz Schiff (it is scarcely surprising to note) stressed the influence of the Bauhaus on revolutionary art and its orientation to the needs of the working class. The photographs which,

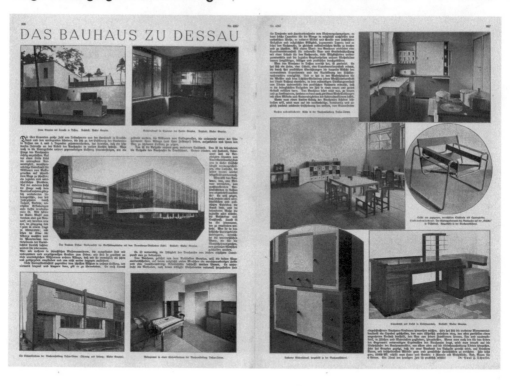

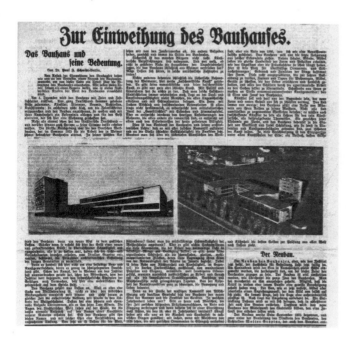

■424 "Inauguration of the Bauhaus", regional preliminary report on inauguration ceremony, supplement to *Anhalter Anzeiger*, Dessau, no. 284, December 1926, Archiv der Massenpresse Patrick Rössler

■425 "The Bauhaus in Dessau", article published on the occasion of the inauguration of the new Bauhaus building. Illustrated feature in *Die Illustrierte Zeitung*, Leipzig, no. 4267, December 1926, pp. 906ff., Archiv der Massenpresse Patrick Rössler

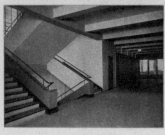

■ 426 "Only the useful is beautiful", report on the Bauhaus programme, illustrated feature in *Blätter für Alle*, Universum-Bücherei, Berlin, no. 2, 1927, cover and pp. 30 ff., Archiv der Massenpresse Patrick Rössler

■ 427 "Bauhaus Dessau", report on the Bauhaus under Hannes Meyer, illustrated feature in *Arbeiter-Illustrierte Zeitung*, Berlin, no. 16, 1929, pp. 8 ff., Archiv der Massenpresse Patrick Rössler

■ 428 "Girls want to learn something", report
on female Bauhaus students, illustrated feature
in *Die Woche*, Berlin, no. 1, 1930, pp. 30 ff.,
Archiv der Massenpresse Patrick Rössler

according to a credit citation, were taken from a feature in the *New York Times*, present the well-known views of the glass facade and atelier building, but are primarily focused on the work of Bauhaus members in the workshops ■427. The style of the article and the selection of pictures indicate that the change in the Bauhaus programme as proclaimed by Hannes Meyer had now found a public echo.[37]

The turn away from a work-oriented and institutional approach to a media presentation focused on the feel for life at the Bauhaus is seen most clearly in a three-page feature in the illustrated magazine *Die Woche* of January 1930. Part of the magazine and publishing empire of August Scherl, this was usually a middle-class and conservative publication, but the headline of the Bauhaus article was a rather racy "Girls want to learn something". A press release portrait photograph of a youthful Carla Grosch ■428 was accompanied by further photographs under the by-line "Lutz" [T. Lux] Feininger, taken for the renowned Dephot agency, showing Bauhaus women at work in the atelier plus music, theatre and sports subjects. It is not altogether certain to what extent this article was a result of the Bauhaus's own PR work, but the complete change in focus shown by the illustrations is very clear.

A later feature, in the *Arbeiter Illustrierte Zeitung* of January 1931, no longer had this light touch. The headline "The Bauhaus on its way to Fascism" showed that the wind had changed direction in Dessau, just as once in Weimar the Bauhaus had fallen out of grace with a number of politicians. In the intervening period Director Meyer had been called to Moscow.[38] The article begins with a picture taken from the Bauhaus student magazine which is described as a revolutionary "cell newspaper"; the text quotes the call by Meyer to cater to the "needs of the people instead of luxury" and praises "construction teaching on Marxist principles". The illustrations show "furniture that is attractive in form and practical, [which is] adjusted to the needs of working people", and also Meyer's departure and his friendly reception in the Soviet state ■429. The Bauhaus had lost control over the image it was presenting in the illustrated press and was never to regain it.

Swan song

The further relocation of the Bauhaus, this time to Berlin, occurred in 1932, a turbulent year marked by ideological struggles in which the conflicts surrounding an art school were no more than a footnote to the media-relevant events of the time.[39] Appropriately, traces in the press are thin on the ground. A feature by the well-known photo-journalist Alfred Eisenstaedt for Associated Press, which was printed in *Weltspiegel* (the illustrated supplement of the *Berliner Tageblatt*) in autumn 1932, speaks of a "departure without a destination". The pictures reflect, to an exaggerated extent, the wishes and intentions of the photographer; he pushes the studies of the Bauhaus students into the foreground and uses two familiar images with the atelier building balconies and the "Bauhaus" name on the facade ■430.

The suggestion was made at about the same time in *Zeitlupe* (the illustrated supplement of the *Neue Leipziger Zeitung*) that Leipzig should offer itself as a new home for the freshly exiled art school. The anonymously published "Obituary for the Dessau Bauhaus" provides – as appropriate for obituary columns – portraits of the three directors plus the obligatory full frontal view of the Dessau building, two dance photographs and a desk as an illustration of the workshop activities ■431. This intensive personality focus, in particular on the trend-setting Bauhaus directors, is also reflected in the text.[40] In October 1932 *Weltspiegel* reported the Bauhaus relocation to Berlin under the headline "The art school in the factory yard" ■432. The photo-feature series by Hans Reinke for the Degephot press agency[41] was a journalistic snapshot of the situation at the time: it gave a good impression of the improvization talent that was now demanded from Mies van der Rohe and his small remaining troop of students.

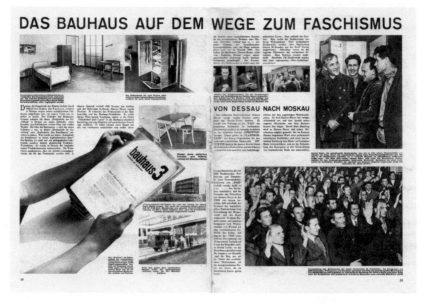

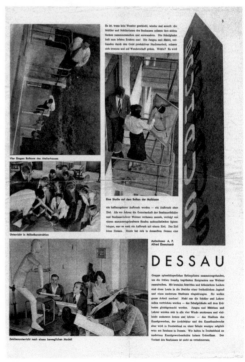

■429 "The Bauhaus on its way to Fascism", report on the replacement of Hannes Meyer, illustrated feature in *Arbeiter Illustrierte Zeitung*, Berlin, no. 1, 1931, pp. 18ff, Archiv der Massenpresse Patrick Rössler

■430 "Bauhaus Dessau", report on the replacement of Hannes Meyer, illustrated feature in *Welt-Spiegel*, supplement to *Berliner Tageblatt*, autumn 1932 p. 3, Archiv der Massenpresse Patrick Rössler

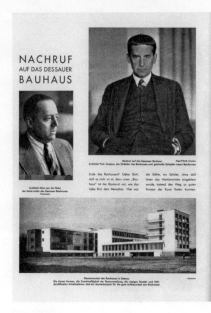

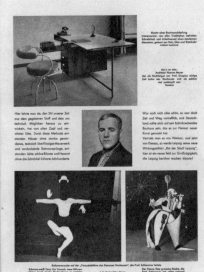

the bauhaus

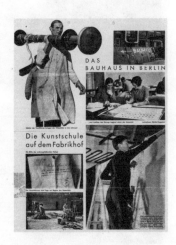

■ 431 "Obituary for the Dessau Bauhaus", article published on the occasion of the closing of the Dessau Bauhaus, illustrated feature in *Zeitlupe*, supplement to *Neue Leipziger Zeitung*, no. 36, 1932 Archiv der Massenpresse Patrick Rössler

■ 432 "The art school in the factory court", report on the occasion of the Bauhaus's move to Berlin, illustrated feature in *Welt-Spiegel*, supplement to *Berliner Tageblatt*, October 1932, Archiv der Massenpresse Patrick Rössler

■ 433 Dessau Bauhaus, cover of advertising brochure for the Bauhaus, 1926, Archiv der Massenpresse Patrick Rössler

Stage Managing Media Coverage

In summary, the Bauhaus was by this time being reported only sporadically in the illustrated mass-circulation press, but the reports were nevertheless achieving a considerable public effect. The visual media still had only a comparatively marginal distribution share, but its powerful impact was of great significance. Putting aside their own Bauhaus books and journals for once, success was achieved, above all by Walter Gropius, in conveying to the public the visual image he and his colleagues wished to present.[42] Whereas Lou Scheper-Berkenkamp, speaking of the Weimar period, once used the exaggerated phrase that everyone at the Bauhaus had their own Bauhaus,[43] the contouring of a unified Bauhaus thinking had been achieved for the first time only in Dessau[44] and later,[45] establishing in the process a brand essence of the moderns. While Gropius understood to perfection how to present the Bauhaus to the public through media coverage and also had Bauhaus people themselves taking the photographs for the corporate communications images, it was essentially corporate behaviour that moved centre stage once he had departed. And from that point on there is virtually no indication that a strategic use was made of visualization techniques for PR purposes.

Despite the picture editors' practice in using only the most exclusive photographs possible, a number of motifs recur in the reporting over and again; and these were the most suitable ones for establishing a kind of visual brand essence for the Bauhaus as an institution. Reviewing these in retrospect, the photographs of the new Bauhaus building in Dessau appeared to have been the most successful. Together with the presentation of the striking Gropius architecture, they created a journalistic position-finding function – an achievement that should not be underestimated. Along with the various views of the building and the glass facade of the workshop sections, the balconies of the atelier building provided some of the most attractive perspectives; these were also a sophisticated way of integrating people into the images. It is thus no surprise that Herbert Bayer also used these unmistakable motifs for the cover of his *Bauhaus Prospectus* of 1926 ■433. Many private photographs taken by people associated with the Bauhaus also focus on this motif, clearly demonstrating how the iconic qualities of these subjects were recognized from the start. It is a perspective that has remained with us up to today as a key motif in visualizing Bauhaus thinking.[46]

1 For an extensive presentation, see Patrick Rössler, ed., *bauhauskommunikation. Innovative Strategien im Umgang mit Medien, interner und externer Öffentlichkeit,* Neue Bauhausbücher, Band 1 Gebr. Mann Verlag, Berlin 2009

2 Patrick Rössler, *The Bauhaus and Public Relations: Communication in a Permanent State of Crisis,* Routledge, London/New York 2014.

3 Marc Etzold, "Walter Gropius als Kommunikator", in Rössler, *bauhauskommunikation,* 2009, pp. 55–76.

4 Walter Gropius, "Das Staatliche Bauhaus in Weimar", in *Der Querschnitt,* year 1, no. 4/5, September 1919, pp. 134 ff.

5 Dieter Georg Herbst, *Corporate Identity. Aufbau einer einzigartigen Unternehmensidentität,* 5. A, Cornelsen, Berlin 2012, and Robert Paulmann, *double loop – Basiswissen Corporate Identity,* Hermann Schmidt, Mainz 2005.

6 Patrick Rössler, "Die visuelle Identität des Weimarer Bauhauses. Strategien und Maßnahmen im Corporate Design", in Helmuth Seemann and Thorsten Valk, ed., *Klassik und Avantgarde. Das Bauhaus in Weimar 1919–1925,* 2009 Yearbook of the Klassik Stiftung Weimar, Wallstein, Göttingen 2009, pp. 367–84.

7 Hans M. Wingler, *Das Bauhaus. 1919–1933 Weimar Dessau Berlin und die Nachfolge in Chicago seit 1937,* 3rd improved edition, DuMont, Cologne 1975; Volker Wahl, *Das Staatliche Bauhaus in Weimar: Dokumente zur Geschichte des Instituts 1919–1926,* Böhlau, Cologne 2009, and Volker Wahl, ed., *Die Meisterratsprotokolle des Staatlichen Bauhauses Weimar: 1919–1925,* Hermann Böhlaus Nachfolger, Weimar 2001.

8 Cornelia Schimpf, *Versagen einer Zufluchtsstadt: Kulturpolitik in der Weimarer Republik am Beispiel des Staatlichen Bauhauses in Weimar von 1919 bis 1925*, Lit, Berlin 2008. An in-depth analysis of the social policy position of the Bauhaus and its communication measures is provided in Éva Forgács, *The Bauhaus Idea and Bauhaus Politics*, CEU Press, Budapest 1995.

9 See the numerous reproductions in Ute Brüning, ed., *Das A und O des Bauhauses*, Edition Leipzig, Leipzig 1995, pp. 53–109, and Gerd Fleischmann, ed., *bauhaus drucksachen typografie reklame*, Edition Marzona, Düsseldorf 1984, pp. 37–102.

10 See the extensive presentation in Klaus Weber, ed., *Punkt Linie Fläche. Druckgraphik am Bauhaus*, g+h Verlag, Berlin 1999.

11 Julyana Raupp, "Architektur und Anekdoten: Die Zeitschrift 'bauhaus' – vom Fachperiodikum zum Publicityorgan", in Brüning, ed., *Das A und O des Bauhauses*, op. cit., pp. 27 ff.

12 Wahl, op. cit., 2001, p. 158.

13 *Offset-, Buch- und Werbekunst*, year 3, no. 7, July 1926 (Bauhaus-issue), pp. 356–410.

14 *Junge Menschen*, year 5, no. 8, November 1924 (Sonderheft Bauhaus), pp. 167–92.

15 *Qualität*, year 4, issue 5/6, May/June 1925, pp. 81–88, and issue 7/8, July/August 1925, pp. 127–36.

16 Patrick Rössler, "Das 'rechte Licht' in der Öffentlichkeit. Bauhaus-Schwerpunkte in zeitgenössischen Periodika", in *Aus dem Antiquariat*, year 7 (N.F.), no. 3, May/June 2009, pp. 163–74.

17 Diethart Kerbs and Walter Uka, ed., *Fotografie und Bildpublizistik in der Weimarer Republik*, Kettler, Bönen 2004, and Patrick Rössler, *Viewing our Life and Times. A Cross-Cultural Perspective on Media Globalization*, Ausst.-Kat. ICA Dresden/ Annenberg Center Los Angeles 2006.

18 See the analyses of Patrick Rössler and Nele Heise, "Das Bauhaus im Spiegel der Presse 1919–1925" and "Presseresonanz im Übergang von Gropius zu Meyer", in Rössler, *bauhauskommunikation*, 2009, pp. 77–98, 127 ff.

19 For an extensive analysis, see Josefine Hintze and Corinna Lauerer, "Medienereignisse am Bauhaus. Die Ausstellung 1923 und die Einweihung des Bauhausgebäudes 1926", in Rössler, *bauhauskommunikation*, 2009, pp. 185–204.

20 See Rössler and Heise, op. cit., 2009.

21 See Walter Gropius, letter to Dr Lion, Dessau, 21 November 1926; Bauhaus-Archiv Berlin (BHA), Walter Gropius Estate, the correspondence (carbon copy).

22 My grateful thanks to Magdalena Droste, who drew my attention to this source.

23 Editorial, *Das illustrierte Blatt*, sent to Walter Gropius, Frankfurt, 6 January 1926; BHA, Walter Gropius Estate, the correspondence.

24 Rössler and Heise, op. cit. 2009, p. 89.

25 Bruno Adler, letter to Walter Gropius, Frankfurt, 24 March 1926; BHA, Walter Gropius Estate, the correspondence.

26 Walter Gropius, letter to the Editor, *Das illustrierte Blatt*, Dessau, 1 April 1926; BHA, Walter Gropius Estate, the correspondence (carbon copy).

27 Peter Zinger, letter to Walter Gropius, Frankfurt, 22 September 1926; BHA, Walter Gropius Estate, the correspondence.

28 Patrick Rössler, "1928: Wie das Neue Sehen in die Illustrierten kam. 'Maxl Knips', Sasha Stone, 'Das illustrierte Blatt' und die Bildermagazine der Weimarer Republik", in *Fotogeschichte*, year 31, no. 121, 2011, pp. 45–60.

29 Peter Zingler, letter to Walter Gropius, Frankfurt, 22 September 1926; BHA, Walter Gropius Estate, the correspondence.

30 "Zur Bedingung muss ich machen, dass die veröffentlichung in der 'bauwelt' nicht vor dem 4. dez. herauskommt, da sonst kompetenzkonflikte mit anderen blättern entstehen." Walter Gropius, letter to Dr Lion, Dessau, 21 November 1926; BHA, Walter Gropius Estate, the correspondence (carbon copy).

31 Peter Zingler, letter to Walter Gropius, Frankfurt, 8 October 1926; BHA, Walter Gropius Estate, the correspondence.

32 Editor Geisenberger, letter to Walter Gropius, Dessau, 29 November 1926; BHA, Walter Gropius Estate, the correspondence.

33 Walter Gropius, letter to the Editor of *Das illustrierte Blatt*, Frankfurt, 21 November 1926; BHA, Walter Gropius Estate, the correspondence (carbon copy).

34 Hans Hildebrandt, letter to Walter Gropius, 2 December 1926; BHA, Walter Gropius Estate, the correspondence.

35 See the summary by Rössler, *bauhauskommunikation*, 2009, pp. 167 ff.

36 See Adolf Behne, "Das Bauhaus in Dessau", in *Reclams Universum*, year 43, no. 12, December 1926, pp. 318 f., and "Das Bauhaus in Dessau" [1.] Walter Gropius: "Die Aufgabe" [2.] Dr Günther Frhr. von Pechmann, "Die Arbeit", in *Velhagen & Klasings Monatshefte*, year 41, no. 7, March 1927, pp. 86–96, and Paul Ferdinand Schmidt, "Vom Dessauer Bauhaus", in *Westermanns Monatshefte*, year 71, issue 848, April 1927, pp. 179 ff.

37 Dara Kiese, "Bauhaus-PR unter Hannes Meyer und Mies van der Rohe", in Rössler, *bauhauskommunikation*, 2009, pp. 131–46.

38 Bauhaus-Archiv, ed., *Hannes Meyer 1889–1954. Architekt Urbanist Lehrer*, Wilhelm Ernst & Sohn, Berlin 1989, pp. 234–93.

39 Diethart Kerbs and Hendrick Stahr, ed., *Berlin 1932. Das letzte Jahr der ersten deutschen Republik*, Edition Hentrich, Berlin 1992.

40 Rössler and Heise, "Spiegel der Presse", p. 88, and "Presseresonanz", p. 129, op. cit., 2009.

41 See the listing by Kerbs and Uka, op. cit., 2004. Degephot was the successor to the former Agentur Dephot.

42 Walter Gropius, letter to Hans Hildebrandt, Dessau, 7 December 1926; BHA, Walter Gropius Estate, the correspondence.

43 Quoted from Eckard Neumann, ed., *Bauhaus und Bauhäusler*, DuMont, Cologne 1985, p. 175.

44 See Brüning, op. cit., 1994, p. 88.

45 See Claudia Heitmann, "Etablierung des Mythos Bauhaus. Die Rezeption in den 60er Jahren – Zwischen Erinnerung und Aktualität", in Andreas Haus, ed., *Bauhaus-Ideen 1919–1994. Bibliografie und Beiträge zur Rezeption des Bauhausgedankens*, Reimer, Berlin 1994, pp. 51–65, and Regina Bittner, ed., *Bauhausstil zwischen International Style und Lifestyle*, Jovis, Berlin 2003, pp. 264 ff.

46 See, for example, the dust jackets of Andreas Hillger, *gläserne zeit. Ein Bauhaus-Roman*, Osburg, Hamburg 2013, and Georg-W. Költzsch and Margarita Tupitsyn, ed., *Bauhaus: Dessau › Chicago › New York*, DuMont, Cologne 2000.

the bauhaus

Annex

Author Biographies

Ute Famulla
studied art history and Scandinavian studies in Berlin and Stockholm and is a research assistant in the field of twentieth- and twenty-first-century art at Kunsthochschule Kassel. Since 2012, she has been working on her doctoral project with the working title "Konstruierte Räume: Ausstellungsgestaltung in der Weimarer Republik" [Designed spaces: exhibition design in the Weimar Republic].

Sebastian Neurauter
studied law in Münster and wrote his doctoral thesis on "Das Bauhaus und die Verwertungsrechte – eine Untersuchung zur Praxis der Rechteverwertung am Bauhaus 1919–1933" [Bauhaus and patent rights – an investigation into the practice of the exploitation of rights at the Bauhaus 1919–1933]. After completing his doctorate, he did his traineeship in Hamburg and at the German embassy in Riga. He has worked as a judge since 2013, first in Hamburg and, from 2015, in the Cologne division of the Higher Regional Court.

Patrick Rössler
has been professor of communication studies at the University of Erfurt since 2004, specializing in empirical communication research/methods. He was vice president for research and young academics between 2011 and 2014. The focus of his research is the impact of the media, political communication and online media. He also undertakes historical research, in particular on the history of visual communication media and the Bauhaus. He is editor of the publication *bauhauskommunikation* (2009).

Arthur Rüegg
studied architecture at Zurich and has worked as an architect in Zurich since 1971. He was guest lecturer in Syracuse, New York and Zurich and was professor for architecture and design at ETH Zurich between 1991 and 2007, at the same time continuing to work in design, running his own architecture office. In addition, he has researched widely, written many publications and been involved in many exhibitions on design, colour, photography and modern domestic interior design.

Dries Verbruggen
graduated from the Design Academy Eindhoven, Department of Man and Living, in 2002. After graduation he founded the studio Unfold with Claire Warnier. In addition to his work at Unfold, he is a mentor at the Masters Department at the Design Academy Eindhoven and previously held positions at Colorado State University, USA; LUCA School of Arts, Belgium, and at the ICT & Media Design Department, Fontys University of Applied Sciences, Netherlands.

Claire Warnier
graduated from the Design Academy Eindhoven, Department of Man and Living, in 2002. She completed her MA at the University of Ghent in 2008. After graduation she founded the studio Unfold with Dries Verbruggen. In addition to her work at Unfold, she is a mentor at the Masters Department at the Design Academy Eindhoven and previously held positions at Colorado State University, USA; LUCA School of Arts, Belgium, and Z33 in Hasselt in Belgium.

Authors of glossaries
Regina Bittner (RB)
Gerda Breuer (GB)
Henning Brüning (HB)
Holm Friebe (HF)
Julie Koté (JKo)
Jolanthe Kugler (JK)
Walter Kugler (WK)
Urs Latus (UL)
Hannes Mayer (HM)
Julia Meer (JM)
Linda Novotny (LN)
Michael Siebenbrodt (MS)
Annika von Taube (AvT)
Wolfgang Thöner (WT)
Ulrich Winko (UW)

Bibliography

Ute Famulla

Ute Brüning, ed., *Das A und O des Bauhauses*, Edition Leipzig, Leipzig 1995

Ute Brüning, "Selbstdarstellung: 'Typochales und Normatives'", in ibid.

Joseph Ganter, "Unsere Publikation", in *Das Neue Frankfurt*, year 4, no. 6, June 1930, p. 141

Walter Gropius, "Bauhaus-Manifest" [1919], in Wolfgang Asholt and Walter Fähnders, ed., *Manifeste und Proklamationen der europäischen Avantgarde (1909–1938)*, Metzler, Stuttgart/Weimar 1995, p. 173

Kai-Uwe Hemken, "'Guillotine der Dichter' oder Ausstellungsdesign am Bauhaus", in ibid., pp. 229 ff.

Ludwig Hilberseimer, "Die Wohnung unserer Zeit", in *Die Form*, year 6, no. 7, 1931, pp. 249–70

Josefine Hintze and Corinna Lauerer, "Medienereignisse am Bauhaus. Die Ausstellung 1923 und die Einweihung des Bauhausgebäudes 1926", in Patrick Rössler, ed., *bauhauskommunikation. Innovative Strategien im Umgang mit Medien, interner und externer Öffentlichkeit*, Neue Bauhausbücher, vol. 1, Gebr. Mann Verlag, Berlin 2009, p. 186

Annemarie Jaeggi, "Das Großlaboratorium für die Volkswohnung. Wagner. Taut. May. Gropius. 1924/25", in Norbert Huse, ed., *Siedlungen der zwanziger Jahre – heute. Vier Berliner Großsiedlungen 1924–1984*, Publica Verlagsgesellschaft cop., Berlin 1984, p. 29

Robin Krause, "Die Ausstellung des Deutschen Werkbundes von Walter Gropius im '20E Salon des Artistes décorateurs français'", in Isabelle Ewig and Thomas W. Gaehtgens, ed., *Das Bauhaus und Frankreich – Le Bauhaus et la France*, Akademie Verlag, Berlin 2002, pp. 275–96

Dara Kiese, "Bauhaus-PR unter Hannes Meyer und Mies van der Rohe", in Patrick Rössler, ed., *bauhauskommunikation*, op. cit., p. 141.

Dara Kiese, "Hannes Meyers Bauhaus – die 'Wanderschau' 1929–30", in Patrick Rössler, ed., *bauhauskommunikation*, op. cit., pp. 215–22 et pass.

Kunstgewerbemuseum Zürich, ed., *Wegleitung des Kunstgewerbemuseums der Stadt Zürich*, nos 77–107, 1928–31

Monika Markgraf, "Funktion und Farbe. Das Bauhausgebäude in Dessau", in Bauhaus-Archiv Berlin, ed., *Modell Bauhaus*, Hatje Cantz, Ostfildern 2009, pp. 196 ff.

Adolf Meyer, *Ein Versuchshaus des Bauhauses in Weimar*, Bauhausbücher, vol. 3, Albert Langen Verlag, Munich 1924

Adolf Meyer, "Der Aufbau des Versuchshauses", in ibid., p. 24.

Hannes Meyer, "bauhaus und gesellschaft", in Lena Meyer-Berger and Klaus-Jürgen Winkler, ed., *Hannes Meyer: Bauen und Gesellschaft. Schriften, Briefe, Projekte*, VEB Verlag der Kunst, Dresden 1980

Winfried Nerdinger, *Der Architekt Walter Gropius: Zeichnungen, Pläne und Fotos aus dem Busch-Reisinger-Museum der Harvard University Art Museums, Cambridge/Massachusetts und aus dem Bauhaus-Archiv Berlin, mit einem kritischen Werkverzeichnis*, Gebr. Mann Verlag, Berlin 1995

Patrick Rössler, "Flucht in die Öffentlichkeit? Ausstellungen als Instrument zur Selbstpräsentation des Bauhauses", in Bauhaus-Archiv Berlin, ed., *Modell Bauhaus*, Hatje Cantz, Ostfildern 2009, pp. 337 ff.

Ludovica Scarpa, "Das Großsiedlungsmodell: von der Rationalisierung zum Städebau", in Norbert Huse, ed., *Siedlungen der zwanziger Jahre – heute. Vier Berliner Großsiedlungen 1924–1984*, Publica Verlagsgesellschaft cop., Berlin 1984, p. 21

Mary Anne Staniszewski, *The Power of Display. A History of Exhibition Installations at the Museum of Modern Art*, MIT Press, Cambridge, Massachusetts 2001, pp. 143–52

Anke Te Heesen, *Theorien des Museums zur Einführung*, 2nd edition, Junius, Hamburg 2013

Wolfgang Thöner, "'Der zeitgemäßen Entwicklung der Behausung dienen, – Zur Rolle der Architektur in der Öffentlichkeitsarbeit des Bauhauses,", in Patrick Rössler, ed., *bauhauskommunikation*, op. cit., pp. 205–14 Phillipp Tolzinger, "Mit Hannes Meyer am bauhaus und in der Sowjetunion (1927–1936)", in Bauhaus-Archiv, ed., *Hannes Meyer 1889–1954, Architekt Urbanist Lehrer*, Wilhelm Ernst & Sohn, Berlin 1989, p. 253

Mies Van der Rohe, "Zum Thema: Ausstellungen", in *Die Form*, year 3, no. 4, 1928, p. 121

Karin Wilhelm, "Typisierung und Normierung für ein modernes Atriumhaus. Das Haus am Horn in Weimar", in Bauhaus-Archiv Berlin et al., ed., *Modell Bauhaus*, Hatje Cantz, Ostfildern 2009, p. 149 ff.

Karin Wilhelm, "Die Bauhaus-Ausstellung in Weimar 1923. Ein Rechenschaftsbericht", in Museumspädagogischer Dienst Berlin, ed., *bauhaus weimar 1919–1924*, Berlin 1996, pp. 29 ff

Klaus-Jürgen Winkler, ed., *Hannes Meyer: Bauen und Gesellschaft. Schriften, Briefe, Projekte*, VEB Verlag der Kunst, Dresden 1980

Christoph Zuschlag, "'ein eisenbahnwaggon ausstellungsgut'. Die Bauhaus-Wanderausstellung 1929–30 und ihre Mannheimer Station", in Peter Steininger, ed., *"als bauhäusler sind wir suchende". Hannes Meyer (1889–1954). Beiträge zu seinem Leben und Wirken*, Baudenkmal Bundesschule Bernau, Bernau bei Berlin 2014, p. 34

Jolanthe Kugler

Ute Ackermann and Ulrike Bestgen, ed., *Das Bauhaus kommt aus Weimar*, Ausst.-Kat., Klassik Stiftung Weimar und Deutscher Kunstbuchverlag, Berlin 2009

Giulio Carlo Argan, *Walter Gropius und das Bauhaus*, Rowohlt, Reinbek bei Hamburg, 1962

Wolfgang Asholt and Walter Fähnders, ed., *Manifeste und Proklamationen der europäischen Avantgarde (1909–1938)*, J. B. Metzler, Stuttgar/Weimar 2005

Joseph Beuys, *Soziale Plastik. Materialien zu Joseph Beuys*, Achberger Verlagsanstalt, Achberg 1976

Christina Biundo, *Bauhaus-Ideen 1919–1994. Bibliographie und Beiträge zur Rezeption des Bauhausgedankens*, ReimerVerlag, Berlin 1994

Jan Boelen and Vera Sacchetti, ed., *Designing Everyday Life*, exhibition catalogue, Park Books, Zurich 2014

Bernhard E. Bürdek, *Geschichte, Theorie und Praxis der Produktgestaltung*, 3rd edition, Birkhäuser, Basel/Boston/Berlin 2005

Lucius Burckhardt, "Design ist unsichtbar", in *Design ist unsichtbar*, exhibition catalogue, Löcker, Vienna 1981

Walter Dexel, *Der Bauhausstil, ein Mythos: Texte 1921–1965*, Keller, Starnberg 1976

Eisele, Petra and Bernhard E. Bürdek, ed., *Design, Anfang des 21. Jahrhunderts*, AV Edition, Ludwigsburg 2011

Jeannine Fiedler and Peter Feierabend, ed., *Bauhaus*, Könemann, Cologne 1999

Holm Friebe and Thomas Ramge, *Marke Eigenbau. Der Aufstand der Massen gegen die Massenproduktion*, Campus, Frankfurt am Main/New York 2008

Rainer Funke, "Moralische Dimension von Design", in Petra Eisele and Bernahrd E. Bürdek, ed., *Design, Anfang des 21. Jahrhunderts*, AV Edition, Ludwigsburg 2011

Christian Grohn, *Die Bauhaus-Idee. Entwurf, Weiterführung, Rezeption. Reihe Neue Bauhausbücher*, Gebr. Mann Verlag, Berlin 1991

Walter Gropius, *Architektur*, Fischer Bücherei, Frankfurt am Main 1956

Reginald R. Isaacs, *Walter Gropius. Der Mensch und sein Werk*, vol. 1, Gebr. Mann Verlag, Berlin 1983

Bibliography

John V. Maciuika, *Before the Bauhaus. Architecture, Politics and the German State*, Cambridge University Press, Cambridge 2005

Tomas Maldonado, *Digitale Welt und Gestaltung*, Zurich University of the Arts/Birkhäuser, Basel/Boston/Berlin 2007

Ezio Manzini, *Design, When Everybody Designs*, Massachusettes Institute of Technology, Massachusetts 2015

Enzo Mari, *Autoprogettazione*, Corraini, Milan 2002

Golo Mann, *Deutsche Geschichte des 19. und 20. Jahrhunderts*, Fischer Bücherei, Frankfurt am Main 2009

Sebastian Neurauter, *Das Bauhaus und die Verwertungsrechte*, Mohr Siebeck, Tübingen 2013

Viktor Papanek, *Das Papanek Konzept*, Nymphenburger Verlagsbuchhandlung, Munich 1972

Nikolaus Pevsner, *Der Beginn der modernen Architektur und des Designs*, DuMont, Cologne 1972

Cathrin Pichler and Susanne Neuburger, ed., *The Moderns. Wie sich das 20. Jahrhundert in Kunst und Wissenschaft erfunden hat*, exhibition catalogue, Springer, Vienna 2012

Gert Selle and Jutta Boehe, *Kultur der Sinne und ästhetische Erziehung, Alltag, Sozialisation, Kunstunterricht in Deutschland vom Kaiserreich zur Bundesrepublik*, DuMont Reiseverlag, Ostfildern 1981

Gert Selle, *Geschichte des Design in Deutschland*, 2nd edition, Campus Verlag 1992

Michael Siebenbrodt and Lutz Schöbe, *Bauhaus 1919–1933 Weimar–Dessau–Berlin*, Parkstone Press International, New York 2009

Tendenzen der Zwanziger Jahre. 15. Europäische Kunstausstellung Berlin 1977, exhibition catalogue, 3rd edition, Dietrich Reimer Verlag, Berlin 1977

Volker Wahl, *Das Staatliche Bauhaus in Weimar*, Böhlau, Weimar 2009

Volker Wahl, ed., *Meisterratsprotokolle des Staatlichen Bauhauses Weimar 1919–1925*, Hermann Böhlaus Nachfolger, Weimar 2001

Volker Wahl, ed., *Henry van de Velde in Weimar. Dokumente und Berichte zur Förderung von Kunsthandwerk und Industrie (19902 bis 1915)*, Böhlau, Cologne 2007

Christoph Wagner, ed., *Das Bauhaus und die Esoterik*, exhibition catalogue Kerber, Bielefeld/Leipzig 2005

John A. Walker, *Designgeschichte. Perspektiven einer wissenschaftlichen Disziplin*, Scaneg, Munich 1992

Sebastian Neurauter

Sebastian Neurauter, *Das Bauhaus und die Verwertungsrechte*, Mohr Siebeck, Tübingen 2013

Lothar Lang, *Das Bauhaus 1919–1933 – Idee und Wirklichkeit*, Zentralinstitut für Gestaltung, Berlin 1965

Horst Claussen, *Walter Gropius, Grundzüge seines Denkens*, Olms, Hildesheim 1986

Rolf Bothe, *Das frühe Bauhaus und Johannes Itten*, Ostfildern, Hatje Cantz 1994

Hans Maria Wingler, *Das Bauhaus 1919–1933*, 3rd edition 1975

Peter Hahn, *Bauhaus Berlin*, Kunstverlag Weingarten, Weingarten 1985

Patrick Rössler

Bauhaus-Archiv, ed., *Hannes Meyer 1889–1954. Architekt Urbanist Lehrer*, Wilhelm Ernst & Sohn, Berlin 1989, pp. 234–93

Adolf Behne, "Das Bauhaus in Dessau", in *Reclams Universum*, year 43, no. 12, December 1926, pp. 318f.

Regina Bittner, ed., *Bauhausstil zwischen International Style und Lifestyle*, Jovis, Berlin 2003

Ute Brüning, ed., *Das A und O des Bauhauses*, Edition Leipzig, Leipzig 1995

Marc Etzold, "Walter Gropius als Kommunikator", in Rössler, *bauhauskommunikation*, 2009, pp. 55–76

Gerd Fleischmann, ed., *bauhaus drucksachen typografie reklame*, Edition Marzona, Düsseldorf 1984

Éva Forgács, *The Bauhaus Idea and Bauhaus Politics*, CEU Press, Budapest 1995

Claudia Heitmann, "Etablierung des Mythos Bauhaus. Die Rezeption in den 60er Jahren – Zwischen Erinnerung und Aktualität", in Andreas Haus, ed., *Bauhaus-Ideen 1919–1994. Bibliografie und Beiträge zur Rezeption des Bauhausgedankens*, Reimer, Berlin 1994, pp. 51–65

Dieter Georg Herbst, *Corporate Identity. Aufbau einer einzigartigen Unternehmensidentität*, 5. A, Cornelsen, Berlin 2012

Andreas Hillger, *gläserne zeit. Ein Bauhaus-Roman*, Osburg, Hamburg 2013

Josefine Hintze and Corinna Lauerer, "Medienereignisse am Bauhaus. Die Ausstellung 1923 und die Einweihung des Bauhausgebäudes 1926", in Rössler, *bauhauskommunikation*, 2009, pp. 185–204

Junge Menschen, year 5, no. 8, November 1924 (Sonderheft Bauhaus), pp. 167–92

Diethart Kerbs and Hendrick Stahr, ed., *Berlin 1932. Das letzte Jahr der ersten deutschen Republik*, Edition Hentrich, Berlin 1992

Diethart Kerbs and Walter Uka, ed., *Fotografie und Bildpublizistik in der Weimarer Republik*, Kettler, Bönen 2004

Dara Kiese, "Bauhaus-PR unter Hannes Meyer und Mies van der Rohe", in Rössler, *bauhauskommunikation*, 2009, pp. 131–146

Georg-W. Költzsch and Margarita Tupitsyn, ed., *Bauhaus: Dessau › Chicago › New York*, DuMont, Cologne 2000

Qualität, year 4, issue 5/6, May/June 1925, pp. 81–88, and issue 7/8, July/August 1925, pp. 127–36

Walter Gropius and Günther Frhr. von Pechmann, "Das Bauhaus in Dessau. Die Aufgabe. – Die Arbeit", in *Velhagen & Klasings Monatshefte*, year 41, no. 7, March 1927, pp. 86–96

Eckard Neumann, ed., *Bauhaus und Bauhäusler*, DuMont, Cologne 1985

Offset-, Buch- und Werbekunst, year 3, no. 7, July 1926 (Bauhaus issue), pp. 356–410

Robert Paulmann, *double loop – Basiswissen Corporate Identity*, Hermann Schmidt, Mainz 2005

Julyana Raupp, "Architektur und Anekdoten: Die Zeitschrift 'bauhaus' – vom Fachperiodikum zum Publicityorgan", in Brüning, ed., *Das A und O des Bauhauses*, op. cit., pp. 27 ff.

Patrick Rössler, *Viewing our Life and Times. A Cross-Cultural Perspective on Media Globalization*, exhibition catalogue, ICA Dresden/Annenberg Center Los Angeles 2006

Patrick Rössler, ed., *bauhauskommunikation. Innovative Strategien im Umgang mit Medien, interner und externer Öffentlichkeit*, Gebr. Mann Verlag, Berlin 2009 (Neue Bauhausbücher, vol. 1)

Patrick Rössler, "'Das 'rechte Licht' in der Öffentlichkeit. Bauhaus-Schwerpunkte in zeitgenössischen Periodika", in *Aus dem Antiquariat*, year 7 (N.F.), no. 3, May/June 2009, pp. 163–74

Patrick Rössler, "Die visuelle Identität des Weimarer Bauhauses. Strategien und Maßnahmen im Corporate Design", in Helmuth Seemann and Thorsten Valk, ed., *Klassik und Avantgarde. Das Bauhaus in Weimar 1919–1925*, 2009 Yearbook of the Klassik Stiftung Weimar, Wallstein, Göttingen 2009, pp. 367–84

Patrick Rössler, "1928: Wie das Neue Sehen in die Illustrierten kam. 'Maxl Knips', Sasha Stone, 'Das illustrierte Blatt' und die Bildermagazine der Weimarer Republik", in *Fotogeschichte*, year 31, no. 121, 2011, pp. 45–60

Patrick Rössler, *The Bauhaus and Public Relations: Communication in a Permanent State of Crisis*, Routledge, London/New York 2014

Patrick Rössler and Nele Heise, "Das Bauhaus im Spiegel der Presse 1919–1925" and "Presseresonanz im Übergang von Gropius zu Meyer", in Rössler, *bauhauskommunikation*, 2009, pp. 77–98, 127 ff.

Cornelia Schimpf, *Versagen einer Zufluchtsstadt: Kulturpolitik in der Weimarer Republik am Beispiel des Staatlichen Bauhauses in Weimar von 1919 bis 1925*, Lit, Berlin 2008

Paul Ferdinand Schmidt, "Vom Dessauer Bauhaus", in *Westermanns Monatshefte*, year 71, issue 848, April 1927, pp. 179 ff.

Volker Wahl, ed., *Die Meisterratsprotokolle des Staatlichen Bauhauses Weimar: 1919–1925*, Hermann Böhlaus Nachfolger, Weimar 2001

Volker Wahl, *Das Staatliche Bauhaus in Weimar: Dokumente zur Geschichte des Instituts 1919–1926*, Böhlau, Cologne 2009

Klaus Weber, ed., *Punkt Linie Fläche. Druckgraphik am Bauhaus*, g+h Verlag, Berlin 1999

Hans M. Wingler, *Das Bauhaus. 1919–1933 Weimar Dessau Berlin und die Nachfolge in Chicago seit 1937*, 3rd improved edition, DuMont, Cologne 1975

Arthur Rüegg

Justus A. Binroth et al., *Bauhausleuchten? Kandemlicht! Die Zusammenarbeit des Bauhauses mit der Leipziger Firma Kandem*, Arnoldsche Art Publishers, Stuttgart 2002

Hans Brockhage and Reinhold Lindner, *Marianne Brandt*, Chemnitzer Verlag, Chemnitz 2001

Roger Ginsburger, *Französische Ausstellung*, Wegleitung 98, Kunstgewerbemuseum der Stadt Zurich, 1931

Charles-Edouard Jeanneret, *Étude sur le mouvement d'art décoratif en Allemagne*, Haefeli, La Chaux-de-Fonds 1912

Burckhard Kieselbach, Werner Möller and Sabine Thümmler, *Bauhaustapete. Reklame und Erfolg einer Marke*, DuMont, Cologne/Gebr. Rasch, Bramsche 1995

Lothar Lang, *Das Bauhaus 1919–1933 – Idee und Wirklichkeit*, 2nd expanded edition, Zentralinstitut für Gestaltung, Berlin 1966

Le Corbusier, "Pédagogie", in *L'Esprit Nouveau. Revue internationale illustrée de l'activité contemporaine*, no. 19, December 1921

Adolf Loos, "Schulausstellung der Kunstgewerbeschule" [1897], in Adolf Loos, *Ins Leere gesprochen 1897–1900*, Editions Crès et Cie, Zurich 1921

Hannes Meyer, "Mein Herauswurf aus dem Bauhaus. Offener Brief an Herrn Oberbürgermeister Hesse, Dessau", in Lena Meyer-Bergner and Klaus-Jürgen Winkler, ed., *Hannes Meyer: Bauen und Gesellschaft. Schriften, Briefe, Projekte*, VEB Verlag der Kunst, Dresden 1980

Hannes Meyer, "Die neue Welt", in *Das Werk*, year 3, no. 6, July 1926, pp. 205–24

Matthias Noell, *Im Laboratorium der Moderne. Das Atelierwohnhaus von Theo van Doesburg in Meudon – Architektur zwischen Abstraktion und Rhetorik*, gta, Zurich 2011, pp. 54–60

Arthur Rüegg, "Der Anfang – oder das Ende der Geschichte? Neo-Historismus, Re-Editionen und Hommagen", in Renate Menzi Brändle and Arthur Rüegg, ed., *100 Jahre Schweizer Design*, Lars Müller Publishers, Zurich 2014

Arthur Rüegg, "Kunstgewerbe, Kunstindustrie, Maschinenkunst: Vom Möbeltyp zum Typenmöbel", in *100 Jahre Schweizer Design*, 2014

Arthur Rüegg, "Notizen zur Glaslampe", ed. Meike Noll-Wagenfeld, in Joan Billing and Samuel Eberli, ed., *Wilhelm Wagenfeld*, Katalog 10, Design und Design, Baden 2010

Arthur Rüegg, *Le Corbusier – Möbel und Interieurs 1905–1965*, Scheidegger & Speiss, Zurich 2012

Georg Schmidt, "Zur Einführung", in *Bauhaus-Wanderschau 1930*, Wegleitung 34, Kunstgewerbemuseum der Stadt Zurich, 1930

Stanislaus von Moos, "Le Corbusier und Loos", in Stanislaus von Moos, ed., *L'Esprit Nouveau. Le Corbusier und die Industrie 1920–1925*, Wilhelm Ernst & Sohn, Berlin 1987

Volker Wahl, ed., *Die Meisterratsprotokolle des Staatlichen Bauhauses Weimar 1919–1923*, Verlag Hermann Böhlaus Nachfolger, Weimar 2001

Klaus Weber, ed., *Die Metallwerkstatt des Bauhauses*, for the Bauhaus-Archiv Berlin, Kupfergraben Verlagsgesellschaft, Berlin 1992

Claire Warnier and Dries Verbruggen

Christopher Frayling, "We must all turn to the crafts", in Daniel Charny, *Power of Making. The importance of being skilled*, V&A Publishing, London 2011, pp. 29–33

Walter Gropius, "Grundsätze der Bauhausproduktion", *Bauhausbücher 7*, 1925

Päivi Jantunen, *Kaj & Franck: Designs & Impressions*, WSOY Publishers, Helsinki 2011

Malcolm McCullough, *Abstracting Craft: The Practiced Digital Hand*, MIT Press, Massachusetts 1996

E. F. Schumacher, *Small Is Beautiful: A Study of Economics As If People Mattered*, MIT Press, Massachusetts 1976

Paul Atkinson, "Orchestral Manoevres in Design", in Bas Van Abel, Lucas Evers, Roel Klaassen and Peter Troxler, *Open Design Now. Why design cannot remain exclusive*, BIS Publishers, Amsterdam 2011, pp. 24–31

Image Credits

Acknowledgements

Our sincere thanks are due to

our co-operation partner
Kunst- und Ausstellungshalle der Bundesrepublik Deutschland

our sponsors and supporters
HUGO BOSS
Mercedes-Benz
Baden-Württemberg
IKEA Stiftung

our advisory board
Jan Boelen, Joseph Grima, Wilfried Kuehn, Olaf Nicolai, Philipp Oswalt

Joseph Grima/Space Caviar, Olaf Nicolai, Philipp Oswalt and
Julia Meer, Adrian Sauer and Wilfried Kuehn for their contributions
to the exhibition

our lenders

Special thanks go to Bernd Freese for his generous support.

Klassik Stiftung Weimar/Bauhaus-Museum Weimar
Stiftung Bauhaus Dessau
Bauhaus-Archiv Berlin
Thüringisches Hauptstaatsarchiv Weimar
Deutsches Patent- und Markenamt, Berlin
Stadtbibliothek Hannover, Schwitters-Archiv, Hannover
Staatliche Museen zu Berlin, Kunstbibliothek
Bauhaus-Universität Weimar, Archiv der Moderne
Bibliothek der Friedrich-Ebert-Stiftung, Bonn
Johannes Itten-Archiv, Zürich
Rasch-Archiv, Bramsche Tapetenfabrik Gebr. Rasch GmbH & Co. KG
Scala Group Spa
Akademie der Künste, Berlin
von Bodelschwinghsche Stiftungen Bethel
Galerie Berinson, Berlin
Josef and Anni Albers Foundation, Bethany, CT, USA
Pace Gallery, New York/London
Thomas Gallery Ltd, New York, NY
Galerie Ulrich Fiedler, Berlin
Ragnar Kjartansson, i8 Gallery, Reykjavík
Spielzeugmuseum der Stadt Nürnberg
Museum für Kunst und Gewerbe Hamburg
Germanisches Nationalmuseum, Nürnberg
Deutsches Spielzeugmuseum, Sonneberg
Burg Giebichenstein Kunsthochschule Halle
Stadtmuseum München
Museum of Contemporary Art, Zagreb
Staatliche Kunstsammlungen Dresden, Museum für Sächsische Volkskunst
Schlesisches Museum zu Görlitz
Zentrum Paul Klee, Bern
Shchusev State Museum of Architecture, Moscow
Harvard Art Museums, Busch-Reisinger Collection, Cambridge, MA, USA
Museum Folkwang, Essen
Museum für Gestaltung Zürich
Alessi
Naef Spiele AG
Hugo Boss
Mercedes-Benz
Alexander von Vegesack, Domaine de Boisbuchet, Lessac
Bernd Freese, Frankfurt
Peter Büscher, Cologne
Beate Dorfner-Erbs, Weimar
Sammlung Christina and Volker Huber, Offenbach am Main
Udo Breitenbach, Aschaffenburg
Angelika Ulfstedt, Lörrach
Mario Minale, Studio Minale Maeda, Rotterdam
Michel Brignot, Basel
Sebastian Jacobi, Bad Ems
Sauerbruch Hutton, Berlin
Nachlass Scheper, Berlin
Opendesk, London
Thomas Lommée, Intrastructures, Brussels
Mike Meiré, Cologne
Ifeanyi Oganwu, Expand Design Ltd, London
Hella Jongerius, Jongeriuslab, Berlin
Satyendra Pakhalé Associates, Amsterdam
Unfold, Antwerp
AYRBRB
Edward Barber and Jay Osgerby, London
Alberto Meda, Milan
Yuya Ushida, Nagoya

the interview partners
Karo Akpokiere (Germany), Alberto Alessi (Italy), Benny Au (China), Edward Barber (United Kingdom), Humberto and Fernando Campana (Brazil), Alan Chang (China), Sandy Choi (China), Antonio Citterio (Italy), Katy Taplin, Dokter and Misses (South Africa), Eva Eisler (Czech Republic), Lord Foster (United Kingdom), Yinka Ilori (United Kingdom), Hella Jongerius (Germany), Ragnar Kjartansson (Iceland), Arik Levy (France), Thomas Lommée (Belgium), Minale Maeda (Netherlands), Mia Maljojoki (Germany), Alberto Meda (Italy), Mike Meiré (Germany), MIRO (China), Lucinda Mudge (South Africa), Ifeanyi Oganwu (United Kingdom), Opendesk (United Kingdom), Jay Osgerby (United Kingdom), Satyendra Pakhalé (Netherlands), Jirí Pelcl (Czech Republic), Dorothea Prühl (Germany), Karim Rashid (United Kingdom), Tobias Rehberger (Germany), Daniel Rybakken (Sweden), Sauerbruch Hutton (Germany), Benedetta Tagliabue (Spain), Troika (United Kingdom), Yuya Ushida (Japan), Maya Varadaraj (USA), Gorden Wagener (Germany), Clemens Weisshaar (Germany), Jason Wu (USA)

our catalogue authors
Regina Bittner, Gerda Breuer, Henning Brüning, Ute Famulla, Holm Friebe, Joseph Grima, Julie Koté, Wilfried Kuehn, Walter Kugler, Urs Latus, Hannes Mayer, Julia Meer, Sebastian Neurauter, Olaf Nicolai, Linda Novotny, Philipp Oswalt, Patrick Rössler, Arthur Rüegg, Adrian Sauer, Michael Siebenbrodt, Wolfgang Thöner, Annika von Taube, Dries Verbruggen, Claire Warnier, Ulrich Winko

the editors and translators
Textschiff – Christina Bösel
Jane Havell
Büro y´plus – Maria Nievoll, Susannah Chadwick, Kate Howlett Jones, Joseph Lancaster, Richard Watts
Erika Pinner

the photographers
Andreas Sütterlin
Jürgen Hans

Kuehn Malvezzi – Wilfried Kuehn, Mira Schröder, Nina Beitzen, Thomas Güthler for designing the exhibition
Greige – Mark Kiessling and Birthe Haas for designing the catalogue
GZD Media GmbH – Markus Bocher for the lithography
Graphicom – Barbara Cinquetti and Antonio Zanella for printing, Chiara Martini for organization

Thanks for their support go to
Ute Ackermann – Bauhaus-Museum Weimar, Helge Aszmoneit – Rat für Formgebung, Daniela Baumann – HfG Ulm, Ulrike Bestgen – Klassik Stiftung Weimar, Christina Bitzke – Museum für Angewandte Kunst Gera, Udo Breitenbach, Regina Bittner – Stiftung Bauhaus Dessau, Caroline Burghardt – Luhring Augustine Bushwick, Wenke Clausnitzer – Bauhaus-Archiv Berlin, Tanja Cunz, Brenda Danilowitz – The Josef and Anni Albers Foundation, Bernd Dicke, Berthold Eberhard – Bauhaus-Archiv Berlin, Heinrich Famulla, Bernd Freese, Klaus Frentzel – Mercedes-Benz, Ulrike Growe – Josef Albers Museum Quadrat Bottrop, Hans-Joachim Gundelach, Sabine Hartmann – Bauhaus-Archiv Berlin, Ita Heinze-Greenberg – Institut gta ETH Zürich, Heiko Hillig – Naef, Catherine Ince – Barbican Centre, Randy Kauffman – Bauhaus-Archiv Berlin, Anette und Rudolf Kicken, Burckhard Kieselbach, Amelie Klein, Axel Kufus, Walter Kugler, Constanze Lange, Marion Lichardus-Itten, Andreas Marjanovic – Mercedes-Benz, Friedrich Meschede – Kunsthalle Bielefeld, Chrissie Muhr, Carolin Westermann – Hugo Boss, Henrike Mund – Kunsthalle Bielefeld, Matteo Pirola, Hans Peter Reisse, Kassel-Wilhelmshöhe, Jens Riederer – Stadtarchiv Weimar, Renate Riek-Bauer – Mercedes-Benz, Lutz Schöbe – Stiftung Bauhaus Dessau, Ina Schmidt-Runke – Galerie Kicken, Michael Siebenbrodt – Bauhaus-Museum Weimar, Daniel Spanke – Kunstmuseum Bern, Joseph Straßer – Die Neue Sammlung München, Wolf Tegethoff – Zentralinstitut für Kunstgeschichte München, Wolfgang Thöner – Stiftung Bauhaus Dessau, Anna Vartiainen – Artek, Wilhelm Wagenfeld Stiftung, Christoph Wagner – University of Regensburg, Klaus Weber – Bauhaus-Archiv Berlin, Joachim Uhlmann – Ministerium für Wissenschaft, Forschung und Kunst Baden-Württemberg, Peter Takacs – Ikea Stiftung

and to our colleagues at the Vitra Design Museum and at the Bundeskunsthalle Bonn.

Jolanthe Kugler
Weil am Rhein, August 2015

Imprint

This publication was issued on the occasion of the exhibition
The Bauhaus #itsalldesign

The Bauhaus #itsalldesign is an exhibition of the
Vitra Design Museum and the Art and Exhibition Hall of the
Federal Republic of Germany (Bundeskunsthalle)

Vitra Design Museum:
26 September 2015 – 28 February 2016

Bundeskunsthalle:
1 April 2016 – 14 August 2016

Further venues are planned.

www.design-museum.de

Catalogue
Editors: Mateo Kries, Jolanthe Kugler
Editorial management: Jolanthe Kugler, Linda Novotny
Project coordination: Textschiff – Christina Bösel
Editing: Jane Havell
Translations: Büro y´plus – Maria Nievoll, Susannah
Chadwick, Kate Howlett Jones, Joseph Lancaster, Richard
Watts; Erika Pinner; Marian Kaiser ("violett")
Image rights: Linda Novotny
Lithography: Markus Bocher, GZD Media GmbH
Production management: Stefanie Krippendorff
Distribution: Stefanie Krippendorff, Irma Hager
Graphic design: Greige – Mark Kiessling, Birthe Haas
Printing: Graphicom, Vicenza, Italy

Exhibition
Vitra Design Museum Directors: Mateo Kries, Marc Zehntner
Curator: Jolanthe Kugler
Assistant curator: Linda Novotny
Bundeskunsthalle Directors: Rein Wolfs, Bernhard Spies
Exhibition Manager Bundeskunsthalle: Susanne Annen
Advisory Board: Joseph Grima/Space Caviar, Olaf Nicolai,
Philipp Oswalt, Jan Boelen, Wilfried Kuehn
Exhibition design/Exhibition graphics: Kuehn Malvezzi
Technical direction: Stefani Fricker
Installations: Michael Simolka, Anthony Bomani, Marc Gehde,
Martin Glockner, Patrick Maier-Blanc, George Pruteanu,
Dominic Sütterlin, Manfred Utz
Media technology: Ina Klaeden
Conservation: Susanne Graner, Leonie Samland, Grazyna Ubik
Registrar: Boguslaw Ubik-Perski
Curator collection: Serge Mauduit
Archive: Andreas Nutz
Press and public relations: Viviane Stappmanns, Denise Beil,
Sabine Müller, Gianoli PR
Partnerships: Yvonne Radecker
Exhibition tour: Reiner Packeiser, Sarah Aubele
Welcome & Information: Annika Schlozer
Education & Visitor Experience: Katrin Hager, Anna Deninotti,
Sarah Kingston

The German National Library lists this publication in the
German National Bibliography. Detailed bibliographical data
is available on the internet at http://dnb.dnb.de

Das Bauhaus #allesistdesign
ISBN 978-3-945852-01-9 (German edition)

The Bauhaus #itsalldesign
ISBN 978-3-945852-02-6 (English edition)

**Vitra
Design
Museum**

BUNDESKUNSTHALLE

Global Sponsors:

Funded by:

Baden-Württemberg
MINISTERIUM FÜR WISSENSCHAFT, FORSCHUNG UND KUNST

IKEA Stiftung

With the support of: